Darlene Davis

Vision and Invention

Vision and

Invention

A COURSE IN ART FUNDAMENTALS

Calvin Harlan

PRENTICE-HALL, INC., ENGLEWOOD CLIFFS, NEW JERSEY

VISION AND INVENTION:
A Course in Art Fundamentals

Calvin Harlan

© 1970 by PRENTICE-HALL, INC.
ENGLEWOOD CLIFFS, NEW JERSEY

All rights reserved.
No part of this book may be reproduced
in any form or by any means without
permission in writing from the publisher.

Current printing (last digit):
10 9 8 7 6 5 4 3 2 1

13–942243–9

Library of Congress catalog card number:
69–10224

Printed in the United States of America

Prentice-Hall International, Inc., London
Prentice-Hall of Australia, Pty. Ltd., Sydney
Prentice-Hall of Canada, Ltd., Toronto
Prentice-Hall of India Private Ltd., New Delhi
Prentice-Hall of Japan, Inc., Tokyo

to Felix

"The simplest form of teaching is to start a person on the plane of his imagination. This discloses his powers—or lack of powers—of observation."[1] Thus spoke Mark Tobey, the American artist, who, by all accounts, possesses many of the attributes of a great teacher. Observation, imagination, and, one would add, invention would be at the head of any list of qualities an instructor must promote, no matter what his program may be. These qualities, by their very nature, are personal; and any course in art must be judged, first and always, by its contribution to personal development. In order to help the student find his way to new visual experiences, the instructor will introduce him to works of both the past and present, and to what is beginning to happen in the student's own work. He will seek useful similitudes in the other arts, in the sciences, in the social milieu, and in nature. He will share enthusiastically many of his own discoveries and insights. In the degree to which his teaching becomes a spontaneous act, the more he will vary his language and approach. This being so, no course that he teaches, not even a foundation course, can remain exactly the same from one year to the next.

But certain principles, pertaining especially to structure, do remain remarkably constant, even in art of disparate function, style, and origin. It is these that deserve the most careful attention from the instructor, not entirely for the sake of making them understood theoretically by the student, but in order that they may influence his work from within. The latter consideration is important, for, while it is desirable that the student acquire a thorough understanding of the elements, principles, materials, and techniques of art, as a student in any other branch of study (e.g., physics, medicine, or engineering) would be expected to do, it is hoped that an immediate, facile manipulation of these ingredients will not stand in the way of further development in depth. The danger that it may has never

1] Colette Roberts, *Mark Tobey* (New York: Grove Press, Inc., 1959), p. 44.

been more real than in our own time, when art is a subject of constant speculation, and is, in many contemporary examples, a product of intellection, analysis, and improvisation. A great portion of modern art has come about, not from something as old-fashioned as "inspiration," but either through determined application of "concepts" (a favorite formalist term) or through use of available syntactical elements and displaced forms and images, especially in techniques known as *collage* and *assemblage*. Useful and attractive though these methods may be, they are not magic passports to art. The student cannot be reminded too often that in art, architecture, and design, the means never guarantee the ends. There are no shortcuts worth taking, unless optical sensation, pure and simple, or, far worse, sensationalism of every kind are considered fair goals.

The abbreviation "EX." in the text is used to indicate each problem. It is meant to denote two words—Experiment, Exploration —either of which could apply. This presupposes that most studies will be approached, after all, from the point of view of means. If this is true—and what course of training in art, other than the old apprenticeship system, can avoid doing so entirely?—it is important that each problem be seen in a larger context of time, place, and purpose. The teaching and the learning of art in modern times must occur along the shifting frontier where tradition (determined by numerous concrete acceptances and rejections) and experimentation meet. Otherwise, something very important is missing. Tradition alone (no matter how admirable), experimentation alone (no matter how "daring"), tend to produce sterile or ephemeral results, and engender little artistic stamina and discrimination in the student. The problem is, then, to devise studies in a particular sequence that will bring together, in action, the determinate and the indeterminate, the familiar and the unfamiliar, sensation and feeling, perception

and intuition, in a manner not unlike that of a game.

A foundation course is only a beginning, but it can set a student off with a self-confidence that will hasten his development throughout his school years and afterwards, when he is on his own. Facility and cunning, however, will not take precedence at any time over insight. Art, the supreme embodiment, focal point, and harbinger of human realities, will not be confused with empty contrivance.

The author is not as eager that this book be used as the basis of a course, either "as is" or in some modified form ("lineally" or formally, as studies occur in the text, or according to a more circuitous program), as he is that it encourage both instructor and student to ponder the central problem of art education: how to know "what we can afford to leave out." The intelligent student cannot leave this problem entirely to the instructor or the school, for in no contemporary discipline is he more responsible for his own development than in art. In the end, he should know, better than most, the meaning of the term "a liberal education."

Harold Rosenberg makes these appropriate comments in "Educating Artists":

. . . The basic substance of art has become the protracted discourse in words and materials echoed back and forth from artist to artist, work to work, art movement to art movement, on all aspects of contemporary civilization and of the place of creation and of the individual in it. The student-artist needs, while learning to see and execute, above all to be brought into this discourse, without which the history of modern painting and sculpture appears a gratuitous parade of fashions. What used to be called talent has become subsidiary to insight into significant developments and possibilities. In a word, art has become the study and practice of culture in its active day-to-day life. Begin by explaining a single contemporary painting (and the more apparently empty of content it is the better), and if you continue describing it you will find yourself touching on more subjects to investigate—philosophical, social, political, historical, scientific, psychological—than are needed for an academic degree.[2]

2] *The New Yorker*, May 17, 1969, p. 123. See an essay on a similar theme by Mr. Rosenberg: "Where to Begin," in *Encounter* (London), Vol. XXVIII, No. 3, March 1967, 36–40. See, also, Rosenberg's brilliant book on recent art, *Artworks and Packages* (New York: Horizon Press, 1969).

ACKNOWLEDGMENTS

My wanting to do something as basic as teaching a course in art fundamentals probably sprang from my desire to examine thoroughly all of those elements, concepts, and structural principles few instructors I had studied under seemed to know or care much about—and which I had been obliged to discover on my own after leaving art school. My original impulse was probably more selfish than altruistic, but I soon became interested in the way a comprehensive, questioning course in art could open the eyes and minds of students to hitherto neglected objects, realities, and feelings extending in almost all directions. At this point my work with students became more of a collaboration, and immediately more rewarding. While they were learning from my experience, I was learning from theirs. Therefore, my thanks must go to them first; whether they would wish to admit it or not, they are implicated in the writing of this book. A few contributed directly, in one way or another. Most are present or former students in the School of Art and Architecture, the University of Southwestern Louisiana.

I should like to express my appreciation to the University of Southwestern Louisiana and to the Louisiana State Board of Education for allowing me to go to Great Britain to participate in foundation programs at the Leicester College of Art and the Cardiff College of Art, both of which were organized by the gifted artist-educator, Mr. Tom Hudson. I gained greatly from that experience.

I must also express my appreciation to the museums, galleries, institutions, publishers, copyright holders, artists, and authors for the use of illustrations and quotations.

Finally, I thank Mr. James Kraft, Mr. Hardy Allbritton, and Mr. Leighton Williams, photographers, and Miss Barbara Clark, Mr. John Covell, and Mr. David Grady, of Prentice-Hall's editorial and production staffs, for their assistance, and Mr. Louis Baudean and Mr. James M. Guiher, of Prentice-Hall, and my wife, Joan, for their patience.

C.H.

Contents

Part III

Vision and Invention

Rediscovery of Color

To be original is to return to the origin.
ANTONIO GAUDÍ

To rediscover color is to revive an original sensibility. To have lost the full exercise of this rich, human gift is to pay the price of growing up at a time when feeling and intellect are not often allowed to thrive as equals. Theoretical, literate education is assumed to be more important than esthetic education. Our teachers, with few exceptions, are required to be more conversant in the language of abstraction than in the language of experience, despite the multiplication of vast impersonal powers in the "Organized Society" Paul Goodman describes in *Growing Up Absurd*.[1] Ours is a society that places training above education, that assigns jobs instead of roles;[2] therefore, it can come as no surprise that the unique qualities of many individuals fail to survive adolescence.[3] The education of both feeling and perception is neglected.[4]

But the challenge is gradually being met, and ideas of great teachers like Maria Montessori, Susanne K. Langer, Sir Herbert Read, and others are being recognized in a few places to good effect. The interest shown during the past 60 years in the art of children and of ancient and primitive societies has, in itself, provided useful insights about the foundations of human development. It has helped to introduce a new attitude toward color and symbolic expression, in opposition to a tendency characteristic of our classical tradition, which was to mock the love of bold forms and patterns in "savages," "peasants," and "barbarians," and to associate it, disparagingly, with "physical" (i.e. sensual, emotional) rather than "intellectual" qualities. But if we were more responsive to color, sound, and texture as children, or as primitives, it was because, at that moment in our lives, the boundaries between ourselves and our environment were not so sharply drawn, "the present sprawled out, heavy with sensed immediacy,"[5] and a sense of being in the

1] New York: Vintage Books, 1956.

2] Marshall McLuhan, *Understanding Media: The Extensions of Man* (New York: McGraw-Hill Book Company, 1965), p. 17.

3] Wylie Sypher, *Loss of the Self—In Modern Literature and Art* (New York: Random House, Inc., 1962).

4] See "The Biological Significance of Art," in Sir Herbert Read, *The Origins of Form in Art* (New York: Horizon Press, 1965).

5] Ernest Becker, *The Revolution in Psychiatry: The New Understanding of Man* (New York: The Free Press, 1964), p. 86.

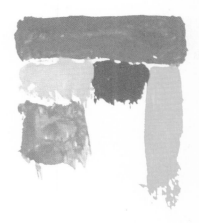
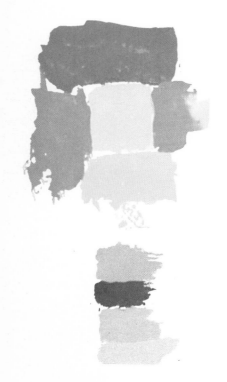

world, of feeling part of an esthetic-mythic reality was not yet embarrassed by intellect limited to "pure reason" or skeptical rationalism.

The Romantic movement of the later decades of the eighteenth century and the first half of the nineteenth century drew special attention to the child and to feeling. As Roger Shattuck states in his book, *The Banquet Years*, a "mood developed which re-examined with a child's candor our most basic values: beauty, morality, reason, learning, religion, law."[6] He adds: "Artists became increasingly willing to accept the child's wonder and spontaneity and destructiveness as not inferior to adulthood."[7] (The word destructiveness is not used here in a pejorative sense, but as the functional opposite of constructiveness. Both construction and destruction, acceptance and rejection, are involved in most creative acts.)

It is possible that a brief but intensive study of color may provide a most effective link to an earlier and perhaps more vivid state of awareness. The artist, more than anyone, needs to retain the capacities of both childhood and adulthood. He cannot afford to relinquish either in our "runaway technological civilization."[8]

Pigments

Serviceable colors seem always to have been in good supply from animal, mineral, and vegetable sources in most parts of the world. Clays rich in iron and manganese oxides evidently provided the few essential colors for Old Stone Age societies. In the New Stone Age, however, when man began to live in settled communities, raise his own animals and foodstuffs, develop his tools and techniques, and elaborate his arts and ceremonies, many more colors were needed.

These were often found in strange and unlikely places. The Indians of Mexico and Central America prepared a red dye from the dried bodies of the females of a small insect, the cochineal, that lives on cactus. Artists and scribes of ancient Mediterranean cultures discovered a brown (sepia) in the ink sac of the cuttlefish. A purple was found in the murex shell. A blue and a green came from azurite and malachite, both crystals of copper carbonate. Cinnabar provided orangey reds. From the leaves of the indigo plant and from many other herbs, roots, and barks were extracted the most subtle colors for dyeing textiles. But, for extravagance and brilliance, nothing in nature could surpass one source: tropical birds. Plumage in the art of featherwork was one of the splendors of Amerindian cultures.[9]

We shall begin with the more familiar, modern pigments, since these materials, in one form or another, will be used in most of the experiments to follow. Since the middle of the last century, they have been available in tubes as oil paints, water-based paints, and, more recently, acrylic paints. From about the same time, they have increased in range of color, tincture power, and permanency through advances in color chemistry.[10] Therefore, the choice of paints, including type and manufacture, for the studies that lie ahead deserves careful consideration. Designers' colors, or gouache, a semi-opaque water paint, are cheaper and easier to control than most types. They are not as delicate in consistency as watercolors proper, nor are they as heavy as casein. Oil paints dry rather slowly. The fact that they are sometimes "messy" should not be allowed to prejudice anyone against their use, even in these early experiments.

One thing is certain: the visual arts cannot be created from "thin air." Some kind of

6] (Garden City, N.Y.: Anchor Books, Doubleday & Company, Inc., 1961), p. 32.

7] *Ibid.*, p. 32.

8] Susanne K. Langer, *Philosophical Sketches* (New York: Mentor Books, 1964), p. 94; see also Martin Heidegger, *An Introduction to Metaphysics* (New Haven, Conn.: Yale University Press, 1959), and R. G. Collingwood, *The Principles of Art* (New York: Oxford University Press, Inc.—Galaxy Books, 1958).

9] See S. K. Lothrop, *Treasures of Ancient America*, (Skira, 1964), Aztec Ceremonial Shield, p. 67.

10] "The chemistry of the pigments is interesting: ivory black, like bone black, is made from charred bones or horns, carbon black is the result of burnt gas, and the most common whites—apart from cold, slimy zinc oxide and recent bright titanium dioxide—are made from lead and are extremely poisonous on contact with the body. Being soot, black is light and fluffy, weighing a twelfth of the average pigment: it needs much oil to become a painter's paste, and dries slowly. Sometimes I wonder, laying in a great black stripe on a canvas, what animal's bones (or horns) are making the furrows of my picture." Robert Motherwell *Black and White*, exhibition catalogue, New York, Samuel Kootz Gallery, 1950 [see Frank O'Hara, *Robert Motherwell* (New York: Museum of Modern Art, 1965), p. 43].

medium is required, some physical substance —paint, wood, paper, metal, stone, glass, plaster, rags, or even bones. Most media are "difficult" until one begins to appreciate their intrinsic qualities. Getting used to mixing and handling oil paints may prove to be a valuable experience, especially for students who plan to continue in so-called fine arts. Students who hope to receive further training in graphic design and other forms of applied or functional design may prefer the water-based media for their two-dimensional studies.

The experiments to follow will require all of the available reds, yellows, and blues (the cost of many may be shared, initially, by the whole class). The reds in most manufactured paints include the cadmium reds, vermilion, alizarin crimson, burnt sienna, Indian (or Venetian) red, and Mars red. The cadmium reds, light, medium, and deep (and cadmium orange), are heavy mineral colors, combinations of cadmium sulphide with cadmium selenide. Modern vermilion is a variety of mercuric sulphide. Modern alizarin crimson is an artificial dye color; before the middle of the last century it was a genuine organic color, made from the madder root. Burnt sienna is an earth color. Indian red is an iron oxide. Mars red and, in fact, all the Mars colors are artificially prepared iron oxides.

The yellows include the cadmium yellows, lemon yellow, yellow ochre, Naples yellow, raw sienna, and Mars yellow. The cadmium yellows, pale, medium, and deep (and lemon yellow), are varieties of cadmium sulphide. Yellow ochre is an earth color; so is raw sienna. Modern Naples yellow is likely to be a combination of cadmium yellow, white, and ochres.

The blues include the important dye color pthalocyannine blue (usually given the name of the manufacturer, e.g., Winsor blue); Prussian blue, a ferrocyanide of iron; ultramarine blue, either the genuine lapis lazuli or the artificial sort made of a variety of materials and in a variety of ways, depending on price and manufacturer; cobalt blue, taking its color mainly from aluminate of cobalt; and cerulean blue, a stannate of cobalt.

These colors, because they are made of pigments that range in quality from heavy to light, are not of the same density and strength, even if they belong to the same medium. Oils, especially, vary greatly in body and consistency, which affects their ability to mix with each other, their covering power, and often their rate of drying. Molecular structure and grain differ with each pigment. These and other physical characteristics can be appreciated only by mixing and applying colors of various thicknesses to different kinds of surfaces.

The student will need, at the outset, a complete set of reds, yellows, or blues, a supply of large heavy, white paper, a board and thumbtacks to hold the paper while working, a large portfolio, a baking sheet or piece of glass of a generous size for use as a palette, a palette knife, a supply of rags, a cheap 1½- or 2-inch household brush, one or two artist's bristle brushes, turpentine or turpentine-substitute (if oil paints are chosen), and a coffee can or jar for holding turpentine or water.

Physical qualities

In the first experiment, primary attention should be given to the physical qualities of the medium. The paint should be squeezed

onto the palette in what would seem a suitable amount for each undertaking. Most of the mixing and thinning of paint in this and subsequent experiments should be done *on the palette*, not on the paper to which the paint is applied, if streaky mixtures are to be avoided. The palette knife should be used for mixing—not the brush, except for last minute adjustments. If large rags are torn into napkin-size pieces and discarded as they become loaded with paint, there is less likelihood of paint being transferred to hands, face, and clothes. These and similar "studio hints" are useful at the beginning, but eventually each person evolves his own best way of handling materials.

EX. 1

Apply the colors—all of the blues, all of the reds, *or* all of the yellows—to the white paper, with attention first to physical qualities, that is, relative thickness or thinness, observing the nature of each pigment. Apply the paint with a loaded palette knife as you would apply soft butter to toast. Then drag it on other areas of the paper, slanting the knife towards its edge while pressing down hard. These two operations should produce a "wet," or viscous, and "dry" quality, respectively. A brush will produce a different effect, depending on whether the paint it carries is thick or thin. If the paint is very thin, the result will be a stain. These purely physical qualities—*not* "expressive," gestural, pictorial, or decorative qualities— are *all* that require attention at this stage. Some will have to resist a tendency to go beyond this simple aim. Squarish shapes, touching and overlapping, are preferable to dashing strokes and fancy "artistic" flourishes. When quite a large area has been covered with every imaginable application of every color pertaining to a single family or

hue, pin the paper before you or the class and examine the results.[11]

Psychological qualities

We may single out, for purposes of instruction, two separate qualities in the results of this experiment: the physical and the psychological. The physical qualities are more immediately recognized and appreciated. They appeal to the sense of touch or that aspect of touch that seems to carry over into sight or memory. Psychological or perceptual qualities, on the other hand, are likely to be more deceptive, and require the kind of sustained examination of visual phenomena that this course will attempt to encourage. The eye, the optic tract, and the center of vision in the brain, functioning like a rare television instrument, transform the energy of light received into a kind of electrochemical energy within. While doing this, they also translate a multitude of stimuli into meaningful unities or percepts. It is this second function—the ordering, abstracting, and translating of visual data—that commands special attention, for it and the reservoir of experience, memory, underlie all image-making. (Why, one may ask, is there no art based on the sense of smell, in spite of the fact that certain odors are capable of arousing the most deeply buried memories? Could it be that scent, unlike tone or even color, is not amenable to "measure"?)

The psychological properties referred to here are usually of comparative rather than absolute value. We distinguish light colors from dark, intense from somber. We refer to some areas as warm and others as cool. We say that some colors seem to advance, others to recede. Some colors, no matter how thickly applied, seem opaque, some transpar-

ent; some "heavy," some "light" (in weight); some "wet," some "dry."

EX. 2

These and other illusory qualities will appear in another experiment in which paints of the three basic hues are mixed in combinations of two and three, and some, perhaps, with white [**P-1**]. Since many more elements of contrast will exist among these mixed colors, the observer will probably be made aware of effects hitherto ignored, such as expansion and contraction, or "slow" and "fast" (the intense yellows seeming "faster," the blues and violets "slower"). This experiment will also result in a number of broken or diminished colors, which will be the subject of more discussion in Part III: "Color."

It is not necessary that the mixtures be placed together in one large block of colors. They may be more effective if arranged in large and small patches consisting of three to six colors only. They may vary in size, shape, and density, from heavy impastos to stains, and may touch, overlap, or lie within each other.

Color In Found Objects

EX. 3

a● In order to extend this experience to the environment of everyday life, collect as many small objects as possible of red, yellow, and blue coloration, regardless of how bright or dull, or how clean or soiled they may be. They should be rather flat so that they may be glued down on heavy paper without too much difficulty, and the glue must be fast-drying and strong. Leaves, scraps of colored paper or cloth, cellophane, bits of glass, pieces of pottery, painted surfaces, flowers, plastics, thin

strips of metal, metal foil, and similar, generally available, worthless materials will serve admirably. Arrange these "treasures" in groups consisting of two or more pieces of the *same* color family, giving them as much affectionate attention as you would give to things of value. Allow contrasts among large and small sizes and textures, rough and smooth, to play a part in each assemblage.

b● After completing several studies in one color key only, the student may wish to combine objects of two hues. He may also wish to add color with paint to any group, to the scraps themselves, or to the areas around them. His aim should not be merely the creation of tasteful arrangements, but the juxtaposition of colors that "come alive" and command attention, that seem strange, or even vicious. He could try to visualize these imaginatively—perhaps as carnival folk or gypsies who, for the moment, have made a vivid encampment.

Color in Nature

EX. 4

A final study should be made from a single object from nature—a flower, preferably. Having chosen a flower of some variety of hue, the student should examine it *inside and out* for the most subtle permutations of color and condition. He should be prepared to "tell" more about a flower than he is likely ever to have gained from previous viewings. Normally our habits of observation are so cursory and our visual memory so imprecise (most husbands, we are told, cannot remember the color of their wife's eyes) that only by sustained, purposeful examination and a kind of color "note-taking" may we hope to appreciate the color structure of one of nature's most beguiling creations.

If our purpose here were to understand more about the phenomenon of color in bird plumage, fishes, butterflies, moths, beetles, flowers, or eyes—the secrets of pigmentation

12] "Newton did not destroy the beauty of the rainbow when he resolved white light into its constituent colors, nor did Willstätter dim the beauty of the rose when he isolated flower pigments and found their chemical nature. Van Gogh painted the sunlight in a field of poppies; Willstätter and Stoll pointed out the oxygen atom, caught in a ring of carbon atoms and carrying a positive charge, that is characteristic of the poppy pigment and most anthocyanins. Surely it is permissible for one man to enjoy both kinds of insight, the artist's and the scientist's." Harold F. Walton, "The Humanistic Values of Science," *The Colorado Quarterly,* Vol. XIII, No. 3 (Winter, 1965), 215.

—we should have to divert our attention to one of the most fascinating and speculative areas of natural history.[12] But our aim is merely to examine each part of a single flower at close range, mix color equivalents of what we are able to find, then state these broadly as shape or form equivalents, also abstracted from the flower.

Basically, to abstract is to extricate, to draw forth only a few of the many elements seen in organic unity in the object, and to reconstitute these features in a "structurally purified" way. Once this is done, the drawing, painting, or sculpture bears only a "symbolic" or semblative relationship to the source. No art, no matter how "realistic" it may appear, can come closer to the condition of nature than this. The patterns of form and energy in art do correspond to those in nature, but they exist in a very different context. Their order, which is one of the most gratifying that man is able to experience, is autonomous *and* intensely human, whether or not it contains clear references to nature. Art's ultimate value lies in its ability to contain, in surprising equilibrium, something of man's world, past and present, and something of the world of phenomena. It represents a human encounter that promises meaning. In the degree to which it reconciles man to nature, to his own domain, his own condition, and his authentic self, art extends the experience of the individual beyond the limits of his restricted field. It broadens the dimensions of reality by transforming sight into "a kind of oracular insight."[13] It becomes the bright, projective vision—the construct, the artifact—in which life contemplates itself from without.

Mix the color equivalents accurately on the palette, even those colors that are the result of deterioration in the flower. Different types of surfaces on or within the flower may make recognition of the true local colors difficult, and the problem of color proportion may require more sustained observation than has been directed to any single object before.[14] The results, however, will vindicate one's efforts. Put down each color with palette knife or brush in what seems to be its correct area extension, in shape equivalents that are conveniently large, audacious, and simple. It is of particular importance that shape and color analogues be determined with care, and that every mark committed to paper be the result of direct experience, not guesswork.

We are reminded that all creative activity of the highest order takes place at the "height" of particular historical periods, and that, although modern art and science may have separate aims, there is no reason to believe that the most perceptive artists and scientists are as opposed in attitude and spirit as some would like to suggest.[15] In our most vital and characteristic art and science, for instance, reality is understood not as forms existing independently in a vacuum, but in terms of pattern and process, organism-environment transaction,[16] and according to the way we, as human beings, apprehend and interpret experience.

Images of the sort that are likely to result from these and other studies may not conform to an older vision of reality, but they will have their own value. Some of them will be not merely instructive, but beautiful in their own right. Their importance for us will depend mainly on the wealth of germinal ideas (from the Greek *idein*, to see) they evoke. The enhancement of our ability to recognize and develop these ideas will be among the important benefits we may hope to gain from this or a similar course.

13] P. A. Michelis, "Aesthetic Distance and the Charm of Contemporary Art," from Leo A. Jacobus, *Aesthetics and the Arts* (New York: McGraw-Hill Book Company, 1968), p. 33.

14] It is advisable that the student mix *all* of the color equivalents on the palette first, and arrange them in a corner of the paper as swatches in the same ratio as they occur in the flower. Then the same colors may be restated as shape or form equivalents derived from the anatomy of the flower.

15] "A fundamental revision of man's attitude towards life is apt to find its first expression in artistic creation and scientific theory." José Ortega y Gasset, *The Dehumanization of Art* (Garden City, N. Y.: Anchor Books, Doubleday & Company, Inc., 1956), p. 39.

16] "Environments are not passive wrappings but active processes." Marshall McLuhan, *Understanding Media: The Extensions of Man* (New York: McGraw-Hill Book Company, 1965), p. vi.

Point

Man needs to "imagine the real."
MARTIN BUBER

The point, the first of several elements we shall work with, is not likely to pose great difficulties. Most people, young or old, can make a simple arrangement of points with no previous experience of "making art," even if some seem able, at first attempt, to create more lively combinations than others. But the question of talent that so often arises, even at this early stage, will not be our first consideration. Each person must discover on his own, in due time, why he has chosen art as a language, a "means of self-expression," a satisfying activity, a vocation, and whether or not he is able to bring to it the necessary energy, imagination, and enthusiasm.

The purpose of this book is to outline a course of inquiry and exploration that is broad enough to allow each student to make many important discoveries in his own way, and, ideally, in his own time. His achievements may appear, on the surface, to be purely technical and to pertain to an altogether new set of skills. But, at a different level, they should have an important bearing on his whole outlook, depending on how penetrating and personal his experiences have been. Art, as a creative act, is a method of trying to know the world through feeling, and ourselves *in* the world. It is not merely a skill taught in an art school that one can eventually turn on and off as the occasion demands. Certainly it is not undertaken through the learning of rules and formulas. Nothing can obscure the importance of research, imagination, and invention.

But the arts do involve disciplines that are often as subtle and demanding as those associated with the sciences and technology. Few people recognize this today, though presumably no one would have doubted it during the Renaissance. Indeed, it would hardly have occurred to anyone at that time that art and science were separate activities. Leonardo, in the true spirit of the age,

I-5

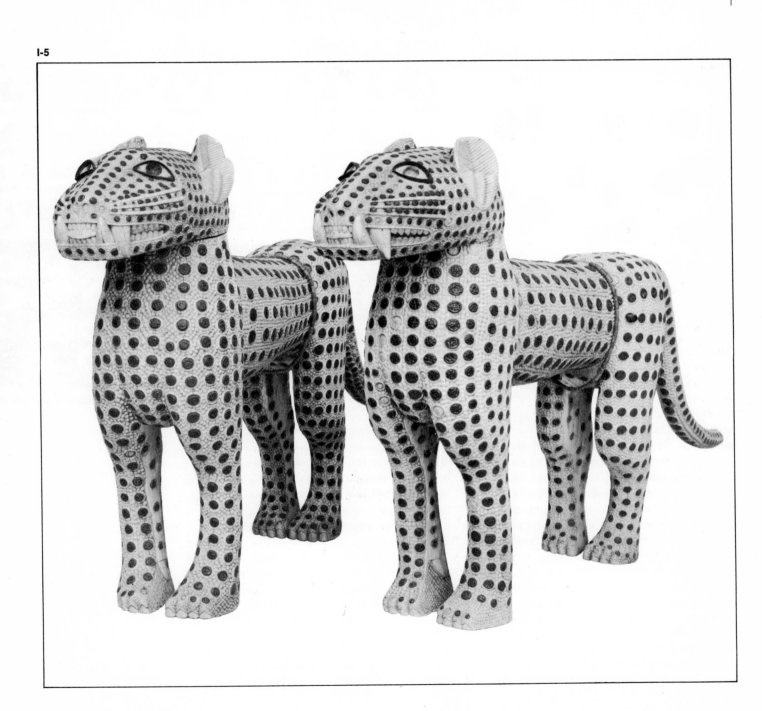

I-1

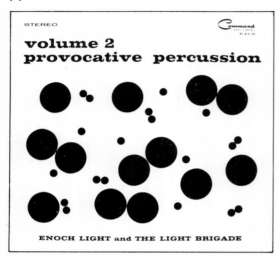

STEREO Command records

**volume 2
provocative percussion**

ENOCH LIGHT and THE LIGHT BRIGADE

I-2

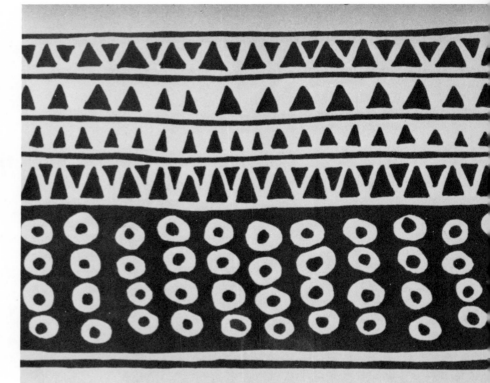

I-1 Record cover design by Josef Albers. Copyright 1960 Grand Award Record Co., Inc.

I-2 This sequence of round and triangular points is from a small baked clay object or stamp from the region of Mexico City. From *Design Motifs of Ancient Mexico*, compiled by Jorge Enciso (New York: Dover Publications, Inc., 1953), p. 3.

proved to his satisfaction that painting was, as he put it, a "true science."[1] Such an idea would not occur to artists of the present age, even though both they and modern scientists engage in continuous experimentation. Many painter-sculptors of recent years have chosen to put aside all traditional attitudes and methods in their ways of working—and, seemingly, all fidelities except the most private and, some would add, the most "successful."[2] No doubt they have had their reasons for doing so, since no worthy artist, composer, or poet of the twentieth century has been able to avoid taking stock of his "position" vis-à-vis the startling, ubiquitous realities of the modern

age and, therefore, of his mode of expression. But it is also true that every artist cannot expect to remain disengaged. The potter, the designer, the woodworker, and the architect, for instance, cannot as easily escape the demands of materials, processes, and purposes, now or in any other age. Each is forced to examine the origin and the function of his art and its sources in the past and present, in himself and in his environment.

Our "point of departure" would be the point itself, the most rudimentary element of design. It may or may not derive from something seen in nature, although nature does embellish many of her forms with this device: bird feathers, seashells, flowers, and

1] "It is usually said that the Greeks had no word for art, and the word *techné* is substituted; but the Greeks had no word for art because they did not conceive it as separate from the apprehension of reality, the establishment of being, from physics and metaphysics." Herbert Read, "The Origins of Form in Art," from *The Man-Made Object*, Vision + Value Series, G. Kepes, ed. (New York: George Braziller, 1966), p. 45.

2] Peter Yates, author and critic, makes the following comment in a letter to the author on a lot of characteristic and successful art of recent fabrication: "Certainly something is trying to become apparent through all this labor, but the suc-

10

I-3 A decorative bird from the side of a large Indian pot from New Mexico. The points have been applied by light, staccato jabs of the brush. Collection of the author.

I-4 Franz Boas includes in his book *Primitive Art* this double necklace of the Thompson Indians of British Columbia, which is a fine example of beadwork. The rhythmic series of beads (points) follows this order in the inner and outer lines—black, red, yellow, green, blue, green; and this order in the connecting links —black, red, yellow, green, red, blue. From Boas, *Primitive Art* (New York: Dover Publications, Inc., 1955), Fig. 36, p. 41.

I-5 Benin Ivory Leopards. On loan from the Royal Collection to the British Museum. Copyright reserved. By permission of the British Museum and the Lord Chamberlain.

I-6 Braille. The raised points are arranged at regular intervals, vertically and horizontally though positions in the grid are often skipped.

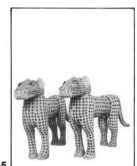

I-5

I-4

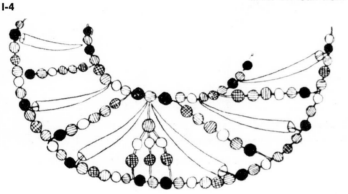

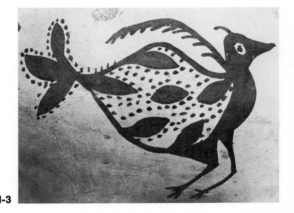

I-3

cess of whatever appears, as salable object, defeats the effort to go beyond it: one is drawn ever ahead in the same direction. The consequence is what we know to be 'salon art,' of our period. Who in some hidden place is challenging the entire project?"

3] Gerard Manley Hopkins, *Poems of Gerard Manley Hopkins*, 2nd ed. (London: Oxford University Press, 1930), p. 30.

4] See Plates 79 and 82 in Wolf Strache, *Forms and Patterns in Nature* (London: Peter Owen Ltd., 1959).

5] Command Records, e.g., RS 810 SD, Vol. 2 "Provocative Percussion" and RS 812 SD "Bongos/Flutes/Guitars."

fish—the "rose-moles all in stipple upon trout that swim" of Gerard Manley Hopkins' poem, "Pied Beauty."[3,4] It could even have a certain interest or beauty of its own, especially if viewed very closely. But, as a point, it is always limited to a size too small for sustained interest. It is almost always seen in combination with other elements, such as other points, lines, or shapes. Like a single note in a musical composition, it is only one of a group or series, important mainly because of its place, its position in the series.

This introduces two of the most fundamental considerations in all design: position and repetition. Position is relative. Points must relate to other points, other elements, as well as to the intervals of space between them. Nothing in design is more important than the latter, though many students begin with little appreciation of space, the indispensable if "silent" partner in even the simplest design.

Some designs consist of points alone, such as those seen on printed fabrics, decorated wrapping paper, and wall paper. The noted artist and teacher, Josef Albers, recently used points almost exclusively in a series of designs for record covers, with results both simple and sophisticated [I-1].[5] Primitive societies, in general, seem to favor point design in textiles [I-2], on painted surfaces of

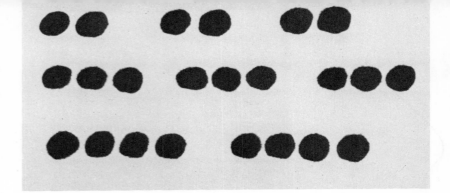

I-7

all types [**I-3**], in the arrangement of beads, baubles, and shells in their jewelry [**I-4**], on the surfaces of their pots and sculpture [**I-5**], and even on the human body itself in the art of scarification and tatoo. Our modern use of points frequently extends beyond the realm of art and decoration. The Morse Code, the Braille System for the blind, and the perforated electronic tape are examples of other ways of using points, related, in these instances, to another mode of communication [**I-6**].

If a point in itself is of little importance, it gains importance as soon as it takes its place in a design. This is our first consideration: not points as such, but the arrangement of points in variously related positions that give rise to some kind of repetition. Repetition underlies virtually all design, no matter how simple or complex. We immediately recognize three types of repetition: 1) sequence, 2) rhythm, and 3) balance. We begin with the simplest type, sequence, which is repetition of points, lines, shapes, or forms at equal or regularly varying intervals, as in a row of buttons on a shirt or the windows of a building.

Regular Repetition—Sequence

EX. 1

a● Place several points of about equal size in a horizontal sequence or row. Start with a row of single points made with a soft pencil, soft charcoal stick, or a small pointed brush and India ink, spacing them fairly evenly. Then put down several rows of points consisting of groups of two, three, or four points [**I-7**]. These groups will form simple motifs or individual design units. In order that they be recognized as such, care should be taken to separate them by intervals slightly wider than those that lie within the groups.

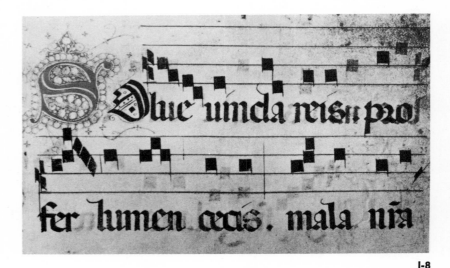

I-8

I-9

I-10

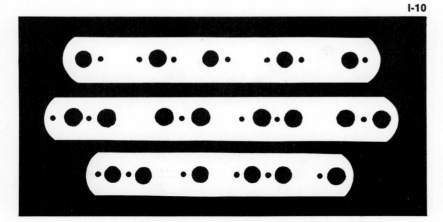

I-7 Three rows of points arranged in groups of two, three, and four points. The eye may move to the right or to the left, and any row may be continued indefinitely.

I-8 Music manuscript of a hymn (c. 1415). By permission of the British Museum. Musical notation makes use of points to signify patterns of sound and rhythm.

I-9 Rows of point motifs in which certain points have been shifted (staggered) in one or more directions.

I-10 Rows of point motifs containing large and small points in both balanced and un-balanced arrangements. Here is the beginning of rhythm. The strong and weak accents or beats (large and small points) may be tapped out with the fingers or a pencil on a table top.

If these horizontal rows resemble musical notation to some extent, the reason is clear: sequence is of the very nature of music, occurring in patterns of tone and rhythm over a period of time [I-8]. The sequence happens; we listen, we pay attention. As we place points on paper, one following another, they also happen, but once the series is finished, we, the observers, will probably retrace the event by assimilating the points as directional movement, to the right or left. In the case of regular repetition or sequence, the eye may choose to move in either direction. In the case of rhythm, the eye will probably be induced to move in a particular direction. (Whether most observers, young or old, experienced or inexperienced, follow pictorial movement in quite such an orderly fashion is open to question. Nevertheless, sequence and rhythm have always been two of the most effective constituents of art. In dance, drama, and music, sequence and the order of perception are integral parts of the work itself—its form and, to some extent, its content.)

b● When several rows of points have been completed, with units (motifs) of from one to four points, the student may then alternate two or three different units in a series. He may wish to develop this in still another way by staggering in one direction—either to the upper right or upper left, or to the lower right or lower left—one or more points of each unit [I-9]. The student may also use points of two sizes, large and small, or in graduated sizes, or "solid" and "hollow" ones, and so on, either in straight sequence or staggering sequence [I-10]. These regularly varying examples anticipate the problem of accented repetition, or rhythm.

Accented Repetition—Rhythm

Rhythm, unlike mere sequence, is directional movement or progression, created by a pattern of strong and weak pulsations. The rhythmical configurations of music are, of course, music itself. The rhythmical configurations of art and architecture, though of great importance, are of a different order. They consist, as it were, of implied or "frozen" rhythms. Rhythm, instead of being a constituent of actual time and movement, as in music, is recast and presented simultaneously. It lies in wait of an observer. It may be modest and lie on the surface, decoratively, or it may inform the whole design to a depth that is beyond simple analysis. Its energy is discovered by those able to participate imaginatively in great paintings, sculptures, and buildings.

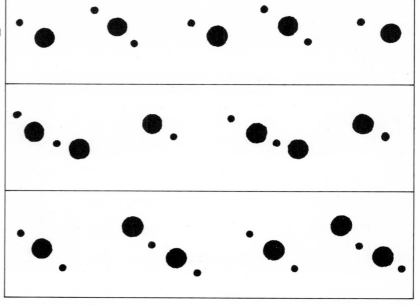

EX. 2

The student may create a rhythmical sequence by arranging large and small points in variously staggered positions [**I-11**]. A combination of strong and weak accents, rising and falling attitudes, wide and narrow intervals of space, or alternating motifs will produce effective pulsating movements.

Stabilized Repetition—Balance

The third type of repetition is stabilized repetition or balance; though it may occasionally have elements in common with sequence and rhythm, it will not suggest movement along a continuous path. It restrains movement and organizes weights and tensions around a "center of gravity" that may not be stated in the design. If there is movement or "pull" in one direction, there is counter-movement in the opposite direction across this center. Weights balance each other as do two children on a seesaw —the fat boy sitting near the fulcrum on one side, the thin boy sitting farther away on the other. However, the kind of balance we encounter in art, while not contradicting the law of the lever, is of a sort felt intuitively by the observer, and therefore not very easy to set forth in words or figures.

Occult or Asymmetrical Balance

Occult or asymmetrical balance is particularly difficult to describe. It involves a balance of various interests and qualities more than a balance of weights. Examples would include a large area of blue against a small area of red, a solid against a void, an area of great interest against an area of little interest, or near objects against far.

The finest examples of occult balance occur in ancient Chinese and Japanese paintings, the art of flower arranging, and

I-11 The alternation of motifs, the staggering of points, and the strong and weak accents in this series create a more graphic illustration of rhythm and establish a more positive directional movement, as in a dance.

I-12a The sixteen points in this absolutely symmetrical arrangement are placed at regular intervals, vertically and horizontally.

I-12b These arrangements are more interesting as designs. They demand a bit more of the observer.

I-13 In these arrangements, two groups are pitted against each other—the large points and small ones. Their conflict is resolved in the total arrangement in each example.

I-12a

I-12b

the art of the Japanese garden. Japanese domestic architecture is apt to be of the same order, in contrast to the hieratic symmetry of temples and shrines. Occult balance is preferred in most instances because of its "naturalness," informality, and, possibly, because it involves the spectator to a greater degree than any other type. Since he is made to feel the unequal rhythms and tensions, he participates a bit more actively in the internal life of the design.

Obvious Balance

Obvious balance, as the name suggests, is the sort that most people have little trouble recognizing. Many will prefer it because it is familiar, stable, absolute, and "safe," but after a time it becomes very dull unless relieved by internal contrasts and rhythms. We encounter it in the house with a front door placed dead center between two bay windows, or in a mantelpiece with a clock at the geometric center of the space between two brass candlesticks. With or without the clock, the balance would be perfectly symmetrical.

EX. 3

a• Five to ten points made with a soft pencil will serve well enough to create examples of both obvious and occult balance. In each of the following studies, try to place the points at equal intervals apart, vertically and horizontally, as in a grid.
b• If necessary, use graph paper at first and place the points at the intersections. After a little practice, one should be able to judge positions accurately without any artificial aid, occasionally skipping over one or several intervals for more unusual designs.
c• Many studies should be made in both obvious and occult balance with points of equal size at first. Then, having experienced some degree of success in these, the student should make several more designs with points of two sizes [**I-12a, b**] A new system of relations will be recognized in these. The large points will form a pattern of tensions between themselves ("tension connects"); the small points will form another. One may start with a solid, symmetrical block or field of evenly spaced points, and then, by making one or more of these points larger than the others, transform the whole arrangement into a more precarious sort of balance [**I-13**].

I-13

I-14

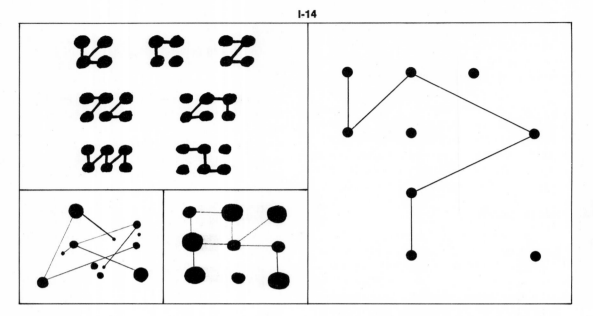

I-14 An arbitrary system of tensions is created in these examples by means of lines that connect most of the points.

I-15 "Ink Drawing, 1926," by Pablo Picasso. From Alfred H. Barr, *Picasso, Fifty Years of His Art* (New York: Museum of Modern Art, 1946; distributed by Simon and Schuster, Inc., N.Y.), p. 144. Permission SPADEM 1967 by French Reproduction Rights, Inc. In this kind of inspired doodle, Picasso has used points and lines to create playful movements in space.

d● Similar results may be achieved by positioning points of the same size and then connecting some or all of them with straight lines running vertically, horizontally, or diagonally [**I-14, I-15**]. The original arrangement of points may be either symmetrical or asymmetrical. The lines will disturb the old tensions and create new ones of greater force and complexity.

All-Over Patterns

That repetition is one of the basic principles of design will be demonstrated in this group of studies in which points are repeated in a variety of ways across entire surfaces. Points are used to mark positions and establish interesting space relations in the diagrammatic fields used in patternmaking. Weavers of textiles and designers of printed fabrics, wallpapers, and other surfaces, such as mosaic pavement, which are covered with either simple or complex patterns, have to decide upon some scheme of repetition for each of their designs. Although design units or motifs may be interesting when viewed separately, they must lend themselves effectively either to regular or regularly varying repetitions, even at the risk of being obscured by the larger complex. The field method is perhaps the simplest way of dealing with all-over pattern repeat. The design motif replaces the point in the field. It may be inverted, it may alternate with one or more motifs, but its position is determined by the basic field pattern. This method works well enough until one attempts the use of intricate line motifs. Then the problems arising from area division and strong curved or angular line rhythms demand other solutions.

Dividuality—Individuality

Paul Klee, the great Swiss painter and teacher, introduced the terms *dividuality* and *individuality* in several of his prepared

I-15

lessons in design. He applied dividuality to those structures that may be extended indefinitely, or divided arbitrarily, without causing any significant change in their structural pattern. The elements employed in these structures may be point or line. Our diagrammatic field is a perfect example of dividuality.

Individuality, on the other hand, applies to those structures that are *not* divisible (as the word, in-dividual, denotes). We frequently use the word individual to describe someone who stands out from other people because of some distinctive trait or achievement. He may be willing to take part in group affairs, but is not likely to remain an anonymous participant. The more individual, the more eccentric or complex a person he is, the less likely is he to join the rank and file.

Design motifs share the same characteristics. They are self-contained units of definite measure, of unique structure. Nothing can be added or subtracted without changing them entirely. But, depending on their degree of complexity, they may submit to repetition, as in all-over patterns. A structure that is "non-rhythmic," different in every part, may resist any manner of repetition. Such a unit would not be the type we refer to as a motif.

Properly understood, a motif is a relatively simple, individual unit that does not resist repetition or even development, as in a musical composition. Beethoven was fond of simple motifs, and developed them into the most elaborate structures of sound. The first movement of his Fifth Symphony provides a familiar example in the four-note motif of its first measure. A less familiar example is the staggered two-note motif of his Sonata for Piano No. 30, Op. 109. From this simple figure he was able to weave the greater portion of its first movement.

EX. 4

a● The student may begin this study by creating six or more individual point motifs with stamps cut either from pieces of potato or from gum erasers [I-16a, b]. One or two colors may be used to print these simple units. They *must* be simple, consisting of not more than one to five components; one should bear in mind that, however interesting each motif may be in its own right, it must lend itself effectively to repetition, with or without a partner. As this study is pleasant and relatively easy, the student may wish to experiment quite extensively.

The second operation is begun by inventing several diagrammatic field-patterns or points (graph paper is useful in this). Patterns based on horizontal sequences in perfect vertical alignment, and then in alternating positions in succeeding rows, are commonly used examples [I-17]. In both instances, the horizontal and vertical intervals are equal.

A more intricate field is the result of unequal spacing. For example, the horizontal intervals may be wider than the vertical, or vice versa, or the points (positions) may be grouped by twos or threes, and so on [I-18].

When it comes to stamping the chosen motif at these point positions in the chosen field, one may create a surprising number of variations by inverting the motif, staggering its vertical location in succeeding rows, or alternating two agreeably contrasting motifs [I-19]. There is no need to adopt a new motif for each experiment in all-over pattern. Instead, one should use the same motif (or motifs) on other diagrammatic fields. The field pattern alone, with each new arrangement of positions, is capable of transforming the design almost indefinitely [I-20].

In order to be effective as all-over design, an area at least four inches square should be printed. Then the possibility of the design being used on a variety of surfaces—cloth, paper, or clay (ceramics)—will be recognized immediately.

I-16b

I-16a

I-16a Six individual point motifs made with potato stamps. The circular one was chosen for all-over repeat; since it had a line through its center, it could be repeated with variations in orientation (see I-19).

I-16b This design, which bears a slight resemblance to a snow crystal, is made from a variety of small, simple motifs (five in all). It would not lend itself to repetition quite as easily as any of the smaller points from which it is made.

I-19 Six examples of all-over pattern design.

Each makes use of a simple diagrammatic field. Variety and interest is achieved by the alteration of motifs, colors, or orientation, or by heavy and light stamping.

I-20 A section of steel plate with raised (anti-skid) areas arranged in all-over repeat.

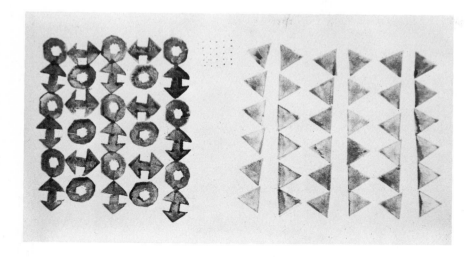

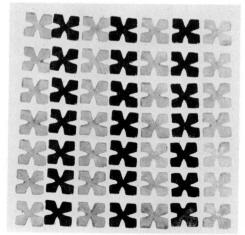

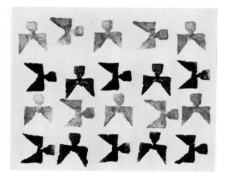

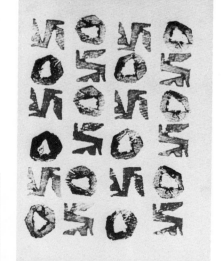

I-19

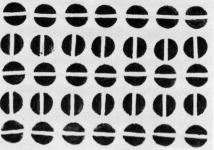

I-17

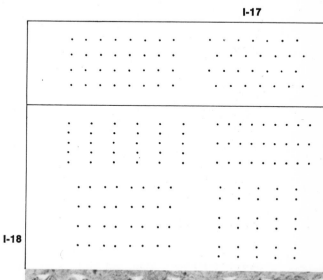

I-18

I-20

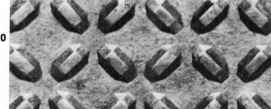

b● After so much regularity, the student may enjoy arranging point motifs in less predictable ways, by combining the expected with the unexpected, the regular with the irregular [1-21]. The results will resemble a kind of visual joke at times. For example, a motif may be repeated on what appears to be a regular field and then, for no apparent reason, one or more positions in a row may be skipped, the motif may be placed out of line, appear in another color, go from solid to hollow, or be oriented in another direction. "Mishaps" of this nature add variety and a certain interest to a design.

These studies may be carried out with either potato stamps or pieces of cut paper about the size of the thumb nail, which are glued in place once their positions have been determined.

The rows of tesserae (small blocks of colored marble or glass) in a mosaic design are often fascinating because of similar anomalies. The forces of nature arrange such forms as pebbles, flotsam, and clouds in the most intricate regular-irregular patterns. In the arts and crafts, and in all objects made by hand rather than machine, these qualities are not taken for granted, but are valued highly by those who enjoy the interplay of chance, human skill, materials, and natural forces, as, for instance, in the making of pottery. This is not meant to imply that the machine cannot be used to create its own kind of beauty, although perhaps one of a more predictable order.

Constellations

From the irregular placement of motifs on a predetermined field, the student may go on to a kind of arrangement that dispenses with field pattern altogether. His designs will depend to a greater extent on intuitive

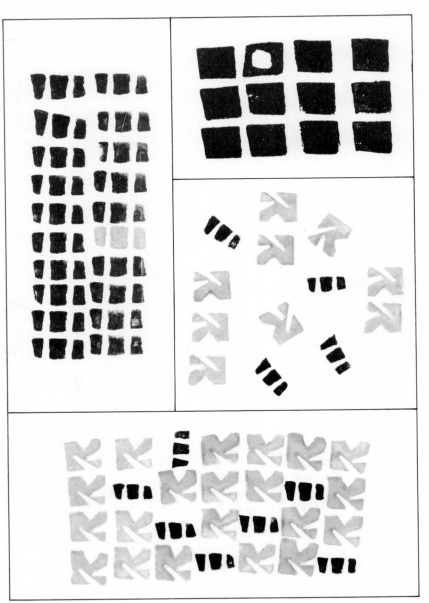

I-21

I-21 In these sample all-over patterns, there is at least one element of surprise—an unexpected color, a change of orientation, a gap, and so forth.

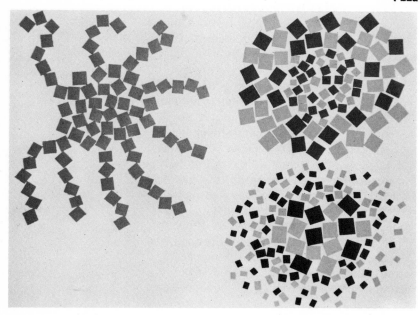

I-22a

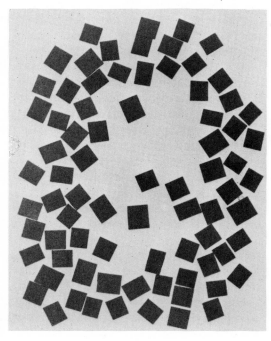

I-22b

I-22a Small pieces of paper arranged concentrically.

I-22b Another arrangement of small pieces *away* from the center (eccentrically).

choices and spontaneous decisions. His maneuvers will resemble a game of chess minus a board. The law of chance, affecting the way things simply fall into place, will be a stimulating factor, and may even account for some of the best groupings in this study.

EX. 5

a• This study may be approached in several ways. First, try placing 5 to 15 points together in a highly irregular but cohesive arrangement, like a familiar pattern of stars or a flght of blackbirds in winter. Vary the intervals. Feel out the tensions in all directions.

b• Then create a kind of "milky way" pattern with perhaps 200 or more points, using the rubber eraser of a pencil as a stamp, or potato stamps of two or three sizes. Vary the density of the elements by letting them crowd together in some areas and scatter in others. Use points to create various types of transition. Let them graduate in size from large to small, or in value from dark to light. Let them stand progressively farther apart, or vice versa, or use them to describe movement from one place to another, widening here, narrowing there, sending out "feelers" into space, and so on.

c• Then choose a ground, a square or rectangular piece of paper of any color, and place or simply drop onto it perhaps 50 small, squarish pieces of paper of another color or value. These pieces may be arranged in as many ways as possible: toward the center (concentrically) [**I-22a**], away from the center (eccentrically) [**I-22b**], in situations of great density or sparsity, touching, not touching, or in several small clusters within the larger group. When a pleasing arrangement has been discovered, the small bits may be pasted down permanently.

d• Another approach allows the introduction of certain useful principles that apply universally to both simple and complex arrangements. The stu-

dent may start with the same materials, a large rectangular sheet of paper and several smaller pieces, except that the smaller pieces should be in two contrasting colors or values, light and dark. They may also be made in two sizes, regardless of color. In these arrangements, the student will have to contend with two separate groups or complexes established by the contrasting colors. The larger and smaller sizes will also affect his decisions. Therefore, the "game" will admit of new complications as well as new possibilities.

Gestalt psychology

The sense of sight is both the most miraculous and the most practical sense we possess. We depend on it at every waking moment without realizing how efficiently it functions. But as our understanding of it increases, we become more amazed by its several capabilities.

The principles formulated in the early 1920's by German psychologist Max Wertheimer provide useful guides to the ordering of sense data from the world of light, space, form, color, and movement. Wertheimer's most noted contribution to Gestalt psychology was the identification of four principles by which the organs of sight create order from chaos. According to his findings, objects, figures, and qualities are related to one another perceptually by: 1) nearness, 2) similarity (this being perhaps the basic principle), 3) direction, orientation, or continuance, and 4) closure (a logical extension of the factor of direction and continuance). Undoubtedly, artists have long been aware of these factors intuitively, but Wertheimer's findings made it possible to acknowledge them objectively in learning, teaching, and the creative act.

The eye is able to focus sharply on small objects and shapes within a limited radius. Objects or shapes within this narrow circle become related to each other, even if they are dissimilar (the factor of nearness). If they are alike, the eye will have less difficulty relating them to each other as a group, whether they be close together or somewhat scattered (the factor of similarity). In addition, if points, lines, or shapes are placed along a definite path, share the same kinetic energy or speed, or are long and aimed in the same direction, or even if they subdivide into two or more directional complexes, the eye will establish sense and order (the factor of orientation). Finally, if the eye can, it will reduce even the most fragmentary shape to its simplest ordered structure. It will complete a semicircle, a broken arch, a damaged or distorted square, and, in so doing, make it comprehensible (the factor of closure—see "open" and "closed" structure and form-space development, Parts II and IV).

One or more of these factors may apply to this study. The student will probably recognize them after the creative act, so they may not influence his decisions crucially. It must be admitted, however, that theories and principles are of value when they are capable of giving support and direction to genuine creative energies. Academic theories fail when they remain stubbornly attached to styles and hierarchies of quality in art of the past, e.g., the art of the Italian Renaissance. The Gestalt theory restates and clarifies old principles, but it also frees them momentarily from problems of style. Because of this, it is more useful than less general theories, especially to beginning students, who are learning to see in a different way through productive activity.

The elements or coefficients of a design set up a system of tensions the moment they are placed in the field. It could be said that

we take advantage of these perceptual factors pointed out by Wertheimer and others by developing them, consciously or unconsciously, in the design. Some become powerful integrating forces. Working against these are other forces that provide the necessary contrast or counter-tension. The give and take between them is essential to the life of any design.

The student will have to remind himself to place his points at both wide and narrow intervals, risking far-flung positions, like those observed in certain constellations in the night sky. A single isolated point frequently takes on extra importance and is capable of "balancing" large clusters at a considerable distance. Inasmuch as these studies develop a good eye for weights and tensions, they should be repeated many times in as many ways as possible. Sooner or later the student will discover the useful trick of unfocusing the eyes for a more comprehensive or "wide-angle" assessment of the forces he has set to work in his designs.

Compositions with Points

If these forces or tensions, which are both cohesive and segregating, are organized within a predetermined area, we may call the design, for the sake of convenience only, a composition. The size and shape of the area or format, as it is sometimes referred to, is accepted from the outset, as is the ring for a boxing match or the corrida for a bull-fight. Before anything is placed in this area to disturb its blank but perfect unity, it reveals an intangible system of tensions of its own —rather, we read tensions into it. Instead of vanishing when the drama of line, shape, and color commences, the tensions become part of the drama; they condition it.

The square and the rectangle remain favorite formats for the good reason that they are more "neutral" than other areas. They do not intrude too forcibly in the events taking place within them. French painters recognize three basic types of stretcher frames for their canvases: 1) *Figure*, which is almost square, 2) *Paysage*, or landscape type, which is similar to the Golden Section rectangle (see Part II: "Line"), and 3) *Marine*, a very long rectangle recommended for seascapes. Circles, triangles, and rhomboids are difficult types because they are very commanding in their own right. The perceptual forces in the square or rectangle are easier to work with. They run from top to bottom, side to side, and corner to corner diagonally through the center where all tensions cross, unless modified by a tendency of the eye to seek an area just above this point as the psychological center of gravity— the visual center, as it is sometimes called. There is also a tendency in many people to sense more visual weight or pull to the right than to the left of center, a desire to slide into this area by a left to right movement of the eye. Drama directors are acutely aware of left-right, forward-backward positions and movements on the stage, and their visual and emotional effect on the audience. (It is said that most people automatically look to the left as the curtain rises. This may explain why directors often place important characters or props, or locate important episodes downstage in that area. Could it be that, in doing so, they establish a psychological emphasis there that counterbalances a greater potential of weight or movement toward the right?)

Added to these forces are both the physical and psychological "realities" of the flat surface, in the case of drawings, prints, and

paintings. The physical surface, per se, seems to endeavor to maintain its integrity unimpaired; and instead of our seeing a point or line as lying directly *on* it, we are likely to perceive it as though it were lying just *in front of* the surface, or, in more complex arrangements, *behind* it. This is the beginning of pictorial depth, which, in most designs, is a welcome dimension. It enhances both the quantity and the quality of space. Our aim is to become extraordinarily aware of this phenomenon so that it may be used to expressive and structural advantage.

A point placed low in the format is likely to appear nearer the observer than one placed higher. A point placed near the edge of the format seems to advance more than one placed toward the center. Several points are capable of setting up all manner of forward-backward, ascending-descending movements, but a single point is enough to disturb the old order and, if sensitively placed, can set up a new dynamic balance of considerable complexity. If placed near the edge, the point seems to exert pressure against that edge, and, from this narrow "high-pressure" area, a kind of energy seems to flow into the "low-pressure" areas existing in other parts of the design. In addition to this, the point seems to create for itself a spatial environment, almost making us forget the physical surface, as one forgets the pane of glass while peering through a window.

EX. 6

a● One's first action will be to draw several formats—squares and rectangles—on light or dark paper. Then, almost as in a game, several attempts may be made to place a single point in each of these areas where it will create the greatest interest throughout. A round point of about ¼ to ½

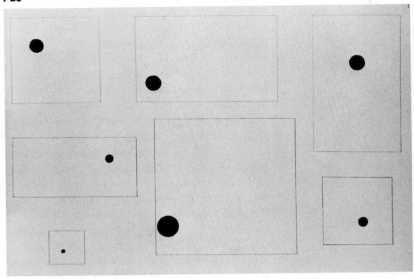

I-23

inch in diameter, cut from paper of another color, will allow one to try many positions in the field before deciding on a final position, at which the point may be glued permanently [I-23]. Each position will establish a new set of tensions, rather like that of a magnet, within the field. The point will establish its own unequal tensions with each corner and with each of the four sides of the format. In a successful design, these disturbances are resolved in a new order of space, movement, and balance. The point, though insignificant in itself, gives meaning to the space.

b● The student may create other compositions containing three or more points, in which even more complex relations will exist [I-24]. (This time he may choose to make them with pencil, crayon, or ink in more than one color.) The points will set up a system of tensions among themselves which, if illustrated diagrammatically by means of straight lines, as in one of the earlier problems, would create geometric planes tilting forward and backward in space. Some groupings may create a sense of rising and falling movement, others, because of proximity to each other, may form separate groups

I-23 Point compositions with a single point.

I-24 Several points create even more complex relationships, not only with the corners and the sides of the format, but between the points themselves. Groups of large and small points add still another set of tensions.

I-24

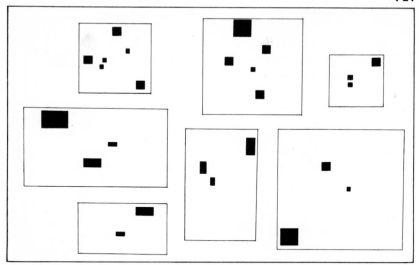

within the whole. If larger and smaller points are used, or lighter and darker colors, relationships through similarity may also occur. The eye will tend to leap between things and qualities that are alike before relating things and qualities that are dissimilar (the principle of similarity established by Wertheimer). Similar elements form patterns.

Three-Dimensional Experiment

Heretofore all experiments have been two-dimensional, in the sense that they have taken place on a flat surface. This is not to deny that, in other ways, they have suggested more than mere height and width. Drawings and paintings sometimes reveal the struggle of the artist to make the most of pictorial ambiguity by arranging forms, lines, colors, and movements *in depth* while retaining more than a hint of the original flat surface. Many painters since Cézanne and Seurat have made a particular virtue of this.

But this schematic experiment with points will be, in a very real sense, three-

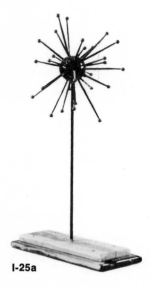

I-25a

dimensional. In many instances, the student must be encouraged to develop his "ideas" right out into actual form and space. Not very long ago, painters and sculptors were expected to occupy separate provinces. The painter, it was thought, should limit himself to the flat surface. The sculptor and the architect should restrict their activities to physical form and space. Modern developments in art and architecture have obliterated these academic boundaries. Le Corbusier, the architect, was also a sculptor and a painter; Picasso, the painter, is also a sculptor—or vice versa. A recurring theme in Picasso's work, resulting in some of his most entertaining statements, is that of the artist in his studio. He parodies all sorts of ideas about the artist—what he is, and what he does.

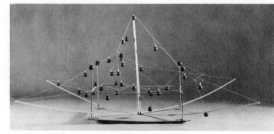

I-25b

EX. 7

In this experiment, points may be interpreted as projections into space, as lying on the ground, or as holes in the ground. Projections of perhaps two widths and heights may be made from commercial wooden dowels. The base or ground from which they project—or *through* which they project—may be of plywood, cardboard, or plastic of suitable size and shape. Points as holes may be made in the base. Paint of two or three contrasting colors (for example, black, white, and red) may be applied to some or all surfaces to enhance the play of form in space, both forward and backward [I-25a, b].

These are only suggestions. The student may choose to develop quite another set of possibilities. He may attempt a design that will resemble one of those constructions of small colored spheres, glued together or connected by rods, which are made by scientists to illustrate the structure of molecules in organic and inorganic substances. He may arrange wooden beads of various sizes and colors on balsa wood strips or on wire. Or he may design an unusual string of beads—not necessarily for wearing.

Points in Nature

Our interest in points in nature could be limited altogether to the decorative surface markings on flora and fauna. The source is inexhaustible. The need for camouflage, and seemingly for decoration for its own sake, exists in many species, and formulas are repeated and varied ingeniously in widely separated biological types, from guinea hens to cheetahs. Accurate two-dimensional equivalents of these are not difficult to make. But three-dimensional "points" in nature—nature's smaller units—also deserve our attention. Most of us would choose a seed or a grain of sand—the Biblical choice—as the smallest form, forgetting that the age of science has provided glimpses of still smaller ones through the microscope—the cells of animals and plants, bacteria, and fungi—and has even persuaded us to accept the existence of infinitely smaller particles in the diminishing magnitudes of viruses, molecules, atoms, electrons, and protons, and still smaller entities about which little is known. Even in the case of sight itself, the radiant image focused upon the retina by the lens is picked up by millions of separate, infinitesimal points, the receptors, and relayed to the brain as a "mosaic of punctiform stimulations."[6]

"Perceptual concepts"[7] and "representational concepts"[8]

What we perceive immediately and what we reckon or believe to be true of the world about us are both important in the creation of art and scientific theory. Art ranges widely between these experiences. In paintings by artists of primitive American, Scandinavian, and Australian societies, for instance, the outside as well as something of the inside of animals are represented simultaneously.[9] At the opposite extreme from totemic or tribal image-making is the teaching of human and animal anatomy in traditional art schools. If challenged seriously, this practice is defended on the ground that it helps the student to acquire the necessary technical knowledge of physiological structures and the correct articulation of bones and muscles which cannot be seen, but give form to outward appearances. A very sound argument, it would seem. But whether a scientific approach peculiar to Renaissance art, its heroic, figurative style and humanistic ethos, and to a civilization that would "replace perceiving with measuring, inventing with copying, images with intellectual concepts, and appearances with abstract forces,"[10] can claim universal respect is a question frequently raised in the twentieth century. There are also questions related to training and application: How and where should one start, and how thorough should one be in the study of anatomy? How and where can this experience be used except, quite obviously, in some form of illustrational art? These and other questions pertaining to drawing demand careful answers by both instructor and student. Reg Butler, the English sculptor, has this to say about the life-class:

6] Rudolf Arnheim, *Art and Visual Perception: A Psychology of the Creative Eye* (Berkeley and Los Angeles: University of Calif. Press, 1957), p. 57.

7] *Ibid.*, p. 29.

8] *Ibid.*, p. 133.

9] See illustrations "Variation and spread of the X-ray style," from Andreas Lommel, *Prehistoric and Primitive Man* (New York: McGraw-Hill Book Company, 1966), p. 22.

10] Rudolf Arnheim, *Toward a Psychology of Art* (Berkeley and Los Angeles: University of Calif. Press, 1966), p. 9.

11] Reg Butler, "Lecture Four: Study," *Creative Development* (London: Routledge & Kegan Paul, Ltd., 1962), p. 56.

12] *Ibid.*, p. 6.

13] See Paul Schilder, *The Image and Appearance of the Human Body* (New York: Science Editions, John Wiley & Sons, Inc., 1950), and Lawrence D. Steefel, Jr., "Body Imagery in Picasso's 'Night Fishing at Antibes,'" *Art Journal*, XXV, No. 4 (Summer 1966), 356–63.

14] Matthew Lipman, "The Aesthetic Presence of the Body," *The Journal of Aesthetics and Art Criticism*, XV, No. 4 (June 1957), 428. See also Edward Lucie-Smith, "Death of the Nude," *Encounter*, XXXI No. 4 (Oct. 1968), 33–37.

15] J. Bronowski, in an essay entitled "The Machinery of Nature," [*Encounter*, XXV, No. 5 (Nov. 1965), 48] says this of the way we achieve an "interlocked picture" of the world and "of all our dealings with nature": "The picture is not the look of the world but our way of looking at it: not how the world strikes us but how we construct it. Other people and other ages had different pictures from ours, and that is why incidentally they drew differently. We must not think that those who stitched the Bayeux Tapestry [late 11th C. (?)] habitually saw in perspective but did not know how to draw in it. No doubt they could see in perspective, as we can manipulate an optical illusion in our heads; but their habit, their total cast of mind, was to look at relations in the world differently, and that is what they drew. A modern story from Margaret Mead makes the point.

" 'This relationship to the physical environment is a kind of *being in* rather than *seeing* the environment. There is a very moving instance of a group of Australian aboriginal children who were incarcerated in a reform school, far away from their own people. One of the custodial staff, who had been a teacher, started the children in crafts and drawing. Suddenly, one day, a little boy shouted "I see, I see! You don't draw it the way you *know* it is. You draw it the way it looks!" And the idea of perspective was born anew in his mind.' "

16] There is probably no awareness in the child and the primitive of *inventing equivalents* of objects. "The image does not *stand for* the object; it *is* the object" in their minds.

I believe it should primarily be thought of as a means of furnishing the raw material of creation. A blind and deaf man, with no tactile sensibility, would not have much opportunity of collecting experience with which to create. Put crudely, what comes out has first to go in, and objective study is an intensive method of taking in, taking in the forms of which plastic experience is made up; of the animal kingdom in general, of all growing organisms, visible and microscopic, and of inorganic matter, for these are the vocabulary of the plastic arts and the subjective rearrangement of nature is the basis of their practice.[11]

(Elsewhere he says: "The whole problem of art education must be approached on the basis that we do not know what we can afford to leave out.")[12]

Where the human figure is concerned, there is much more to the problem than learning anatomy and "taking in" forms through objective study. Perhaps the characteristic failure of most life-drawing classes is the failure to relate anatomical studies to "body-image," the body as a qualitative presence, the idea each person has of his own body,[13] or emphatically of another body. Anatomical studies must submit to body-image. It is entirely conceivable that some body "situations," some states of being, may be realized in figurative drawings without the artist's resorting to any knowledge of anatomy; examples would include fatigue, pain, some emotional attitude taken toward the body, or some artificial or mechanical extension of the body. On the other hand, drawings depicting some physical effort, e.g., a straining arm or leg, or the act of jumping or dancing, may be made all the more convincing by virtue of the artist's understanding of muscles, bones, and tendons, and how they function. Drawings should "tell" what it is like to lift, push, feel heavy, feel light, feel erotic, feel well or sick, be "beside oneself," be old, be young, be clothed or be naked, and perhaps include some hint that none of these conditions is static. Neither are they totally private in origin and implication: "There are few symbols which are so charged with emotional significance as are drawings of the human figure."[14]

How each art—ancient, traditional, and modern, the art of children and of primitive societies—reflects the sensory apprehension of reality is a question that interests not only psychologists, but also historians, anthropologists, and sociologists. Is it possible, they ask, to find factors common to the myriad kinds of art seen under the roof of a great museum nowadays? How is it that styles in art can differ so if they are all the products of human beings having the same eyes and hands, and the same human intelligence?[15]

Most art would seem to derive primarily from perceptual patterns, general structural features, and sensory categories (See Part IV: "Shape, Plane and Form"), rather than from abstract ideas. Because of the involuntary, creative nature of perception and the more voluntary, creative translation of visual percept into some kind of structural equivalent —into point, line, shape, form, color, and so on—art is the outgrowth of both perceptual *and* conceptual processes. Hence the title of Klee's pedagogical book, *The Thinking Eye*. Moreover, the artist of any time, even the child and the primitive, must *invent* these structural equivalents with whatever medium he chooses, and, inevitably, what he perceives, remembers, loves, fears, and what his cultural environment has trained him to see and do, all enter into the process.[16] "Perceptual concept," "representational concept," and the medium influence one another at almost every stage in the realization of form.

A study of points in nature will be of most

value if, instead of limiting our interest to decorative manifestations, we try to relate points to growth and structure. Points on some seashells reveal the slow, outward spiraling of the shell itself. They are a record of biological energy and change.

EX. 8

Choose an object from nature—animal, mineral, or vegetable—that, if examined normally or through a microscope, would reveal simple units of structure that have been influenced, shaped, or arranged in varying degrees of regularity by pressure, cohesion, or according to the "stacking and spacing patterns" of biological growth [I-26, I-27]. Select only those elements that may be reduced to point equivalents either in black or in color. The pattern of small pebbles and broken twigs and bark left by the rush of water after a heavy rain may also be recreated as points, showing the work of fluid energy.

In this and other nature studies to follow, it is important to understand the purpose of one's inquiry. Try in every case to appreciate the object from the *inside* rather than from the outside only. Look beyond surface "accidentals" to the *history* of the form: what forces made it, when it was made, how it was made, to what extent it is the result of a supra-elemental order in the universe, and to what degree it is the result of its own unique freedom of excursion and deviation. Take note of every change of size, spacing, and color in point formations, for these form both the rule and the vital exception to the rule.

The more understanding we gain of the "creativity" of nature in her forms, functions, and transformations, the more insight we are likely to have into our own creative processes. Our receiving, ordering, and developing of visual experiences are related, at least by analogy, to processes discernible in nature.

I-26

I-27

I-26 An ear of Indian corn, with rows of variegated points (kernels).

I-27 A study of a section of indian corn, showing both regular (the horizontal rows) and irregular formations—the pressure of one kernel upon another, resulting in distortion and displacement.

Line

*I can think of no essential factor in art or artistic creation
of which the seed is not recognizable in the work of children.*
RUDOLF ARNHEIM*

The single point is chiefly an element of location or position and is, therefore, static. But a series of points or dashes, as we have already seen, becomes a broken line. The eye, following the path of these simple marks, will grasp the original movement or motor act. The speed and urgency of certain movements are often best expressed by a line that skips across the paper as a tossed pebble skips across the surface of a pond. In action studies by nineteenth century artists Géricault, Delacroix, and Toulouse-Lautrec, in paintings by the American, Jackson Pollock,[1] in the famous prehistoric drawings in the caves of Southwestern France and Northern Spain, in modern photography, and in the bizarre gyrations of electrical signs, points, dashes, and whipping lines are the hieroglyphs of energy.

The experience of movement and the imagery of movement are so common in the twentieth century that we are surprised and perhaps a little amused that the Italian artists known as the Futurists should have made such a fuss about them in the years immediately preceding World War I. True, we are accustomed, after a mere half-century, to speeds they could hardly have imagined. But their ability to translate movement into images of such force as those drawings and paintings celebrating speed and the machine was—and remains—impressive [**II-1**]. We are tempted to compare the best ones with the great animal drawings of Altamira, where the movement of line is seemingly the movement of life itself. To those shadowy humans of early Europe who witnessed the appearance of these images on the walls of their caves, drawing must have seemed not a skill, but a very special power exercised by the shaman. Even today, line, as a means of representing both the visible and the invisible, reminds us of the origin of art in magic.[2]

The earliest "drawings" by infants are

*] Rudolf Arnheim, *Art and Visual Perception: A Psychology of the Creative Eye* (Berkeley: University of California Press, 1957), p. 135.

1] See black and white drawings and paintings by Pollock in Bryan Robertson, *Jackson Pollock* (New York: Harry N. Abrams, Inc., 1960).

2] See S. Giedion, *The Eternal Present: The Beginnings of Art* (New York: Bollingen Foundation, 1962).

II-1 "Study for Dynamic Force of a Cyclist, I" by Umberto Boccioni (1882–1916), Futurist. Ink Drawing, 8½ x 12¼ inches. Courtesy of Yale University Art Gallery, Collection Société Anonyme.

marks, smears of food, perhaps, made with the finger. After about the first 20 months of life, these exercises enter a phase that may be called proto-drawings, since they contain patterns and devices the child will develop over the ensuing months and years [**II-2, II-3**]. These marks or scribbles are made by large gestural movements of the whole arm, engaging the body and mind in concentrated effort. They consist of zigzags, spirals, crude circles, single lines, and points. As a motor activity, they are a considerable advance on the very first phase of physical experimentation, and the child's delight in his new ability is quite obvious. Soon his special marks will provide five or six diagrams or ciphers, such as circles, crosses, and squares, which he will combine and recombine endlessly. At about the age of 4, his circles will become heads (or, more commonly, heads that are also bodies), trees, and even tables and houses, which normally are not round but square. His zigzags and spirals will become hair, grass, clouds, smoke, and so on. His straight marks running vertically will become legs. Horizontal marks will become outstretched arms which are meant simply as arms, regardless of position, and often continue right to the edge of the paper. Later, diagonal lines and elongated sausage shapes will be added to this basic repertory, increasing the child's ability to represent movement and more subtle articulations. The profile will begin to replace the rigid frontal view. Finally, at about 6½ or 7, the child will start to invent compound shapes of considerable complexity. He will begin to describe entire forms by outline, even if occasionally reverting to the use of favorite old marks and emblems. The circle will probably remain his indispensable form.[3]

The evolution of art from primitive to ad-

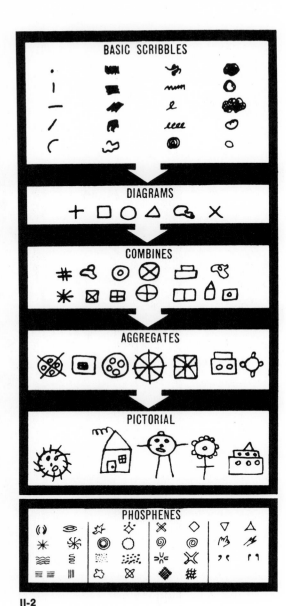

II-2

II-2 and II-3 Miss Rhoda Kellogg of the Golden Gate Nursery School of San Francisco, who has spent 35 years as a nursery educator and who has examined several thousand drawings by very young children, concludes that early drawings are made up of 20 "basic scribbles," which are located on the paper's area according to about 17 "placement patterns." These "basic scribbles," shown at the top of the chart (II-2), were extracted from the marks of two-year-old children of varied racial and national origin. [See "Form-similarity between Phosphenes of Adults and pre-School Children's Scribblings," *Nature*, Vol. 208, No. 5015 (December 11, 1965, London), 1129–30.] It was also discovered that, at about the age of three, most children move on to the creation of six "diagrams" (Greek cross, square, circle, triangle, odd-shaped area, and diagonal cross), and thence to the use of "combines" and "aggregates," which are an extension of the

3] Viktor Lowenfeld and W. Lambert Brittain explain this development in their most interesting book *Creative and Mental Growth*, 4th ed. (New York: The Macmillan Company, 1967).

"diagrams." Once these patterns are clear in his mind, the normal child proceeds to use them in a pictorial way, i.e., they become suns, buildings, vehicles, plants, animals, and humans. This occurs at about the age of four. Meanwhile, Drs. M. Knoll and J. Kugler of the Institut für Technische Elektronik, Technische Hochschule, and the Universitäts-Nervenklinik in Munich, have collected subjective light patterns or phosphenes observed by subjects when their brains were electrically stimulated. Three-hundred-thirteen adult volunteers reported seeing, while their eyes were closed, some 520 phosphenes, which have been classified by Drs. Knoll and Kugler into 15 form groups. These are called: arcs, radials, waves, lines, combined figures, circles, multiple figures, odd figures, quadrangles, spirals, "poles," lattices, triangles, fingers, and "cherries." A remarkable thing about them is that a high proportion (60–86 per cent) can be found among the 20 "basic scribbles" and "diagrams" from children's drawings. Moreover, as is clear from II-3, there seems to be much in common between phosphenes, children's patterns, and the signs and symbols of "primitive

adult" and "prehistoric adult" art.

Miss Kellogg sees child art as a necessary prerequisite to both intellectual and esthetic development in the individual, and believes that "to be able to enjoy child art, not for its humor or mystery only, but for its aesthetic merit, is to see eye to eye with the child on more than art" ["The Esthetic Eye of the Preschool Child," Rhoda Kellogg, 1966. See also Rhoda Kellogg with Scott O'Dell, *The Psychology of Children's Art* (San Diego, Calif.: a CRM–Random House Publication, 1967)].

II-2: By permission of *Nature*, where this chart originally appeared (see above), Miss Rhoda Kellogg, Drs. M. Knoll and J. Kugler, and *The Observer* (London).

II-3: From "International Aspects of Child Art," Rhoda Kellogg Child Art Collection, 2714 Steiner Street, San Francisco, Calif. Reproduced by permission from the Rhoda Kellogg Child Art Collection, San Francisco.

	Preschool Child	Primitive Adult	Prehistoric Adult
Suns, Radials Concentrics			
Mandalas			
Lined Areas			
Right-left Balance			
Four Balance			

II-3

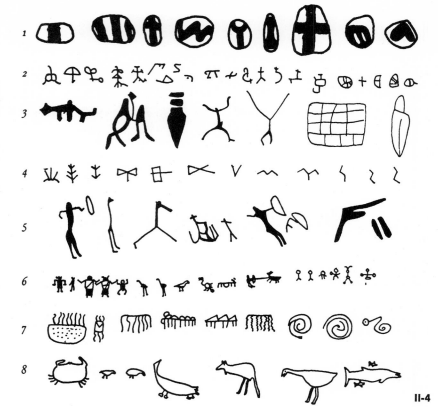

vanced stages seems to follow a similar path in both the individual and the society. Image-making by the child and in the pre-literate society is a means of coming to terms with things, events, and feelings through conceptual expression. Intellectual and emotional development and increasing skill in the use of the hands and of tools are accompanied by growth in visual comprehension and the solving of problems of representation. It is interesting to note that the great painted caves of Altamira in Spain and of Pech-Merle and Lascaux in France were discovered by children—in 1879, 1920, and 1940, respectively. Since these first discoveries, we, in turn, have "discovered" the art of children and of primitive societies in general.

If one tried to enumerate the various uses man has made of line, one would probably conclude that, of all the available plastic elements, line alone is indispensable. Even color, its frequent partner, could be put aside, albeit reluctantly, as a means of expression. Although seldom eliminated entirely, color has been assigned a secondary role at times, even by artists with outstanding gifts as colorists. Even Matisse once advised students to give attention first to drawing! ("If drawing is of the Spirit and color of the Senses, you must draw first to cultivate the spirit and to be able to lead color into spiritual paths."[4]) Line, depending on its use, may recall, inform, arouse deep-lying associations, explain, describe, or illustrate forces and tensions—all with impressive economy. Lines as pictograms, ideograms, or words, i.e., lines as writing, symbolize things, actions, concepts, and conditions, often of the greatest subtlety [II-4, II-5]. Chinese script is an interesting case in point. It supposedly evolved from an ancient pictographic or ideographic writing [II-6] that represented objects in whole or

in part, and because it did not break altogether with this early phase, as other forms of writing have done, it still retains a special link with painting and image-making. The discipline of brush and ink in both China and Japan applies to writing and painting alike; a Chinese poet is, in a sense, both writer and artist, and an ineffable part of his poetry resides in the nature of his own brushwork.[5] This could hardly be said of the work of any poet of our culture, no matter how beautiful or "expressive" his handwriting may be. In phonetic and alphabetic writing, words stand for sounds before they stand for objects, ideas, or conditions. Neither they nor the letters by which they are formed bear any resemblance to objects anymore.[6] But handwriting, so often neglected in the twentieth century, partly because of the decline of the over-elaborate style of the nineteenth century—and perhaps in reaction against

II-4

4] Letter from Henry Matisse (1869–1954), Vence, February 14, 1948, to Henry Clifford, Curator of Painting, Philadelphia Museum of Art.

5] It was said of Wang Wei, the great T'ang poet and father of the southern school of Sung landscape painting (960–1279), that "his pictures were poems and his poems, pictures."

6] Read Marshall McLuhan's account of the profound social, psychological, and cultural effects the invention of a phonetic alphabet has had and continues to have, even in the twentieth century, in certain parts of the world. Marshall McLuhan, Understanding Media: The Extensions of Man (New York: McGraw-Hill Book Company, 1965), Part 9: The Written Word—An Eye for an Ear; or see Sir Gerald Barry et al., The Doubleday Pictorial Library of Communication and Language: Networks of Thought and Action (Garden City, N.Y.: Doubleday & Company, Inc., 1965).

Original pictograph	Pictograph in position of later cuneiform	Early cuneiform	Classic Assyrian	Meaning
				heaven
				god
				earth
				man
				pudenda
				woman
				mountain
				mountain woman
				slave-girl
				head
				mouth
				to speak
				food
				to eat
				water
				in
				to drink
				to go
				to stand
				bird
				fish
				ox
				cow
				barley
				grain
				sun
				day
				to plow
				to till

II-5

II-6

II-4 Prehistoric conventionalized figures and geometric symbols: 1) painted pebbles of the mesolithic Azilian culture, painted with peroxide of iron, from Mas d'Azil, Ariège, South France; 2) geometric signs from Spain; 3) conventionalized figures and signs from Italy; 4) symbols on masonry and pottery from Crete; 5) conventionalized figures from North African rock paintings; 6–7) petroglyphs from California; 8) petroglyphs from Australia. From David Diringer, *Writing* (London: Thames and Hudson Ltd., 1962), p. 26, by permission of the publisher.

II-5 Development of cuneiform symbols from pictographs to Classic Assyrian. From David Diringer, *Writing* (London: Thames and Hudson Ltd., 1962), p. 38, by permission of the publisher.

II-6 Seal writing; inscriptions from the T'ang period (A.D. 618–759). From Chiang Yee's *Chinese Calligraphy*. (Reproduced by permission of Charles E. Tuttle Co., Inc., Rutland, Vermont, from *The Way of the Brush* by Fritz van Briessen, 1962).

this so-called Spencerian or Victorian Copperplate style—is one of the few uses of line in which most people could still take pride of achievement. One's handwriting is both a means of communication and a subtle reflection of personality or temperament. Therefore, the recent revival of interest in the trim, cursive style of the Renaissance, Italic handwriting, which was the style of Michelangelo and Queen Elizabeth I, should be welcomed by anyone who has not abandoned all interest in the appearance of the written word.

In societies whose religions either forbid or inhibit the making of "graven images" or idols, writing, pure decoration, and architecture become the highest forms of visual expression. This is especially true of Muslim or Islamic societies. Their incredibly musical writing, Arabic, which evolved from the use of the flat reed rather than the brush, is integrated into every sort of decorative scheme across great areas of their mosques.

The invention of writing—picture-writing, ideographic writing, and those forms that contain both ideographic and phonetic elements—must have given early peoples as much satisfaction as picture-making gives the child. It would be difficult for us to realize the excitement of either, except through our own intense creative efforts. To be able to write was to be able to communicate beyond immediate boundaries. Spoken language, by means of writing, was "made capable of transcending the ordinary conditions of time and space."[7] Graphic quality and stylistic refinements gave added clarity and beauty, hence the great attention paid to "hand" by monks and scribes down to the time of the invention of printing (*ca.* 1450). But our cursive writing can hardly be expected to rival the practice of calligraphy in old China and Japan, where the use of the brush by poets, scholars, and gentlemen of leisure, often on a heroic scale, attained a degree of expressiveness unimaginable in any other form of writing. It has been said that only in the art of bowing stringed instruments do we approach the subtlety of this ancient discipline. In both, use of the whole arm, control of movement, pressure, attack, and release are essential. As phrasing and "areas of silence" are important in music, so are the negative spaces important in calligraphy, both within and between figures.

This unique tradition of brushwork continued in the decoration of pottery. The pottery of the great periods in China, Korea, and, later, Japan struck a balance of form and decoration of unsurpassed vitality. Taoism and Zen Buddhism fostered this spirit of inevitability and naturalness, inducing both feeling and thought processes to work together harmoniously. At one time, it was believed in Japan that children possess these qualities in greater balance and purity—with the suggestion that they would make better decorators of pots than adults. Indeed, a few surviving pieces do testify to their direct and lyrical handling of the brush. But whether assertive or retiring, elegant or earthy, the great pots of the Orient possess an aliveness that is almost a magical co-extension of man and nature [**II-7**]. Although most pots and other craft objects of earlier times were not conceived primarily as "works of art," they usually combine both beauty and utility. In preindustrial societies, common crafts and skills were infused throughout with the life of the spirit. "It is the movement of life from inner to outer whether of East or West."[8] The Japanese have an appropriate saying: "Great pots are born, not made."

Admittedly, most uses of line lie well

7] David Diringer, *Writing* (London: Thames and Hudson, 1962), p. 13.

8] Bernard Leach in Introduction to *A Potter's Portfolio* (London: Lund Humphries & Co. Ltd., 1951), pp. 10–11.

II-7

II-7 Chinese stoneware jar. Tz'u-chou Ware. Sung Dynasty (A.D. 960–1279). Height, 17 inches. By permission of the Royal Ontario Museum, University of Toronto. Bernard Leach, the noted potter, describes this great jar in *A Potter's Portfolio* (London: Lund Humphries and Co. Ltd., 1951), p. 23: "Brown pigment over white slip, transparent glaze, oxidized. Subject, the Chinese phoenix, the mythical Ho-o. It would be difficult to find more brilliant linear brushwork in the whole field of ceramics: the rhythms, the variety, the weights, the aerial delight and certitude— as free as a swallow's flight—no correction— no cloying sweetness." The horizontal bands, the point pattern at the collar, the rhythmical pattern at the foot, and the extraordinary drawing around the belly, instead of distracting one's attention from the form of the jar, emphasize natural intervals and provide paths and a network of movements which cause the eye to embrace the jar almost physically from any angle of vision.

beyond the province of traditional arts and crafts, even if these uses do often produce the most striking results. Maps showing roads, paths, lakes and rivers, property boundaries, and the rise and fall of the land itself, and weather and sea charts showing the flow of air and water over vast areas of the earth's surface are among the most interesting of documents. Maritime devices made of bound strips of bamboo and shells by South Sea Islanders for the purpose of showing the direction of ocean swells and the location of small islands in a particular region have the attractiveness of both charts and works of art. Their visual properties equal their functional properties.

That line may serve in ways often considered far removed from esthetic purposes is seen in the highly technical drawings of engineers, scientists, and mathematicians. Theirs are "specialist" languages which the layman may not be able to appreciate, except on a purely sensory level, as in the case of the bamboo sea chart. Nevertheless, they sometimes have more in common with drawings by artists than one would expect. In Leonardo's *Sketchbooks*, for example, we discover a true meeting of artistic and scientific interests. Drawings are the vehicles by which patterns of movement and mechanical principles are sought. Line is the operative instrument. Its essential transparency allows the draftsman to show form within form and the function of parts and systems throughout the anatomy of machines and organisms.

It was once the opinion of some old-fashioned "purists" that lines, because they are not found in nature, must be excluded from art. Presumably they were prepared to make exceptions for the work of mapmakers, engineers, scientists, mathematicians, and even cartoonists. (Indeed, one wonders how scientific technology could have fared without the use of line, how invention could have

flowed from the mind via the drafting board to fill the world with so many forms not found ready-made in nature!) They failed to appreciate that line is the most "natural" graphic equivalent of perceived or imagined form.

It would be more to the point to say that there are no *straight* lines in nature. It is difficult for humans to make straight lines without the aid of a ruler, hence the common excuse about "having no talent" and not being able to "draw a straight line." Nevertheless, the straight line, whether absolutely true or not, is a very human device, a kind of basic "tool," favored even by the child for all that it can "make" and "do," and for its structural simplicity. As the ancient agent of measurement, of geometry, it is the father of architecture and mechanical invention. It describes flat planes, sharp edges, and clear architectonic forms with ease. It is understandably less effective in describing rounded forms that turn away from the viewer, revealing only the horizon of their curved contours. Our dogmatic purist would say that nature is, after all, entirely a matter of horizons, denying once again the way the mind deals with contours as linear percepts.

Articulation of planes, corners, the abrupt edges of forms, and horizons is not the only function of line in drawings. There are those "invisible" lines that follow the skeletal structure of forms—imaginary core lines, lines of an inner framework—which are of considerable interest to artists and designers and are often included in drawings. There are those objects in nature that reveal their skeletal systems openly—leaves, flowers, and seed heads of grasses, for instance. Others, like small fish, yield their delicate boney structures intact after having been cooked or filleted. These are so like lines that they

II-8 A French salad basket. The structure of this useful household object (an example of container form approaching open form) is, like its shadow on the ground, eminently translatable into linear equivalents.

require remarkably little effort of translation into graphic equivalents [II-8]. The X-ray photograph provides many more examples from nature.

Forms that are not of a skeletal nature or that reveal from the outside no definite inner structure, i.e., volumetric or stereometric forms, are also treated by the artist as though they did contain a system of axes or radii tilting at various degrees through their centers—the longer axes signifying greater thrust outward from their centers, the shorter ones signifying less internal pressure. In the skeletal structure of forms, whether hidden or revealed, lies the important system of coordinates that governs proportion, over-all form, and function.

Because outlining is not always the most efficient way of representing curved surfaces, another "kind" of line may be used to reveal rotundity of form, "hills and valleys," or

topographical features. This is the contour line, or, to be more precise, the cross-contour line, which, like the skeletal line, is often purely imaginary (see Part IV). This line and a kind of shading are sometimes used separately or together, in the most arbitrary way, to describe solid form and the rising and falling of surfaces [**II-9**].[9]

Line and space

Little mention has been made as yet about line in relationship to space. If it is true that a point will appear to lie not *on* a surface but behind or in front of it, it is even more true of line, as any line other than a true vertical or horizontal will appear to project forward and backward in space. The surface will appear to give way to pictorial space. Moreover, when a line turns back on itself, as in a loop, it will create a shape, a figure, and become outline. The figure it creates will immediately assume a

curious density and a relatively stable position in space. We speak in such a case of a figure-ground relationship, but this relationship will be understood as something other than that of an inert shape superimposed on a nebulous, inactive "background," if, instead of thinking of delineated shape or form always as outline, we persuade ourselves to think of it also as *inline*. This would suggest a more dynamic interaction, more give and take between form and space, each depending on the other for character and identity (see Part IV). We begin to recognize a system of internal and external forces at work here, even as we become more aware of similar forces at work in the world of nature and human society.[10] Since the last quarter of the nineteenth century, artists and designers have shown increasing interest in form-space dynamics. Because they are so versatile, lines have been used most frequently to signify, define and diagram these forces.

II-9 A pencil drawing of a folded piece of paper. The ruled lines on the paper serve fortuitously as cross-contour lines. Shading is used as an added means of creating curved surfaces.

9] See Kimon Nicolaides, *The Natural Way to Draw* (Boston: Houghton Mifflin Company, 1950).

10] The biologist's definition of form: "The diagram between the inner urge of a body and the resistance of the (physical) medium." J. E. Cirlot, *A Dictionary of Symbols* (London: Routledge & Kegan Paul, Ltd., 1962), p. 116.

II-9

II-10a

II-10b

Marks

The suggestion that the student start with marks is not meant to imply that he was not allowed to soil his mother's walls and furniture to his heart's content with food, pencil, or crayon during the first few months of his life! It is simply that marks, in one medium or another, are the beginning of all pictorial expression, even for the adult. Visual concepts must be translated into pictorial concepts, and lines as marks, images, optical guides in space, coordinating links, definers of form and space, and symbols of idea and feeling perform the principal role.

EX. 1

a● Collect as many graphic "implements" and media as possible for making marks—wide and narrow, wet and dry, hard and blurred, coarse and delicate ones. Consider the kinds of surfaces on which marks may be made—coarse and smooth, wet and dry, hard and soft, and so on. The difference between a line and a stain or smear may depend on these factors alone. Graphic and textural qualities are inherent in even the most casual mark on a surface. Since all art, even a sacred icon, must exist first of all as a physical substance, it must bear some evidence of the hand of the artist or his technique, and of the stuff from which it was made. Only our stubborn dogmatist would deny this and insist on disguising every trace of both maker and material. But, again, the material structure of a drawing or painting is not that of nature!

These experiments will bear a close resemblance to the first ones recommended in Prelude: Rediscovery of Color. The aim there was to explore both physical and psychological qualities in color and its application. Here the problem becomes more personal: the student is encouraged to dis-

II-11

II-12

II-11 "Drawing No. 26," by Ida Kohlmeyer. By permission of the artist. This drawing is almost entirely about the pleasures of mark-making and about closed-open relationships. It vibrates as though filled with light and color. This is the result of a fine gradation of values from dark through several middle tones to white, and of a great variety of graphic textures.

cover his own powers of "presentation," of making "things" and images where previously there were none, of making his own signs and "commitments" where previously there was total blankness. The quality and variety of these marks, whether rapid, slow, "angry," "calm," rhythmical, or erratic, will depend on his temperament, inventive capacities, and the amount of satisfaction he is able to receive from simple motor acts and gestures.

b● If handwriting is expressive and personal, these marks must be considered equally so, even if no one could say with any degree of certainty what they express. However, a game of finding words for images may be played by pinning several sheets before the group and soliciting critical comment. It will be discovered that some results reflect both physical and imaginative boldness, others a kind of linear-*cum*-lyric poetry, and some an even wider range of expressive qualities [II-10a, b, II-11]. The less interesting ones will reveal a lack of involvement and a denial of the full potentialities of bodily action and the medium.

It is advisable that the student begin by making vertical marks in a kind of picket fence pattern, using different "tools" (including the fingers) and media, placing wide marks beside narrow ones.

c● After that he may move directly toward more varied statements [II-12]. He may even stamp marks by means of a stiff cardboard, matt board, or veneer from about one to three inches in length,

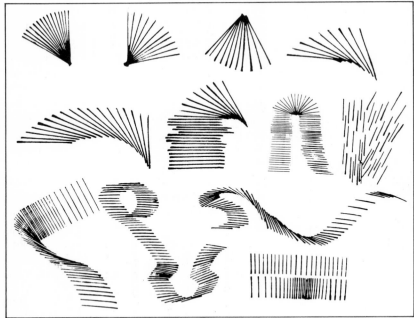

II-13

II-15

II-14

in parallel, fan, zigzag, and other rhythmical patterns [**II-13**]. In this and in most work to follow, it is hoped that the student will recognize possibilities for further development and initiate his own excursions, as long as they do not deviate entirely from the problem at hand.

No artist has given more attention to line—to its playful, expressive, rational, or tectonic qualities—than the Swiss artist, Paul Klee (1879–1940). The same could be said of his use of color. In his many graphic works and paintings, and especially in his pedagogical books, lines occur in the most varied roles. They seem to range over the whole repertory, reminding one, in turn, of petroglyphs, of the first forms of writing, of children's drawings, of "telephone doodles," of scribbles and *graffiti* on public walls, of

sacred script, and of the most esoteric projections by modern scientists. However, in every instance they emerge as his own creation, inextricably allied to a particular medium and a kind of visual poetry.

Klee was also a musician and, not surprisingly, he brought to his art a special interest in melody, rhythmical pattern, and those complex interrelationships peculiar to musical form. His compositions, drawings, and writings reveal a musical-mathematical-metaphysical sensibility, and his teaching of art, judging from his books, approached the teaching of musical theory at the most imaginative level.

The phrase, "go for a walk with a line," was used by Sir Herbert Read, a great admirer of Klee, to describe a kind of line often encountered in Klee's art. It is one that is related to melody as a living entity in its

own right—a single, meandering line reminiscent of one of those long melodies known as plainchant (or more commonly as Gregorian chant), from the liturgy of the Medieval church, or of folksong, or an unaccompanied air by Bach. Or it could be compared as effectively to a leisurely walk through a woodland park, or to the flow pattern of a creek or river seen from an airplane.

EX. 2

The student may wish to try his hand at several of these.

a● A slow, uncalculated movement of pencil or pen will produce the most interesting results [II-14].

b● Afterwards, combine two lines, as in a duet [II-15].

c● Then several lines of this sort could be combined in a polyphonic (literally, many sounds or voices) arrangement [II-16], where lines are allowed to repeat each other, more or less, above and below, converging at certain points and moving away from each other at other points. The term counterpoint—point-against-point—may also apply here, as it does to the great development in Renaissance music. Similar structures in both art and music result in a richer pattern of tensions and thematic contrasts. Lines may be allowed to oppose each other by crossing each other. Straight sections may oppose curved. Studies involving only two lines of a similar or a dissimilar nature, curved and straight or dominant and subdominant, also in the manner of a duet, may yield the clearest results, particularly at the beginning.

d● Another study may develop from a single line

II-16

—a wavy line—drawn across the middle of the paper. Other lines of much the same pattern of movement, above and below, will create the strange optical effect of a highly mobile plane [II-17a, b]. As the lines flow downward into the "valleys," they move closer together to suggest greater concentration or density. As they flow upward across the "hills," they move farther apart. Fill a whole sheet with these lines.[11]

Linear Rhythm

Although the lines described above may bear a close resemblance to melody and musical counterpoint, few will exhibit the kind of regularity associated with rhythm, or accented repetition.[12] Another type of line must be sought, and one need not look far to find it, for no tradition of art and decoration seems to have omitted it entirely. The more familiar examples derive from Greco-Roman sources, or were given universal application and currency in classical architecture, pottery, and mosaic design. This kind of line is known as the Greek fret or "key" pattern. That a similar running pattern did occur in various other parts of the world, entirely remote from European influence, is not too strange, if one considers that craft techniques in weaving, knitting, and basketmaking almost certainly result in this same kind of rhythmical repeat. Weaving techniques, by their very nature, usually produce angular, step-wise lines. As so frequently happens in isolated parts of the world, a favorite motif related intrinsically to one craft will be used quite arbitrarily in another. Clear examples of this practice would be the technical interweave (rope, netting, and basketry) and metal craft or jewelry patterns (symbolic animal and vegetable, and purely abstract themes)

II-18

II-18 Ahenny North Cross, West Side, County Tipperary, Ireland. One of the many great stone crosses found in Ireland, on Iona, and on the Isle of Man. This cross, dating from the ninth century, possibly from the eighth century, is more decorated with linear motifs than a later type, the "high cross," dating from the tenth century. Along with the more purely technical and abstract interweaves, there is a very amusing one of four men (the fifth panel from the bottom). With their heads pressed hard into the four corners of the square area, their bodies and limbs intertwine like eels.

II-17a

II-17b

II-19

11] See drawings 4, 11, 13, 30 in Herbert Bayer's *Book of Drawings* (Chicago: P. Theobald, 1961).

12] Rhythm in music is both dividual and individual (see Part I). The basic meter or beat is dividual; the melody or time-pattern above it is individual.

13] See Ludwig Bieler, *Ireland, Harbinger of the Middle Ages* (London and New York: Oxford University Press, Inc., 1963).

14] See Gordon R. Willey, *An Introduction to American Archeology*, Vol. I, *North and Middle America* (Englewood Cliffs, N.J.: Prentice-Hall, Inc., 1966).

15] See Ernst Fischer, *The Necessity of Art* (Baltimore: Penguin Books, Inc., 1963), pp. 35—36, and the writings of the French anthropologist, Claude Lévi-Strauss.

that are utilized on the splendid "high crosses" of Ireland [II-18].[13] Welsh crosses of roughly the same period, though perhaps more irregular, "pagan," and crude, are even more powerfully expressive than Irish crosses. Their almost hypnotic presence owes as much to their bold surface embellishments as it does to their strange forms.

For variety of decorative invention, the art of the Indian cultures along the Pacific coast of the Americas, from Alaska to Chile, is probably without equal anywhere in the world. In application of rhythmical decoration to pottery and weaving, the old societies of Ecuador and Peru are incomparable. In the stonework, pottery, and featherwork of Mexico, the basketry and pottery of California and the Southwest, and the woodwork of the Northwest Pacific coast, rhythmical configurations appear in endless proliferation.[14]

A profound consciousness of rhythm in man and in nature—in walking, running, breathing, the alternation of night and day, the phases of the moon and sea, the utterances of animals and birds, and the vibrations of insects—was a necessary constituent of life in the old, non-literate, erotic societies. Dance and ceremonial displays were cultural counterparts of cosmic and organic rhythms. One of the most astonishing aspects of these societies was, in fact, the emphasis placed on the ritual art of dance. Evidently it was one of several ways of coming to terms with nature, and was also one of several languages by which these societies were elaborated and maintained.[15]

Embellished line very often exists in conjunction with rhythmical line [II-19]. It is found in greatest variety in cultures of a freer social and esthetic development, where image-making is closely related to calligraphy, cursive writing, and description. Linear embellishment is one of the delights of Chinese, Korean, and Japanese art, of early

Cretan and Greek vase painting, and of Hispano-Moresque pottery and tile decoration. The daily use of brush or pen inevitably results in lines of great energy and grace, and in all manner of point and line accessories. Nature provides many examples— branches with leaves, thorns, and buds, various types of inflorescence (raceme, corymb, umbel, compound umbel, capitulum, spike, compound spike, panicle, cyme, thyrsus, and verticillaster), and the skeletal filigree of animal and mineral forms.

EX. 3

Use any kind of pen or an Oriental brush to create several examples of embellished line.

Although we of the twentieth century have a special affection for the forms and patterns of so-called primitive art, old or recent (they have exerted an important influence on European art since Gauguin), and have given them a place of honor in our homes and museums, we tend to tire rather quickly of rhythmical or decorative patterns that are, at most, two-dimensional. We have been conditioned to patterns and movements that operate on more than one level, and expect all energies to reveal themselves in both time and space. This is presumably one reason why decoration, so important during the last century that even architecture was judged by it (John Ruskin, the great English critic, writing in the 1840's, said: "Ornamentation is the principal part of architecture"), is now used with great caution. It is admitted only where it has a definite role to play in the total design. Even the style known as Art Nouveau, which sprang up in the 1880's as a welcome alternative to the debased eclectic decoration of the nineteenth century, was

swept aside before very long because it, too, was mainly a surface affair and, though based more or less on nature, lacked integral structure and contrast. A truly new art was emerging in the 1880's and 1890's that would render Art Nouveau and all other purely decorative or "cosmetic" styles inadequate. Perhaps this explains why the word "decorative" is so often used disparagingly in the twentieth century. The new art and vision began to emerge in the spatio-plastic structure of paintings by Cézanne, and in the architecture and design of Charles Rennie Macintosh, Louis Sullivan, and Frank Lloyd Wright. Rhythm was conceived as part of the total structural order of form and space.

One's powers of invention may be stimulated by the recollection of as many rhythmical actions as possible: organic rhythms (animal movements, plant movements), cultural rhythms (dances of all kinds, acrobatics, the hand and arm movements of a conductor describing 2/4, 3/4, 4/4, 5/4, and other less familiar time units); and mechanical rhythms (the rhythms not only of machines but of work). If the student will experience these with something more than passive interest before trying to recreate them on paper with pencil, pen, or brush, he will achieve livelier results. He should rehearse some of the rhythms with his arms, using large, uninhibited movements. It is important that bodily action and control be acknowledged.

Whereas there are a number of interesting similarities between our early art, e.g., Medieval art, and the art of the East, there is little in our cultural background to compare with the dance of India or of Southeast Asia; nor is there much in our tradition of athletics and physical culture to compare with the psycho-physiological disciplines of the Orient. Therefore, we must start with the experience

II-20 "Composition," 1965, by K. R. H. Sonderborg (b. 1923, Denmark). Ink drawing, 36 x 24¾ inches. Lefebre Gallery, New York. The electrical-mechanical snap of Sonderborg's point and line rhythms is unmistakably of this century. Stop for a moment at any time of the day and listen in an unfocused way to the near and distant sounds of a city—to gears, horns, sirens, trucks, motorcycles, pneumatic hammers, pile-drivers, radios, lawn-mowers, and so forth.

II-20

16] See Ernest Becker, *The Revolution in Psychiatry —The New Understanding of Man* (New York: The Free Press, 1964), and "Paranoia —The Poetics of the Human Condition," in *Angel in Armor—A Post-Freudian Perspective on the Nature of Man* (New York: George Braziller, 1969), pp. 121–55.

17] "The notorious tag 'I don't know anything about art but I know what I like' is habitually held up to ridicule in books on art appreciation. It may yet become the cornerstone on which a new art can be built." Ernst Gombrich, "The Tyranny of Abstract Art," *Atlantic Monthly*, Vol. 201, No. 4 (April 1958), 48.

of the child and utilize free experimentation, the base from which much modern dance has developed. In times like the present, when traditional symbols, designs, concepts, and usages seem to be breaking up or vanishing, the various "languages" by which man communicates begin to feel cumbersome and restrictive. It is necessary to start once again at the primary level of playful behavior—with movement, "acting things out," and experimentation.[16] This, one would assume, is the attitude taken by John Cage, Robert Rauschenberg, Merce Cunningham, and other musicians, artists, dancers, and technicians of their persuasion—an attitude that would lead, one would hope, to more than a shallow, techno-scientific esthetic of sensation and immediacy, to pure externalism. A whole generation seems to be asking urgently whether it is possible to be more spontaneous, aware, and human in the modern world. The arts assume a curious

importance here; but, stretched thin and to their limits, they may have to look more and more to philosophy (e.g., to Ortega's ratio-vitalism), to the unified human sciences, and to the ways of other cultures for corroborative or corrective insights. Each art—or two or more combined, as in certain works by the American composer, Harry Partch—has to build up gradually a new "framework of references."[17]

EX. 4

a• Studies may be based on rigid or fluid movements or on combinations of the two. By varying the pressure and angle of a flat pencil, pen, or brush, it is possible to create thick and thin marks signifying strong and relaxed beats. Try to describe both simple and compound rhythms, and those that move slowly and with grace, as in a courtly dance, and others that move with the frenetic energy of the machine age [II-20].

b● It would be worthwhile at this point to combine the non-rhythmical movements of EX. 2 with the more strictly rhythmical movements just mentioned [**II-21**]. It would help one to appreciate the natures of these two types of motion which play such an important part, either separately or together, in all art of outstanding vigor and unity. Two simple analogies may help to identify each one: a bird soaring with wings outstretched on a current of air (non-rhythmical movement); a bird beating its wings in flight (rhythmical movement). The first is a free, undifferentiated flow of energy describing slaloms, in the manner of a skier. The second is a measured sequence coinciding with a definite pulse, a pattern of physical tension and relaxation, lunging forward and pausing.

Vertical Lines

We continue our examination of the potentialities of line into what would seem a more technical role: as a definer of intervals of space. The first of these studies may seem merely a refinement on the earlier vertical marks, but there are important differences, both of kind and degree. In addition to their being put down with greater care and precision—perhaps with the aid of a transparent straight edge—the lines should be looked upon entirely as boundaries to space, as setting up a system of expanding and contracting energies and establishing greater and lesser densities. Several vertical lines of identical size and station placed equal distances apart create a simple sequence, a kind of monotonous one-beat rhythm. But the same lines, placed at irregular intervals in a "free-rhythm" pattern, will give up some of their significance as lines to the dynamics of the space that arises between them [**II-22**]. Unequal pressures will also result in forward and backward positions in

II-21

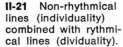

II-21 Non-rhythmical lines (individuality) combined with rythmical lines (dividuality).

II-22 Vertical lines of equal length and width placed at unequal distances apart. The wide and narrow intervals create expanding and contracting energies, which keep the eye well occupied right across the design.

II-22

depth from interval to interval. This will become more pronounced if the lines, though remaining the same length, are stationed at higher and lower elevations, i.e., staggered. Making some thicker and others thinner, some longer and others shorter, will draw attention to them, once again, as lines. The result will then be an even richer pattern of perceptual forces, involving contrast of intervals and contrast of size in the lines themselves.

II-23a

We must digress at this point to consider psychological qualities ordinarily taken for granted even by artists. European art since the latter years of the Middle Ages has depended on the artist's ability to achieve depth by the disposition of line, shape, value, texture, and color on a flat plane. There is nothing in any of these elements to suggest that either deep or shallow space will be the result of their use. But the moment they are put down or even "thrown" down—two or three lines, two or three colors or values (strong and weak, "warm" and "cool," or dark and light), or rough and smooth textures —some experience of advancing and receding parts will be noted by the observer.

18] Rudolf Arnheim, *Art and Visual Perception: A Psychology of the Creative Eye* (Berkeley: University of California Press, 1957), p. 223.

Rudolf Arnheim, accepting a suggestion made by James J. Gibson in his book, *The Perception of the Visual World*, says that three-dimensional space is created by "perceptual gradients." He defines these as "the gradual increase or decrease of some perceptual quality in space or time. For example, oblique parallelograms contain a gradient of location, in that the slanted figure lies at an evenly changing distance from the normal axes of the horizontal and vertical."[18] Even a single oblique line contains a gradient of location or distance in relation to the horizontal and vertical axes (usually repeated in the sides, top, and bottom of the paper or canvas). A series of lines or shapes, wherein elements diminish in height or in width, contains a gradient of size. If the intervals of space between these figures grow narrower or wider, they, too, contain a gradient of size [**II-23a, b**]. The other gradients are those of value (lightness gradient) and

II-23a Parallel lines turning obliquely in space. They contain two gradients, both of which create depth: a gradient of location (obliquity), and a gradient of size (the wide and narrow intervals between the lines).

II-23b Linear composition that contains two or more gradients, resulting in fluctuating space and a curious transparency.

II-23b

II-25

II-24

of texture, as suggested; still another depends on relative sharpness. But gradients are not dependent on anything seen in nature. They pertain entirely to pictorial space, whether or not they are used to represent anything.

Arnheim states, in conclusion, that "gradients make for depth when and because they represent perceptual distortions, and that distortions do so because their compensation in the third dimension produces the simplest available patterns."[19]

The flat surface plane—paper or canvas—is forced to "give way" in order that the eye may achieve order *in depth*.

If the student will fill two sheets of paper with vertical marks or stripes of fairly uniform width and placement, from top to bottom, he can perform an experiment that will force the eye to resolve all sorts of discrepancies three-dimensionally. Using one sheet as a ground, paste cut or torn pieces of the second sheet on it in various positions. If wider and narrower stripes are used as well, advancing and receding effects will be created [**II-24**].[20]

EX. 5

a● Create several independent units of six or more straight, vertical lines, all the same length and width, paying very close attention to interval relationships. Try to achieve the maximum of potential energy, creating compression in some areas and expansion in others. Try to keep the eye occupied *throughout* by avoiding those intervallic repetitions and sequences that cause tensions to slacken. As in the previous studies with point (EX. 5, Part I), experiment with concentric and eccentric forces, of greater pressure inward in some and greater pressure outward in others. No part should call undue attention to itself. On the contrary, the

19] *Ibid.*, p. 226.
20] These and other studies in line and shape (e.g., EX. 12, Part IV) may be carried out as prints with little more than balsa sticks, glue, corrugated cardboard, a printing roller, and printing ink. See Peter Green, *New Creative Print Making* (New York: Watson-Guptill Publications, 1965), Section 5.

observer should experience long and short periods of concentration and relaxation while scanning the whole design. This is important to the understanding of visual order and proportion: the rhythm of attention and concentration, the act of continuous measurement. The eye likes to move away from areas of greater size and interest to areas of lesser size and interest, and then back again in rhythmical counter-play.

b• In studies using staggered locations, the play of intervals becomes more difficult to recognize. The student will tend to relax his control of lateral forces while concentrating on the upward and downward placement of the lines. His attention will also be drawn to the much deeper "push and pull," forward and backward. He will be reminded of tree trunks or posts demarcating locations and progressions in a pictorial environment.

c• These two experiments may be carried into freehand sketches from nature. Tree trunks provide a common experience of vertical elements haphazardly spaced. Landscape painters have made great use of these and other architectonic elements as part of the formal structure of their compositions—witness the paintings of Cézanne and of Poussin. Trunks and limbs may be treated, summarily, as skeletal lines, not cylindrical volumes. Diagonals need not be excluded, since absolute purity is not the main consideration here.

Horizontals and Verticals

The structural complementary of the vertical is, of course, the horizontal. The child, by means of the horizontal, articulates arms, feet, leaves, and limbs in his drawings. We use it and its partner to describe the square, the cross, the post and beam, and other peculiarly human inventions. Nature uses the horizontal and the vertical in the orthogonal "cracking pattern" of surfaces as different in substance as paint, dried mud, and the bark of trees. They create the image of order and stand for the "conjunction of opposites" and their reconciliation.[21]

Horizontal and vertical lines give proportion and character to each other. They also define the essential two-dimensionality of the ground upon which they exist by pointing the direction of the axial forces inherent in the picture plane. When they intersect or bisect, they create "open" or "closed" areas associated immediately with tectonics, the art of constructing buildings, vessels, implements, and machines.

EX. 6

a• Once again, before attempting anything complex or overly ambitious, it is better that the student limit his preliminary studies to two lines only. With these he can create an endless variety of relations: thick and thin and long and short lines, touching and not touching, bisecting and intersecting, and so on. Some of the relations may be active, some inactive; some may have an ascending, some a descending, quality. Each configuration will be unique in structure, graphic quality, and expression, like signs and symbols.

b• Afterwards, several lines may be employed to create cross-relations of horizontal and vertical intervals of varying dimensions and pressures [**II-25**]. These areas may be either closed or open. Some designs may be conceived entirely as "open structure," wherein space moves in and out as in a game or maze; some may consist entirely of the more familiar "closed structure"; others may strike a compromise between the two. It is to the first type that special attention is drawn, because of the importance it has assumed in modern art and architecture.

It would be difficult to determine conclusively how a principle such as open structure

21] See Part XI, "Supremacy of the Vertical," in S. Giedion, *The Eternal Present: The Beginnings of Architecture* (New York: Bollingen Foundation, 1964), pp. 436–92.

gains ascendancy at a particular time—what subterranean cultural forces suddenly thrust it to the surface in works by one or two generations of artists. In order to have gained such impressive authority as a concept, and to have continued as a vital factor in the work of almost every important artist, designer, and architect of the present era, it must have emerged from the deepest reservoirs of intellect and feeling. Its emergence through form rather than theory gives support to the idea that art is able to embody in its very fabric the first principles of a new vision. Certainly during the years from 1880 to 1914 there was evident in the work of several artists a unique obsession with order. Seurat's atomic color units—points; his reinstatement of Golden Section proportion (see below) in pictorial design; his reduction of forms to their simplest structural equivalents; and Cézanne's related interest in dynamic synthesis and universal geometrics (the sphere, cylinder, cone, and cube) are but a few outstanding examples of creative regeneration. Other examples could be sought in architecture, music, literature, and the sciences. The human psyche does not function in total isolation, nor does it manifest itself exclusively in one activity. But it is the unique faculty of the arts—the plastic arts, in particular—to body forth "the forms of things unknown."

Trans-cultural influences are often fleeting and unreliable, but the interest of outstanding European artists—Manet, van Gogh, and Gauguin—in Japanese prints from the 1860's, and of Western architects in Japanese houses from the turn of the century, seems to have been much more than a temporary esthetic flirtation. The Japanese use of line, plane, and color, their handling of space in their prints, and their modular partitioning of area and space in their buildings continues to inspire Western artists and designers with admiration. If this is significant, it is probably because some kind of basic language of design, bridging time and place, has gained recognition in the twentieth century. Museums, the camera, photographic reproductions in books and magazines (André Malraux's "museum without walls"), and travel bring all art together for comparison. Beneath much of this development is the persistent need for a new spiritual orientation appropriate to life in the twentieth century.

The discipline of straight lines—horizontals and verticals—in relationship to themselves has brought us to a consideration of the more technical applications of lines. We shall take up this theme again in Part IV, dealing with planes, and there we shall note once again that, in art, the rational must play a game at all times with the irrational.

The earliest examples of right-angle lines coincide with the earliest examples of drawings from the caves of Southern France and from Mesopotamia. Pictorial representations and a rudimentary geometry (tectiforms) seem to have sprung up in the household of man as twins; this is not surprising, since both partake of man's eagerness to understand his surroundings and his need to build his own defenses against its seen and unseen powers. If fear, hunger, and the need for ritual communion with the spirit world led to the drawing of animal images, then the building of snares, corrals, and shelters, the technique of weaving, and the making of tools led to the second type of imagery. In the primitive society, where acquisition of food by hunting or foraging and protection of the clan against its foes were all-consuming occupations, both of these symbolic functions

existed in intimate and vital conjunction.

Techniques of weaving and plaiting, of binding saplings together to form rectangular pens (traps?), and, later, the making of bricks provided a repertory of forms which, in turn, served as "models for thinking." They were aids to a simple arithmetic and, ultimately, to geometry and standardized measure, e.g., the knotted cord of the Egyptians.

We assume that the brick, which was invented in Sumeria in 3500 B.C. or earlier, led immediately to every kind of variation in the art of house construction. The brick, because it was made by hand to a certain uniform size and could be repeated indefinitely, also embodied the concept of a basic unit of measure, a module.[22]

Tools and techniques altered man's environment even as they transformed the potentiality of man himself. Symbols, both drawn and spoken, helped him to grasp the objects of his environment psychologically, to subdue them or placate them; for to draw or name a thing is, in a sense, to domesticate it, to hold it in the mind, to arrest it. Therefore, image-making, abstraction, language, and conceptual thinking are of the same origin, or lead to one another by a process of cultural growth and development.

Geometry, as we understand it, goes back to the ancient Egyptians. The word provides a key to its origin and use: *geo* = land, *metry* = measure. The problem of "land-measure" arose every year because of the flooding of the Nile valley and the Egyptian practice of levying taxes according to the extent of land ownership. Egyptian surveyors evolved the ingenious device of the knotted cord, which led to a way of finding a right angle as a component of a right-angle triangle, making it possible to calculate nearly all sizes and shapes of arable land. (A 3000-year-old Egyptian mural shows surveyors in a field of ripe grain laying down a cord. This cord, containing twelve knots, when pulled into a triangle with sides of 3, 4, and 5 units, gave a right-angle triangle.) But the Egyptians had more complex uses for geometry and for the right-angle triangle—in the great building and engineering enterprises of the Pharaohs, and in the priestly art of numbers and astrology.

It is believed that Thales brought the knotted cord and triangle idea back to Greece in the sixth century B.C., and presumably from this alone the Greeks developed geometry as an independent science, requiring only a piece of string, two sharp points, and a smooth surface on which to demonstrate the most intricate propositions. Geometry was to them a divine exercise, an absolute and perfect way to create designs, dealing only with relations which were ideal and applicable only in such activities as the building of temples, making pottery, sculpturing of statues of gods and heroes, and speculating upon the essence of matter or the movement of the celestial orbs.

Anthropocentric measures

The straight line, understood as the venerable tool of measure, is related to geometry through architecture and other human products. But measure itself must be understood, first of all, *not* in terms of arithmetic, but in terms of the dimensions and the practical, functional energy of the human body. Pure geometry can exist without these or any other considerations of size or measure, since it deals only with absolute proportion. Art and architecture must deal with relative proportion, and this presupposes a unit of measure which is human in origin.

22] See Philip Morrison, "The Modularity of Knowing," in *Module, Proportion, Symmetry, Rhythm,* Vision + Value Series, ed. G. Kepes (New York: George Braziller, 1966), pp. 1–19.

It would be natural to suppose that this unit of measure derived quite simply from some portion of the human body at some unrecorded moment in the past; this would appear to be true if one considers that, while it is a unit of length, it is also a unit of energy. The major Egyptian unit, the cubit, is the length of the forearm from elbow to the middle finger outstretched, and we can assume that it was chosen because it is the preeminent working unit. Similarly, the English foot rule is not merely (or even approximately) the length of the average human foot, but the distance between the rungs of a ladder. As such, it corresponds to the amount of energy required by both legs and arms in the act of climbing. The yard is the distance from the center of the body (the tip of the nose pointing forward) to the tip of the extended arm and thumb and is (or was) associated intimately with the measuring of rope or cloth.[23]

Until the invention of the metric system in France at the end of the eighteenth century, all measurements of length, plane surfaces, weights, volumes, and time were related to some aspect of human activity, organic or social. The acre, quart, bushel, second (equaling the two-beat rhythm of the heart under normal conditions), minute, hour, and the various larger units of the day are all related to human functions and capacities. We refer to some of these casually, but not incorrectly, as measurements by "rule of thumb." As Le Corbusier has said: "The elbow, the pace, the foot and the thumb were and still are both the prehistoric and the modern tool of man."[24]

The spirit of the French Revolution was so pervasive that even the foot and inch system, the old anthropocentric measures, were brought to trial. The idea of adopting more scientific measurements in keeping with the age of reason and the spirit of progress was not new, but it was given official sanction in 1790 by the National Assembly. A committee was appointed to examine two proposals, and by 1799 a decision was made as to the length of the meter. In the same year, the value of the meter and of the kilogram, the weight of a liter of water, became law. The metric system is now obligatory in most non-English speaking countries, and is legalized for special purposes in almost every country of the world. There are, then, two radically opposing systems of measure in use in this age of scientific technology, world trade, and communication. Each system has its own undeniable merits.

The metric system, in the manner of its origin, is a masterpiece of mathematical absurdity, the meter being the one ten-millionth part of a meridional quadrant of the earth. (King Babar, the elephant, and his helpers could not have worked it out more cleverly!) But, for all that, it is remarkable in its unity, clarity, and versatility.[25]

By comparison, the Anglo-Saxon inch-foot-and-yard system is awkward and antiquated, but because of its relation to the human body it remains a better visual measure than the indifferent meter. According to some authorities, this explains why reasonably good proportions in architectural and furniture design have prevailed in countries where the old system has been retained, and why poorer proportions are observed in countries where the metric system is used exclusively.

Steen Eiler Rasmussen tells how a fellow Dane, Kaare Klint, made studies over many years of the dimensions of all kinds of domestic articles in an effort to establish a "basis for general architectural proportioning." Rasmussen continues:

II-26 Dining table (Frenchman's Cove No. 2) by George Nakashima, woodworker, New Hope, Pennsylvania. The aristocratic simplicity and vigor of Nakashima's table, Frenchman's Cove No. 2, may be attributed to a number of things: to an appreciation of human measurements and functions, to a sensitivity to internal proportions—of part to part and of part to whole, i.e., to scale, to an understanding of tradition (Oriental, American, and English), and to a respect for furniture woods and what they offer the craftsman as a challenge to his skill and imagination. Mr. Nakashima, a Japanese by birth whose back-

23] King Henry I of England (1068–1135) is said to have established the precise length of the yard as the distance between the tip of *his* nose and the end of *his* thumb.

24] *Le Modular* (Cambridge, Mass.: Harvard University Press, 1958), p. 19.

25] The author is reminded of a conversation with a French schoolmaster in which he tried to describe certain aspects of the old Louisiana Territory. When he remarked that the Mississippi River, the Eastern boundary of the Territory, was, at one time, a "French River," being the water route of French explorers, fur traders, and priests, and that its course, with some exaggeration, runs "due North and South," the French gentleman exclaimed: "Indeed, how very French!"

ground and training as architect-woodworker have been both Oriental and Western, makes this statement in a catalog of his work: "Young trees, like people, are relatively unstable but strong. A young hickory makes a better axe handle than an old one. But the best furniture wood comes from mature trees or even trees beyond maturity. The great old trees, the monuments and landmarks, often have as extraordinary a character when cut into lumber as when standing.

"Lumber with the most interest sometimes poses the most difficult problems, as so often the best figuring is accompanied by knots, areas of worm holes, deep openings, checks, cracks and other so-called defects. Occasionally, these defects are so numerous that the lumber is hopeless, and can be used only in very small sections. But just short of being worthless, a board often has the most potential and can be

In his work on [Frederik's Hospital in Copenhagen —now the Museum of Decorative Art—built by the great Danish architect, Nicolai Eigtved, in about 1750] he [Klint] discovered that when the buildings were measured in meters and centimeters it was impossible to find any coherent system in their proportioning. But measured in feet and inches the whole thing became lucid and simple. In his earlier studies he had found that many of the things we use in daily life were already standardized without our being aware of it. These included bed sheets, table cloths, napkins, plates, glasses, forks, spoons, etc. You can design a new pattern for the handles of spoons but a tablespoonful and a teaspoonful must remain an invariable quantity as long as liquid medicine is given in spoonfuls. Not only were the dimensions standardized but in feet and inches they could be expressed in integral numbers. Many kinds of furniture, too, have standard dimensions based on the proportions of the human body—such as seat heights and heights of tables for various purposes, etc. Klint was not trying to find a magic formula that would solve all problems; his only desire was to determine, by scientific method, the natural dimensions of architecture and to find how they could be made to harmonize with each other again. . . .[26]

Klint's work has been an important influence on the designing and manufacturing of furniture in Denmark since about the time of World War I. Perhaps this explains in part why chairs and other items from that country are so appealing, chairs being among the most difficult of all objects to design.

Mention has already been made of the continuing influence of traditional Japanese architecture on American designers, in particular.[27] The reason is to be found not only in the Japanese way of handling natural materials or their sensitive understanding of form/space and indoors/outdoors relations, but especially in their system of proportioning of all things that pertain to practical, everyday use, such as household objects [II-26]. Their designs are constructed on an ancient module that is very much to the measure of man. It is embodied most clearly in the *tatami*, the thick, durable, straw mat, measuring approximately 3 x 6 feet, so many units of which cover the entire floor

almost human in that respect."

Fine handcrafted furniture and pottery, when genuinely appreciated, provide an excellent base from which to approach almost any work of art—a drawing, a painting, a building, a piece of sculpture. Their combination of the esthetic and utilitarian, the concrete and the illusory, the tactile and the visual, of delicacy and strength, deliberation and spontaneity make them irreducible entities that lie beyond facile "message" and the tedium of "personality."

26] Steen Eiler Rasmussen, *Experiencing Architecture* (Cambridge, Mass.: The M.I.T. Press, 1959), pp. 124—25.

27] See Clay Lancaster, *The Japanese Influence in America* (New York: Walton H. Rawls, 1963).

II-26

area and are both for walking (with house-slippers) and sleeping upon. It is said that these dimensions, like so many other things in Japanese art and architecture, owe much to Zen Buddhism; this is the size of the bedroll or pallet carried by itinerant *samurai* who honored the Zen principle of economy in all things. It provided him enough surface space for sleeping and enough space for the seated gentleman and his few possessions. Be that as it may, the dimensions of all rooms in the traditional Japanese house are a multiple of this mat.[28]

Scholarly inquiry and analysis has demonstrated persuasively that all important architecture of the ancient world was modular in plan and construction. Architecture was a priestly art or an art practiced by a few men who, while being artists of the highest order, were also initiates into the mysteries of mathematics and secret harmonies. It was also related closely to sculpture, in that form and mass assumed greater importance than space. We would classify it generally as closed form or structure (see Part IV), which is understandable when one considers the nature of Egyptian and Greek religions. They were very different from each other, to be sure, but were alike in one respect: their great religious buildings, such as the temple at Edfou or the Parthenon, were intended as shrines or sanctuaries, not places of worship in the Christian sense, where large numbers of people gather indoors. Their spaces were small, and dominated by thick walls and great cylindrical columns. Therefore, it is reasonable that the module should have been one of form, of solid physical substance, rather than of space (as in Japanese architecture and most modern architecture). It would also seem logical that the one circular element of the plan, the column, deriving undoubtedly from the trunk of a tree in the case of Greek architecture, should have contained the basic unit for each monument. The column was the one element of structure with which the individual could identify himself by sight, touch, embrace, and sympathetic imagination (empathy). He could, in more than a mathematical sense, "take its measure," and appreciate the scale and rhythmic unity of the whole building. As Rasmussen explains it:

The basic unit was the diameter of the column and from that were derived the dimensions not only of shaft, base and capital but also of all the details of the entablature above the columns and the distances between them. These ratios were laid down and illustrated in handy pattern-books of the "five orders." Where small columns were used, everything was correspondingly small; when the columns were large, everything else was large too.[29]

This provides an excellent clue to the marvelously human scale of the temples of the Acropolis, the Parthenon, and the Erectheum, and, conversely, to the overpowering, super-human scale of many buildings erected during and after the Renaissance—such as banks, railway stations, government buildings, and churches—where columns in "large orders" were used indiscriminately for grandiose effects.

The Greek temple, of which the Parthenon was the supreme achievement, was built according to a predetermined basic scheme. It remained for the architect of each monument, in Hellas or one of the maritime colonies, to work out problems of proportion and scale to the best of his ability. Either by an innate sense of "right proportions," or use of the Golden Section or the root-5 rectangle, or both intuitive *and* mathematical means, he made whatever adjustments he

28] See Bruno Munari, *Discovery of the Square* (New York: George Wittenborn, 1965), pp. 74–75.
29] Steen Eiler Rasmussen, *Experiencing Architecture*, p. 120.

felt necessary of parts to each other and to the whole in order to achieve an arresting unity.

The golden section

Most attempts to explain the origin of the Golden Section, its use in antiquity, during the Middle Ages, the Renaissance, and the twentieth century trail off into legend, speculation, and metaphysical or mathematical obscurities. Some say that it originated in Egypt, as one of several proportional systems used by the Egyptians in their buildings, statues, and paintings. Others connect it, more convincingly, with the work of certain Greek savants and geometers, notably Pythagoras and Eudoxus, both of whom probably knew the Egyptian achievements well. Pythagoras believed that one could demonstrate order in the universe by expressing all relationships among the parts of things in terms of simple whole numbers; he believed that such relationships do exist among the perfect intervals of tones produced by sounding a stretched string. It is difficult for us to conceive of this experiment in quite the same spirit as Pythagoras, since we have moved such a great distance from early Greek assumptions about nature and a static, unitary cosmos. Pythagoras' work with acoustical measurements, aroused (so the story goes) by his hearing the ring of a smithy's hammers, was presumably the basis of Greek tuning and the six modes or scales, which carried over into the music of the Middle Ages. Taut strings of different lengths, when related to each other according to simple numerical ratios, produce agreeable sounds, or euphony. When the length of a single string is halved, the kindred tone an octave higher is produced. A ⅔ division of the string produces the dominant tone, the

so-called perfect fifth—the mathematical ratio being 6 : 4 : 3. These harmonic (acoustical) intervals were applied, on occasion, to architectural design, particularly during the Renaissance. However, their first imaginative use was by the disciples of Pythagoras in their attempt to explain the position and velocity of the heavenly bodies. They combined astronomical and musical discoveries in the famous doctrine of "the harmony of the spheres."

These periodic and seemingly unavoidable excursions into the realm of music bring to our attention a strange kinship between the visual and musical arts. Their proportional and rhythmical elements have curious similarities and differences, both structurally and perceptually. All comparisons, therefore, must be understood figuratively rather than literally, for constitutionally they are poles apart—one is an art of simultaneity and the other an art of sequence, in which the order of our perceptions is part of the unfolding sound.

Eudoxus (third century B.C.) is the principal of another legend in which the "truth" of fiction is perhaps as acceptable to us as the "truth" of fact. He is said to have carried with him a stick—very likely a walking stick—which he asked friends to divide at whatever point they sensed to be the most pleasing. Much to his satisfaction, they chose, more often than not, the point of the Golden Section. Fact or fiction, this tale illustrates something important in art and design: the close relationship of intuitive perceptions or felt ratios to reasoned conceptions or mathematical ratios. Presumably it was Eudoxus who originated several theorems of the Golden Section of a line, but this came some time after the Golden Section of a line and the Golden Section of an area had been

employed as regulating devices in Greek architecture and in the designing of pottery.

The American artist, Jay Hambidge,[30] removes almost every element of doubt concerning whether the architects of the Parthenon (fifth century B.C.), Ictinus, Callicrates, and the sculptor Phidias, made use of an advanced understanding of Golden Section and root-5 proportions. His geometric analyses and diagrams of plan (floor plan) and elevation (façade and all vertical elements), including every detail, provide evidence of the most incredible sensibility and intelligence.

Eudoxus' stick trick strikes a note of familiarity in most of us, even if our education and environment provide little training in the assessment of proportional relations beyond narrow limits, in either the man-made or the natural world. Most individuals, however, are able to judge relations in some things, depending on their work or special interests. An automobile enthusiast can be expected to judge cars of any make or vintage, not only in terms of performance, but also of design, down to the last fixture; a horse breeder can judge spirit and stamina, frame, muscle, and coat in horses. But evidently few individuals can be expected to carry this kind of interest and skill automatically into assessment of those objects and spaces that make up their private and public environments: homes and offices in all parts and functions, furniture, walls, utensils, and towns and cities.[31] Nor would they bother to protest, unless these forms and spaces produced physical discomfort. "Visual discomfort" is something to which we grow amazingly accustomed in the twentieth century, viewing each new atrocity in our midst with mute resignation. We are remarkably adaptable!

Even so, a spontaneous, visual-intuitive grasp of harmonious proportions must precede and enliven all mathematical formulations, and give energy and direction to every design from the moment of conception. Then, in working out problems from beginning to end, intuition and theory will be able to establish the useful partnership which is at the heart of classicism, of whatever time or place. Other modalities spring from other relations between the extremes of passion and of construction. The classical spirit oscillates at the center of these extremes, or perhaps to the right of center; the romantic spirit hovers more to the left of center.

Writers on the art of Europe sometimes refer to the Northern mode or tradition and to the Southern tradition, pointing to native, instinctual elements in both that predate classicism and romanticism as such. The Northern tradition is said to be allied to that large cultural complex that extended, in very early times, across Scandinavia, Russia, and Northern China. Its art is linear and restless, affirmative, and even lighthearted at times, or can be negative, brooding, and abstract, as in the art of the Celts. The Southern or Mediterranean tradition is said to be "humanistic" to the point of turning nature into "background" and décor. Its art is geometric in spirit, leaning toward the ideal and the architectonic. Its subject is man and the order of man, *not* man in either pathetic or heroic combat with nature. One has only to compare Greek pottery with English Medieval pottery to appreciate two divergent attitudes toward nature and reality.[32]

We conclude from these observations, with a certain caution, that art may spring up at any point between the extremes of passion and construction, but cannot arise exclusively at one pole or the other. At one extreme is pure emotion and chaos; at the other is pure

30] Jay Hambidge, *The Parthenon and Other Greek Temples, Their Dynamic Symmetry* (Yale University Press, 1925). An earlier book by Hambidge deals with dynamic symmetry in Greek pottery.

31] See Peter Blake, *God's Own Junkyard* (New York: Holt, Rinehart & Winston, Inc., 1964).

32] See Sir Herbert Read's remarks on this subject in "High Noon and Darkest Night," in *The Origins of Form in Art* (New York: Horizon Press, 1965), pp. 160–73.

geometry. We look, therefore, for a kind of harmonic-rhythmic conformation in art, where feeling accommodates itself intimately to order,[33] and geometry is a component of expressive structure. The important point is that the geometric mode, of whatever sort, must never be decided upon beforehand and made to serve merely as a frame on which to hang the rest. It must be part of the original idea, and function as an integral part of form and feeling. Having acknowledged this, we can proceed to a study of geometry with no fear of entering upon sterile ground. In any event, one can never be sure from where enlightenment or inspiration will come. Whenever different elements coalesce in a unified hierarchy, problems of proportion arise. These pertain to measurement (addition) and geometry (ratio), on one hand, and to perception and intuition, on the other.[34]

We could start as an ancient Greek would, i.e., with little more than a piece of string, two points, a straightedge, and a smooth surface, and move quickly from one demonstration to another of Golden Section (Golden Number or Golden Mean) proportions. If we had only a line to begin with—Eudoxus'

stick—and wished to find its Golden Section, we could proceed as follows [see II-27]:

Call the line AB. Draw a perpendicular line at B. Take half of AB and mark off this length as C. Draw the diagonal or hypotenuse AC and then, with point of compass (or string) at A, swing an arc across AC from ½ AB. Then, with compass point at C, measure off the length CD. With this measure and the point at A, mark the original line AB at E, its Golden Section. In formal language, the lesser part is to the greater as the greater part is to the whole. (EB/AE) : (AE/AB), or (what is the same thing) they will be in extreme and mean ratio.

If it is not the point of the Golden Section on the line AB that is wanted, but its Golden Section extension, we could draw a perpendicular from B the same length as AB (BC); then, with the point of the compass at ½ the length of AB, swing an arc from across an extension of AB at D. BD would then be the Golden Proportion of AB [II-28].

From line we could move directly to the Golden Section of an area or plane—a matter of greater interest to designers than the Golden Section of a line. Here the square becomes the key figure.

33] Georges Braque (1882–1963), the great French artist, stated, epigrammatically: "I like the rule that corrects the emotion." (In later years he said: "I like the emotion that corrects the rule.")

34] See "The Mathematics of Beauty in Nature and Art," in David Bergamini and the Editors of *Life, Mathematics* (Life Science Library) (New York: Time Inc., 1963), pp. 88–103; and "Module: Measure, Structure, Growth and Function," in Lawrence B. Anderson, *Module, Proportion, Symmetry, Rhythm,* Vision + Value Series, ed. G. Kepes (New York: George Braziller, 1966), pp. 102–17.

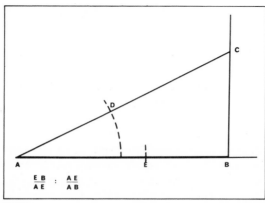

$$\frac{EB}{AE} : \frac{AE}{AB}$$

II-27

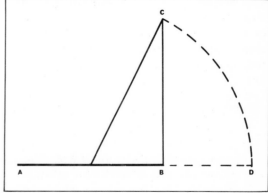

II-28

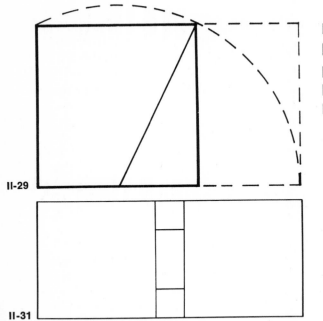

II-31 and II-32 Redrawn after figures 10 and 11, pp. 156 and 157, from Walter Dorwin Teague, *Design This Day* (New York: Harcourt, Brace & World, Inc., 1949). Copyright 1949 Walter Dorwin Teague.

II-29

II-30

II-31

II-32

We could proceed in two ways: by starting with our line *AB* and drawing a vertical from *E* the same length as *AE*, thereby constructing a Golden Section rectangle, consisting of a square and a smaller Golden Section rectangle, oriented vertically; or by starting with a square and placing the point of the compass precisely at the center of its base and describing a semicircle from West to East across its upper corners [**II-29**]. Extension of the base either to the right or left of the square to intersect the semicircle would give the Golden Mean Proportion to the square.

The square in the semicircle—
the root-5 rectangle

The two extensions, right and left, create a new rectangle of great interest and versatility that was the special delight of Greek architects, if we can believe the diagrammatic

analyses of their works. The two Golden Section rectangles overlap to the extent of the square. Viewed in another way, this is a double Golden Section rectangle capable of being read both ways: to the right or left from the central square.

More importantly, it can be divided into five equal parts, each having the same proportions as the parent rectangle. Parent and children are all so-called root-5 rectangles [**II-30**]. Division of the rectangle is achieved by drawing its diagonal from corner to corner, and a shorter diagonal from a third corner, bisecting the first at right angles. The shorter one becomes the principal diagonal of a rectangle 1/5 the size of the original. Still more divisions can be made within this smaller rectangle.

The versatility of the root-5 ($\sqrt{5}$) rectangle is seen in the several arrangements of squares, Golden Section rectangles and smaller root-5 rectangles, juxtaposed and

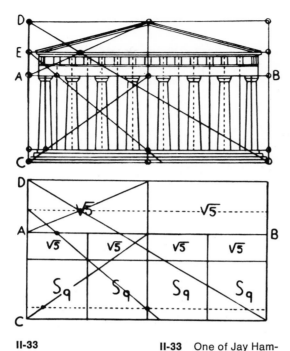

II-33

interlocking, that can be achieved within this magical area. Two variations are shown here [**II-31, II-32**], and another one demonstrating the role the root-5 rectangle evidently played in the design of the Parthenon [**II-33**].[35]

The Fibonacci series

The Greeks developed geometry, not arithmetic. It was so much a part of their philosophical and esthetic preoccupations that it would have been unthinkable to apply our system of decimal fractions (had it existed then) to their ideal constructions. But it was inevitable that the science of numbers should play an increasingly important part in the practical affairs of the world, in both commerce and technology.

At times, geometry and arithmetic meet in a manner which, presumably, would not have been frowned upon by the builders of the Parthenon, insofar as the problem of fractions is avoided. During the thirteenth century, at the height of the "first Renaissance," an Italian merchant and mathematician named Leonardo da Pisa, better known as Fibonacci, proposed a series of numbers, a set of integers, that bear a close resemblance to the rule of the Golden Section. It is called the Summation Series or the Fibonacci Series. Starting with the number one, each new unit is formed by adding together the two preceding numbers: 1, 1, 2, 3, 5, 8, 13, 21, 34, and so on. The higher the series goes, the more accurately it resembles the Golden Section ratio. It gives us the nearest whole number approximation to mean and extreme ratios, and, compared with simple and familiar ratios (straight integers), such as 1:1, 1:2, 2:3, 3:4, it sets up a definite rhythmical progression. The simple ratios are relatively static—dividual (see Part I). The

II-33 One of Jay Hambidge's analyses of the Parthenon, revealing the use of the dynamic rectangles: the Golden Section rectangle, into which the entire facade fits, and larger and smaller root-5 rectangles within this framework. The square is the basic area from which both rectangles spring. By permission of Mrs. Jay Hambidge, The Jay Hambidge Art Foundation, Betty's Creek Road, Rabun Gap, Georgia.

35] Picasso's famous "Guernica" is almost a perfect root-5 rectangle, and it, too, divides compositionally into juxtaposed and interlocking squares and vertical rectangles.

Fibonacci ratio is, by comparison, dynamic —individual. It suggests a kind of sprung energy, and no doubt this is why it crops up in the study of plant and animal growth. It follows nature's most resilient thrust.[36]

Fibonacci's mathematical gleanings from the ancient world and from Arab and Hindu methods of computing caused great excitement at the time they were made known, but there was a lapse of some 250 years before they would strike a vital response in the emergent thoughts, feelings, and ambitions of certain artists who were also mathematicians. They had to await the "second Renaissance"—the "high" Renaissance. During the first quarter of the fifteenth century, Brunelleschi, the architect and scholar, and his protégé, Masaccio (1401–1428), and, later, those artists-mathematicians of rare spirit, Uccello (*ca.* 1397–1475) and Piero della Francesca (*ca.* 1415–1492), evolved an art infused with both a geometry of proportion and a geometry of space, i.e., the new discipline of linear perspective. We assume that their predecessors, the architects of the Middle Ages, the builders of the great cathedrals, applied more than a rule of thumb geometry to their soaring structures, but the precise nature of their methods has been difficult to determine at times.[37]

During the 1490's, shortly after completion of the Last Supper, Leonardo da Vinci met Luca Pacioli, Minorite friar and mathematician, follower of the late Piero della Francesca in matters pertaining to the new discipline of linear perspective, and of Fibonacci in matters pertaining to mathematics. Leonardo had acquired a copy of Pacioli's major work, his *Summa de Arithmetica, Geometria, Proportioni et Proportionalità*, soon after its publication in 1494. The two men became close friends and collaborators. Pacioli gave Leonardo aid in measurements and calculations for the casting of his great horse (which, unfortunately, was never completed), and Leonardo worked with Pacioli on his new book, *Divina Proportione*. This book, published in 1503, was illustrated by Leonardo and, as its title suggests, contained many of the collected theories about the Golden Section, or the "Divine Proportion," as Pacioli chose to call it, reasoning that, if God saw fit to use this ratio in the structure of natural forms and of man, his noblest creation, it must, indeed, be divine.

The book seemed to focus the elements of the humanistic movement: the scientific study of perspective and shadows, and the study of anatomy and geometrical proportion, all of which had been emerging steadily during the preceding century, and had been forecast earlier in the art of Giotto. It was certainly to influence the character of European art for several generations to come. A further exploration of the mysteries of proportion and their application in artistic structures is to be found in paintings by Raphael, Titian, and Dürer, to name but a few, and in buildings by Palladio and other architects up to the nineteenth century. By that time, the original spirit had been lost sight of, become debased, or been exhausted. The Golden Section rectangle was not the only proportioning device used. The 5- and 6-pointed stars, the harmonic intervals of the musical scale, and other systems were tried. Some of them did not yield dynamic ratios.

Then, during the last quarter of the nineteenth century, there arose two artists who would signal a return to order—not to the frozen order of academism, or even to that of the Renaissance at its peak—but to a new order based on perception and a reinterpre-

36] See Jay Hambidge, *Practical Applications of Dynamic Symmetry* (New York: Devin-Adair Co., 1960).

37] See Heath Licklider, *Architectural Scale* (New York: George Braziller, 1966), pp. 53–54. Elsewhere (p. 56), Licklider says of proportional systems, modern or ancient, that they "are used by the architects as a matrix, to solidify and extend their imaginative grasp of the relationships to be controlled. The mathematical ratios and geometrical figures are useful only when they are accompanied by a vivid imaginative grasp of the part of the design to which they are applied."

38] See Rudolf Arnheim, "A Review of Proportion," in *Module, Proportion, Symmetry, Rhythm*, Vision + Value Series, ed. G. Kepes (New York: George Braziller, 1966), and *Toward a Psychology of Art* (Berkeley: University of California Press, 1966).

II-34 Le Corbusier's "Modular," "a measuring tool based on the human body and on mathematics" (rendered at the sides in the more familiar inches instead of centimeters). From Le Corbusier, *The Modular,* 2nd Ed. (London: Faber and Faber Ltd., 1951), Fig. 22.

The man is 183 cm (6 feet) tall, and, with arm raised, reaches 226 cm (about 7½ feet). His head height, if partitioned according to the Golden Section, gives 113 cm, or the height of his navel, which, curiously enough, is half the height of the raised arm. From these and a fourth essential point of the human figure, the parting of the legs (or the place where the right hand rests, 86 cm above the base), two series of measurements have been derived: the reaching height (the *blue series*), and the head height (the *red series*), each divided into diminishing portions based on the Golden Section.

II-34

tation of form and space relations. They were, of course, Cézanne and Seurat. Seurat, as mentioned before, made an exhaustive study of the Golden Section and of the compositions of Piero della Francesca. The new vision emerged in painting, as it had done during the fifteenth century. It gained momentum, definition, and direction in Cubism, and from Cubism radiated immediately into abstractionism and non-figurative modes, and into architecture. Cubism reinstated the straight line and, with it, a new geometry of form, space, and movement. It established a new discipline.

Before claiming all in the name of Cubism, we must note that at least two architects, working on their own beyond the influence of twentieth century painting, created an architecture which is not unlike Cubism in concept and spirit. These were Charles Rennie Macintosh, the Scottish architect and designer, and Frank Lloyd Wright. Their works also embraced a geometry of uncompromising severity and elegance (e.g., Wright's Unity Temple, 1906), and incorporated (especially Wright's buildings), a rare interplay of form and space, light and shadow, both inside and out.

Evolving directly from Cubism is the work of another man of genius, in which we find not only a synthesis of form, space, and structure, but a convergence of the old, dual considerations of human proportion and harmonic proportion. Le Corbusier's *Modular* is an important achievement, whether or not it gains universal acceptance or, indeed, whether its usefulness falls short of its author's high hope.[38] It expresses a super-confident spirit, a modern-*cum*-ancient dream of man in an ordered world, where mind and body complement each other [II-34].

A "final" reason for the special appeal of the Golden Section ratio, or any other harmonic ratio arrived at mathematically or intuitively, has yet to be given. Perhaps there is no single, easy explanation beyond the assumption that the laws of proportion are, in some way, inherent in visual perception. The sequential nature of vision, the measuring, abstracting, and comparing that goes on unconsciously, the searching for relations that are neither so well balanced as to be dull, nor so precarious as to be irritating, are all involved to some extent. The eye quickly exhausts any area that is divided in strict symmetry, such as an open book. Here the relationship of part to part is non-dynamic, and the eye's pattern of perceptivity is lacking in rhythmical tension. A division of the same area by a 1:2 or a 1:3 ratio, though resulting in a condition of unbalance, would be almost as lacking in prolonged interest. The eye can "measure" these regular divisions without much difficulty. But the Golden Section division, while irrational, is neither too difficult to grasp spontaneously nor easy to exhaust. It plays a game with the eye—a tug of war. Equilibrium is threatened, as in the other divisions, e.g.,

1:3 or 1:4, but a kind of tension arises that is curiously cohesive. The eye will try to coax the division back to the center of the area or, failing that, to some other "regular" position; in its resistance there develops a field of pressure and counter-pressure. The eye and the mind will try doggedly to restore a more stable balance. Unequal partitioning, the tension it arouses, and the back-and-forth, long-and-short rhythm of perception will join in such a way as to vitalize every square inch of the area [**II-35**].

The first four defining (delimiting) lines of a two-dimensional area are, in a sense, the first four lines of a design or composition. The internal tensions they inaugurate may, especially in the case of the Golden Section and root-5 rectangles, arouse optical interest without further partitioning or "pictorial incident." The energized blankness of these two fields is arresting in itself. But perhaps this is too soon to stop; these areas are seldom used vacantly. More lines and shapes inscribed within them are capable of establishing other tension patterns that serve both functional and esthetic purposes related variously to painting, architecture, interior design, furniture design, graphic design, and layout.[39]

Place anything in a blank format, even a point, and horizontal and vertical divisions will immediately be sensed (see Part I, EX. 6). These tensions, intersecting at the location of the intruding element, are the invisible governing lines of a composition—its skeletal structure. When developed still further in a composition or painting, either implicitly or explicitly, they not only divide the composition into large and small two-dimensional areas, they also conjure up fast and slow, up and down, side to side, diagonal, and step-

II-35

II-35 Redrawn after plates 242 and 244 in *Decouverte de la Peinture* by René Berger, Éditions Guilde du Livre et Fauconnières, Lausanne.

wise movements on the surface and in depth (see diagram II-36).

There is a classic type of composition, seen in paintings as diverse in style and content as the works of Vermeer, de Hooch, Degas, Matisse, Kitaj and Rauschenburg, in which the "hidden" skeletal grid organizes the field proportionally and also provides channels of movement of the sort mentioned above—movement throughout the painting, forward and backward in depth. The eye, if so inclined, may be taken on a "guided tour" with, of course, many opportunities for lingering, browsing, and digressing [**P-2, II-36**].[40]

Similar governing lines, spelled out three-dimensionally in proportion and scale, in form, space, and function, are seen in great works of architecture. The architect, by the way he creates approaches, passageways, cavities—wide and narrow, high and low, open and closed—"programs" the movement of our eyes and bodies, and influences both our sense of well-being and our vital efficiency.

39] See Rudolf Arnheim, "A Review of Proportion," *Toward a Psychology of Art*, pp. 117–18.
40] See "The Not-So-Private Eye," *Life*, Vol. 62. No. 16 (April 21, 1967), 80A.

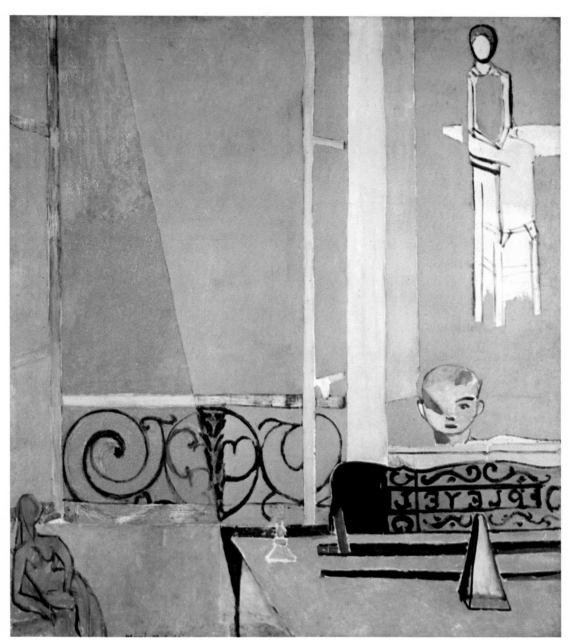

P-2

P-2 Henri Matisse.
"Piano Lesson." (1916).
Oil on canvas, 8 feet
½ inch by 6 feet 11¾
inches. Collection,
The Museum of Modern
Art, New York. Mrs.
Simon Guggenheim
Fund.

II-36 A diagram of Matisse's "Piano Lesson" (1916). The basic skeletal structure or grid divides the composition into two vertical areas and four intersecting horizontal areas. These provide both slow and fast channels of movement for the eye, depending on their width. If the eye starts at the nearest object in the picture, the pyramidal metronome on the crimson piano top, it finds itself in a narrow vertical panel, where a natural vertical is quickened by the upward thrust of the metronome itself, by the pinkish plane, and by the legs of the white stool. Before this movement has reached its climax in the head of the music teacher, in rather deep space, another movement has contravened. It points to the left through the equally narrow horizontal panel at the top of the composition and is then retarded and deflected downward by the denser green, a symbol of the green outdoors.

The bright green of this wedge-shape leads to the modified yellow-green of the small object on the piano, and that to the metronome, where the journey originated.

But there are other organic movements and correspondences in the painting. The black wrought-iron balcony rail moves into the black music rack in one of Matisse's favorite outside-inside transactions. The overall grey ground performs a rather similar function by creating a sense of unity and of spatial ambiguity.

The broken yellowish pink of the boy's face and the adjacent panel is echoed in the broken yellow-orange of the little piece of sculpture in the lower-left corner, setting up a curious see-saw motion as the eye focuses first on one and then on the other image. The light muted discord of the vertical blue panel rhymes with almost identical blues to the right and to the left.

II-36

c● Create several two-dimensional designs in square and rectangular fields with pencil and ruler, using only horizontal and vertical lines as partitioners of surface space [**II-37a, b, II-38**]. Observe concentric and eccentric pressures, as before, in wide and narrow areas. Divide the format either intuitively or by some method related to Golden Section geometry or the Fibonacci Series. Observe also the kind of optical tensions and movements on the surface and in depth that these large and small areas are likely to establish. Proceed from large divisions to small. Avoid complexity for the sake of complexity. Try to strike relationships that will arouse some sense of disequilibrium in the observer, but will keep him agreeably occupied for a while. Let each design promise some kind of resolution or fulfillment.

d● One could make use of the Fibonacci Series in a frieze-like composition [**II-39**]. Each number of the series from, for example, 2 to 21 could correspond to the same number of inches or, perhaps, half-inches. These could then be used to measure sections of paper having the same height but varying widths, according to the series. These sections could be cut out and arranged in the most effective sequence, horizontally or vertically, and painted alternately light and dark for more dynamic emphasis.

Diagonals

The horizontal and vertical scheme, the right-angle relationship, while being the clearest structure and, in so many ways, the most useful, is limited in at least one respect. It does not admit much distinction between things standing at rest and things in motion. At some time in the child's development, it becomes very important for him to be able to make figures walk, run, and fall, branches to reach upward, birds to fly, and soldiers to fight. Motion in himself and in his environment is something he must find a way of

II-37a

II-37b

II-38 "The Panel Exercise" based on the "Modular." From Le Corbusier, *The Modular*, 2nd Ed. (London: Faber and Faber Ltd., 1951), Fig. 39. Le Corbusier says: "You take a square, say, and divert yourself by dividing it up in accordance with the measures of the 'Modular'. This game can be played indefinitely"—meanwhile, one can "try to decide which of the combinations are the most satisfactory or the most beautiful" (*The Modular*, pp. 92–93). Le Corbusier makes frequent references to the game, to play, and to intuitive judgment.

II-38

II-39

stating convincingly. The same could be said of the artistic and perceptual development of primitive peoples: there comes a time when worrisome ambiguities must be overcome. The limitations of certain formulas, used for untold generations and accepted as the ritual style and form-language of the society, give way, little by little, under the pressures of greater comprehension and psychological necessity. We observe this kind of evolution in sculpture as well as in drawings and paintings. A hieratic stiffness is succeeded, after a time, by movements of every kind and degree of expressiveness.

It seems simple from our vantage point, but discovery of oblique lines is a great moment in the art of the child and of primitive societies. In the art of advanced societies, the oblique line plays a dual role. It not only conveys action, but is one of the principal means of creating pictorial space. What is Renaissance perspective but a mathematically formulated use of the oblique line? With or without mathematical rules, the oblique line becomes, for us, a gradient of location. Often it serves two purposes in the same drawing, design, or painting; not infrequently, motion and depth are rendered simultaneously by the same diagonal line. Works as different as Uccello's battle pieces ("The Battle of San Romano," for example), Tintoretto's panoramic paintings, and modern graphic designs, use the diagonal to express the conflict of forces or swift and arbitrary movements in and out of deep space.

The diagonal is at variance with the law of gravity—the pull toward the earth's center —as well as with the sense of equilibrium in the observer and the parallel sides of the pictorial format. It signifies objects in the throes of change, acting or being acted upon. As change must occur in time and in space,

II-40

II-41

both time and space, in a pictorial sense, are affected, owing to the nature of perception.

Sir Kenneth Clark, in his book, *The Nude*, cites the relief sculptures from the frieze of Mausoleum (*ca.* 350 B.C.) as "an admirable example of heroic energy, and in particular, of the means through which it was so long expressed, that pose, or rhythmic accent, which I may call the heroic diagonal."[41] In his chapter on energy, he traces the use of the "heroic diagonal" in the paintings of Pollaiuolo (1431–1498) and the works of Michelangelo, where the "heroic diagonal" became the "heroic spiral," a continuous movement in space. The latter was the dominant structural motif of Baroque (seventeenth century) sculpture and painting.

It is interesting to compare this development with that of Frank Lloyd Wright, beginning sometime in the 1930's, when he based the design of certain houses on the 120° angle or the hexagon, instead of the more conventional 90° angle or the rectangle. The result was a much easier flow of space and the "destruction" of corners, facilitating both physical and psychological movement throughout the building. Then, during the early 1940's, Wright's ideas about "plasticity

and continuity of space and structure" led him away from "straight-lined architecture," away from the triangle and polygon, the "folded planes," toward the circle. Finally, as though following the logic of organic and esthetic geometry, Wright favored more and more the principle of the spiral (e.g., in the S. Guggenheim Museum of New York).[42]

Cubism, because it placed so much importance on the straight line and articulation of movements in space by means of directional planes, led directly to a kind of painting in which diagonal action would reign supreme. Movement and counter-movement would return to art once again in a new idiom—in the prismatic, spiraling action of Delaunay's paintings of the Eiffel Tower (*ca.* 1912), in the kind of cinematic movement seen in Marcel Duchamp's "Nude Descending the Staircase," in Futurist paintings, or in the sensitively balanced weights, the multiple perspectives and cadences of Paul Klee's art. These are but a few examples, all of which owe much to the dynamic pictorial geometry of Cubism.

Another development that also owed a certain debt to Cubism was that of the Russians, the Suprematists-Constructivists—

41] Kenneth Clark, *The Nude: A Study in Ideal Form* (New York: Pantheon Books, Inc., 1956), p. 187.

42] Ian Nairn, architecture critic and author of *The American Landscape*, lists the following among the "seen and unseen things that are wrong with modern architecture": "Obsession with rectangular design, avoidance of curves and angles. At best this is the easy way out, the designer's immediate reaction on coming to his drawing-board and T-square (one of the biggest revolutions might be to make that awful instrument adjustable, so that it provided other angles but 90 degrees). At worst it is the true arrogance of man stamping over the landscape in jackboots. . . .
"The simple fact is that there are many things you just cannot do with a rectangular design, because once you have had the first view, that's all there is. Continuous space, individual projections and recesses, odd angles—all become impossible; and now that industrialised systems are providing units which can only be rectangular it is all the more important that their siting and relationship be subtly managed." [From "Stop the Architects Now," *The Observer* (Feb. 13, 1966), 21.]

Malevich, Tatlin, Rodchenko, El Lissitzky, Gabo, Pevsner, and others. Their interests centered fundamentally upon pure spatio-plastic relationships. Free-floating, overlapping, and interpenetrating planes, arranged in diagonal counterpoint, were almost the sole ingredients of their paintings and constructions.

The camera, Japanese prints, and the popular theatre of the later nineteenth century had more than a little to do with the use of diagonals in modern paintings. Degas and Toulouse-Lautrec discovered in each of these a new way of seeing things. Japanese prints, since they were first "discovered" in the 1850's and 1860's, had suggested a more casual way of placing objects and people in space. Soon afterwards, the camera would be able to "freeze" bodies in even more unorthodox perspectives. The spectacles of the music halls and cabarets of the 1880's and 1890's, where so much of the vitality and high spirits of the age was concentrated, would provide ideal subjects. Views from the balcony, the orchestra, and the wings resulted in paintings full of abrupt diagonal thrusts.

EX. 7

a● In order to get the feel of diagonals, create several independent units in which a single diagonal is related to a single vertical or horizontal, or to another diagonal [II-40]. Let them touch, stand apart, intersect, and bisect each other, as in previous studies. Be particularly aware of the structural disposition and "gesture" of each unit.

b● Then make several designs of diagonals alone, combining as many as six or eight lines in such a way as to achieve a synthesis of movement and counter-movement, as in the action of a pendulum, back and forth across the vertical pull of gravity [II-41]. Play long diagonals against short ones, thick ones against thin ones, in relationships that totter on the brink of chaos.

c● In this connection, try scattering several matches on a table top and drawing, in the most summary fashion, the diagonal relations that occur purely by chance [II-42a]. The heads of the matches may be rendered as points and the sticks simply as lines [II-42b]. Or create a linear motif (see Part I) and repeat it additively, varying only its size. Let each motif join the others in the manner of crystal formations or of a tree with branches and twigs.

II-42a

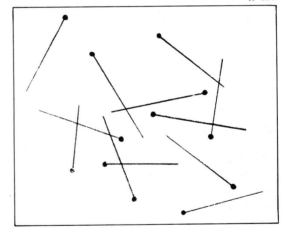

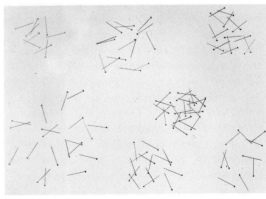

II-42b

Diagonals and curves are deceptive. They often convey the very essence of random disorder, as with the scattered matches or in the prodigal disarray of nature or the ubiquitous junk heaps of the industrial landscape. They are associated as often with destructive energies as with constructive energies. But because they are associated in some way with energy, they provoke one to look beyond the accidental to underlying patterns and conformations. Nature, the original *grande dame*, does not often choose to reveal her secrets clearly and openly. She clothes them in ambiguity.

The familiar checking pattern of concrete, ceramic glaze, bark, paint, or of a field of mud that has dried under a hot sun, would probably qualify in the minds of many as the most accidental or capricious pattern in nature. Yet these patterns are all remarkably alike and conform very closely to what is known as the orthogonal net. Despite their curvature and directional orientation, most lines (cracks) join each other at a right angle; some join at about a 120° angle. They are the expression of potential energy, one of two forms of energy. But herein lies an interesting paradox, especially if these lines are looked upon as the pattern of over-all structural stability—the lines of equilibrium. How can a pattern of weakness serve as a "model of stability"? In the process of discovering an answer to this riddle, one is led to consider a famous axiom by architect Louis Sullivan: "form follows function."

If form, as structure, can be interpreted as a pattern designed to give the greatest strength at the weakest points, then the cracking pattern of a material is surely the perfect plan for skeletal reinforcement. This being true, it would seem to place form and function in nature in an even more intimate relationship than that implied in Sullivan's statement. As Yeats said, "How can we know the dancer from the dance?"

d● The network system of the cracking pattern is curiously beautiful because it represents forces in perfect equilibrium, not by mechanical means, but by variations on a universal principle: the law of least effort. It combines (by inversion) lines of stress (tension) and strain (compression). It combines the expected and the unexpected. Therefore, a pen or pencil study of any example would provide a pleasant introduction-by-contrast to the studies that follow, which are based on the second form of energy: kinetic energy, or energy in motion.

We encountered the idea of kinetic energy at the very beginning of this chapter in the line that is the result of a point or points in motion, in lines that "go for a walk," and in rhythmical patterns. We understand what Klee meant when he said: "All figuration is movement, because it begins somewhere and ends somewhere."[43] The problem is to gain some knowledge of the energies—potential and kinetic—that "create and articulate forms in nature,"[44] in order that they may "serve as a basis for the creation of free and composite forms"[45] by the artist and designer. Knowledge, not only of these energies considered as separate types, but of their synthesis in various forms, patterns, and organisms in nature, must accompany individual developments. Figuration must represent something definable in the "life history" of the object and its function. Perhaps one reason why the drawing of objects, the human body and landscape forms included, has fallen into the doldrums in many art schools is because of an attitude taken to objects as though they were corpses. The still-life

43] Paul Klee, *The Thinking Eye* (New York: George Wittenborn, 1961), p. 195.
44] *Ibid.*, p. 64.
45] *Ibid.*, p. 64.

room is a kind of morgue, and the drawing and painting of still-lifes—*natures mortes*, as the French call them—is carried out like an exercise in the art of embalming! But surely even art schools must acknowledge that the ancient view of the world as static and discontinuous is inadmissible in the twentieth century. What we know and study are forms in transition; our drawings must demonstrate the capacity of these forms for action.

We would do well to study Chinese landscape paintings, especially of the Sung dynasty, for examples of forms that were conceived almost entirely in terms of energy or vital force. Cézanne's landscapes would yield similar evidence, and Leonardo's nature studies, because they are more scientific and, therefore, more "familiar," would convince us of the need to adjust our looking and thinking even beyond the cultural framework of his time. Sir Kenneth Clark makes these comments on Leonardo and his preoccupations:

I remember that the Virgin with St. Anne was painted at a period in his life when his mind was absorbed by three scientific studies, anatomy, geology and the movement of water. The movement of water symbolized for him the relentless continuum of natural force; anatomy the complexity of life and its power of renewal; and from his geological studies he had formed the concept that the whole world was breathing and renewing itself like a living organism. In one of his manuscripts he says: "The earth has a spirit of growth. Its flesh is the soil, its bones the stratifications of the rock which forms the mountains, its blood the springs of water; and the increase and decrease of blood in the pulses is represented in the earth by the ebb and flow of the sea."
Everything in nature, even the solid-seeming earth, was in a state of flux.[46]

We no longer find it difficult to accept the

46] Kenneth Clark, *Looking at Pictures* (New York: Holt, Rinehart & Winston, Inc., 1960), p. 164.
47] See the remarkable illustrations and comments in Alan E. Nourse and the Editors of *Life, The Body*, Life Science Library (New York: Time Inc., 1964), pp. 64–75.

idea that all things move, that, in the cosmos, primal motion is the norm. But from our limited human perspective, the point of view of ordinary experience, some things move and change more rapidly than others. Some things seem hardly to change at all. Therefore, we characterize some forms as static and others as dynamic. The former consist mainly of verticals (upright figures, withstanding the pull of gravity) and horizontals (fallen figures, overcome by gravity) based on our visual and physical experience of gravitation. The latter consist mainly of curves.

Curved Lines

We look to curves of several types for secrets of natural or organic form-development. Since only the perfect circle, or absolute centric symmetry (which does not exist in nature), expresses equal tensions on all sides and in all directions, we recognize from the start that unequal tensions are the true order of nature, and that all of nature's forms are the result of dynamic-static synthesis.

Stress and strain, tension and compression, follow curves.[47] Growth follows a curve, liquids follow lines of flow which are curved, objects hurtling through space follow curves (according to the Theory of Relativity, space itself is curved), erosion creates curved forms and surfaces. Therefore, whether in the living event, the happening, or the forms themselves, we recognize curves as the very essence of the dynamic principle. We feel the dynamic principle in our own bodies as we gain more and more motor control in work or play. As Arnheim says: "The lever construction of the human body favors curved motion. The arm pivots around the shoulder joint, and subtler rotation is provided by the

elbow, the wrist, the fingers."[48] He points out that animals reveal mastery of circular movements in the paths they make. A covey of pigeons will practice the most beautiful "banking" or three-dimensional slalom movements in the air, especially on a fine day. Here and elsewhere, the curve is also associated with joy and with mastery.

The purest, most universal form of motion is the spiral; the counter-clockwise spiral— the levogyre—is the one found most often in nature. We discover it in the growth of trees and vines, in the motion of the great spiral nebula in Andromeda, in the orbits of planets around the sun, describing "open" curves rather than "closed" curves, in the long bones, and in sea shells [**II-43**]. There are also examples of double spirals, as in the seed-head of sunflowers or the checkered surface pattern of a pineapple. As with curves, so with spirals: they are not all alike. The equiangular or logarithmic spiral of the beautiful chambered nautilus[49] is one type, seen also in the sunflower seed-head and the pineapple, in the horns of wild sheep, and in pine cones. It is interesting to note that the double spiral of the sunflower corresponds to the mysterious ratio of the Fibonacci Series. If you count the number of seed in a clockwise spiral and the number of seed in an intersecting counter-clockwise spiral, the two figures will be that of a sequence in the Fibonacci Series. The same would be true of a pine cone.

Wright, in his late work, emulates the spiral of the nautilus. Buckminster Fuller, the architect-engineer-mathematician-utopian, uses thousands of equilateral triangles conjoined to form a geodesic dome of great economy and strength. The geodesics are curved lines, the shortest paths across the dome's surface. (Euclid said that the shortest

II-43

II-43 A strand of Spanish moss.

II-44 Strange rock formations. Utah. These images, resembling armored warriors, are the results of wind, sand, and water erosion. (Courtesy United States Department of the Interior, Bureau of Land Management.)

II-44

We learn to see how things are born. We see them develop, grow, change, blossom, flourish and die. . . . And the grain matures.

The fundamental principle is "from the inside out" (contrary to appearances). Everything in life is in essense biological. The biology of a plan or section is as necessary and obvious as that of a creature of nature. The introduction of the word *"biology"* illuminates all researches in the field of building. Living, working, cultivating body and mind, moving from place to place, are parallel processes to those of the blood, nervous and respiratory systems.

From the inside out. . . . The value of all things lies in their purpose, in the germinating seed. Nothing is seen, admired or loved except what is so fine and beautiful that from the outside one penetrates into the very heart of the thing by study, research and exploration.

By devious ways, we therefore reach the centre.[50]

Algebraic geometry and the geometry of growth appear to have some things in common. We can identify curves in living forms by those that pertain to the realm of pure mathematics—the parabola, the hyperbola, the ellipse, the spiral, and so on. But we have to take into account another important factor: the role of nature as *sculptor*. The curve of the seashell, the crabshell—of each seashell or crabshell—is the result of the give and take between biological geometry and environment, i.e., forces working from within against forces from without, one kind of physical substance against another kind of physical substance. It would be difficult to find a form in nature, except perhaps sub-microscopic forms (such as viruses), that would serve as a model of mathematical perfection throughout. The surface configuration of most forms would reveal curves of far greater variance, having been "sculpted" by erosion, by the action of wind and water, i.e., a process of subtraction in the case of earth formations [**II-44**]. Or an erosion

distance between two points is a straight line. Modern mathematics and astronomy conceive it as a curved line.) Le Corbusier moved slowly toward the use of large curved forms in his later works. He said that the inspiration for the roof of his chapel at Ronchamps came from a crab shell which he found on a beach on Long Island, New York, several years earlier. The works of these men show a deepening interest in the geometry of energy, the geometry of growth, worthy of comparison with Leonardo. The creative authority and uniqueness of their inspiration does not reside in any single idea or interest, but in a coming together of several hitherto unrelated, or very loosely related, elements. This conjoining has a quality of mystery about it, and its products seem to possess the unity and inevitability of forms in nature. They are the results of creative intuition. The language and imagery of biology were often used in the talks and writings of Wright and Le Corbusier, e.g., Wright's term, "organic architecture." Le Corbusier wrote on drawing:

48] Rudolf Arnheim, *Art and Visual Perception* (Berkeley: University of California Press, 1957), p. 137.
49] See Bergamini and the editors of *Life, Mathematics (Life* Science Library), pp. 92–93.
50] Le Corbusier, *Creation is a Patient Search* (New York: Frederick A. Praeger, Inc., 1960), p. 201.

II-45

II-46

II-47

pattern would have been "built in" by nature, over perhaps millions of years, as in the form of most aquatic creatures—fish, crabs, shell-fish, seals, and squids—their "pre-eroded" surfaces having been designed by nature to offer the least resistance to the force and density of water.

These curves—the serpentine lines of flow, the analytic curves or conic sections (hyper-bola, parabola, ellipse), the logarithmic spiral, the catenary curve, "flat" curves and "bank-ing" curves—are the repertory of curves with which the artist-designer works, whether consciously or not.[51] We discover by analysis that lines and form profiles of particular beauty and strength are those that reveal considerable contrast in the *kinds* of curves that follow one another. They consist of "deep" (ellipses or hyperbolas) and "shallow" curves (parabolas or catenaries), and long and short curves. They flow into each other with a naturalness usually absent from the

pure curves of mathematics, especially the circle or any portion of it.

Diagonals and curves, expressed either two-dimensionally as lines or three-dimen-sionally as flat and curved planes, e.g., in a drawing or piece of sculpture, are the artist's form-equivalents of kinetic energy. Graham Collier writes[52] of overt or kinetic energy in terms of thrust, and identifies three common manifestations: 1) point thrust—seen in the arrow, the column or shaft, the steeple, 2) centripetal thrust—seen in the clock spring, the spiral seashell, and all spiral forms, natural or man-made, where energy uncoils from a center, and 3) pressure thrust—seen in the balloon, ripe fruit, eroded earth forms, water-worn pebbles, the pre-eroded forms of sea creatures, the skull, the head of the femur, the egg, and all forms that are the result of tensions fairly evenly and widely distributed [**II-45**]. These kinds of thrust are often seen in combination with elements of

II-45 Left to right: Point thrust, centripetal or spiral thrust, and pressure thrust.

II-46 Left: A section of cracking pattern from a Chinese bowl. Right: The same crack-ing pattern could quite conceivably resemble a portion of the Grand Canyon, except that over thousands of years a pattern of potential energy has been superseded by the pattern of kinetic energy of the Colorado River.

II-48b

II-49

II-48a

51] "Not even the shape of an ellipse can be taken for granted. Things most taken for granted need most to be doubted." Piet Hein, Danish poet-scientist and originator of the "super-ellipse," in Jim Hicks, "A Poet with a Slide Rule," *Life*, Vol. 61, No. 16 (Oct. 14, 1966), 55.
52] In *Form, Space and Vision* (Englewood Cliffs, N.J.: Prentice-Hall, Inc., 1963), p. 134.
53] Paul Klee, in his *Pedagogical Sketchbook* (London: Faber and Faber Ltd., 1925), illustrates a "trichotomy" of functions—active, medial, and passive—in five diagrammatic drawings of: 1) muscle (active), tendon (medial), and bone (passive); 2) waterfall (active), waterwheels (medial), and triphammer (passive); 3) hill and gravity (active), waterfall (medial), and waterwheel (passive); 4) seed, soil, nutrition, and growth (active), leaves in light and air (medial), and blossom (passive); and 5) heart (active), lungs (medial), and circulating blood (passive).

potential energy, as in a tent, a clothesline, or a suspension bridge, where the point thrust of the pole or pylon is complemented by the catenary arc of the canvas, the line, or the cables, or, contrariwise, in the association of discontinuous and continuous patterns in the formation of mountains. Witness, for example, the combination of craggy earth forms and winding river beds in the Grand Canyon—the cracking pattern of the earth's crust married to the sinuous flow pattern of erosion [**II-46**].[53]

EX. 8

a● Try several experiments with curved lines, using pencil, conté, and/or brush. Start, as in previous studies, with two lines—separated, touching, crossing, and so on [**II-47**].

b● Then put together several lines of equal length in convex and concave attitudes vis-à-vis one another [**II-48a, b**]. Arrange them horizontally and vertically, *only*, separated by both wide and narrow intervals. Try to create pulsating, expanding and contracting actions—pneumatic pressure thrusts [**II-49**].

c● Next, put down several lines in a more spontaneous or "accidental" relationship. Include long and short, deep and shallow, thick and thin, continuous and broken lines. Use any medium, wet or dry, but give priority to the brush. The flexibility of a good brush, preferably a sable or Chinese bamboo type, and relaxed but controlled movements of the whole arm will give the best results. Assume a standing position and hold the brush near the end of its handle.

d● Ink and rubber cement may be used effectively. Make various linear movements and flow patterns with brush and rubber cement; when the cement is dry throughout, paint over the entire surface with black ink. When the ink is dry, rub or peel away the cement. (One could start with a black paper and apply white paint over the cement in this "resist" technique.)

e• One could also create linear designs on a piece of plate glass with oil paints or ink and make a transfer or mono-print from this directly onto paper. Turpentine may be used to thin the oil paints to make them more pliant. Several kinds of paper may be used, including cameo paper.[54]

f• One could also cast slabs of plaster (about one to two inches thick), color or blacken their flatter surfaces with paint or ink, and "draw into" them by means of a knife or gouge of some sort in the manner of *sgraffiti*, i.e., scratchings, seen on rocks, metal and ceramic surfaces, old walls, or in etching and engraving techniques. In drawings of this sort, from the earliest times to the present, including the works of Braque and Miró, lines may be used to express transparency and simultaneity. A few intersecting lines can suggest a mobile space where forms interpenetrate as in an X-ray photograph.

Jackstraw Lines

Stepping downward to what is probably the lowest degree of plastic order, bordering on chaos, we come to a kind of linear configuration known as jackstraw lines. Even though they may appear to be the very denial of plastic sense, they do have a place in the visual language. They correspond to things seen and are eminently expressive. Also, they differ greatly in quality and function. Some may suggest a network of space, a microcosm or a macrocosm, some may resemble a cluster of energized particles, like a swarm of insects, while others may fluctuate on the surface as a kind of over-all texture. Each medium and each kind of movement will produce different results.

EX. 9

a• Make several experimental studies with crow quill pen, brush, a stick, a string, or a piece of

II-50a

straw. Try different methods with each implement or tool—fast and slow squiggles with pen and stick, or slapping or dragging movements with ink-loaded string or straw, allowing chance to enter freely into each operation [**II-50a**]. Try trailing or dripping thin paint onto the surface, and then perhaps blowing it in several directions, or tilting the paper so that it runs in different directions [**II-50b**].

Many artists have admitted lines of this sort in certain areas of their drawings and graphic works, and even paintings, but few have made such extensive use of jackstraw and similar "chaotic" lines as Dubuffet, Masson, Pollock, or Tobey (his "white

54] See Henry Rasmusen, *Printmaking with Monotype: A Guide to Transfer Techniques* (Philadelphia: Chilton Book Company, 1961).

55] See Daniel Cordier, *The Drawings of Jean Dubuffet* (New York: George Braziller, 1960).

writing").[55] The expressive content of their works differs considerably, despite the fact that their characteristic means are a multitude of marks, scratches, squiggles, and arabesques. Mention was made earlier of the way small children resort to a kind of "action-drawing" to express, not objects as such, but the movement of objects. It would not be intended as either facetious or disrespectful to say that the artists just named, and others, use lines for much the same reason. They, too, evolve graphic equivalents for a universe that is, in essence, a labyrinth of energy.

One does not have to look far to find examples of form for which lines of all the "types" mentioned throughout this part of the text serve as plastic equivalents. It is better, in fact, to start with something small enough to be held in the hand. A small, single object is likely to offer fewer distractions or compromising elements. Those elements which it does contain may seem, at first glance, rather unpromising. This being the case, one will *have* to ferret out every scrap of visual information, like a starving animal in search of food. This kind of experience prepares one for larger and more complicated groupings, such as crumpled rags and papers, bottles, or wood and wire constructions on one's own desk or work table, and, finally, for the great tangles of wire and industrial scrap, and live and dead vegetable matter that exist in towns, cities, and in the country. (During World War II, the French artist, Léger, based a series of paintings on the interweave of vines, weeds, and abandoned farm implements that he discovered on a farm in upper New York state.)

b● Start with a small handful of grass, straw, string, or excelsior, and translate some portion of this jumble into line equivalents. Choose the most

II-50b

II-51a

II-51b

appropriate medium—crow quill, lettering pen, flat pencil, sharpened charcoal stick, or brush. Try to capture a "tangle of space."

c● Then move to an assortment of objects on a table top; the more untidy they are, the better. Use black and white conté crayon or pencil to translate these into line-space conformations [**II-51a**]. Make every possible use of "open" structure, so that space may flow throughout the whole complex. Resort to a kind of shorthand, where lines do not tell all, but tell what they do accurately and incisively [**II-51b**]. Be particularly aware of contrasts of thick and thin, broken and continuous lines, of horizontal and vertical, diagonal and curvilinear relations, and of directional tensions and thrusts. Use the white conté to "correct" the black. "Fix" the drawing immediately with spray.

d● Finally, take courage from these experiments and go outdoors. Make studies of bushes or piles of limbs, roots, and branches that have been assembled for burning. Or visit one of the great

metal scrap heaps that lie at the edge of every city. All are rich in imagery.

Nature and Environment Studies
EX. 10

All the other linear figurations identified in foregoing paragraphs and used separately in schematic studies may now be discovered in a wide assortment of forms in the physical environment.

a● Once again, start with a small single form—a seed pod, a flower, a leaf, a vegetable, a fruit, or a pebble—and study the profile (or profiles) of its form for concave, convex, long and short, deep and shallow curves. Put these down strongly and clearly, being especially careful to acknowledge each bend, each change of direction. A transparent object—a glass or a bottle containing water or perhaps some solid object—is very good for this purpose. It is full of distorted lines and shapes gathered in from objects in its environment. One could draw one's own hand in different expressive attitudes, such as clenched, open, graceful, or

56] "THERE IS NO MADNESS IN MY CURVES. The plumb line in determining the vertical direction forms, with its opposite, the horizontal, the draughtsman's points of the compass. Ingres used a plumb line. See in his studies of standing figures this unerased line, which passes through the sternum and the inner ankle bone of the leg which bears the weight. Around this fictive line the arabesque develops. I have derived constant benefit from my use of the plumb line. There is something vertical in my spirit. It helps me give my lines a precise direction and in my quick drawings I never indicate a curve, for example, that of a branch in a landscape, without a consciousness of its relationship to the vertical. There is no madness in my curves." Henri Matisse. Translation of the artist's holograph text by Monroe Wheeler, in *Jazz*, a booklet printed for the members of The Museum of Modern Art, New York (Munich: R. Piper & Co. Verlag), p. 42.

II-51a A drawing of an assortment of objects, with a free use of open structure. Black and white conté.

II-51b Two very "open" drawings of a Coca-Cola bottle, a distorted wire grid, and one or two other objects. Black and white conté.

II-52 Centripetal or spiral thrust. A drawing of a strand of Spanish moss.

II-53 Cathedral Oak. St. John's Cathedral, Lafayette, Louisiana. This ancient tree requires that the observer walk slowly around it several times, looking often to the right and to the left side of the trunk and along the powerful limbs, so that he may be able to appreciate the magnificent display of form and the patient, leftward spiral of growth.

II-53

"angry," concentrating on those contours that convey the essential "mood," not on the total form.

Curves are "slippery." Therefore, an ancient method of plotting their course is to relate them to a system of horizontals and verticals. These more "rational" elements are made to intersect each curve at every change of direction.[56] Moreover, diagonals may be placed alongside each curve to demonstrate its orientation. Artists of the past learned to draw from statues and plaster casts; sculptural form in the classical mode was their basic discipline. They learned to scrutinize curvilinear relations in inanimate subjects before being allowed to tackle them in the living form, the nude model.

Before proceeding to more difficult forms and combinations of forms, examine the curvilinear shapes of leaves of several species. Emphasize their differences by rendering their shapes in firm, abstract lines. In this connection, examine the silhouettes of several different pots or vases. Apply the horizontal-vertical grid to their shifting contours, demarcating each section: "foot," "belly," "shoulders," "neck," and so on.

b● Then look for a form or complex of forms in which there are examples of point thrust, pressure thrust, and spiral thrust, referred to earlier. These may be found in bones, shells, driftwood, wood grain patterns, a cross-section of fruits and vegetables, crumpled paper or cloth (e.g., as in Cézanne's napkins), or the hard and soft areas of animal and human anatomy [II-52]. A union of potential energy, kinetic energy, and material substance is seen in the counter-play of tension and gravitation in the structural dynamics of buildings, especially those based on the principle of the dome and the arch, and in the growth dynamics of great trees [II-53]. Tree trunks and main limbs provide excellent examples. Color may be used arbitrarily in these and other studies to help identify the various forces at work.

II-52

Artists of the past studied drapery, usually in connection with studies in anatomy. However, cloth placed over an assortment of forms on a table, or a coat hung on a chair or peg, are enough to provide a rich display of point thrusts, catenary arcs, lines of force, bulges, and "hills and valleys." They are created by the response of a flexible material to various pressure patterns and tensions, and to the pull of gravity.

Earth forms, jagged or eroded, illustrate the anatomy of force on a heroic scale. If you live among hills or mountains, or near cliffs or quarries, study, with pencil in hand, the bulging, jutting, tilting formations. There is no need to draw complete forms and masses. Put down only those lines that tell, very briefly, the essential story of internal action and response.

c• It would seem appropriate, at this stage, to make use of several of these linear elements in a design where movement, rhythm, continuity, and expression coalesce. It would also seem appropriate to bring forward the point, giving it a role in the composition along with line, its frequent companion. The student could set for himself any number of propositions. He could pursue ideas either two-dimensionally or three-dimensionally in a wide range of media, including collage. He could combine aspects of both sculpture and painting.

The following ideas come to mind. One could create a frieze (of whatever height and width that seemed appropriate), making use of point, line, and color to establish a progression from left to right—or from right to left, as in a Chinese scroll painting. It could include quick and slow, angular and curved movements, cross-rhythms and linear counterpoint forward and backward in depth. It could be climactic or non-climactic. It could be based on a simple story or a fairy tale, like the "folded-stories" by Warja Honegger-Lavater.[57] An-

other frieze could derive from the flow pattern of water around stationary points or other "barriers." Repeated lines, as in EX. 2, could be used diagrammatically to represent the gliding, dodging, converging-diverging action of fluid in a field. Or one could make a folding calendar—a modern Book of the Hours—in which each season and month is "expressed" by point, line, and color alone, words and numbers being omitted. Summer, autumn, winter and spring, could each have a separate "mood," conveyed entirely by abstract elements (See Part VI). Each month falling within these seasons could be given some individual treatment, but the continuity of time and season must exist in the design itself, from beginning to end. The problem of continuity is taken for granted in the frieze, but it exists in all the visual arts. In architecture it assumes both functional and esthetic dimensions, and involves the spectator in both physical and sensory activities.

Three-Dimensional Studies

EX. 11

Three-dimensional studies relating to several of the foregoing experiments may be undertaken now or at an earlier time. Perhaps it is advisable that all two- and three-dimensional experiments develop directly out of each other, this being the more "natural" sequence, and one that artists of the modern era tend to follow.

a• For example, the study in linear motifs (EX. 7) could be carried out three-dimensionally in at least two ways. A basic motif could be invented with balsa strips. The same motif could then be added to itself indefinitely, varying only in size (length and thickness). The results may resemble the skeletal structure of a bush, developing from heavy stem to delicate branches, or a more crystalline form, such as the snowflake.[58]

b• Instead of the motif's being linear in character, it could take the form of a four-sided pyramid (a

57] See *Graphis*, No. 102 (1962), 418–29.

58] See "Modular Ideas in Science and in Art: Visual Documents," in *Module, Proportion, Symmetry, Rhythm.* Vision + Value Series, ed. G. Kepes (New York: George Braziller, 1966), pp. 75–101.

59] See H. Martyn Cundy and A. P. Rollett, *Mathematical Models*, 2nd ed. (London: Oxford University Press, 1961).

II-54

tetrahedron, one of the five "Platonic solids")[59] made with rounded toothpicks joined end to end. This motif could then be repeated additively by the most simple, economical engineering, to create a great variety of structures. (The basic unit would be the single toothpick and its uniform length.)

c● When vertical lines and problems relating to spatial intervals and projections operating at different levels in depth are taken up, a three-dimensional study could evolve in the following manner. Vertical elements could consist of strips of wood of similar or varying lengths, widths, and thicknesses. These could be mounted on a plywood base of appropriate size with a good glue. If all strips were of the same length, they could be placed in perfect alignment at wide and narrow intervals. They could extend to the edge of the ground or base, or terminate within the ground or beyond it. A more complex and perhaps more interesting design would be the result of using strips of greater variety—long and short, wide and narrow, thick and thin. These could be used not only to initiate expanding and contracting sequences horizontally, but their positions could be staggered and they could be used to create strong and weak emphases and high and low projections. Two grounds or platforms could be utilized in some, with vertical elements passing above and below each other. Two or three colors could enhance the play of intervals, the perceptual sequence, and consolidate certain relations and give greater emphasis to high and low projections. In no sense should they be used merely to decorate. The problem relates to one of the Gestalt principles mentioned in Part I: the factor of similarity. The eye will establish an immediate link between colors that are alike. By taking advantage of this tendency, we may correlate certain elements (ground areas, top planes, and sides of the wooden strips) as color complexes that interlock significantly and may be viewed from several angles.

d● Horizontal and vertical experiments would find their counterpart in a "cage" or space-frame design made with ¼-inch balsa wood strips [**II-54**]. The proportional partitioning of the six sides and the space within the cage should be so well coordinated that no view can fail to offer a taut and satisfying harmony. It could be based on Golden Section intervals or on intervals determined purely by trial and instinct. Inasmuch as this kind of design exists within the narrowest formal limitations, it must be carried out with Spartan economy and precision. Awkward or non-dynamic proportions or poor fabrication will be painfully obvious. Much the same could be said of the preceding construction.

e● Instead of using balsa strips, one could use a length of flexible narrow-gauge wire bent so as to form a rectilinear design of rather more "open" relationships. Right-angle bends could be made to describe large and small "pockets" of space that merge freely with other pockets in their vicinity. Linear movement and the more ambiguous but

equally important spatial movement should be entirely interdependent.

Other wire studies, relating more specifically to experiments in the use of curved lines may follow directly. Formal and informal designs may serve to point up the expressive and structural qualities of each.

f• Take a single wire of the same gauge—a shorter piece, perhaps—and twist or bend with the hands or pliers into the most varied and imaginative patterns. Each design should be a kind of linear statement in space, an arabesque, a gesture —"slow" or "fast," graceful or gnarled.

g• Finally, with a rather long piece of wire, and one of a slightly heavier gauge, perhaps, create a continuous, curvilinear movement in space, incorporating long and short and deep and shallow curves. The design may be free-standing, or may spring from a wooden base. In either case, it

II-56

should sustain the interest of the viewer from *all* directions. Moreover, it should "lead" the viewer from place to place, not by line alone, but by the "current of space" that flows through it [**II-55**].

h• To end this series, the more common procedure of working from two-dimensional experiment to three-dimensional statement could be reversed. The preceding linear design could be used as a model for a drawing [**II-56**] made the same size as the wire structure, clearing the way immediately for more important and elusive matters.

These have to do with the problem of translating a three-dimensional form to the two-dimensional surface without "cheating" the form or ignoring the demands of the surface. Cézanne is supposed to have remarked that he could draw objects indefinitely from one position; all he needed to do, he said, was lean a bit to the right and a bit to the left from time to time. This provides important insight not only into Cézanne's drawn and painted images, but into those of Poussin, Ingres, Degas, Picasso, and other great draftsmen—insight into the plastic integration of data obtained from more than one point of view. Certain lines and forms align themselves conveniently to the horizontal and vertical axes of the picture plane. Others depart from the picture plane obliquely or at an angle of 90°, like a pencil held in such a way as to make it possible to see the small circular end, but nothing of its length. Similarly, the line of which the wire structure consists will depart from or turn toward the observer by both slow and abrupt curves. How is justice to be done to these wayward curves? Cézanne's approach would be to reconcile both front and side views or, perhaps, high and low views of every movement, to note precisely every change of

direction, and then to arrange all of this information in such a way as to make it "read" clearly. Sections would be raised or lowered, moved inward or outward, or otherwise "adjusted" in order that they and all other parts of the line, from end to end, come together in a new organization compatible with the flat field. The same procedure would apply to solid form—a transference from the world of volume to the world of surface.

Degas once said: "Drawing . . . is a way of looking at form." Certainly his drawings bear witness to his own remarkable powers of observation and synthesis. The instinctive desire of the artist, the sculptor in particular,

would seem to be the power to see the far side of a form while looking at the near side, i.e., the power to see, to embrace, the total form. Unable to do this, he treats form in a drawing or piece of sculpture in such a way as to present to the observer a tantalizing display of "information," a plenitude of form from any angle of vision. In one way or another, he turns a limitation into an extraordinary virtue. The draftsman (of the type of Degas, at least) establishes a tension between the drawn form and the surface of the paper, while the sculptor establishes a tension between form and inchoate mass, and between distension and restraint.

Color

I shall try to tell you a few useful things about colors.
PAUL KLEE*

It has been said many times and by many people, including artists and teachers, that color cannot be taught. They insist that one has to be born with a certain "sense of color," a mysterious faculty or special gift. It would be tedious to try to prove them wrong, but one feels that such an opinion ought not be allowed to go unchallenged, particularly when it is used as an excuse for halfhearted instruction. Perhaps it is true that color, like art itself, cannot be "taught" in the same way that arithmetic or grammar can be taught. There are so many things to be considered once the subject is undertaken seriously, including the properties of light and of surfaces and materials that affect light, color perception, color interaction, color and form, color and space, color and expression, circumstance, cultural conditioning, personal preference or prejudice, habituation, fad, fashion, and taste. Moreover, color for the artist at work in the privacy of his studio cannot be dealt with in the abstract, as in a scientific laboratory. No single aspect of color can be isolated from other factors without robbing color of some of its unique power. The artist must be able to "juggle" several of these factors simultaneously. He must "know" them and unify them in the creative act. Where, then, does one start with color? Is it any wonder that most attempts at teaching it seem ineffective?

The great nineteenth century French painter Eugène Delacroix (1798–1863) complained of the failure of art instructors, even of his day, to present the problems of color imaginatively and forcefully to their students, of their tendency to relegate color to a special category vaguely beneath that of line and form.[1] If those instructors had possessed the least portion of Delacroix's interest in and passion for color,[2] they might have been able to provide some useful alternatives to academic dogma. But they felt no particular

*] Paul Klee, *The Thinking Eye* (New York: George Wittenborn, 1961), p. 467.

1] "Secrets of color theory? Why call those principles secrets, which all artists must know and all should have been taught?" —*Delacroix.*

2] "Give me mud, let me surround it as I think fit, and it shall be the radiant flesh of Venus."—*Delacroix.*

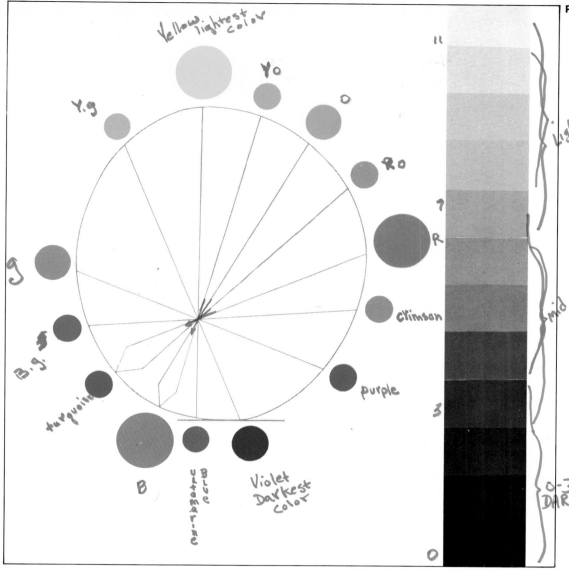

Handwritten labels on figure: Yellow lightest color; YO; O; Y.g; RO; R; Crimson; G; purple; B.g; turquoise; B; ultramarine Blue; Violet Darkest Color; light; mid; O-3 DARK; 11; 7; 3; 0

tween these two extremes, the cool colors ranging along the left side, the warm colors along the right side. The cool colors, because they are contractive, lie nearer the center. The warm colors, because they are expansive, lie further from the center; hence the warped wheel. The primary colors occupy the large circles; the secondary colors occupy the medium-size circles; and the tertiary colors occupy the small circles. Therefore, reading clockwise from violet, we have: 1) ultramarine blue, 2) blue, 3) turquoise (green-blue), 4) blue-green, 5) green, 6) yellow-green, 7) yellow, 8) yellow-orange, 9) orange, 10) red-orange, 11) red, 12) crimson, 13) purple, and, finally, 14) violet. The achromatic or grey scale, to the right, has been arranged in such a way as to approximately parallel the values of the colors from top to bottom of the wheel. There are 12 values in all, making it possible to divide the scale into three registers: the dark register, running from 0 (black) to 3; the middle register, running from 4 to 7; and the light register, running from 8 to 11 (white).

P-3 The psychological wheel—so named because it is based, as nearly as possible, on the psycho-physiological phenomenon known as the negative afterimage. This means that colors connected by lines (or spokes) running through the center of the wheel are the negative afterimages of each other. They are called *complementaries*. (It was considered sensible to focus the lines from yellow-orange and orange on blue, and the lines from red-orange and red on turquoise, there being no practical reason for "hair splitting" in these instances.)

The wheel is also based on the Natural Order of Color. Yellow, being the lightest of all colors in its natural order, is placed at the top of the wheel; violet, being the darkest, is placed at the bottom. All other colors fall be-

need for it beyond the limitations of an official style (Neoclassicism). The kind of color in Delacroix's paintings was, after all, the beginning of a new venture in nineteenth century French art.

During the first quarter of the century, a new interest began to be taken in color by a few artists and theorists. Delacroix and Géricault had been excited by certain "color effects" they discovered in the works of two or three English contemporaries, notably the paintings of Constable and Bonington. There is a story of the occasion in 1824 when Delacroix, having seen a small landscape, "The Hay Wain," submitted by Constable to the annual Paris salon, decided instantly to "rework" important areas of his large painting, "The Massacre of Chios," intended for the same exhibition. Whether true in every detail, this story symbolizes the beginning of an interest in light and color in French art that led to Impressionism in the 1870's and to even more daring uses of color in the works of van Gogh, Gauguin, and the group called Les Fauves ("the wild beasts"), the first twentieth century colorists. By 1900, artists had discovered the pictorial art of the Middle Ages, the art of Japan and Persia, and that of so-called primitive societies. Appreciation of the potentialities of color was enlarged by these discoveries. They pointed the way, in that feverishly creative decade before World War I, to bold concepts of color and space, and color and expression.

In seeking the roots of this color revolution, one goes back to the outset of the Romantic movement—to the nature poetry of Wordsworth, the development of the informal English garden and parkland,[3] the eighteenth century tradition of English watercolor painting, and emergence of landscape as an important pictorial subject in its own right.

One looks especially to the singular achievement of J. M. W. Turner (1775–1851). His was a new treatment of atmospheric light, allied to favorite themes of fire, water, and turbulent movement. His radiant effects, obtained with mere paint, remain unique even after Impressionism. In their own way, Turner's paintings are a kind of Impressionism, excepting, of course, their more heated emotional content. In one heroic leap, they superseded the use of color in Renaissance and Baroque paintings. They replaced the old technique of light and dark contrast with the finest gradations of colors, all—or nearly all—very light in value. While rejecting traditional chiaroscuro, Turner also rejected representation of solid bodies compactly arranged, as though on a stage. In painting after painting, he created resplendent effects of color permeating atmosphere and deep space. His sketchbooks reveal a background of experimentation with bands and blocks of colors placed side by side in various combinations. But his discoveries and his method of handling oil paint were meant for himself alone. As it so often happens, however, in human affairs, a similar interest in light, color, and space was soon to be taken up by other artists. The laws governing color interaction had already become the subject of theoretical speculation in Germany and France.

M. E. Chevreul (1786–1889), the French chemist,[4] published his findings on color interaction, *On the Law of Simultaneous Contrast in Colors*, in 1839. His observations were known to the Impressionists and to Seurat, who, in the 1880's, developed his method of painting with points of almost scientifically adjusted colors, a method not very different from techniques of color reproduction in common use today. Seurat's

3] See Miles Hadfield, *The Art of the Garden* (New York and London: Dutton Vista Pictureback, 1965).

4] See LIFE Magazine, Vol. 61, No. 26 (Dec. 23, 1966), 40–41. Also M. E. Chevreul, *The Principles of Harmony and Contrast of Colors and Their Application to the Arts*, with a special introduction and explanatory notes by Faber Birren (New York: Reinhold Publishing Corp., 1967).

Pointillism or Divisionism (the latter being a more definitive term) sought to create the desired colors in the eye by retinal fusion rather than by the more familiar method of blending colors physically on the palette and then applying them in flat areas to the canvas. Color luminosity as a quality inherent in the painting, not simply illusionistic rendering, was his principal aim.

The artists referred to here were not *taught* color in any academic sense, but one would have to agree that, in one way or another, they *learned* and *discovered* very much, indeed, about color. The Impressionists talked at great length about color, sunlight, and perception, exchanged "studio secrets," and seemed to agree generally on a few "working principles" which could be demonstrated quite readily with paint. There were several new ideas to consider. Scientists and artists seemed to have a common interest for the first time since the Renaissance.

Our understanding of color would not conflict radically with theirs, though our use of color would differ greatly from that of Impressionism. We would proceed from experimentation to personal handling and expression, taking into account important achievements since the 1870's and 1880's. But whatever the approach, it would seem advisable that both objective and subjective experiences be admitted at all times. No harm is likely to come from recognition of a few "working principles" as guides to discovery and development. Without some degree of objectivity, artists tend to repeat the same color combinations again and again, with little regard to form, space, subject-matter, or the quality of expression desired.[5] Learning about color is an endless process that advances on more than one level of mind and emotion. Undoubtedly Charles Baudelaire

in his essay, "On Color," was correct in assigning great importance to "temperament," but even the most gifted colorists do not develop without much trial and error and tireless observation of color in nature, their own art, and the art of others, even the art of children.

Matisse fulfilled the prediction of his master, Gustave Moreau, in his 70's and 80's! His way of "simplifying painting" was through color, a development that sustained his interest over more than half a century.

Color Systems

The above would seem to suggest that all color systems, the Ostwald, the Munsell, or any other of the sort, are of doubtful value to the artist. Most artists would agree that the theories these elaborate are at the same time too simple and too complex for practical purposes. Moreover, they seem too inflexible for all those unpredictable situations in which the artist has to relate color to color, color to shape and proportion, or color to form and space. But in fairness to these systems, which are, after all, the work of color scientists, not artists, it should be remembered that they have more than one function and application. Color is not the exclusive province of the artist (however much difficulty one may have suppressing the thought that only in the work of the artist does it take on special significance).

The Munsell system has been adopted by the American Standards Association mainly because it provides a reliable color notation chart. Manufacturers and users of paints, dyes, and colorants of all types may consult this chart in order to describe or specify any color accurately, not only by hue, but also according to two characteristics of

5] "Color is nothing if it is not suitable to the subject, and if, in imagination, it does not add to the effect of the painting."—*Delacroix.*

color: color intensity (relative brightness, saturation, or chromatic strength) and light intensity (relative lightness by a scale of values ranging from black upward through the color spectrum to white). A manufacturer of dyes in Chicago could respond immediately to an order for 12 ounces of "turquoise blue" if both he and his client in Atlanta have made use of their Munsell charts. The order would then read "12 ounces of blue-green 7/4," meaning 7 degrees up the vertical axis from black in lightness (value) and 4 degrees outward from this point in intensity or brightness (chroma). The Munsell "color tree," with its vertical axis or trunk forming a scale of values from black to white, and its outward span of colored squares resembling leaves, is the attractive embodiment of a system devised for the standardization of color. This system and others are actually meant to serve two purposes: color identification, illustrated above, and achievement of color harmony. It is with the latter purpose that most artists would differ. They would point out that, even in those ingeniously contrived color schemes made available by paint manufacturers to interior decorators and the general public, there are few instances where colors settle down together with ease. Moreover, it is not always a question of achieving "harmony." Too much obvious harmony is boring, and any system that places too much emphasis on harmony of this cosmetic nature limits the expressive range of color. The same would be true of a system of harmony in music that sought to eliminate dissonance altogether; dissonance has become as important as consonance in most modern music. Consonance and dissonance, "harmony" and contrast, adaptation and repulsion are other words used to identify qualities referred to earlier; they denote those dual forces of cohesion and segregation. A work of art of any sort may be examined for the way it organizes these forces, the way these are made to function in a unity of form, space, and feeling. It is in this higher order that true harmony resides.

If the artist and the art student have little to gain directly from these systems, they may wish to refer to them for some understanding of the physics of color, which, along with the psychology of color, underlies its use. Perhaps the student will not have forgotten all that he learned about light and the prismatic spectrum in high school. If he has forgotten, the following excerpt from an article on color, which appeared in LIFE magazine on July 3, 1944, may be of some help. The whole article, with its excellent technical illustrations, is recommended.

Color begins with light. The sensation of color is aroused in the human mind by the way in which the eyes and the brain centers of sight respond to the waves of light which bear the world in on our perceiving consciousness. The perception of color is, therefore, a highly personal experience. It is influenced by association and aesthetic preference, by fatigue, by sharpness of vision and by color blindness. Yet for all human eyes, the perception of color is linked firmly to physical reality and depends first of all on the nature of light.

The waves of visible light are a narrow band in the known spectrum of radiant energy. This spectrum moves from the invisible, miles-long waves of radio through the infra-red waves of heat across the visible wave lengths of color to the invisible ultra-short ultraviolet waves and on out to the infinitely short waves of cosmic rays. Within the visible spectrum light waves themselves vary from 700 millimicrons (billionths of a meter) to 400 millimicrons in length. When a beam of white light is dispersed by a prism and separated into its component wave lengths, . . . it is seen at once that each of these wave lengths stimulates a different color response in the human eye.

The colors that compose into visible white light are shown in greater detail in a spectrogram of

solar light [in one of the technical illustrations accompanying this article]. The major colors which the eye can discriminate in this gamut are red, yellow, green, blue and violet.

White is the total addition of color. It is perceived when a surface reflects all colors equally. Black is the total subtraction of all color. It is perceived when a surface absorbs all colors equally. White and black are exceptions in nature. The rule is the partial absorption and hence subtraction of a band of color from the spectrum and the reflection or transmission of the rest. The mixture of the reflected or transmitted spectrum colors is the color of an object.

All colors, even the pure colors of the spectrum, can be produced by mixture. There is one class of colors, called primaries, which perform this operation most efficiently. Despite widespread misconceptions to the contrary, the primary colors of light are red, green and blue. These three colors are related directly to three response factors in the mechanism of human vision about which nothing is known except that they resolve mixtures of wave lengths into mixtures of colors. The three primaries cannot be broken down into component colors. They can be produced by mixture only when they are themselves components of the mixing colors. When added in pairs or all together in equal or unequal strengths they produce all of the possible colors, including the mixtures of red and blue (the purples), which do not appear in the spectrum, and white. In fact, for all practical purposes in color mixture, white light may be defined as a mixture of red, green and blue.[6]

Any artist or designer in the present age is certain to have acquired some of this information in or out of school, but unless his work involves use of direct light, as in the theater, he may feel that he has little need of a technical understanding of colored light and the peculiarities of additive and subtractive mixing. He is likely to be more involved with another medium—paint and the peculiarities of paint (i.e., pigment) mixture. Instead of working with colored light (luminous color), he works with reflected or transmitted color.[7] His mixtures never do what colored light is able to do; no paint mixture can ever "add up" to white, least of all to white light. On the contrary, the components in almost every mixture will subtract some color, particle, or semi-chrome, each from the other—the more ingredients brought together, the more they will cancel toward black. Another set of circumstances is involved here, including the quality of each type of paint or pigment used, whether oils, watercolors, crayons, inks, or any other. The artist creates within these limitations, as the musician composes within the narrow range of the musical spectrum and musical instruments—unless, of course, he is a composer of electronic or computer music.

The artist is concerned primarily with the color given out from pigments and surfaces. The material quality of these substances (rough, smooth, soft, hard, transparent, opaque, wet, dry), the intensity, color, and direction of the light playing upon or through them, the way they "take" the light—all of these greatly affect color. But to say that the artist is "concerned with color" is to state matters a bit too vaguely. He is concerned with *appearance*, there being a considerable difference between color as physical fact (measurable wave lengths) and as perceived fact (what one actually sees). Color is the most enigmatic element in art, always revealing itself to the observer in a state of mutual reaction or interaction. Place any color in a new setting and it will appear to have altered like a chameleon. Moreover, colors will take on curious illusory qualities, appearing transparent or opaque, or near or far, though the pigment be of the same density in every case. These qualities appeared in the first series of studies in "Rediscovery of Color."

This may seem the barest introduction to

6] From "The Science of Color," LIFE Magazine (July 3, 1944), © 1944 Time Inc.

7] It would seem evident that more and more artists will want to know how to use colored light. Color courses could easily include a few simple experiments.

the complexities of color perception. But to read about color is not to appreciate its infinite subtleties. A purely mental image of a color is probably the most uncertain of all images. One has to *look at* colors, mix and arrange them personally in order to judge how they affect one another. Therefore, the problem of color perception must be taken up in the series of studies to follow, where the dynamics of color interaction may be discovered in context and at first hand. The problem, however, does not end with these studies. It arises in every creative act involving color.

If there is no system of color that serves the artist in the privacy of his studio, what does he rely upon? If the Impressionists were not very assiduous theoreticians, what rule of thumb principles did they evolve? What did Bonnard, in later years, and Matisse understand about color? Was van Gogh merely a wild colorist, a "mad artist" lacking in understanding and judgment? What did great colorists of the past—Egyptian muralists, Byzantine mosaicists, Medieval decorators and manuscript artists, Persian and Indian miniaturists—understand about it? Did Piero della Francesca, Brueghel, and El Greco work entirely by instinct? If research and inquiry have produced few common rules by which to explain the coloration of works as diverse as the windows of Chartres Cathedral, a Persian rug, or a painting by Rubens, they have revealed a slow evolution of color towards more elaboration and subtlety as the technique of a given craft has increased in complexity. These were localized developments in most cases, and evolution through experimentation, invention, and happenstance continued over long periods of time. Artists of the past, unlike musicians, did not leave much detailed information

about their concepts of color, possibly because of the nature of the guilds and workshops where they received their training and where traditional coloring was applied to traditional forms and patterns associated with specialized and often secret techniques, and also because a terminology of sufficient objectivity and subtlety did not evolve until the first half of the nineteenth century. The innovations of the masters took place quietly within the larger framework of tradition.

Perhaps a simple diagram that can be kept in the mind, along with a few easily remembered principles pertaining to it, is all any artist needs, aside from years of practical experience. The musician, in spite of the evanescent nature of sound, is in a more fortunate relationship to his craft than the artist. The language of music is unique because of its mathematically defined vocabulary. Successive intervals of a regular order form scales, and combinations of intervals arranged "vertically" produce chords of predictable quality and effect. The music student must still study harmony and counterpoint, even if, as a composer, he chooses to dismiss some or all of his musical heritage. He will rely upon some understanding of the intervals of scales, of intervallic combinations and progressions, and of musical notation in order to transfer his ideas to paper. The rough equivalent for the artist of these musical intervals would be, first, the natural intervals of the color wheel, and, second, the kind of "color chords" he may expect to derive from them. But since colors resist formulation according to such strict mathematical orders, and so many circumstantial matters enter into their use, the artist is often left with little but instinct and private experience to guide him—an irony in an age when so much more is known about color!

There is no reason to expect the color wheel to help beyond a certain point, and there is no need to learn it at all unless it serves some useful purpose, however limited. Unfortunately, the color wheel is to many artists and students the symbol of all those color courses they had to take in art schools, to no recognizable purpose whatever.

The Color Wheel and the Natural Order of Color

The color wheel we shall use [**P-3**] is based on two natural phenomena, but the scientific exactitude of its design would probably be difficult to justify. Even certain purportedly scientific systems differ on certain points. Our wheel is based on what we shall refer to as the Natural Order of Color and the psycho-physiological curiosity known as the negative afterimage. The idea of a natural order derives, to some extent, from the work of American scientist O. N. Rood. It is hoped, therefore, that it contradicts neither scientific theory nor modern artistic practice. Artists and designers must work with ideas that are simple and practical, that will submit to both empirical and intuitive verification.[8]

The term Natural Order of Color means simply that some hues, in their pure state, no matter where they are discovered—assuming, of course, they are seen in a good light— are light in value; others are of a medium value; still others are dark in value.

Absolutely pure hues are encountered less often in nature than one would suppose. When they are found, for example, in certain flowers and insects, bird plumage, certain stones and minerals, or a spectacular sunset, they do tend to conform to a natural scale of chromatic values. (There are interesting anomalies in some of the examples cited which will be mentioned in the section on Discord.) If one follows the drama of a sunset from beginning to end, one discovers a gradual movement of color *down* the natural order, from yellow to red, and finally to violet —and nightfall.

Another way of expressing this gradation would be to say that color manifests itself according to a scale of values ranging from light to dark. Certain hues, such as violet, purple, and ultramarine blue, pertain to the dark register, or the bottom of the scale; red and green, for instance, belong to the middle register; yellow and yellow-green belong to the light register, or the upper end of the scale. Yellow assumes the position of the lightest hue and ultramarine blue or, more likely, violet, that of the darkest, *in their natural order*. That they are also complementaries is another factor accounted for in the wheel, the spokes running from one side directly to the other indicating the natural opposites found in the afterimages. The point to be emphasized is that the Natural Order of Color is based on a scale of values, or relative lightness—*not* to be confused with brightness or intensity, assuming, of course, that each color is seen in its purest state. This scale of values corresponds to the Achromatic Scale or Grey Scale, which is the trunk or stem of both the Ostwald and Munsell color forms (e.g., the Munsell "tree"). That no hue in its natural order touches the extremes of the achromatic scale is readily understood: pure yellow cannot be as light as pure white (although yellow has been referred to as "a denser, material white"), and pure violet cannot be as dark as pure black (technically, the absence of all color, despite the fact that

8] See G. S. Brindley, "Afterimages," *Scientific American*, 209, No. 4 (Oct. 1963), 84–93, and other essays on color perception, e.g., Edwin H. Land, "Experiments in Color Vision," *Scientific American*, 200, No. 5 (May 1959) 84–99, and Edward F. MacNichol, "Three-Pigment Color Vision," *Scientific American*, 211, No. 6 (Dec. 1964), 48–67.

most artists habitually accept black as a "color"). The color scale, the wheel, exists *within* this wider range of values. The student will bear in mind that we are dealing with *pigments* and the appearance of color in pigments, not with colored light (luminous color) or radiation, which strikes the eye with far greater energy than color from a painted surface.

Our color wheel is known as the Psychological Wheel. There are two other types: the Physical Wheel, based on light primaries (blue, with a tinge of violet, green, leaning slightly toward yellow-green, and red, with a tinge of yellow) and complementaries [yellow (minus blue), red-violet (minus green), and green-blue (minus red)]; and the Pigment Wheel, which is meant to "correct" certain discrepancies in the Psychological Wheel by indicating a bit more precisely the way complementaries would seem to want to arrange themselves *as pigments*. For example, the psychological complementaries yellow and ultramarine blue, if mixed in equal portions, would produce a diminished green, *not* a dark grey, as complementaries should. But if *violet* and yellow were mixed, they would indeed "break" each other and produce some sort of grey.

Some wheels contain 8 hues, some 12, others 14. Sir Isaac Newton, who in 1666 performed the famous experiment with a beam of sunlight and a glass prism, acknowledged seven colors. Our wheel contains 14, derived from pigments in common use and called, in most instances, by the names both artists and paint manufacturers recognize, whether or not they be the best of all possible names. Purple-blue in the Munsell system is called ultramarine blue here, since this is the name by which one would normally

purchase it. Practicality in these matters must take precedence.

The afterimage

If you stare for a few seconds at a spot of red in a good light, and then shift the eye quickly to a blank white or grey surface, you will detect a light greenish-blue glow.[9] This "glow" is the negative afterimage; it is the natural opposite or complementary of red. The color receptors in the human retina, after absorbing a particular stimulus, become momentarily "fatigued" or insensitive, and react by registering the complementary of that stimulus. This pale, ghostly "projection" or afterimage will overlay and modify any color gazed upon next. If we gaze at red and then at yellow, the yellow will appear quite green. If we stare at red and then at a neutral blue, the blue will be transformed into a vivid blue-green. One can begin to understand why the ancients thought the eyes sent forth "sight rays," rather like a modern cinema projector.

This kind of compensatory response in the eye is always present when we are looking at colors, but we are not often aware of it. The afterimage of every color in a color scheme will affect every other color to some degree, either favorably or unfavorably. An achromatic or neutral tone will "pick up" a bit of color from the afterimage, if it is placed within or beside a bright hue. White is capable of becoming quite saturated with the afterimage of a strong stimulus. Painters have been aware of this for a long time; Leonardo described the effect in some detail. (The effect is more noticeable in small areas and along the edges of adjacent colors, suggesting a good reason why one should

9] Better still, hold a piece of red (or any color) paper over a white surface and stare at it for a few seconds. Then, without shifting the eye, slide the colored paper away slowly. Its afterimage will appear to trail behind it like a wake. Try the same colored paper over a colored surface.

use black outlining with caution if color vibrancy is wanted.)

Complementary colors "demand each other." This is how Goethe, the great German poet-philosopher-scientist, described the interaction of chromatic opposites. It was also he who described how objects lit by colored light cast shadows that contain the complementary of the light. He felt, perhaps rightly, that the secret of color and its use lies in this "calling up" of one color by another. Chevreul, in the course of his duties as dye chemist and colorist for the Gobelin tapestry studios, worked out, quite independently and empirically, a set of theories, based on the dynamics of complementaries, which he called simultaneous contrast (see p. 85). He described how *any* two colors will appear to modify each other in both hue and value; the afterimage of each will overlay the other. Only in the case of true complementaries will colors intensify without otherwise changing each other, according to his judgment. Appearance and deception are the words that apply, for when one is dealing with color, one is unavoidably dealing with optical trickery. If this were not so, there would be little magic in color.

Our color wheel places yellow at the top and violet at the bottom. Stepping downward from yellow on the red side, in their natural order, are yellow-orange, orange, red-orange, red, crimson, purple, and violet; stepping downward from yellow on the blue side are yellow-green, green, blue-green, turquoise, blue, and ultramarine blue—a total of 14 hues. *As each hue takes its proper place down one side or the other from yellow, it should appear slightly darker in value than the one above it*. This is important to all that follows, if this wheel is to serve the purpose for which it is intended.

The primary, secondary, and tertiary hues

EX. 1

One should make one's own color wheel, whether or not the results be "perfect," or whether it serve, at most, only a temporary purpose. In doing so, try, first of all to obtain the "middle" or mean color of each of the primary hues, red, yellow, and blue; it is from these three hues that all other hues derive—theoretically, if not always in practice.[10] No color from the tube may be assumed to be absolutely correct in every sense for any one of the primaries or for any of the other hues, but some may require less adjusting of value and chroma than others. The blues and violets, as well as the greens, are usually much too low in pitch, too dark, when taken straight from the tube. The pure reds, except for alizarin crimson, are not as far out of pitch. The pure yellows and orange are ordinarily even less out of pitch.

The groups of red, yellow, and blue paints required in the first section, "Rediscovery of Color," may be used again. First, choose a red (possibly a cadmium red, medium) that seems to approach a middle red, being neither too light nor too dark, nor too warm (red-orangish) or too cool (crimson or purplish). Add a bit of white to it if it should need to be lighter (white also tends to cool a color slightly). Add another color—perhaps another cadmium, light or deep—to make it darker, or warmer or cooler. Every precaution should be taken to avoid contaminating, "breaking," or diminishing the color. It should retain its native brilliance, unimpaired. This means not only that no black or broken colors, such as the siennas or ochre, may be added; it also means that the palette and palette knife must be kept very clean during each mixing.

Yellow is very easily muddied. In order to obtain the correct yellow for the top of the wheel, compare the two or three pure yellows in the tubes for relative lightness and warmth. The final yellow should contain no trace of orange (red semi-

10] It must be admitted that, from a strictly scientific point of view, it would be considered inaccurate to refer to red, yellow, and blue as primary colors; but from the more practical standpoint of the artist and of color (pigment) mixing, they do have a primary significance.

chromes) or green (blue semi-chromes). Perhaps a bit of white is all that will be required to produce the desired quality.

Choose a blue that is not too dark (two steps up from violet) and not too light (about on a par with purple or perhaps crimson, horizontally across the wheel from it), not warm (containing no semi-chromes of red, as does ultramarine blue, directly below it), or greenish (like turquoise, which would be just above it). One of the monastral or pthalo-cyannine blues, which are usually given the name of the manufacturer, would probably be a good first choice. White added to lighten it somewhat, and perhaps another color to correct its "temperature," would produce an acceptable middle blue.

All of this may sound easy, but the actual doing requires patience and good judgment. It must be borne in mind, where the primaries are concerned, that red, theoretically, is *only* red, yellow is *only* yellow, and blue is *only* blue. The secondary hues, orange, green, and violet, are ideally the results of a balanced mixture of two primaries: red and yellow create orange, yellow and blue create green, and red and blue create violet. But no three colors in any combination will produce all other hues at high intensity. A good violet, for instance, is almost impossible to obtain by mixing red and blue paints, even of the best quality.

When all 14 hues are obtained, including the intervening hues, sometimes called the tertiary hues—yellow-orange, red-orange, crimson (violet-red), purple (red-violet), ultramarine blue (violet-blue), turquoise (green-blue), blue-green, and yellow-green—a final adjustment may be required in order that each hue assume its proper place in its natural order on the wheel. In arranging the hues around the wheel in circles of one inch or more in diameter (or, by whatever device one prefers—the primaries could be round, the secondaries square, the tertiaries triangular), it is not too important whether the warm hues are placed down the right side or the left. The right side of a design

is usually the side of greatest psychological "weight," as we discovered in Part I. Similarly, red and its neighbors are usually felt to consist of more expansive energies than the blues and greens. Therefore, if red is placed on the right, the wheel may seem less balanced as a design than it would if red and its neighbors were placed on the left side. But since this is not actually a problem in design, a more important consideration would be fixing the wheel in the mind's eye in a certain way from the very beginning, so that it may be recalled instantly when needed.

In order to complete the wheel, one must draw spokes diametrically from each color to its complementary. One may also link the primary hues by means of a triangle, and the secondary hues by another, leaving the six tertiary hues free.

The idea of making a warped wheel, as reproduced here, is not to complicate an issue about which there are still many artistic and scientific differences of opinion. Quite the contrary; it is meant to establish, a bit more accurately and perhaps more interestingly, the location and thrust of each hue from top to bottom and from cool side to warm side. The warpage allows one to place ultramarine blue, the psychological complementary of yellow, just above violet, reckoned to be the darkest hue in its natural order; it also allows one to place the reds and yellows at the farthest remove from the center in order that their more radiant energies may be emphasized. The result is a more dynamic image, as a symbol of the chromatic compass should be. It not only shows the concentric nature of the cool colors and the eccentric nature of the warm ones, but also follows the movement of receding and advancing hues (clockwise into depth from violet, and forward again through yellow and red, and so on).

The achromatic scale

EX. 2

a• It would be almost as valuable an experience to make an achromatic or grey scale to go along with the wheel. The adjustment of values by trial and error, comparison from black (0) to pure white (11) would train the eye for an important purpose: recognition of value relations, not only in drawings, prints, and photographs, where no color is used, but in those more common instances in art and nature where color does exist.

The recognition of achromatic value relations will be taken up in more detail later in this part and in Part IV. It is more difficult to recognize value—various levels of lightness and darkness—in color than in arrangements of greys, black, and white. Our daily acquaintance with "black and white" photographic reproductions in books, magazines, newspapers, and television amounts to a kind of unconscious training in recognition of the most subtle configurations of black, white, and greys. It is doubtful that a member of a primitive society could make sense of the welter of printed pictures we decipher automatically every day of our lives from about the age of two or three. But, as artists and students, we often have to train ourselves to recognize values in *color*. Squinting seems to help; it tends to suppress chroma somewhat and allow one to concentrate on value differences. Training the eye to distinguish light and dark values in color—chromatic values— in any condition whatever, strong or weak, on the flat surface or in the world of light and space about us, is one of the purposes of studies to follow.

b• The actual making of an achromatic scale, similar to the Munsell scale which forms the trunk of his color tree, would not be time wasted. It could be placed alongside the color wheel and divided into three registers, light, medium, and dark, in much the same way the musical octave is divided into tetrachords.

The following studies will provide some training in recognition of chromatic values through the actual mixing and matching of colors. It is possible to acquire visual acuity as a spectator, but the artist or designer is a "maker," a "doer," and seeing for him is coupled with the handling of materials. It is in "doing" that skill of both eye and hand is acquired—in the give and take between the artist and his medium. Instruction may help to spare him many false starts and unprofitable ventures, but skill, as such, is personal and non-transferable.

Color nomenclature

Before taking up the next study, it may be advisable to define certain terms, several of which have already appeared. Hue denotes the generic or family name of a color (such as red or blue). Value denotes relative lightness in a scale ranging from black to white. Intensity is one of several words (e.g., chroma, brightness, saturation) used to indicate the quality of a hue, its degree of strength or chromatic energy. A tint is a mixture of a pure, undiminished hue and white. A shade is a mixture of a hue and black. A tinted grey is a mixture of a very small amount of a hue and white and black (i.e., grey). A broken color is the result of a mixture of unequal portions of *all three of the primary hues*. These pigment colors, because they are of different materials and reflect varying wave lengths, tend to cancel each other in evenly balanced mixtures of all three. Normally one or two will dominate and a dull red, yellow,

green, orange, and so on, will emerge. Broken colors are the most common colors in nature; for example, the so-called earth colors—browns, tans, and dull greens. Tone seems a good word, judging by the frequency of its use by decorators, paint manufacturers, laymen, and artists. But it is borrowed from the vocabulary of musical terms and used to denote a confusing variety of qualities. Perhaps it could be used interchangeably with the term value—if everyone agreed!

This points up the problem of establishing a kind of professional vocabulary for artists, designers, critics, art students, and laymen: a few dozen words that will have the same meaning for all. Musicians have a dictionary of terms, most of which are Italian. Many artistic terms in use today are French in origin, possibly because Paris, from about 1825 to 1939, was the main nerve center of art in the Western world. Music, despite changes in form and content since Beethoven, has maintained many of its old disciplines and techniques, whereas, in the art of the present day, diversity of method, motivation, concept, and purpose demand constant assessment. Revolution seems to run deeper in the visual arts, perhaps because they establish a more immediate and challenging physical and ideological relationship to the world in which they exist. Experimentation in them seems to depart radically from tradition.

Chromatic gradations—tints and shades
EX. 3

a● Choose four hues of light, medium, and dark values in their natural order, and create a few chromatic gradations by adding first white, then black, to the original hues. The first set will consist of a series of tints—three to six of each hue should be enough—and a series of shades. Try to see how closely you can relate the chromatic steps to those of the grey scale. To do so, you must locate the position of the original hue relative to the grey scale, and then match the tints upward from that position, and the shades downward. Some hues allow little variation in tint or shade. Yellow, for instance, can go very little lighter than it is without becoming white; the least bit of black added to it will destroy its identity, making it a rather uncertain green. Likewise, violet, at the opposite end of the color wheel, cannot be made very much darker without seeming black. If raised very high, as a tint, it will lose its original character and become a wispy lavender. On the other hand, red, partly because it lies in the middle register in its natural order, admits of much more variation up or down without suffering loss of identity.

b● With the mixtures left over from this study in tints and shades, make a design of *wide* and *narrow* stripes, running vertically or horizontally. Place the stripes side by side, touching, in arbitrary sequence, making use of a few tints and shades as well as some of the original hues of all four sets. Study the results for vibration, dominance, harmony, and contrast.

Tinted greys—warm and cool

Tinted greys (or chromatic greys) are those colors often favored by popular taste, used by many interior decorators and "color advisers" for walls and furnishings in buildings of various types, frequently without much regard for the effect of environment upon us and the way color and light are able to transform environment. Apropos of this subject, must the interiors of all types of public buildings be painted the same kind of institutional green or cream?

There is nothing wrong with these colors (or with any single color) but, because of their relative neutrality, tinted greys lend themselves to use by people who give little

thought to the effect of color on mind and emotion, who are, perhaps unknowingly, "afraid" of color. Nor is taste the surest guide in these matters. Color psychologists, notably Faber Birren, in his book, *New Horizons in Color*,[11] have suggested other criteria in recent years, not only in choice of colors, but also in the lighting of interiors of every sort. Homes, factories, offices, and libraries require individual consideration, and architects are increasingly inclined to include lighting and color as essential elements in their designs related intimately to form, space, and feeling.

Tinted greys were used with great skill by French artists of the middle of the nineteenth century: by Corot in his landscapes, which derive much of their quality and originality from his sensitive adjustment of earth colors to chromatic greys; and by Courbet in his paintings of the woodlands, hills, and caves of his native Franche-Comté, and in the rain-heavy skies in his seascapes. The marine or *plage* (beach) painters, Boudin and Jongkind, used tinted greys to simulate moist atmosphere and veiled sunlight over sand and water. The American painter, Whistler, who knew what was happening in French art in the 1860's and 1870's, used grey tones in his mood pictures, or Nocturnes, as he called them. But the master of tinted greys in the 1860's and later was Manet, who based his new technique of painting, *peinture claire* ("light painting"), on a most sensitive handling of values, chiefly in the middle to light registers. He softened all light and shadow contrasts, illuminated his subjects broadly and evenly, and virtually eliminated traditional modelling. His colors, though light, were not the pure tints of the Impressionists who followed him (who, in fact, owed much to his new vision, light palette, and spontaneous brush work), but were, on the whole,

fine gradations of warm and cool greys.

Greys of this sort have been used by many French artists on the fringe of the Impressionist tradition to the present day. One can recognize a characteristic School of Paris grey, which, in too many cases, is almost the death of color (Père Tanguy, the beloved color merchant and patron of the Impressionists, scorned the use of black). Greys, especially dark neutral greys, may act as a kind of sponge or "acoustical agent," and absorb a great deal of color energy from their environment. But greys may also be among the most useful and beautiful of colors. The painter Vuillard revealed the poetry of chromatic greys in his intimate interiors and street scenes.

Ancient Korean and Japanese pottery, especially those pieces associated with the Zen tea ceremony, are admired for the subdued colors of their glazes—the colors of natural objects, such as stones, bark, sand, and sea shells, and weathered and mossy surfaces of all types. Because they are associated with nature and are rich but quiet, they "wear well" in the eyes of the beholder. It is only fair to add, however, that qualities eminently suited to pottery may not, even in Korean and Japanese cultures, seem appropriate for other things. Silks and other fabrics may require a more festive coloration, depending on occasion and use. Taste, age, association, mood, symbolism, function, and culture have powerful influences on how, when, and where colors are used.[12] Ancient cultures seem to reveal a surer sense of color usage than our modern industrial civilization; the relationship of color to both internal and external conditions seems to have been understood in greater depth. Color must not be applied indiscriminately to any surface lest it become debased. Since

11] New York: Rheinhold Publishing Corp., 1955.
12] "Colors can be gay and playful, playful and sad, rich and gay, rich and sad, commonplace and original." —*Baudelaire, "On Color."*

color can be separated from its context in objects and the environment, and examined on its own, it may be used as we are using it here: as a means of training us to see the world afresh. But because color is so available, it must not be abused.

The problem of temperature in color will be taken up in more detail later, under *Contrast.* At the moment, something should be said in an introductory way about "warm" and "cool" as they apply to chromatic greys. It is commonly agreed that red or one of its neighbors on the wheel, possibly red-orange, is the warmest color, and neutral blue, or possibly green-blue (turquoise), the coolest. That they do not *radiate* heat, feel warm or cool to the touch, is obvious. Benjamin Franklin seems to have been the first person to demonstrate the degree to which light and dark colors physically *absorb* heat from sunlight; colored squares of cloth placed on fresh snow in direct sunlight melted their way down into the snow according to their values, the black one descending fastest. However, these terms, "warm" and "cool," and others, such as "aggressive" and "retiring," refer to *psychological*, perceptual-feeling reactions in people. Red wave lengths are longer than blue or violet wave lengths, but even this would not seem as important a factor as some sort of early association of color with other sensory experiences—hence, cool blue sky or water, red hot coals, and so on. Greys, in the very slight degree to which they partake of reds, oranges, and yellows, or of blues and greens, are said to be warm or cool.

EX. 4

a● In order to make a set of warm and a set of cool chromatic greys in the light, medium, and dark registers, it is advisable to start by mixing batches of white and black in roughly those three registers. Then a selection of two or three hues from the warm side of the wheel may be made for creating a set of six or more tinted greys; a selection of as many hues from the cool side may be made for the creation of a set of cool greys. In both sets only a small amount of colorant should be added to the neutral grey, since too much is likely to result in a mixture that fails to "read" as a kind of grey. Pure hues from the wheel are not the only coloring agents one may use for making warm and cool greys. The broken colors made by mixing all three of the primaries in various proportions, and those that come ready-made in tubes—the Mars colors, the ochres, umbers, and siennas—produce beautiful mixtures with the addition of neutral grey or white. The addition of white or light grey will tend to make a color seem cooler, and the addition of black will make some colors seem warmer. A color's neighbors will affect its temperature even more, by virtue of the afterimage. Pure tints (unbroken hues plus white) and tinted greys are easily influenced, happily or unhappily, by strong neighbors. Neutral greys may be forced to seem tinted, and tinted greys which, in quiet surroundings, seem dead, are capable of springing to life in the radiant atmosphere of strong neighbors. If not rudely overpowered, they may play a useful part in a color scheme.

b● To demonstrate this, make a design using an assortment of warm and cool greys plus two or three strong colors from both sides of the wheel, placing them together in large and small squares, rectangles, and stripes, rather like a patchwork quilt. Observe carefully which tinted greys gain and which lose in the chromatic contest.

Broken color

If the term *broken color* seems strange, it may take on a clearer meaning if, for broken, we substitute the word "damaged" or

"diminished"; a broken color, seen on its own, is one that emerges from a tug of war with other color particles or semi-chromes in its body. The hue from which it derives its name and identity—and in certain very broken colors this is not easy to determine—has been compromised in strength and vitality by the discordant vibrations of incompatible elements in the mixture. The conflicting interactions of wave lengths are not unlike those set in motion by the striking of several keys of the piano with the fist, though the results in the case of color may not seem at all unpleasant. The kind of color under consideration is the result of a process called subtractive mixing. The ultimate product of subtractive mixing in pigments is a murky grey. At this stage, all the hues or semi-chromes have reduced each other almost to zero, have "subtracted" almost all chromatic energy from each other. Fortunately, most battles stop short of this extreme, and most broken colors are the result of *partial* victories by one hue or another.[13]

Of course, colors, pure or broken, are seldom seen entirely on their own. Afterimages have their effect on the appearance of all juxtaposed colors—some gain and some lose in chromatic energy, depending on their neighbors.

As explained earlier, every hue on the psychological wheel is made up of the primaries, either in their pure state or in some combination of them (except, of course, a combination of all three). Any two primaries combined equally will form a secondary color. A two-parts-to-one combination of any two of the primaries will form the remaining tertiary hues—or, in theory, should.

Diagram III-1 (see p. 120) will serve to indicate the extent and proportional involvement of each primary around the wheel. The primaries are absolute; they stand alone. All the other hues around the circle are the result of equal or unequal mixtures of two primaries. As for broken colors, which have no place on the wheel, one can see immediately how any mixture of two hues *across* the diagram would provide the requisite combination of red, yellow, and blue semi-chromes. One need only total the number of primaries from both sides to determine whether a broken color will be the result of their mixture. The simplest way to create a broken color is to add to any hue a bit of its complementary, or a bit of one of the hues lying to the right or left of its complementary, i.e., one of the so-called split-complementaries. If a kind of mustard yellow is desired, add a bit of ultramarine blue, or perhaps violet or purple, to a very much larger portion of pure yellow. If a rich brown is required, add some green-blue to red-orange.

Most colors seen in nature are broken. A board painted a pure green and placed in the greenest forest would demonstrate, by comparison, how very much less than pure is the color of foliage. We are fortunate, perhaps without realizing it, that we do not live in a world of pure colors. To many artists, designers, potters, and weavers, the sombre colors are the more desirable. They are considered more rich in associations, more compatible, and less tiring. Pure hues, by comparison, seem aloof, like proud virgins.

Certain broken colors in certain circumstances do have unpleasant associations for some people. But the artist will know what Delacroix meant when he said that a smear of mud, if used in combination with other colors, is capable of taking on rare beauty. Broken colors may often be dull and lacklustre in themselves, but are capable of

13] We normally speak of colors as we do of the sun "rising" or "setting." We know, of course, that the sun does not literally or scientifically rise or set, even as we now know that colors do not reside in paints and surfaces as a physical substance. Color is an energy reflected from substances onto a retina that is specially equipped to receive and translate it. Edwin H. Land, going even further, states in "Experiments in Color Vision" [*Scientific American*, 200, No. 5 (May 1959) 84–99.] that "rays are not in themselves color-making. Rather they are bearers of information that the eye uses to assign appropriate colors to various objects in an image."

gaining in compatibility all that they lack in intensity. They "go well" with other colors, partly because they are related to every other color, like country cousins. No color should be judged on its own.

Broken colors are often difficult to distinguish from shades. To add black to many colors is, in a sense, to break them; pigments cannot always be relied upon to yield pure colors when mixed. Often the results are far from perfect.

EX. 5

a● Making a set of nine or ten broken colors can be turned into an easy, profitable game. Choose three hues from widely separated points on the wheel, which, if mixed in pairs (emphasizing one hue in the first batch and the other hue in a second batch) or all three together (emphasizing each hue in three separate mixtures) will result in a broken color *in every case*. (The result of each combination may be surmised according to III-1, in which the extent of each hue is shown.) A bit of white may be added to a portion of each of the broken colors to produce a tint (actually a chromatic grey). These will often be surprisingly beautiful.

Another way of producing broken colors is the one tried in "Rediscovery of Color" (EX. 2): mixing the pure and broken variants of each of the three primaries in twos and threes.

b● The student may carry these studies one step further by creating a design of simple geometrics, using any of the broken colors and tints already mixed, plus two or three pure hues from anywhere on the wheel. The design, from the point of view of color at least, should prove very rich, because of the great "stockpiling" of related semi-chromes. Klee and Bissière, the French painter, were fond of combinations of this sort, in which the high degree of saturation created a kind of smouldering, almost phosphorescent effect. Similarly, the colors

of Javanese batiks, made from natural dyes, derive much of their strange beauty from the association of broken colors and an occasional pure color. Designers of commercial fabrics have not been unaware of these arresting combinations.

Color Interaction
Simultaneous contrast

No eye is so accurate that it cannot be tricked by color, however much we tend to think of sight as the most trustworthy of all our senses.[14] Nor do we realize how much this miraculous faculty is influenced by habit and training. The way of art is, to a large extent, a way of re-training the eye to see, to perceive relationships, and no element in art, while being so pleasant, makes more demands on the eye than color. Most of the ambiguities of color may be related to the phenomenon known as simultaneous contrast: the way colors affect each other mutually by seeming to alter each other in both hue and value. This, in turn, is related directly to the negative afterimage. Only in the case of true complementaries do two hues, when placed side by side, appear not to alter each other, except to make each other seem more brilliant. But even in these there may be discrepancies. Yellow and ultramarine, for instance, are complementaries, but they are also at opposite poles in value. Any juxtaposition of these two in their natural order could cause the ultramarine to appear darker and the yellow to appear lighter, in which case they would both suffer some loss of chroma. One important law of contrast, which we shall examine later, states that *great extremes of value inhibit color intensity*.

EX. 6

It is advisable to start with value contrast alone, and proceed from achromatic to chromatic rela-

14] Some would agree with Sir Kenneth Clark that ". . . we believe more thoroughly in our sense of touch than in sight, hearing or smell. When Dr. [Samuel] Johnson wished to refute a philosopher who said that matter didn't exist, he kicked a stone and thought he had proved the point." Sir Kenneth Clark, "Romance and Reality," *The Listener*, 13 March 1969, Vol. 81, No. 2085 (London: British Broadcasting Corporation), 343–49.

tionships in three related experiments. All three may be done either with black, white, medium grey, and variously colored construction paper, or entirely with paint.

a• Place a medium grey square (perhaps 1 × 1 inch) in the center of a white square (perhaps 3¼ × 3¼ inches). Then place a square of the same grey on a black square. Attention will be drawn immediately to the fact that the grey seems to undergo a change of value, appearing lighter on the black and darker on the white—as in a bit of parlor magic!

b• Then place squares or strips of the same medium grey on six or eight squares of different hues, and observe carefully the effect of the after-image on each of the greys. Warm hues will tend to make the greys seem cool; cool hues will make them seem warm. In addition, darker hues will make the grey areas seem lighter, and vice versa, as demonstrated in part a above.

c• The third experiment may be approached as a kind of free experiment on the principle of simultaneous contrast. One could test the afterimage of three or four hues by playing them against grey backgrounds and colored backgrounds. For example, mix a neutral medium grey and apply it to paper with the palette knife or brush in two areas an inch or so apart. Then place a spot of color the size of a coin inside one of these areas. Or put down, in the same manner, two areas of a brilliant hue and, inside the first one, a spot of grey; or place inside the brilliant hue a larger spot of grey, and, within that, a very small spot of bright color. Move the eye slowly from area to area.

d• Another experiment could take a more personal turn. Choose a favorite hue (or *any* hue, if you have no favorite) either in its natural order or altered in any way you prefer, as a tint, a shade, a chromatic grey, or a broken color, and place a strip or spot of it in the center of six or more colors of different types [**P-4**]. Then take note of the way your favorite hue changes "personality"

in each environment. You may find a word or words to describe its disposition in each instance. Potters sometimes describe glazes as "sultry" or "sleepy." Words such as "raw," "bitter," "acid," "sweet," "dry," "moist," "heavy," "soft," "clear," "opaque," "timid," "aggressive," or even quite poetic words and phrases may come to mind, depending on the circumstances and objects with which the color is associated. This is not meant to be a kind of child's game (would that more of us had the color sense and daring of children!); the power of color lies in its ability to affect us in innumerable ways, directly and through association.

Elsewhere we have used the word sentiment (defined by the New English Dictionary as "mental feeling, especially of the higher feelings or the sum of such feelings excited by aesthetic, moral, or spiritual ideas; a thought, view, or mental tendency derived from or characterized by emotion") to signify the nature of our response to certain lines, shapes, and colors (see Part VI). This "mental feeling" has much to do with the subtle and magical power of art, and, more than any other, eludes descriptive analysis.

Chromatic value contrast

e• If there is some paint left over from the previous experiments, a final study may be made of the effects of extreme value contrast on color, providing the student another opportunity to test his developing sense of value relationships in color. Choose two colors of any hue or quality, a lighter and a darker, and paint three or four spots of each on paper. Then surround these once, twice, or three times with other colors, including black and white, chosen, in each instance, for relationships of mild and extreme *value* contrast. One must be willing to modify the value of any color, up or down the scale, to establish the right degree of contrast.

The finished studies will resemble a collection of unusual bullseyes.

Three considerations attach to this study of contrast: 1) the deadening of chroma by great value contrast, 2) the relative visibility or legibility of colors in certain combinations,[15] and 3) the ease with which the eye is able to "read" colors and values when they are placed in a certain order or progression.

The first of these has been referred to earlier. The second applies to the ability of the eye to distinguish areas of color from near and far. Generally, colors of related hue and similar value are difficult to sort out from 20 or so feet away (depending on proportion, of course). Complementaries such as red and blue-green (which lie left to right across the wheel), though they vibrate fiercely when put beside each other—and partly *because* they vibrate so much—do not make a good pair if high visibility is wanted. They tend to merge optically. But complementaries lying across the wheel from top to bottom do make for rather high visibility, if not the most striking examples one could hope to produce. All complementary encounters are, by their very nature, unstable. Complementaries seek consummation; they yearn for "completion" in white light. The problem of legibility is of special interest to the graphic designer, who wants his "message" to be read from a great distance, if necessary —even from a fast-moving vehicle. It is of equal interest, perhaps in more subtle ways and for different reasons, to the artist, who is concerned with figure-ground relationships of types involving strong and weak contrast, immediate and delayed recognition, much or little emphasis, and "open" and "closed" structure.

The third consideration relates to a tendency of the eye to see things according to the most simple and orderly arrangements or progressions. We have encountered this in other studies. Where color is concerned, the eye would seem to prefer relations similar to those on the wheel: a natural scalewise progression from one hue to the next around the circle. In achromatic arrangements, it would prefer the "logic" of light, to medium, to dark values, or vice versa, rather than the "illogic" of dark, to light, to medium values, or of textures, rough, to smooth, to medium. The eye, of course, does not always get what it wants in art, or even in nature. The problem of art, to a large extent, is *not* to give the eye what it wants in every instance, but what it will accept as inevitable, pleasurable, or "significant." This is not to suggest that the eye, for the sake of art, must be denied all of its natural proclivities. It imposes its own "natural order" of perception, which is not altogether incompatible with that of the natural order of color we have been examining. By allowing both to function simultaneously, it is possible to give breadth and spatial continuity to paintings, designs, or drawings, where these qualities are desired. Braque, in one of his still-lifes, used a progression of greens, from darkish cool ones to lighter yellow-greens, to lead the eye around in space. Grunewald (*ca.* 1475–1528) used colors in a similar way, but for other purposes, in his "Resurrection." As the eye moves upward from the sleeping soldier, through the winding sheet, through the ascending body of Christ, and outward from his head into the great corona of light, it undergoes a transition from darkness to the radiance of yellow and then outward, through orange to green. The movement of color is an integral part of the "idea," the mystical event, and the composition.

15] See Faber Birren, *Color, Form and Space* (New York: Reinhold Publishing Corp., 1961), Chap. 2, "Some Anomalies of Seeing."

From van Eyck (*ca.* 1400–1441) and Leonardo (*ca.* 1452–1519) to the style called Rococo, exemplified in the paintings of Watteau (1684–1721) and much admired by Turner, and again, but by very different means, in Impressionism, artists have relied on a few principles derived from a close study of visual phenomena. Artists of the Baroque era (the seventeenth century) were particularly interested in illumination, the vast kingdom of light, interpreted in smooth transitions of value and in sudden contrasts, represented by alternating "screens" of light and shade setting off large complexes of form in depth. The Impressionists, who also acknowledged the primacy of light, put aside the old interest in chiaroscuro and a theatrical conception of landscape in favor of pure optical sensations of water, grass, clouds, and trees, recreated by the most subtle modifications of the prismatic scale. But, as the wheel demonstrates, color and value are not unrelated, even though artists at different times have chosen to stress one instead of the other. Cézanne, after an experience of Impressionism, created a synthesis of form and space chiefly through modulations of color according to the natural order, rather than by light and shade. Both chiaroscuro and light—i.e., light as the Impressionists understood it—were of secondary interest to him. He sought an intense balance between the way things appear to assert themselves in nature and in depth, and the way they could be realized pictorially. The thrust and tilt of an earth formation, a tree, or a seated figure, the planar formation of a house or a table, the bulge of a ripe fruit or a cheek, the atmospheric vibration of the sky and of a distant mountain, would be seen and felt according to the way these could be "realized" as drawings and paintings.

In drawing and the graphic arts, such as lithography and etching, control of values is all-important. Fundamentally, the recognition of anything (a mark, a stain, or a smear) on a surface depends on some degree of value contrast between the mark (the figure) and the surface (the ground)—the darker the mark (assuming the surface is light), the harder its edges, the more it will stand free of the surface. Conversely, the lighter the mark or the softer its edges, the more it will seem to "give" to the surface and, indeed, the space they appear to conjure up. Added to this phenomenon are the many refinements and subtleties of chiaroscuro seen in the drawings of Leonardo, the opulent drawings of the Baroque masters, and the works of more recent artists—the sketches of Degas and the lithographs of Redon. The student may find it helpful to approach, not only the works of these artists, but also his own drawings and graphic studies, with the achromatic scale and its three registers in mind. He may discover that most artists create shape, form, and space in their drawings by the adjustment of values according to these larger groupings. In many drawings they reduce the values to only one (or at most two) from each register. Picasso and Braque, in their paintings as well as in their prints and drawings, reveal a rare economy of means in the use of lights and darks. The first phase of Cubism, the so-called Analytical phase (*ca.* 1907–1912), is distinguished by a controlled use of shading known as "simultaneous contrast shading." It was used by Picasso and Braque to render the structure and disposition of form in space and the way these are apprehended. Their interest seemed to proceed from form, to form and space, to space, realized almost achromatically, before it led, in about 1912, to other

means: the use of collage and broad areas of color and contrasting textures (Synthetic Cubism).

The more subtle and numerous the gradations of value become, the more a drawing or print will suggest color, light, and atmosphere, rather than form. Study almost any drawing by a Rococo or Impressionist painter or by Vuillard or Bonnard. Spend some time with works of the Baroque period, where light and shade are both dramatic and integrating agents. Study the paintings of Rubens and the drawings and etchings of Rembrandt. Light in the works of Rembrandt seems to emanate from the forms themselves.

"Spreading effect" (or the Bezold effect)

Curious exceptions to the law of simultaneous contrast seem to have been rather difficult to explain. Josef Albers[16] describes one as a special kind of "optical mixture" that occurs when "two or more colors perceived simultaneously appear combined as a third actual color, a mixture which annuls and replaces the previous factual colors." He distinguishes it to some extent from the Bezold effect, named after its discoverer, Wilhelm von Bezold (1837–1907). Ralph M. Evans refers to it as "spreading effect" and, after describing it, expresses the belief that "until this effect can be explained without elaborate assumptions we cannot say that we understand the way in which the visual process operates."[17] It is remotely possible that it has something to do with one of the forms of afterimage (the positive afterimage), or with the phenomenon sometimes referred to as "chromatic aberration"—a slight breaking up of the colored components of light in the eye itself. A recent paper by R. W. Ditchburn presents certain facts and observations that lead one to believe that this effect

(and more besides) may soon be better understood. He says:

It has long been known that small involuntary rotations of the eyeball persist even when a subject attempts to fix his gaze as steadily as possible on a well defined target. These rotations, and also translations of the head, cause the image of any object to move across the retina. Though these movements have been ignored in most theories of visual perception, it has been suggested that the passage of the image of an edge of an object across certain retinal receptors may generate on-and-off signals in the associated nerve fibres and so produce the information required for visual discrimination.[18]

He identifies these eye-movements as: 1) "an irregular rapid oscillatory movement called a tremor," 2) "sharp saccadic movements called 'flicks,'" and 3) "a slow drift." Without them, discrimination of shape, contrast, hue, and saturation are greatly impaired. Almost as interesting is Ditchburn's statement that "the discrimination of blue, green and white from each other depends on eye-movements in a different way from the discrimination of red." (See "Discord," the final section of this part.)

"Spreading effect" will help one to appreciate why outlining an area of color with black will tend to deepen it, make it richer in itself, more jewel-like. Stained glass seems to obtain some of its brilliance from the dark leading around each piece. White outlining of small areas of color will often have the opposite effect; it will appear to spread or "wash" across the color in such a way as to lighten it and rob it of some of its energy.

Outlining in black was a common practice in the art of the Middle Ages and of the Near East. Byzantine art, the first great Christian style, the art of the Copts in Egypt,

16] Josef Albers, *Interaction of Color* (New Haven and London: Yale University Press, 1963), p. 26 (Commentary).

17] Ralph M. Evans, *An Introduction to Color* (New York: John Wiley & Sons, Inc., 1948), p. 181.

18] R. W. Ditchburn, "Eye-Movements in Relation to Perception of Colour," *Visual Problems of Colour*, Vol. 2, National Physical Laboratory, Symposium No. 8 (London: H. M. Stationery Office, 1958), pp. 417–27.

and paintings in little-known thirteenth and fourteenth century churches in Ethiopia reveal the use of very bold outlining. The outlining of eyes, for instance, produced an effect of intense spirituality. Later styles—that of the Renaissance in particular—ruled out this device as primitive and lacking in the kind of naturalistic subtleties of form, color, and expression that were beginning to be admired. It was not until the last century that outlining returned to painting in the works of Blake, the Pre-Raphaelites, and, later, the Post-Impressionists. Its appearance in the works of Gauguin may be attributed to his interest in folk art, in primitive, ancient, and exotic art, including the art of the Middle Ages and that of the Far East. The fashionable style of the time, the 1880's and 1890's, was Art Nouveau, in which line dominated.

Outlining has been condemned by some as a "crutch," though it has been used effectively by Matisse and Rouault, by the Cubists, Léger in particular, and members of a younger generation of artists. Léger once exclaimed in mock horror: "But what would I do without my black lines!"[19] The danger of outlining for the colorist lies in the ease with which it may be used to create "closed" areas, blocking passage or flow between forward and backward positions, and preventing colors from reacting directly on each other along a common boundary. It is along this boundary that the effect of simultaneous contrast is strongest. Colors outlined with black will appear very different if exposed directly to each other. They will lose their independence and frequently cease to hold their proper place forward or backward in the community of colors around them. The problem is to arrange colors so as to create the desired counterpoint of space ("push

and pull") and over-all chromatic balance or sense of directional movement.

Outlining with black or with one or more colors need not be rejected, depending on the nature of one's intentions and the kind of chromatic interaction required. It has both structural and expressive possibilities. Although line seldom or never exists in nature, it may certainly exist effectively in art, provided it is not used to the detriment of color, or does not degenerate into vapid decoration. One way to prevent this from happening in a painting is to outline shapes, not simply with black or white, but with *several* colors, thus forcing the artist to leap directly into the drama of color-space relations. Some of the outlines may remain to the end; others may be obliterated before the painting is finished, but not before they have served a useful purpose. Other experiments in outlining could be undertaken. One could study the results of outlining bright colors with dull or weak colors, or areas of diminished colors with strong colors. In addition, instead of using solid outline in every instance, one could surround colors with points or dashes.

These considerations, particularly where outlining with black and white are concerned, have direct bearing on "spreading effect," a phenomenon that printmakers, graphic designers, fabric designers, and weavers are likely to encounter very often.

f● One may test this capricious optical effect with a piece of construction paper of a warm or cool color and strips of white and black paper. Cut the colored paper into two rectangles of, say, 9 × 4 inches, and with a pencil divide them across their narrow dimensions into three 3-inch sections. Then cut several black and white strips in the following sizes: 3 × ¾ inches, 3 × ½ inches, and 3 × ¼

19] "I range between two absolutes—black and white; the rest fall into harmony by themselves. Black is of tremendous importance to me. Early on, I used it for lines, to point the contrast between curves and straight lines. Later, as can be seen in my paintings, the black stroke [outline] became bolder and bolder, finally providing sufficient intensity of tone; and by stressing this I was able to make my colors stand out better. . . ." Fernand Léger, in *Great Tapestries: The Web of History from the 12th to the 20th Centuries,* ed. by Joseph Jobé (Switzerland: Edita S. A. Lausanne, 1965), p. 197.

inches. Place the colored rectangle vertically and start at the lower third by arranging the ¾-inch strips (either the white or black) ¼ inch apart, vertically; then, in the middle section, the ½-inch strips ½ inch apart; finally, in the top section, the ¼-inch strips ¾ inch apart. When these have been pasted down (all white strips on one rectangle and all black strips on the second rectangle), place both studies a few feet away and observe the gradual "wash" of light or dark over the intersections of color from top to bottom of each rectangle, or vice versa.

Some plausible implications of "spreading effect" will be taken up in the final section of this part, as they relate to both warm and cool colors. In the present instance, it is sufficient that the phenomenon be recognized and some distinction made among the reds, blues, and greens on the basis of their separate reactions to the black and white strips. (One could as easily surround 1½-inch spots of these colors with black and white outlines for a comparative study.) Normally the blues appear to merge slightly with the black background, while the warm hues remain firm and brilliant. Warm hues may appear to "give" somewhat to the white surroundings, while the blues against white remain firm.

Retinal fusion or intermingling

Delacroix's obsessive interest in themes of violence (such as massacres and lion hunts) led to his use of complementaries, notably a deep bottle green and a blood red, which extended the sentiment of mortal conflict into the fabric of the paintings themselves. His use of complementaries and "sketchy" brushwork inspired more unfavorable comments than his themes. But the revolutionary implications of these and other examples of

"artistic license" had only to await the ascendancy of proletarian, object-oriented realism in the 1850's, and its transformation in the 1860's by the urbane, discriminating Manet. Artists thereafter would become more selective of subject matter and concerned with sensory and transient data, in place of the earlier preoccupation with "meaning" in objects invested with a certain degree of permanence, "humanity," and weight (*gravitas*), or with important themes. When light was recognized as the principal quality in nature that painting can render, Impressionism emerged. At about this point, the forbidden complementaries and "painterly" technique of Delacroix began to take on special significance.

As the process of selection advanced, not only was the choice of suitable subjects narrowed, but these subjects were reconstituted by means of the new spectrum theory of the Impressionists. This, in turn, brought about a more deliberate, synthetic use of color for purposes that extended beyond a vision of nature toward the "free beauty of formal design."[20] Seurat and the Neo-Impressionist group, thanks to the work of the Impressionists and color theorists like Chevreul and Rood, knew enough about color in the 1880's to make a rational synthesis of prismatic elements. These elements, employed with the greatest care and patience within a classical conception of form and composition—especially in the work of Seurat —became Divisionism. The divided colors, applied as small points (hence Pointillism), were meant to blend in the eye to form the luminous, colorful, harmonious effects desired for every part of a picture. Some results have remained a bit doubtful, in that the color is less vibrant than would have been expected. Léger admired Seurat's paint-

20] Charles E. Gauss, *The Aesthetic Theories of French Artists—1855 to the Present* (Baltimore: Johns Hopkins Press, 1949), p. 33.

ings for their structure, not their Divisionism.
He and others have felt that, had Seurat
developed his vision of the life around him
and his remarkable talent for pictorial com-
position, he might have given the world many
more paintings in his short lifetime—and
more colorful ones, by means of a broader,
simpler technique.

Weavers are "divisionists" by technique
and profession. The many colored yarns we
are able to distinguish at close hand in
woolen textiles mingle at a little distance
into very lively surfaces. Tapestry weavers
of the past understood the effect of plying
yarns of more than a single hue, and weavers
of Finnish rÿa rugs know that strands of
several colors in any given area, plus light
and shadow effects across the surface of the
wool, yield an incomparable richness. The
idea of optical blending lends itself in the
most practical way to weaving. The minute
flecks of color in the finished fabric are of
the right size for intermingling.

g● A few studies could be based on the idea of
retinal fusion, not merely for the sake of under-
standing the technique of the Neo-Impressionists,
but for any use that could be made of it still. Try
first a pairing of complementaries in the following
manner:

Fill three areas with points made with the ends
of match sticks, alternating the colors in ratios of
1) two points of one complementary to one of the
other, 2) one to one, 3) one of the first to two of
the second, and 4) one of the lighter hue to one
of the darker hue—the latter raised quite high in
value as a tint.

Care should be taken that very little of the white
paper show between the points. A grey paper may
be a better choice; or one could apply one color
to the white paper as a stain or smear, and then
apply the other color (or colors) either with a

match end or the point of a small brush. Comple-
mentaries will tend to fuse into an over-all grey-
ness.

h● Afterwards, other combinations of two or more
colors, either pure or as shades or tints, and other
techniques should be tried.

Having distinguished 14 hues and their
variants, and having demonstrated, to some
extent, the nature of color interaction and
interdependence, we have now to consider
color and its use. To be more exact (and,
advisedly, less ambitious), we shall examine
four principles pertaining to the juxtaposition
of two or more colors: Harmony, Contrast,
Clash, and Discord.

Harmony

Harmony is the law or condition most
frequently mentioned by artists and laymen,
but of the four it is probably the most mis-
understood. Most people seem to have their
own, presumably instinctive, idea of what
color harmony is, or make the mistake of
assuming that harmony is the *only* true aim
of color combination. A similar confusion
exists concerning harmony in music. The
word is used rather loosely to describe
theories that apply to the combination of
tones in chords and chord progressions.
However, it denotes barely half of what ac-
tually exists in the music of most composers
since the eighteenth century, and less than
half of most music of the twentieth century.
In the strictest sense, harmony in music
means euphony or concordance—a kind of
"barber shop quartet" harmony. Its opposite,
therefore, is dissonance. The two, working
in controlled contrast to each other, charac-
terize the greater portion of Western music
from the Baroque period to the present. If

only euphony is allowed, as in the music of the Middle Ages and Renaissance (except in the "passing note"), one must look for contrast in other elements: counterpoint (parallel, oblique, and contrary motion) and rhythm. That some form of contrast must exist is certain.

The same is true of color. If only the most "harmonious" colors are allowed, they must be used in such a way as to create contrast—contrast of proportion, if no other. Too much harmony of this limited sort seems artificial and anemic. One would be well advised to proceed from the other direction: from the principle of contrast, which may prove a more useful guide. It may help one to recognize more readily the forces at work in one's designs, and enable one to marshal these forces more effectively. Each of the several types of contrast will be dealt with as they appear, in the sections on harmony, discord, or contrast. This is to say, in effect, that one cannot employ any one of these principles exclusively in a design.

We return now to the color wheel, and to the Natural Order of Color on which it is based.

The most simple harmony is that which exists when three adjacent colors are placed together in their natural order, the middle one being a primary. Although they may belong, by name and classification, to different hues, they will contain among them such a high percentage of identical semi-chromes as to establish a family kinship. Not only will they be closely related to each other in hue, they will also be closely related in value.

EX. 7

a● Another kind of harmony is that which we explored in the color of found objects and scraps in "Rediscovery of Color": a monochromatic arrangement of colors that are variants of a single hue—tints, shades, and so on. Close harmony is inevitable under these circumstances, provided the broken variants do not veer too far from the family strain, and a portion of the original unaltered hue is included in the arrangement. This is likely to be one of the most satisfying of all color arrangements, because it is the most concentrated and economical. Such a superabundance of chromatic energy within a single hue is curiously appealing: the colors animate each other. The broken variants, because they lean away from the dominant hue (we describe them as "bluish," "reddish," "greenish," and so on, depending on the hue *towards* which they lean), provide slight contrast and tension within the group, without which no expressiveness would be possible. The classic axiom, Unity in Diversity, applies to this as to no other color arrangement: a mother color and her offspring!

One of Constable's "secrets," not lost on Delacroix and other artists, was his method of creating rich, vibrant greens in foliage and grass, not in the unempirical, academic way, but by dabs and strokes of *several* greens. Delacroix mentioned in his *Journal* the excitement of discovering this. Byzantine mosaicists might have understood this use of color, judging by the way they arranged tesserae of slightly varying color in what appears at a distance to be a solid, homogeneous area. The variations produce scintillation and "depth" because of a certain amount of fusion in the eye of the observer.

Harmonious colors may be described as "emotional" rather than "visual." Some attention was given to this in an earlier paragraph that raised the question of visibility. The interesting but often neglected subject of color and emotion (or sentiment) will be taken up in more detail later on (Part VI).

One could say that two neighboring colors sing a kind of duet. Their relationship is not quite that of friends and relations, but perhaps more like that of lovers. Although they have a great deal in common, there is just enough difference between them to create an amorous contention (see "Clash").

The kind of study one chooses for demonstrating the virtues of harmony may be strict or free, geometric or spontaneous. In either case, one must bear in mind the need for Contrast of Proportion (Extension) if vigorous design relationships are wanted. This is a prime requisite in all combinations of color. One could be persuaded in the end—perhaps with some justification—to scrap all color theories except one, which may be stated as follows: it is possible to create both beautiful and expressive combinations of color by the use of any assortment of colors whatever, provided one places them together in what seems, in each instance, to be the right proportions.[21] Experienced artists and children would appear to know the "right proportions" with greater certainty than most of us. This sense of proportion does often seem to be a basic gift. How else can one explain the startling balance of colors in children's paintings? Perhaps it is the compromise of individual sensibility during adolescence, especially along the conveyor-belt of public education, where esthetic experience, if admitted at all, is made to seem frivolous and slightly embarrassing, that causes color in much adolescent and adult art to be so impoverished. Few are encouraged to move into a second phase of development following childhood. Children, quite obviously, are not afraid to use color *as* color.

b● The student may undertake one or more studies on harmony by choosing three neighboring colors, a symmetrical trio consisting of a primary and the tertiaries on both sides of it, and placing them together in their true strength in carefully adjusted proportions. The design may be a simple strip design, in which each color will appear once or several times in any sequence.

c● A kind of extended harmony may be achieved by including areas not only of the principals, but a few tints and shades of some or all of them.

Color lends itself to circular or spherical conformations. Newton was presumably the first man to make the familiar sort of color wheel, following his analysis of the spectrum. Yet another kind of wheel could be based on color proportion, after a suggestion by Goethe. It would demonstrate, for example, how large an area of red is required to balance an area of yellow—a heavier, a more "physical" color against a light, radiant color. Goethe's ratios of extension for the primaries and secondaries (in their purest condition) relate, not surprisingly, to our Natural Order of Color. Yellow is awarded the numerical ratio of 9 in a scale ranging, presumably, from black (0 or 1), to white (10), followed by orange (8), then red and green (6), blue (4), and, finally, violet (3). Yellow "spreads" the most, takes up the most room —it "travels"; violet, its opposite, spreads the least—it and blue turn inward. Therefore, a wheel based on these ratios would, from the point of view of harmonious design, be very unbalanced. Johannes Itten, in his very fine book *The Art of Color*,[22] redresses the balance by "taking the reciprocals of the light values": yellow, three times as light as violet, must occupy one-third as much area as violet on his wheel, and so on. This, in a sense, tames the hues by making them behave democratically. Seldom, however, do all hues occur in their maximum purity and strength, nor is it required that all colors in

a work of art be equally assertive. A more organic balance is obtained when one hue dominates in extension as well as in strength. Certainly expressive use of color depends on the dominance of at least one color in a composition.

Contrast

If it is true that contrast is a more useful guide to the artist or designer than harmony, it is probably because there are many more kinds of contrast about which he can be certain. Inasmuch as they often seem more objective, more describable, they admit more easily of demonstration and discussion. This can be useful to the art instructor who sometimes feels—or, in recent times, has been made to feel—that there is not much that he can or should talk about, or even point to with certainty. (The temple of art, like any temple, has steps and portico where instruction and even argument can take place. Eventually, one must *enter* the temple to create art—in most instances, alone.)

Contrast of hue

Several types of contrast have been singled out and described.[23] That is essentially what shall be done in the following studies. We shall not pretend that art is the inevitable result of this kind of activity; nothing translates into art without the play of creative imagination.

Either we have done so already, or shall have occasion soon to deal with the following types of contrast: contrast of hue, contrast of complementaries, contrast of intensity, contrast of value, contrast of temperature, contrast of extension (or proportion), and simultaneous contrast. In contrast of hue, the colors on the wheel are used in such a way as to proclaim their separate identities [P-5].

21] Paul Klee's notation: "To paint well is simply this: To put the right colors in the right place."
22] New York: Rheinhold Publishing Corp., 1961.
23] See Johannes Itten, *The Art of Color*.
24] "Simple colors can act on the inner feelings all the more powerfully as they are simple."—*H. Matisse.*

We find examples of this use of color in peasant art and costumes, in the signs, banners, and decorations of folk festivals. We see it used in paintings expressive of youth, sport, earthly joy, abundance, and communal well-being.[24] Some say that the primary colors, taken individually, are less expressive than the hybrid or broken colors; they tend to remain separate and matter of fact in any color scheme. There is some truth in this, but the whole truth concerning color is hard to pin down. There are some who profess a strong dislike for the contrast of primaries and other bright hues, among them those persons who normally reveal a breadth of appreciation and taste in visual matters. Perhaps the blatant, indiscriminate use of colors in the signs and advertisements which dominate both city and country in the age of the automobile has prejudiced them against undiminished hues. But Léger, the great French artist, who spent several years in America and loved the visual cacophony of our commercial environment, seized upon these brash colors and associated elements of bold shapes and big rhythms for his last important compositions. There is also the example of American artist Stuart Davis, who used the color and imagery of the age of jazz, modern popular culture, and mass advertisement from the time of World War I. One of several American artists influenced by the historic New York Armory Show of 1913, he was the only one that continued pertinaciously to develop an art based on the clamorous colors, shapes, and figures of the American urban scene.

EX. 8

a● Create a design of strong colors, with paint or pasted paper (assorted scraps and/or construction paper), suggestive of carnival or of spiritual joy.

On a different plane of human experience from that of signs and billboards are the brilliant reds, oranges, yellows, greens, and blues used like a chromatic hymn of praise in Medieval illuminations and stained glass windows.

Contrast of temperature

Contrast of temperature has been mentioned earlier as a psychological component of the wheel—the cool zone centering on turquoise and the warm zone centering on red-orange. But even before that we noted that relative degrees of temperature may be discerned in variants of a single hue, there being both warm and cool reds and warm and cool blues [**P-6**].

It was not until the arrival of Impressionism that contrast of temperature was given special recognition, and not until the rude advent of Fauvism and German Expressionism in particular that it became a dominant pictorial means. Warm and cool contrast was undoubtedly known and used in the past. The Italian painters of the early Renaissance used green earth pigment as middle values and "shadows" in faces, hands, and other warm flesh areas. In aerial perspective, as used first by the Northern landscapists and then by Leonardo, whose "stamp of approval" insured its practical acceptance until the end of the nineteenth century, objects grew bluer and cooler as they receded into the distance. Warm colors were reserved mainly for near objects, which were given weight, density, and volume. Rubens, the master of Baroque painting, used cool tinted greys in the transitional half-shadows inside his elaborately modelled forms, with warm lights and background areas completing the radiant play of contrasts. But these examples from diverse styles of the past seem "technical"

by comparison with the more deliberately expressive and coloristic use of cool-warm contrast in the paintings of Renoir and landscapes of Monet. Both artists owed something to Manet, whose warm and cool tones prepared the way for Impressionism, esthetically and technically, in the late 1860's.[25] But in Renoir's opalescent paintings of beautiful young people, we see one expressive result of warm-cool contrast: a quality of tenderness and uncomplicated sensual delight. In Cézanne's still-lifes, especially those with the large white napkins, overlapping strokes of warm and cool colors create an aura of contemplation, of both intensity and stillness. In his landscapes, they weave in and out of earth and sky areas to create a transcendent unity of near and distant spaces, and of solids and voids. Bonnard's warm and cool interiors of later years suggest an almost mystical domestic happiness.

The expressive use of contrast of temperature in these examples is mild compared to the use of warm and cool hues by the German painters known collectively as Die Brücke. They made a special virtue of this type of contrast to convey what were often the most "uncivilized" emotions, and to create a limited but vigorous spatial dynamism. (It has been accepted in recent years that warm colors tend to advance and cool colors to recede, but the issue is by no means settled, as we shall see later.) One encounters the shock of blue against a hot red-orange in characteristic works by Kirchner and Nolde that go far beyond the gentle mood of Renoir, and often beyond the most daring Fauve paintings by Matisse, Vlaminck, and Derain.

b● Create a design of colors from the warm and cool zones of the wheel. Colors may be pure and considerably modified in chroma as broken colors,

25] The cleaning of Velásquez' paintings over the last 30 years, the so-called "Rokeby Venus" in particular, has revealed a technique surprisingly like that of Manet and Renoir. Philip Hendy has the following to say about Venus' body: "As the old varnish was swelled by solvent and wiped away piecemeal, the body was constantly revealing new subtleties, its surface now concave, now convex, turning now this way, now that, where before there had seemed to be only a single plane. It was a vivid demonstration of Velásquez' principles: that form can be richly modelled without any part of it having to disappear into shadow, that it can be made even more live and tangible by maintaining the highest possible key of colour throughout and modelling only with the subtlest variations between cool and warm" [Philip Hendy, "Naked as Velásquez Intended," *The (London) Sunday Times Magazine* (April 17, 1966), p. 74].

tints, and chromatic greys. Avoid too much contrast of value.

Contrast of intensity

Preceding Fauve paintings by little more than a decade were the bold pictorial statements of Gauguin and van Gogh, which command less attention for the play of warm colors against cool than they do for other qualities. The genius of both of these artists as colorists is seen in their use of contrast of intensity and of extension. Contrast of intensity means the variation of chroma chiefly in a single hue or closely related hues. We have dealt with this in previous experiments in extended harmony and monochromatic arrangements. The special virtue of this use of color lies in its economy of means, demonstrating an important truth: good color does not necessarily mean many colors. A great composer is not one who attempts to display in every work his ability to modulate harmonically through every key in the musical spectrum. A great colorist like van Gogh knew the value of making a few things do many things. More than half the areas of most of his canvases contain quiet variations of one or two related hues. Smaller quantities of stronger colors of similar and contrasting hues "charge" or activate these larger areas. The effect is of great internal chromatic energy. The drama takes place in subtle permutations and extensions, not in blatancy, promiscuity, and extravagance. One must look for the "secret" of van Gogh's color in the play between these large areas of suppressed chroma and smaller areas of strong chroma.

Contrast of extension

Contrast of extension need not be unrelated to contrast of intensity; though while extending a color over a wide area in the manner of paintings by Matisse, ancient Ethiopian wall paintings, and Romanesque frescoes in France and Spain, one need not vary its intensity unduly. Our modern understanding of contrast of extension (or proportion) owes much to Gauguin, who, through his own work and his interest in ancient, naive, and primitive painting, realized with unique insight the importance of this concept. He advised his associates at Pont-Aven, their favorite haunt in Brittany, not only to intensify their colors quite arbitrarily, but to extend each hue in both strong and diminished variants over wide areas of canvas. This gave both breadth and simplicity to their paintings. Each hue was put to its fullest use, and contrasts were not softened or disguised. To understand the reason for extension of color (at least the dominant color) in a composition, one must understand that the eye prefers simple, comprehensible structures, or elements to which structure can be given, if only momentarily. Visual memory being what it is, a few colors deployed over a wide area, either continuously or in patches, create a much more intense and lasting impression than would many colors over the same area. Gauguin believed, figuratively speaking, that a square yard of red is more red than a square foot of red. Quantity must make up for quality, meaning that no small area of color, no matter how brilliant, can substitute for quantity or extension. This dictum has some bearing on both contrast of extension and of intensity. In the majority of instances where color assumes an important role, as in Persian and Indian miniatures, this dictum of quantity and quality would be true beyond all doubt. It has been necessary, therefore, to state the principle of color proportion in several connections,

for the intuitive balance of larger and smaller areas of similar and dissimilar colors is of prime importance. Of almost equal importance is the placement and recurrence of these colors within the design.

Relating also to these problems, and to the use of color in modern painting in particular, is the theory put forth by Dr. Charles Henry near the end of the last century, which states that we tend to see color before we see form. This idea, applied esthetically and technically, might have contributed to the freeing of color from the confines of delineated form in the paintings of Matisse and Dufy, in Cubist paintings, and especially in the paintings of Léger, Gris, and Delaunay, from about 1912. As with so many modern pictorial means, more than a germ of this freedom is to be found in Cézanne's paintings, notably his late works. Colors were allowed to "reach out" to what seemed their natural limits, to spill beyond the boundaries of any defined shape, if need be, or to force any shape to expand or contract.[26] Color was allowed to "live a life of its own" on about equal terms with line. When one considers to what an extent color since the Greeks (starting with Greek vase painting, virtually all that remains of two-dimensional Greek art, and continuing through Renaissance painting and its impoverished offspring, the art of the eighteenth and nineteenth century academies) has been dominated by line, shading, and form, one begins to realize how important color-line separation is in the work, not only of the above artists, but also of Kandinsky, Miró, Masson, Gorky, and others. Color, having won its freedom from chiaroscuro, at last gained its independence from line. The two may be compared with the melodic (line) and harmonic (color) structure of music: each element has a distinct role to play at one

and the same time, on two or more "levels" of sound or space within the total design. In order to appreciate the interplay, one must learn to give attention to what is happening simultaneously on these different levels.[27]

Certain American painters (Rothko, Reinhardt, Still, Tworkov, Francis, and Newman) who sprang to prominence after World War II have applied these principles of contrast in a unique way. In paintings by Rothko where no delineated form of any sort occurs, color is allowed to extend to the limits of the canvas; his canvases, like those of the other artists mentioned, are unusually large. Color quality and quantity assume a new adaptation to each other, related to a concept of scale and optics. The size of the canvas increases as pictorial incident (delineated form, shape, or color contrast) decreases. If the eye has little to focus upon in the painting, it will unfocus and "spread" outward as the color spreads. The effect of color-space extension is both psychological and esthetic. The observer is made to feel that he could almost step into the color, as though into a mist. The increase in amount of color makes the threshold of space seem nearer, more hallucinatory. One experiences what is known as "film color," as distinct from the more normal "surface color." The field of view being homogeneous and almost undifferentiated, the viewer has no strong figure-ground experience to seize upon.

Contrast of value

Contrast of value has been touched upon in several places in this part. It will be mentioned in another context in the section on discord, and will be taken up again in Part IV in reference to its practical application to form in illumination and modelling.

26] Matisse once said: "There is an impelling proportion of colors that can induce me to change the shape of a figure or to transform my composition. Until I have achieved this proportion in all parts of the composition, I strive toward it and keep on working." [See Alfred H. Barr, Jr., *Matisse: His Art and His Public* (New York: The Museum of Modern Art, 1951), pp. 234–35, 472–73.]

27] See Charles E. Gauss, *The Aesthetic Theories of French Artists: 1855 to the Present* (Baltimore: The Johns Hopkins Press, 1949).

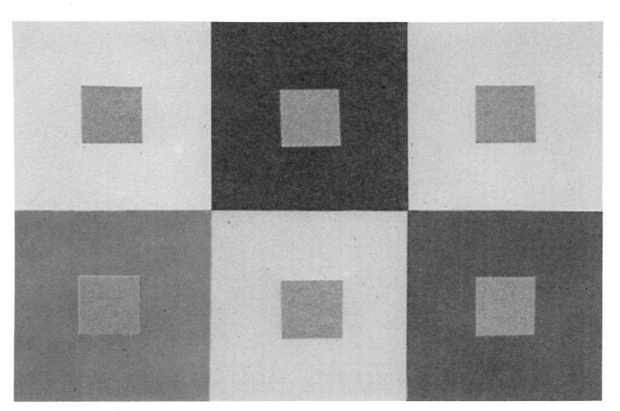

P-4 A study in simultaneous contrast using blue.

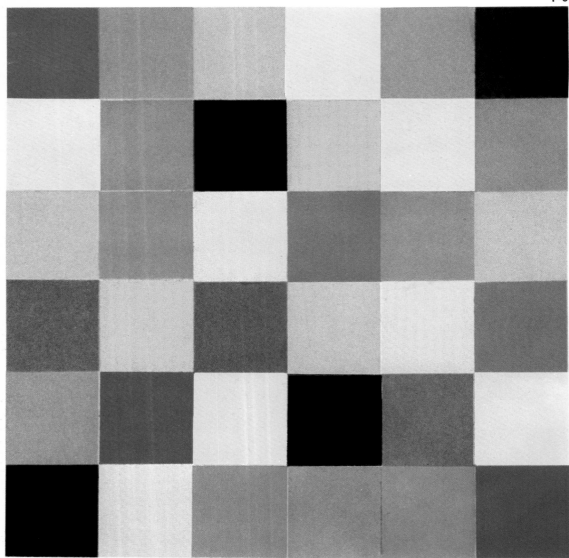

A composition based on contrast of value (black to white) and contrast of hue.

P-6 A composition based on contrast of temperature (warm colors versus cool colors).

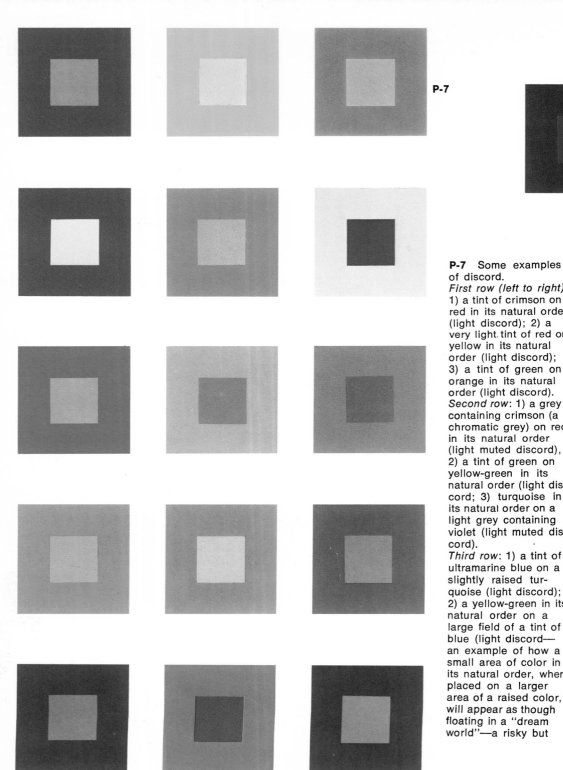

P-7 Some examples of discord.

First row (left to right): 1) a tint of crimson on red in its natural order (light discord); 2) a very light tint of red on yellow in its natural order (light discord); 3) a tint of green on orange in its natural order (light discord).

Second row: 1) a grey containing crimson (a chromatic grey) on red in its natural order (light muted discord), 2) a tint of green on yellow-green in its natural order (light discord; 3) turquoise in its natural order on a light grey containing violet (light muted discord).

Third row: 1) a tint of ultramarine blue on a slightly raised turquoise (light discord); 2) a yellow-green in its natural order on a large field of a tint of blue (light discord—an example of how a small area of color in its natural order, when placed on a larger area of a raised color, will appear as though floating in a "dream world"—a risky but sometimes effective quality; 3) a dark tint of a broken orange on a lighter tint of red (double discord).

Fourth row: 1) a very light tint of red on a broken yellow (double discord); 2) a tint of ultramarine blue on a dark shade of yellow (double discord); 3) a dark tint of a broken violet on a broken yellow-green (double or muted discord).

Fifth row: 1) a dark tint of a broken crimson on a broken red (double muted discord); 2) a red in its natural order on a tint of turquoise (light complementary discord); 3) a tint of a broken purple on a broken red-orange (double muted discord).

Sixth row: an ultramarine blue in its natural order on a larger field of a very darkly shaded red (an example of how a dark discord may be used as a "support" for a blue or any other color from the bottom of the wheel in its natural order).

A little of the history of the symbolic (in the sense that a diagonal line is "symbolic" of depth) and imitative (simulating light falling on form and casting shadows) use of value gradations must be included here and in Part IV, as it is important that both popular and "professional" conceptions (and misconceptions) about "shading" be examined with some care. The use of chiaroscuro (light-shade) and the use of color in paintings has been an uneasy relationship from the beginning. The use of one in a painting seems to require either negation of the other, or at least its suppression. It is better, therefore, that the artist choose one or the other in any work he undertakes, for the most unfortunate results are those in which he has failed or refused to make a choice: too much value contrast having destroyed color, color having compromised form, and so on. His work becomes a no-man's land of conflicting systems. In situations such as this, the artist need have no fear of using a bit of practical intelligence—unless he prefers to "muddle through" every time! In every creative venture, he should know what purpose, if any, modelling, lights and shadows will serve. Would color, on its own terms, serve better? The artist should know if his aims are primarily descriptive or expressive. Are his forms meant to be naturalistic or "abstract"? Does he have any convictions about the interdependency of form, space, and color? Is color, in his opinion, merely a decorative adjunct, like frosting on cake? More particularly, is shading meant to be integral and expressive, or simply a kind of embellishment?

A photographer might not ask quite the same set of questions, but since his work deals directly with light and illumination in a way most art since Impressionism does not,

28] See *Art in America*, Vol. 54, No. 1 (Jan.-Feb. 1966), 22–48.

he must understand contrast of value and the play of light across form as few people do. All of us have been influenced by his images, particularly his black and white reproductions, which are such an ever-present part of the modern scene. In many ways they and the cinema have taken over older functions of painting: narration, documentation, description, drama. Few artists since Degas and Toulouse-Lautrec have been influenced significantly by multiple light and shadow effects—side-lighting, back-lighting, lighting from below, reflection, and especially the uncanny form-dissolving effects of artificial illumination—except, of course, their heirs, the magazine illustrators. The photographer knows how light and shadow can reveal form, "destroy" form, and alter the feeling-tone of objects and environments by stark contrasts or the almost imperceptible, pearly mutations of value across forms and surfaces. The sculptor is also a manipulator of values by the way he articulates the flat and curved, concave and convex planes of his forms, gently or abruptly. These modify the play of light either for the enhancement of form and structure or for expressive purposes, or both simultaneously. His control over these aspects of the work is greater, of course, than his control over the light and environment in which his work will be placed; improper lighting can undo many of his good intentions. Some sculpture, because of the delicacy of its form and surface, is better seen indoors under a particular light. Few modern sculptors, other than Henry Moore, David Smith,[28] and, more recently, Alexander Calder and Tony Smith, have deliberated at great length on the problem of relating form to the light, distractions, and vastness of the outdoors.

It is impossible to train the eye to see as

the camera "sees," i.e., with complete visual impartiality and simultaneity. Few artists have tried to discipline themselves to the task. Even Vermeer (1632–1675), it is believed, used a device known as a *camera obscura*, by means of which he could project images onto a white surface in order to study every change of value across the whole scene. Perhaps he viewed his set-up of objects through a piece of ground glass mounted in a dark box. But whether or not he used artificial devices, he was one of those rare persons peculiarly aware of the phenomenon of light, able to render every effect of sunlight as it fell upon his favorite forms in his favorite corner of the universe.

Another great Dutchman, Rembrandt (1606–1669), though he never visited Italy, was one of a generation of artists to take full advantage of the dramatic chiaroscuro of the Baroque era, when not only painters, but architects and sculptors (Borromini and Bernini) incorporated in their designs enthusiasm for space, movement, illumination, drama, and symbolism. His method, though more deeply personal, especially in his later years, than that of his Italian and Flemish contemporaries, owed something to the development that sprang from the studio of Caravaggio (1573–1610). Rembrandt used light and shadow to convey *internal* rather than external drama. His works contain none of the "operatics" of Caravaggio. Georges de La Tour (1593–1652) in France, and Zurbarán (1598–1664) in Spain, were also influenced by the new Italian chiaroscuro, but they, like Rembrandt, treated light as a mysterious substance; not as the familiar light of day, but as a kind of spiritual effluence in an otherwise rich but sombre world.

Light and shade have been used not only to reveal, but often to conceal, to insinuate an atmosphere of mystery or outrage. Goya's graphic works, his "Caprichos" and "Disasters of War," present a spectacle of human cruelty, stupidity, and madness to match any sinister event of modern social and political history. Picasso's "Guernica" mural was inspired by such an instance of violence, the bombing of a Spanish village in 1937, and while it does not make use of illumination in any conventional way, is composed entirely of black, white, and several greys.

The first uses of shading in Hellenistic art, in Egyptian (Faiyûm) mummy portraits of the first to fourth centuries A.D., and later in Byzantine and Gothic art, would seem to have little to do with light and shadow effects as observed in nature. (It would be inaccurate to say that all Faiyûm artists lacked subtlety; some made considerable use of highlights, cast shadows, and even reflected light, characteristic of Renaissance, Baroque and Rococo art.) Artists probably discovered quite by accident that gradients of value, from light to dark, produce an effect of rounded form, or, in any case, enriched or embellished the form. And so began a primitive type of modelling that served artists remarkably well until the time of Botticelli (*ca.* 1445–1510), Bellini (*ca.* 1430–1516), and Leonardo (1452–1519), when the "envelope" of atmosphere, light, and space, especially in landscape, began to be of increasing interest. But this early type of modelling was not to be abandoned for all time; Léger, Beckmann, and other artists of the modern movement would adopt it, along with other "primitive" devices, in the service of a new vision.

Finally, Impressionism fused the local color of objects and outdoors illumination quite freely into a continuum of high-pitched

rainbow colors, after which Cézanne, that strange Janus figure of modern art who loved the art of the old masters (especially Poussin), retrieved modelling by transforming it into what he called "modulation," a method of painting with small strokes and patches of color that was remarkably close to principles associated with the Natural Order of Color. He gave form in painting a new life by reconciling it to color, space, and depth, while not invalidating the physical surface of the canvas. We know that he preferred to paint on somewhat overcast days. In this he differed significantly from his friends, the Impressionists. Illumination as light and shadow or as prismatic envelopment was not as important to him as color *or* form. He believed that when the color was right, the form and its spatial position were right. Color, after all, appears to reside in objects themselves, independent of directional light and shadows. Children's art and primitive art of all times and places show little concern for illumination and, following Cézanne, neither does modern art, with few exceptions. The lack of strong sunlight and shadow effects across forms enabled Cézanne to analyze the ambiguities of color and structure in nature with greater accuracy, and to apply himself to one of the most stubborn problems in painting: the "realization," in uncompromising pictorial terms, of optical sensations of nature, in spite of the problem of object values (local color) versus illumination values, and of the superabundance of detail in any subject. Having accomplished this with the new chromatic grammar of Impressionism, but without the one-sided Impressionist interest in atmosphere and light, Cézanne would become rather more than "the primitive of a new art," as he once described himself.[29]

29] See "Cézanne," in Clement Greenberg, *Art and Culture: Critical Essays* (Boston: Beacon Press, 1961), pp. 50–58.

But the Cubists, Picasso, Braque, and Léger, did not continue in the use of color modulation. Instead, they adopted a type of modelling that went beyond the primitive type mentioned earlier, particularly in view of the fact that it applied to both figure and ground, to inner and outer areas. They might have discovered more than a hint of it in Cézanne's work, but its most definitive state was found in the drawings and paintings of Seurat, where its use is almost entirely arbitrary, deriving but little from a light source and cast shadows. It has been referred to as "simultaneous contrast shading" because of effects that are analogous to those of color perception. Two values are placed alongside each other in a condition of extreme contrast, light against dark. As they move away from the line of contact, the light one grows darker, the dark grows lighter. If this type of shading is applied to form, one side will oppose light (figure) to dark (ground); the other side will oppose dark (figure) to light (ground). Gradations of value will move outward from these confrontations, across the form, and into the surrounding space. Figure and ground represent two overlapping planes, but the turnabout shading relates both in the most democratic fashion by giving no more emphasis to one than the other. This suited the aims of the Cubists, who wanted to challenge still further the duality of figure and ground, of form and space. Many of the problems of modern design center upon this duality—in painting, sculpture, and architecture, each in its own way. Klee was fond of dualities of all sorts. Not only did he use the type of shading referred to above in many drawings and paintings, but he recommended it to his students at the Bauhaus in more than one classroom exercise. He referred to

it as endotopic and exotopic treatment: shading from within a form and shading from without, and combinations of both in a single form or in two or more interpenetrating forms.

Medical illustrators, artisans, and technicians have found this method of shading useful in a more diagrammatic application, i.e., in achieving a definition of planes without the vagaries of naturalistic light and shade, cast shadows, and reflected light. Their reason for using it is not very different from that of the Persian and Indian miniaturists and Medieval tapestry weavers: to emphasize overlapping forms by the simplest means.

When one considers that the palettes of such old masters as Titian and Rubens were limited and even sombre when compared with ours, especially in the available yellows, reds, and greens (and that, in any case, their interest lay not so much in color as we understand it, but in illumination), the technical history of Western painting since the early Renaissance lies, to a large extent, in the development of methods and skills for control of value relationships. But even in the great Chinese landscapes of the Sung dynasty, the colors are far from brilliant. Although the artists of that tradition were not interested in light and shade as were the artists of the Renaissance, they created an aura of light and atmosphere by the most delicate gradations of value. A quality of profound inwardness and stillness in their work derives as much from attitudes inherent in Taoism as it does from the most patient observation of form and movement in nature.

A schematic analysis of a characteristic painting by any artist of the sixteenth or seventeenth centuries would reveal a range of values through the light, medium, and dark registers, most of which would be greys, rich browns, and tans, with relatively few colors of appreciable strength. These served their purposes well enough; Titian is supposed to have said that a great painter required only three colors. But for proof of this one need not turn to the old masters and their ways of painting. Braque, in his great "Atelier" paintings (1950s), each one containing the ghostly image of a bird, revealed masterly use of a few colors within a rich complex of greys.

c● A study in contrast of values may be based on a problem which was undertaken in the preceding section on line (see Part II, EX. 6c): a composition in which the total space of a square or rectangle is divided horizontally and vertically into large and small areas, resulting in a dynamic relationship of intervals, of parts to the whole, and of movement forward, backward, and around in depth. Lines of partition should not be allowed to exist in this study unless they are thought to be indispensable. Attention should be given entirely to the areas and how they function. They may be divided provisionally by lines but, as they are filled with color, must be allowed to expand or contract until the whole composition achieves balance and unity. The color in this instance will consist of various greys and two or more pure or broken hues. In the interest of organic structure (continuity from area to area, "push and pull"[30] in depth, and so on) within such a rigid, skeletal system, the student may be well advised to give more attention to relationships of mild contrast than to those of strong contrast, reserving the latter for abrupt movements and sharp accents where these are needed.

Simultaneous contrast

Simultaneous contrast, which affects all other forms of contrast, has also been dealt

with earlier. The attention of artists was drawn to this optical curiosity by Chevreul, who based his theory on what his sight told him about the reciprocal action of colors: each color tends to modify the other in the direction of its complementary. Though his conclusions may not be scientifically accurate according to twentieth century standards, they were able to inspire the Impressionists and, especially, the Neo-Impressionists in their search for greater vibrancy. Pissarro, the old Impressionist, who became a friend and follower of Seurat in the 1880's, attributed valuable theoretic and scientific information to Chevreul, J. C. Maxwell (1838–1879), founder of the science of color photography, and O. N. Rood (1831–1902), the American physicist, whose book, *Modern Chromatics with Applications to Art and Industry*, was published in 1879.

The strongest simultaneous contrast effects are ordinarily sensed in contiguous areas, despite the fact that the eye does move from area to area in a painting, relating part to part and part to whole. In color cinema we find a different set of circumstances. Not only does the eye move about—the whole visual field moves. In a painting we are given color without reference to time (duration) except, of course, the time it takes each of us to comprehend the painting; this, in turn, depends on how much visual, emotional, and intellectual experience we are able to bring to looking at the painting. But in motion pictures, and to a certain extent in dance and drama, color combinations undergo continuous change before our eyes. Successive contrast and color continuity take on special meaning and present special problems. The emotional effect of color becomes closely related to sequence and dramatic incident. Cinema has the advantage over

dance and drama in this instance: the total complex of form and field, figure and ground, can move with ease. But the problems involved with such freedom—the temptation of vulgar overstatement, the effect of "color fatigue" on color sequence—are likely to weigh against some of the opportunities. The opportunities, which are in a true sense artistic, have yet to be proven extensively, but the Japanese director Kinugasa, who made *Gate of Hell*, and, more recently, Antonioni in *Blow-up*, have set high standards.[31]

Contrast of complementaries

Perhaps the most "notorious" type of contrast is the contrast of complementaries, since, in the opinion of both artists and laymen, *other* juxtapositions of color also jar or offend (see "clash"). Artists, however, should be able to see these interactions more objectively than laymen, and make a few useful distinctions.

The contrast of complementaries, though the most brazen of all color effects, harbors at least two anomalies. In spite of the fact that complementaries are based on what we must accept as a natural phenomenon, the negative afterimage, they are very difficult to determine according to everyone's satisfaction. Different systems propose slightly different alignments.

A second curiosity, which we shall return to, is this: whereas true complementaries exist as polar opposites in terms of chromatic sensation, they aspire to a kind of dynamic balance, an "animated repose," like the Taoist Yin-Yang circle.

The mixture by addition of the three primaries of light will produce white light. The mixture of any two of them will produce the complementary of the third. But the mixture of these light complementaries will bring

30] Hans Hofmann's famous term.
31] See Chap. III, "Colour and Meaning," in Sergei M. Eisenstein, *The Film Sense* (London: Faber and Faber Ltd., 1948).

opposite results. Each on its own will subtract a primary from white light; the combined subtraction of two of them will yield a primary; the combined subtraction of all three will result in black, the total absence of light.

Psychologists are able to mix reflected colors *additively* in the laboratory by means of a rotating disc. If the surface of the disc is evenly divided like a pie into alternating wedges of true complementaries, and then rotated rapidly, the colors will seem to add up to light grey. But addition of this sort can go only as light in value as the lightest color painted on the disc.[32]

If light primaries will add up to the supreme wholeness of white, pigment complementaries will subtract to the chromatic nothingness of a dark grey. Between these polarities and absolutes in the kingdom of light and color exist all the lesser denizens, the common colors around us, which are the results of compromise and subtraction. There is also the human apparatus itself, the eye, which acts reciprocally on light and color stimuli. After absorbing one color, the eye will conjure up its opposite, as we have seen. It will "demand" its opposite, as Goethe pointed out, in an effort to achieve balance.

Since every complementary pair contains all the three fundamentals or primaries, it is not necessary that the artist use complementaries unless he has reason to do so. The eye will seek completion in the primary and secondary triads which are such universal favorites, especially the former. But, before examining these, it is better that a few studies on complementaries be undertaken so that their rich, barbaric quality may be experienced firsthand.

d• Place two true complementaries (as true as one is able to determine)[33] together, touching, in equal amounts; then place the same pair, or another pair, together—side by side, overlapping, or one on top of the other—in *unequal* amounts. These may be put down directly in paint or cut from colored paper. It will probably be agreed that an asymmetrical relationship of these opponents makes a less strident impact on the viewer.

e• Another juxtaposition may be considered even pleasant: the juxtaposition of complementaries in pure and broken variants. The effect will be rather brusque and "masculine," but will be one with which everyone should be familiar, for it is found very often in nature, partly because most colors in nature *are* broken. The contrasting pigmentation in flowers, between blossom and stem or leaf, frequently results in such juxtapositions as bright red or crimson against broken green or bright green against broken red. In the color changes in leaves in the fall, one is able to follow, from day to day, the breaking of green by the incursion of red, orange, and crimson until, finally, the lighter, warmer hues emerge triumphant.

The student may carry out a study on such an idea from nature by creating a design made of a pair of complementaries in their pure state and one or two broken variants of each. The latter are easily obtained by mixing a bit of one complementary with the other in slightly varying amounts, taking care not to break either complementary beyond recognition. The design, as such, must correlate contrast of hue, intensity, and proportion. It may even suggest the kind of transmutation from one condition to another that one would expect to find in nature. An actual specimen of plant or animal life may serve as a model.

Not only does one complementary "demand" its opposite, but the eye "spontaneously seeks out and connects complementary colors."[34] Because every complementary pair contains all three of the

32] A spin-top made of a cardboard disc about 2 inches in diameter and a matchstick serves equally well. One can make several and experiment with various combinations of color in large and small sections.

33] Instead of accepting someone else's idea of what "true" complementaries are, one, or, indeed, the whole class could undertake an exploration into the matter, starting with, for example, a middle red and a middle green or a kind of yellow and a kind of violet-blue. These could be altered in every possible way—in value, temperature, and intensity—and juxtaposed in various shapes and proportions until the most vibrant interaction is achieved. Colored scraps of paper and other materials could be used together with paint in some arrangements.

34] Rudolf Arnheim, *Art and Visual Perception: A Psychology of the Creative Eye* (Berkeley: University of California Press, 1957), p. 298.

primaries, the eye will also try to unite red, yellow, and blue in a composition. Where one of these is missing, perhaps deliberately, the eye may experience a kind of "yearning" for the missing color.

All of this is seemingly in opposition to the principle of grouping by similarity which, we have discovered, applies to point, line, and orientation, as well as to color. It is a fundamental principle of harmony. But the principle of closure, which has been mentioned more than once, would seem to apply here in a surprising way. Closure denotes the tendency of the eye to "complete" elements into a simply structured whole: a crescent will become a circle, one hue will call forth its mate, and so on. If two complementaries are used extensively throughout a painting, they will contribute to the unity of the whole. If they are placed side by side, or used in a more limited area of the composition, they will tend to turn their backs on everything else around them, like two absorbed lovers. In the light of this understanding, we may be justified in referring to the contrast of complementaries as a kind of harmony, for "every explicit duality is an implicit unity."[35]

One is again reminded of the achievements of two great colorists, van Gogh and Klee, and how well they were able to use complementaries. Van Gogh's "Café at Night" includes two complementary pairs: the deep blue of the night sky and the yellowish light pouring out onto the street from the café, and, elsewhere, smaller patches of green and red. Klee's "Villa R." (1919) also contrasts green and red (leaning toward crimson), and yellow and blue. The chromatic reverberations in both paintings are rather like rich, somewhat dissonant chords sounded by an ensemble of trumpets, trombones, and horns.

35] Alan W. Watts, *Psychotherapy East and West* (New York: Mentor Books, by arrangement with Pantheon Books, Inc., 1963), p. 107.

Mutual Repulsion or Clash

The problem of contrast and harmony must be examined now at close hand in order to determine what bits of information are useful. The nature and meaning of "clash," mutual repulsion, as distinct from adaptation or attraction, deserves special attention, for this could prove to be a most valuable means of achieving spatial articulation. One of the most useful legacies of Matisse, of the Cubists, of Delaunay, Léger, and Mondrian, who were influenced by Cubism, of Kandinsky and the men of the Bauhaus, is the modern concept of color dynamics: expansion and contraction, "push and pull" in depth, adaptation and repulsion. In Part IV we shall inquire more particularly into the relationship of color to form and space. We shall examine the simultaneous relationship of color to area (the actual, flat extension of color across the surface of a design or painting) and to depth (the space created *within* a design), i.e., color-space.

Mutual repulsion always involves common elements. These common elements may be ascertained in any combination of colors by consulting the diagram [III-1], which traces the red, yellow, and blue components of every color on the wheel and makes clear the chromatic anatomy of the primaries, secondaries, and tertiaries. We find that each primary is absolute and unique, and, by consulting the diagram, we also find that they and their complementaries are mutually exclusive. But it comes as a surprise to discover that, in every other pair, complementaries are *not* mutually exclusive. They share one semi-chrome. Both green and purple (red-violet) contain blue, both red-orange and turquoise (green-blue) contain yellow.

III-1

III-1 A diagram of the psychological color wheel showing the hegemony of red, yellow, and blue, and how semichromes of each of the primaries are to be seen, in diminishing proportions, in those colors that move away from a primary in either direction. The influence of each primary terminates at the doorstep of another primary.

Perhaps a re-examination from this vantage point of the studies in the section on harmony, as well as the earlier arrangements of tints and shades, chromatic greys, and broken colors, would be in order. They may reveal more than they did at first, and contribute to a better appreciation of effects and conditions that are the *reverse* of harmony, in the narrow sense.

The primaries, secondaries, and the six (or more) tertiaries represent a descending order of independence and stability. The primaries, like the first (or final) degree of the musical scale (e.g., the C major scale), are stable. As other musical degrees are unstable

(e.g., the so-called "leading tone," the tone just below the tonic, which gravitates determinedly toward the tonic), so are certain colors in the chromatic scale unstable. Such would be true of any of the tertiaries that leans ("leads") hard toward the nearest primary. The relationship of tertiary to primary may not seem very disturbing, but it is far from stable, in the sense that it is asymmetrical. One could compensate for the chromatic imbalance in a simple two-color design by making the area occupied by the tertiary larger than that occupied by the primary, or by placing the two colors beside each other in equal proportions after

having reduced the intensity of the primary.

If the tertiaries resemble the second, fourth, sixth, and especially seventh degrees of a musical scale (the super-tonic, sub-dominant, sub-mediant, and "leading tone," respectively) in their relative instability, and the first and eighth degrees (the tonic) resemble the primaries, then the third and fifth degrees (the mediant and dominant) resemble the secondary hues in their self-sufficiency. But a tertiary beside the nearest secondary will not exhibit the same amorous infatuation it shows when placed beside its alternative neighbor, a princely primary. The secondaries are by nature more compatible, more submissive—one could say more feminine—than the primaries, which have a kind of detached air. The greater chromatic density of the secondary triad yields a more subtle effect than the primaries, because they are more "internal" and held in greater tension by the system of overtones running through them. Violet was given an important role for the first time by the Impressionists. When raised in value (see "Discord"), it engenders a remarkable vibrancy and cohesiveness, qualities that the Impressionists valued highly.

If it takes a while to grow accustomed to the idea that conflict of complementaries is not the only kind of chromatic conflict, it may take even longer to appreciate the phenomenon of mutual repulsion in colors that have more in common with each other and are nearer to each other on the wheel, e.g., blue-green and ultramarine blue (violet-blue). These share an equal amount of the same dominant, blue, in their make-up and are rather like twins, but because absolute or primary blue is not present to hold them together, each veers toward yellow and toward red, respectively. The result is clash

and spatial separation—see the lower right square of Josef Albers' cover design for *Art News*, March 1963.[36] Unlike the contrast of complementaries (as, for instance, the same blue-green and crimson), these produce remarkably little vibrancy; they seem cold and aloof. Another part of Albers' design—the upper right square—contains two more examples of clash. The red center bears a relationship of the type described first to the purple (red-violet) surrounding it: that of a primary and a neighboring tertiary. There is tension between them, but not outright unfriendliness. The relationship between the purple and the outer plane of turquoise involves, on the other hand, complete repulsion. They turn their backs disdainfully to each other (even though, paradoxically, each contains a certain amount of blue). We do not wish to underestimate the influence of color condition, relative value, and intensity in these arrangements. This important matter, which would seem to apply especially to the last two examples, will be taken up in the next section, "Discord."

Why do these colors, which often have close family connections, conflict more acutely than complementaries? A cynic would probably say that this is a classic family situation; their similarities serve to heighten their differences, sometimes to the point of alienation. The three primaries are, in a sense, the three parents. Fortunately, the results of their union are not *always* inharmonious.

If the influence of a primary is subordinate in the two colors, the result is likely to be harmonious, as in the case of a tertiary and the one of its split-complementaries that would seem farthest in chromatic kinship. For instance, the split-complementary of yellow-green we would choose would be

purple (or perhaps crimson), rather than ultramarine blue. If we placed the same tertiary and its alternate split-complementary side by side (i.e., yellow-green and ultramarine blue), we would produce clash, because, to use Arnheim's words, we would have a "structural contradiction for one common element,"[37] an asymmetrical relationship. In the pairing of yellow-green and purple, blue is subordinate and of similar quantity in both colors (see III-1). In the second pairing, blue is subordinate in the first hue (yellow-green) and dominant in the second (ultramarine blue). The first hue lies three or four steps away from the color that each shares to some degree (blue), while the second color lies only one step away; hence the extreme contradiction. Other combinations that would produce clash do not necessarily involve split-complementaries, but would involve colors that lie at quite a distance from each other, i.e., yellow-orange and purple, ultramarine blue and red-orange, red-orange and yellow-green, blue-green and yellow-orange, and purple and blue-green.

Combinations involving secondaries and tertiaries which are neighbors on the wheel create less tension, less conflict. But if a secondary is combined with a tertiary that lies just beyond the nearest primary (for example, orange with crimson, or orange with yellow-green), each will do a distinct if not unpleasant "about-face" from the other. If a primary is combined with a tertiary lying just beyond the nearest secondary, (for example, yellow with red-orange or blue-green), the result will be much more contrasting than that of a primary and a "leading tone." The two colors will try to rebuff each other.

We have been referring thus far to hues as they appear in their natural order, their most ideal condition. We must examine them again in their more normal guise—in conditions of less purity, both in and out of place in their natural order, and jostling with colors which, as often as not, are unsympathetic. The student is advised to combine studies based on the preceding observations with the following, where comparisons will be made between colors both *in* and *out* of their natural order.

Discord

In dealing with the phenomenon known as clash or mutual repulsion, the term discord has been deliberately avoided; it has been reserved for a *particular* application. It must be emphasized again that neither it nor other quite similar terms should be taken to mean that these effects are bad and to be avoided. On the contrary, they may prove to be among the most useful syntactical devices the artist has at his disposal—all the more reason for becoming well acquainted with them. They relate not only to articulation of color as such, but to articulation of form, space, and movement by means of color.

Discord refers specifically to the effect produced when the value of a color, in any arrangement, is *in reverse* of its natural order.[38] The color has either been raised as a tint or a tinted grey, or lowered as a shade or a broken color. Any color on its own, whether technically pure or not, is simply a color out of context. Discord, therefore, is a relative condition. A color treated in this manner creates a light discord or dark discord effect when placed alongside another color that lies above or below it on the wheel [**P-7**]. The student will appreciate why a wheel based on the Natural Order of Color is important to this concept and use of color.

37] Arnheim, *Art and Visual Perception: A Psychology of the Creative Eye*, p. 291.

38] This and other ideas in this part are derived from a book by H. Barrett Carpenter, *Colour: A Manual of its Theory and Practice*, 3rd ed. (London: B. T. Batsford Ltd., 1933), which owes much to the theories of American scientist Ogden N. Rood, as stated in *Modern Chromatics with Applications to Art and Industry* (New York: Appleton-Century-Crofts, 1879), and *Students' Text-Book of Color* (© 1881) (New York: Appleton-Century-Crofts, 1916).

If violet, the darkest color in its natural order, is raised in value (by the addition of white or light grey) *above* the natural value of one of the nearer primaries, such as blue, and placed beside that primary, it will create a disturbance, i.e., a light discord effect. If it is raised by the admixture of light grey, it will create a muted discord effect (a broken violet raised by white would also result, in this context, in a muted or diminished discord). Even if raised to the *same* value level as blue (determined by squinting), it would create the strange effect of unique luminosity or "bloom," one of the most risky but also most delicately beautiful of all color effects. In small portions it enlivens otherwise dull color combinations, as the right amount of spice or seasoning enlivens food. But in large amounts it is like too much seasoning; it cheapens the whole ensemble.

Dark discords (the term discord, for the sake of convenience, may be applied to the single color, if it is understood that the color becomes discordant *only* in the company of another color) are not only less brilliant than light discords, they are easily "upstaged" by almost every other color. They are, after all, diminished by black or dark grey, or are broken. But they are capable of playing "supporting roles" with distinction, as we shall see.

The afterimage and the law of simultaneous contrast affect every color arrangement to some extent, even clash. Their influence on discord is conspicuous. Referring to the second type of conflict mentioned in the previous section on clash, if the two tertiaries red-orange and crimson (or purple), which lie on both sides of red, are placed together in their natural order, they will show an immediate hostility to one another by seeming to "stretch" red toward the other primaries,

yellow and blue, simultaneously. Red-orange and crimson are chosen because they lie along the side of the wheel, and therefore reveal in their natural order a distinct difference of value, red-orange being appreciably lighter than crimson. If white is added to crimson to the extent that it is raised *at least to the same value level of red-orange*, preferably higher, the effect will be that of discord. To conflict of color (in this particular case) is added discrepancy of value, and, as adding white to a color is rather like adding light to it, the result will be very lively. The stronger afterimage of the red-orange (a pale turquoise) will permeate the pink tint, making it seem bluer and cooler. Afterimages are very like discords in the sense that they are always extremely light in value. The afterimage of yellow, ultramarine blue, is as light or lighter than yellow itself. If it is added to a color that has been raised to the level of a tint, the two are certain to pool their chromatic energies. The more the raised color is separated from its partner on the wheel, the more it will resemble the afterimage of its partner, hence the more it will vibrate and create an effect of atmospheric light. These light discords contain a high quota of blue semi-chromes, either because they are the tints of those colors that lie, generally, in the bottom half of the wheel, or because the afterimages of their stronger companions, which they pick up, are usually of this half of the wheel.

The Impressionists, who sought an equivalent of sunlight effects that would be more true to an immediate experience of the outdoors and more lively than the old techniques, based their new method and way of seeing on this concept of color. If, for instance, they chose to paint a tree, a favorite subject, in a particular light—such as the

slightly warm light of a summer day—the illuminated side of the tree would, no doubt, be a warm, light green, and its shadow side and the shadow cast on the ground would be quite dark and, perhaps, a bit bluish. (Goethe, as we have stated, called attention to the complementary of a colored light in the shadow it casts. The blue of the sky and of the moist atmosphere would also infiltrate the shadow of the tree.) This great contrast of value would ironically present the exact set of circumstances the Impressionists wanted to avoid. The old vision and technique was based on the phenomenon of the contrast of values. Manet and, before him, the Spanish painter Velásquez, whose mature works he admired, and certainly Turner, whose works the Impressionists themselves were beginning to discover, had made it clear that strong value contrast and subtle atmospheric colors are incompatible. The choice for the Impressionists was not difficult to make.

Instead of acknowledging the gradation of values from highlight (the highest glint of light) to shadows around and beneath the tree, the Impressionists substituted a gradation of colors *around the wheel*, from a light warm green downward to blue-green and, perhaps, as far down as violet. But instead of their being allowed to remain in their natural order, the values of most colors were raised to about the same high level, the white of the canvas being both the highest level attainable and the reflective ground to which the delicate dabs and strokes were applied. Raising the blues and violets, the darker colors on the wheel, to the level of the lighter ones made a considerable incident of discord inevitable. Far from despising this, the Impressionists took advantage of it, especially in shadow areas, where they were

able to produce an effect of light infiltration and airiness. This, more than anything, led to certain excesses and accusations of "formlessness." Constable's description of Turner's color effects as being that of "tinted steam" could be applied to many Impressionist paintings of the 1880's and 1890's, when the method had reached a great degree of refinement and inspired reaction in Cézanne, Seurat, and especially Gauguin and his associates. The accusation of formlessness is understandable if one realizes that the Impressionists achieved a condition of pure openness, as distinct from that of closed forms and relationships. However, this openness was, in its own way, a kind of structure which would be reappraised about 70 years later (e.g., the works of Sam Francis and the so-called Tachists).

This description of the ways and means of the Impressionists is an over-simplification, as any purely verbal account of such artistic subtleties must be. They had no precise theories which every artist was obliged to follow; each one was encouraged to use his own eyes. As a group, they shared an enthusiasm for light and landscape, used both light and dark discords (broken colors), avoided the use of black and tinted greys wherever possible, and avoided the kind of formal and perceptual problems to which Cézanne dedicated himself with such stubborn resolve.

Bonnard and Vuillard, who were of a younger generation than the Impressionists, and whose attitudes toward Impressionism were conditioned by the divergent opinions of two older men, Redon and Gauguin (through his disciple, Sérusier), proved themselves colorists of outstanding achievement before 1900, particularly in their use of resonant combinations of subdued but

closely related colors and muted discords. Vuillard continued in much the same exquisite vein, apparently avoiding (or ignoring) the challenge of Fauvism. But between 1905 (the year of the first Fauve exhibition) and 1910, Bonnard showed a gradual evolution toward the use of somewhat bolder colors. His discovery in 1910 of the brilliant light and color of the south of France hastened this process. His many visits with Monet, who lived across the Seine from him, and his visits with Renoir during his frequent trips to the south (Bonnard was one of the first men in France to drive a motorcar) provided not only the encouragement and friendship of two famous artists, but a deeper insight into the problems of color. Bonnard, during the next 35 years, would extend the Impressionist inspiration into new areas of expression. From about 1912 he brought to his painting a resurgent interest in color, pattern, and texture. Whereas the Impressionists were content to show the effect of light on surfaces, Bonnard showed the effect of light *through* surfaces—through the skin, glass, fruit, and water—and for effects that exceeded mere descriptiveness. He caused colors to glide from one area into another, in and out of form, by the most subtle permutations. His patterns and embellishments were conceived so as to keep the eye occupied with a plenitude of experience, as a faceted gem stone keeps the eye occupied with a constant display of iridescent light. In this and other ways, his paintings resemble those of Constable—for example, "Constable's snow," the sun-dappled grass, water, and foliage which some of his English contemporaries failed to appreciate.

EX. 9

Next, some attention should be given to secondary hues, in situations other than the more common triadic combinations. (Studies in this series could start with f and proceed through m, then return to a.)

a• Place a secondary beside a tertiary that lies beyond the nearest primary—for example, orange and yellow-green, or green and ultramarine blue. The pair represents a structural contradiction of sorts, chromatic asymmetry (the yellow in yellow-green is in a 2:1 ratio to the blue semi-chromes; the yellow in orange is in a 1:1 ratio to red), but the primary lying between them on the wheel —strongly implied in the arrangement—acts as something of a stabilizing influence. It lessens the conflict. The rich overtones or partials in secondaries and tertiaries tend to reduce conflict, in any case.

b• Then try reversing one or both of them as light or dark discords. It will be noted that a *double* reversal produces less vibration but (therefore?) more separation.

c• The same chromatic interval as in the preceding example (three or perhaps even five steps apart), but substituting a primary for the secondary, will produce a more distinct clash.

d• Pair, in equal or unequal proportions, a primary with a tertiary that lies just beyond the nearest secondary in either direction (e.g., red and yellow-orange or red and ultramarine blue), first in their natural order and then one or both in inverted order.

The uses and abuses of discord

The term discord may not be the happiest choice if it serves merely to create prejudice against the kind of color effect it is meant to signify. Discord, as we have said, may be among the most beautiful of all color effects, if used with discretion and purpose. It may as easily be the most disagreeable and tiresome, as the work of "do-it-yourself" house painters and decorators and garish com-

mercial products and advertisements will testify. In general, large areas of tints and the so-called pastel colors—"baby" blues and pinks, lavenders, and pale greens—should be used with restraint. Since they are out of their natural order, they either set up an inordinate amount of tension with their neighbors, or tend to lack character across broad areas, where there is little chance of their submitting internally to the influence of any other color in their environment. Light discords tend to so weaken the physical "reality" of surfaces to which they are applied that a small area of a color in its natural order, when placed within a much larger area of a light discord, will appear as though in a "dream world." They are usually discovered in nature in small amounts, as in the strange coloring of birds and insects, in flowers and minerals, and in mother-of-pearl.

Light discords, especially in small amounts, are capable of playing a useful role: as a foil to too much harmony (illustrated in music in the use of dissonance). Too much sweetness in color, sound, or food is, after a time, rather cloying. Light discords serve very well in transitional areas between dark and light planes or areas of contrasting hue. They serve to bridge the gap between areas that would otherwise separate uncomfortably and destroy continuity of space and movement. Their tendency to vibrate causes them to act as a weld.

They serve exceedingly well as highlights, the points of reflected light on shiny surfaces, because of their vibrancy. If one were painting an orange in a still-life arrangement and wanted to find an equivalent in paint for the tiny burst of sunlight on the oily skin of the fruit, one would *not* place a small dab of tinted orange, the local color of the fruit, in the correct spot. Instead, one would use a very light discord of red or crimson to create the effect.

Bonnard, whose way with color transcended mere trickery, was a master of discords, as one would expect of an artist who continued to develop Impressionist color well into the twentieth century. The idea of intense optical stimulation was given a more daring application in his paintings, thereby bringing to bear the influence of an enlarged, revitalized Impressionism on the works of such artists as Marchand, Tamayo, Rothko, and Reinhardt, and, perhaps, even on those of recent "color-field" painters, like Kenneth Noland. Bonnard used the secondary triad often, but not as persistently as Gauguin and his Pont-Aven friends. We are told that, after making a preliminary charcoal sketch on the canvas, he would start with green. This would seem a logical first step, for the value of green lies between the darker violet and lighter orange of the triad. But equally important is the fact that the chromatic components of green, yellow and blue, also exist (along with red) in orange and violet, respectively. This chromatic stockpiling, ramified by both light and dark discords and extending even to the use of complementary discords, accounts for some of the rich sensual and spiritual qualities in Bonnard's art.

Light tints in certain circumstances, if they are not meant to become too anemic or ethereal, or to exist as discords, require "supporting" from *above*. For example, if one of the dark hues, blue, purple, or violet, is raised very high as a tint, it must be accompanied by still lighter tints of red, orange, or yellow. Similarly, such dark colors as heavy yellows, broken oranges, and reddish browns, if they are not meant to seem unduly hot or "bilious," must be supported from *below* by the darker hues at the bottom of the wheel.

Conversely, if blues, greens, and violets in their natural order are used in dark color arrangements and required to be awake and active, they, too, must be supported by dark discords of the warmer hues that have been dropped in value *below* the darkest hue on the wheel. The afterimage of these dark discords, by the law of simultaneous contrast, will give back to the blues and violets the blue content they tend to lose in these circumstances. It will cause them to respond somewhat in the manner of light discords, and the result will be a strange, "exotic" richness.

e● It would be both useful and enjoyable to create a design either of curved or rectilinear shapes in which one of the blues, or perhaps a violet, is placed within one or more dark discords. A cool blue supported by a very dark green takes on an extraordinary quality, rather like that of a sapphire in a dark setting.

These comments and studies on discord serve to illustrate a general rule: when two colors are placed beside each other, they should be made to appear different in value—unless one's aim is the most ephemeral, "impressionistic" effect of atmospheric light. Too much ambiguity tends to compromise space-form relations. If colors of very close values are used in a formal rather than impressionistic manner, they must be given definition by means of clean, hard edges.

It will be noted that blue and blue-violet tend to lose some of their blueness and appear to become darker if placed on pure black. However, red or one of the other warm colors, yellow or orange, none of which contains blue semi-chromes, will, in similar circumstances, remain quite brilliant. This is usually explained by a phenomenon known as "chromatic aberration," a slight breaking up of light in the eye. The blue rays, having the shortest wave lengths, suffer the greatest distortion. They are bent in such a way as to converge *in front* of the retina, creating a slightly out-of-focus projection on the retina that spreads beyond the actual contours of the image in sight; the blue of any shape or object appears to lose some of its blueness to the surrounding space, and to grow darker. This is especially noticeable in small shapes or those seen at a distance. Leonardo thought that blue was related to black. If we can no longer agree with him on scientific ground, we do recognize in his opinion a psychological truth: black will appear to absorb a certain amount of blue from any blue shape it encompasses. But, in circumstances described earlier, the bluish afterimages of dark discords surrounding a blue area will appear to restore the blue energy in more than equal measure. The same is true of blue surrounded with white. White reflects a light made up of all the colors of the spectrum, plus an extra amount of blue. This blue from the light (daylight in particular) supplements the blue lost from the image because of "chromatic aberration." The warm colors, on the other hand, if surrounded with white, will receive a pale blue-white "wash" across their surface from the white environment. This will make them seem slightly hazy and a bit "sulky" and withdrawn; at a distance their edges will appear to waver a bit.

The problem of blue is two-fold and seems to involve both psychological and physical factors. Not only does the eye focus blue-violet rays with less precision than those of the warm colors, but the particles of dust and moisture in the atmosphere, acting as tiny prisms, fracture some of the white sunlight,

scatter the shorter blue rays in all directions, and create the blue of the sky and of distant views.[39] The problem, of course, is not in the blue of the sky or of the atmosphere that envelops the landscape. This is an affair of nature with which it would be foolish to quarrel. The trouble for the artist lies in the classical canon—based, undeniably, on empirical evidence—which demands that warm colors be placed in the foreground of paintings and that blue be used, for the most part, in background areas. Leonardo gave this idea authority by virtue of his intuitive understanding of atmospheric "scattering," and his intensely personal interest in the problems of landscape painting in general, including such matters as aerial perspective, the structure of earth forms, and the movement of wind and water. Some Dutch and Italian "primitives," from about the beginning of the fifteenth century, had begun to favor blue for distant forms and spaces and warm colors predominantly for near forms, thus reversing the practices of Byzantine and Gothic art. Adoption of color perspective coincided with the adoption of linear perspective and other classical devices which became an important and undisputed part of Renaissance picture-making, holding sway down to the last quarter of the nineteenth century. Examine any painting in the great tradition, from Leonardo to Delacroix, and you will find intense blues and greens occupying large background areas—panoramic depths—and full-bodied warm colors occurring entirely in solid objects and at points of strong emphasis in the foreground. The blue is sometimes allowed to move forward contrapuntally for the sake of compositional balance in depth, but warm colors do not reciprocate in any real strength. They do, in a few instances, occur faintly in distant areas, particularly in paintings by artists who allowed their eyes to contradict theory—van Eyck and, more noticeably, Cézanne, in whose works distant hills are often as warm as foreground objects. Great artists are never slaves to theory, but even artists of revolutionary vision may continue to use elements of an older tradition wittingly or unwittingly. Cézanne, who made important use of aerial blue in his landscapes (especially his late landscapes, where it creates a vibrant continuum out of which fragments and faceted forms emerge), used blue to represent depth and atmosphere even in the limited space of his still-life paintings!

The Impressionists, because they followed no hard and fast rules, learned most of their lessons about color outdoors through their own eyes (Cézanne is supposed to have said: "Monet is only an eye—but what an eye!"), and felt no particular allegiance to the Renaissance tradition, put an end both to the use of chiaroscuro and to any strict application of the classical laws governing color and space. They often placed warm colors well into the middle distance of their landscapes, and even in far deeper areas. Curiously, they retained more than a trace of classical perspective in their treatment of streets, buildings, and trees, and even in a certain amount of dimming of colors toward the horizon. They were not prepared to abandon all the old habits and conventions as would Gauguin, with diabolical enthusiasm.

After Impressionism, no one with sense and sensibility could go back to the old disciplines. Impressionism had taught the eye to perceive the myriad effects of light and color with far greater accuracy than the old vision had ever admitted. It provided a means of entering unexplored regions of the mind and spirit.

39] This is noticeably true in northern Europe, where the amount of moisture in the atmosphere is often very great. John Tyndall (1820–1893), the Irish-born natural philosopher who performed outstanding experimental studies on the color of the sky, asked why the sky is blue and gave the almost poetic answer: "Because we live *In* the sky, not under it." The thing that we call sky is merely a depth of scattered rays in the very atmosphere we breathe.

What happens, then, to the old belief that red advances and blue recedes, or that red makes things seem solid and blue makes things seem thin and weightless? It is inevitable that we in the twentieth century compare these assumptions with those which preceded them, the attitudes inherent in the tradition of the Middle Ages and in branches of that tradition that survived well into the modern era, especially in faience and other ceramic arts. If the art of the twentieth century establishes a link with any art of the past, it is, in matters pertaining to color, with the art of the Middle Ages. In this art we discover an alternative or secondary tradition in which there is a reversal of the roles of blue and red, noticeably in the art of tapestry. Red and other warm colors served as well for background as for foreground areas, there being little concern for space as we understand it—consider, for example, the use of inverse perspective. Blue was, in fact, justifiably preferred for solid bodies, for, in its natural order, blue is darker and far less luminous and expansive than yellow, orange, and red. It is "concentric" by nature, inward-turning and retiring; they (the warm hues) are "eccentric," radiant, and outgoing. Why not use the warm colors to suggest space and limitless distance, and blue to express the weight, density, and structure of foreground subjects, or, indeed, use *either* type of color, forward or backward in depth, with the freedom demanded by expression and pictorial necessity? We recall with amusement the academic furor that arose over Gainsborough's "Blue Boy," with so much blue used in a solid form in the foreground! One wonders what Gainsborough's contemporaries would have thought if they could have seen a 1940's painting by André Marchand of a large blue nude seated in front of a swimming pool of red water![40]

If the Impressionists felt relatively free of traditional laws, the Post-Impressionists, van Gogh and Gauguin, and the Neo-Impressionists, Seurat and Signac, encouraged by new optical theories, clearly had no further use for Renaissance color-space concepts. Signac, in his most daring landscapes, allowed strong reds, oranges, and yellows to penetrate into the farthest regions, and blues, greens, and violets to move well forward.

The Fauves, soon after the turn of the century, carried this practice to even more startling conclusions. Vlaminck, in particular, not only employed the purest warm and cool hues in both near and distant areas, he also replaced the local color of any object with whatever color he preferred, or arbitrarily divided the object into several colors for spatio-plastic purposes. The trunk of a tree would be made to change color three or four times along its entire length, depending on the ground, the color, and the space behind it.

The two artists, both born in the 1860's, who drew together the bright fragments of the color revolution and fashioned an art of great beauty and undiminished influence were Bonnard and Matisse. It cannot be said that they abandoned all classical principles (there is an innate French classicism in the work of both men); rather, they gave them a new articulation through experimentation and an interest in pre-Renaissance and non-European uses of color. Matisse's radiant over-all grounds in his interiors (e.g., "The Studio," 1911) and still-lifes, from his early variations on "La Desserte" to the works of the 1940's, represent absorption of the classical tradition by the rejuvenated alternative tradition.

Gauguin was inclined to treat the niceties

40] See "Color into Space" by the French artist-scientist, Charles Lapicque, from the annual, *Portfolio*, including *Art News Annual*, No. 1, 1959 (New York: The Art Foundation Press, Inc.), pp. 72–95.

of Impressionism with a measure of contempt. He told Sérusier, one of his followers, to render the faint blue of distant shadows by means of the strongest blue he had, and delicate pinks by means of the strongest red! He, Redon, and van Gogh, each in his own way, brought to color many of the Symbolist preoccupations of their generation. Color was seen as more than an equivalent of light and more than a thing in itself. It was thought to be allied with moods, presentiments, states of being, and hidden meanings.[41]

From this concept of color to that of much recent art (Pop-art and Op-art) is a step from an internal to a more external condition, where color arouses little more than sensate reactions. In German Expressionism, in the paintings of Klee and Kandinsky, and in the works of Braque and Picasso from about 1921 (increasingly with the influence of Surrealism), there is a closer tie between color and emotion.

A series of studies may now be based on the phenomena clash and discord. It is important that the two be seen together in order that their differences may be well understood and appreciated. Color-form and color-space syntax may depend, to a large extent, on how effectively clash and discord are used. It could be argued that, basically, there are only two types of color combinations: those that produce *little or no* optical vibration or dazzle, and those that produce *much* optical vibration. Combinations referred to as clash or mutual repulsion would pertain to the former category, and juxtapositions of complementaries and those referred to as discord would pertain to the latter. One results in segregation or discontinuity, the other in cohesion or continuity. One sets colors apart in depth, the other binds them together.[42] Colors may be arranged, for experimental purposes, in the simplest stripe designs in which the

only type of formal contrast will be the indispensable contrast of proportion. Wide and narrow bands and stripes may be placed either horizontally or vertically. In the next part, on shape, plane, and form, similar color combinations may be used in areas of greater structural variety.

f• Looking back to the section on mutual repulsion and taking each example in the order in which it appears in the text, choose a primary, preferably red or blue, as it appears on the wheel, and experiment with it in the following ways:

Place it and its upper or lighter tertiary neighbor together in their natural order in a carefully adjusted design (let the eye suggest how large an area or how many bands of one is needed to balance the other). The tertiary or "leading tone," whether it be the lighter or darker, will arouse an amorous contest with the primary, too tender, perhaps, to call clash. Also, they will press inwardly rather than outwardly.

g• Add black or dark grey to the same tertiary, or break it (by adding to it a bit of its complementary), and make another simple design with the unaltered primary. The value of the tertiary must be at least as dark, preferably darker, than the value of the primary. The result will be a dark discord. The effect will probably be of raising the value of the primary by simultaneous contrast. A quite similar effect can be obtained by placing a primary, or any hue, alongside a broken version of itself, e.g., a red-orange beside a burnt sienna, either taken directly from the tube or raised by the admixture of white nearer the value of the pure red-orange. The effect will be one of great chromatic saturation, a kind of "Mexican" intensity.

h• Place the primary beside its dark neighbor. Again, the relationship will be chromatically unstable, asymmetric, but not unpleasant.

i• Then add white or light grey (or both, separately) to the tertiary, raising it in value *above* the value of the primary. The result will be a light discord (or a muted discord, if grey is added) of

41] See the statements of van Gogh and Gauguin about color and color symbolism in their own works: van Gogh in his letters to Theo [e.g., Letters 520 and 534 in *Further Letters of Vincent Van Gogh to His Brother, 1886–1889* (Boston: Houghton Mifflin Company, 1929)], and Gauguin's description of the genesis of his famous painting, "Manao Tupapau" (The Spirit of the Dead Watching) and his analysis of it in his Journals [*Paul Gauguin's Intimate Journals*, trans. Van Wyck Brooks (New York: Crown Publishers, 1963)].

considerable lustre. Proportional adjustments may be made to countermand too raucous an effect.

j● A more distinct example of clash may be created by pairing the two tertiaries lying immediately to the right and left of a primary. With the primary physically present forming a center of gravity, as it were, they hold together; without the primary, they tend to pull away from each other. It could be said that one veers toward the cool zone, while the other veers toward the warm zone. Test this reaction by placing side by side, touching, one or more bands of two tertiaries in their natural order.

k● Then reverse one or both of them by adding white or light grey to the darker, and black, dark grey, or a bit of its complementary to the lighter. Place the resultant colors together so that they may react directly on each other across wide and narrow areas.

l● A third form of clash, described earlier, is that involving the relationship of colors that lie at a considerable distance from each other on the wheel. Place together balanced portions of two hues (yellow-green and ultramarine blue, yellow-orange and purple, ultramarine blue and red-orange, red-orange and yellow-green, blue-green and yellow-orange, or purple and blue-green) in their natural order.

m● Then place them in arrangements where one or both hues is in reverse of its natural order.

If individual color studies are mounted for presentation, it is advisable that they be mounted on white, grey, or black rather than on a colored ground.

Color-space relations in many modern paintings (in Abstract Expressionist paintings, for example) are ambiguous—often intentionally. But in some quite recent works where areas are treated without ambiguity, flatly, evenly, and frontally, color seems to have demanded precise three-dimensional articulation by means of attached forms and projections. In these works, traditional boundaries between painting and sculpture have been crossed. It could also be said that as sculpture has departed more and more from the use of volumetric form and closed structure, with their strong appeal to the sense of touch (haptic sensations), and has become more open, spatial, and almost entirely visual in its appeal, color has been called upon to play a distinctive role. It would be difficult to imagine some recent sculpture without color (e.g., the works of Anthony Caro). As a matter of history, the conjugation of color and three-dimensional form was undertaken by Picasso in some of his Cubist constructions as early as 1912, then by the Dadaists and by artists from Holland, Hungary, and Russia, whose ideas converged on the Bauhaus School of Design in Germany after World War I. However, despite the passing of more than 50 years since this work was begun, few artists, designers, and architects have yet to realize the full implications of the idea—its possibilities and limitations.

Stated briefly, the history of color from Turner to the 1960's is a gradual transition from concepts pertaining to subject matter of an emotive nature to form and space concepts remarkably free of associational content—or from color as an equivalent of light, sensation, and feeling to color as seemingly a reality in itself (e.g., the works of Ellsworth Kelly). Thanks to the work of the artist, the designer, and the color chemist, color has been set free from every prejudice and restriction—so much so that it shouts from millions of surfaces with the voice of a commercial hawker. Its liberation is complete. Now it is up to the artist to give it meaning, to make it sing.

42] "I did not want to use complementary colors next to each other. I wanted to arrive at colors which isolate themselves. A red which is very red, a blue which is very blue [contrast of hue]. When one puts yellow next to blue, the immediate result is a complementary color, but when one puts it next to orange, the relationship becomes structural." Fernand Léger, *The Figure* (New York: Chalette, 1965), p. 9. Also: "I never juxtapose complementary colours. In other words, I avoid placing red beside a green, an orange next to a blue or a mauve by a yellow; because each of these colours loses its own local strength when seen side by side with another. The reason is the well-known phenomenon of vibration which is set up between complementary colours. This was thoroughly explored by the Impressionists and their relief effects were obtained through vibration. Whereas I, on the other hand, relate colours which give a constructive effect." Fernand Léger, in *Great Tapestries: The Web of History from the 12th to the 20th Centuries*, ed. by Joseph Jobé (Switzerland: Edita S. A. Lausanne, 1965), p. 197.

PART IV

Shape, Plane, and Form

Because he [the artist] is a man, I grant him everything. But his special privilege is to imagine, to recollect, to think, to feel in forms.
HENRI FOCILLON*

Because it is such a vital element, one that both children and adults use instinctively, line is the most common means of describing shape, plane, and form. More than one authority has stressed the primacy of outline in the way the eye actually perceives form. Norbert Wiener has stated that "somewhere in the visual process, outlines are emphasized and some other aspects of an image are minimized in importance. The beginning of the process is in the eye itself."[1] "The eye receives its most intense impression at boundaries, and . . . every visual image in fact has something of the nature of a line drawing."[2] This may help to explain why many people seem to have a more immediate grasp of two-dimensional than of three-dimensional images, especially in the modern environment, where so much visual data exists (as though partly predigested) on the printed page, in photographs, television, and motion pictures, and where forms and images

are apt to be seen at a distance and in rapid succession. In earlier and simpler times, most of the images with which man concerned himself were three-dimensional and made by hand. The unerring strength and authority of Egyptian, African, and pre-Columbian objects, whether large or small, testify to the time, patience, and skill that went into their creation. The relationship of maker to object was as close as that of mother to child.

Shape is understood in this part as an essentially flat or silhouette image pertaining to area rather than to volume or mass. Form is used here and at other times to designate three-dimensional structure, solid or hollow, actual or virtual. By "virtual" is meant that even a drawing or painting can be said to have form. A drawing by Degas or Picasso, for example, can appear to have *more* form than an actual object! But line, because it is so active, tends to create forms that are somewhat passive or negative in

*] *The Life of Forms in Art* (New York: Wittenborn, Schultz, 1948), p. 47.
1] Norbert Wiener, *Cybernetics; or Control and Communication in the Animal and the Machine* (Cambridge, Mass.: Technology Press, 1948), p. 156.
2] *Ibid.*, p. 159.

IV-17b

IV-1 A continuous line drawing of a classroom. Tonal areas were added at the end of the linear process.

character. Their drama and interest lie more at their edges than their centers, from which energy is usually expected to emanate. It was suggested in Part II, on line, that the familiar term *outline* would have greater meaning if it were used along with its functional opposite, *inline*. The two together would foster a clearer understanding of the internal and external forces at work between form (or shape) and environment.

If there remains any doubt concerning the ability of line to describe the co-incidence of space, form, and movement, the student may start this series by using line to record his experience of an interior [**IV-1**].

EX. 1

Take a pencil and paper and place yourself in a room that contains an assortment of furniture and other objects in foreground, middleground, and background positions. Pretend for the moment that you are blind and must discover these objects in this environment by the touch of the hand alone,

moving slowly from the edge of one form to another, measuring heights, widths, and intervening spaces. Your pencil point will travel the path of the searching hand, which, in your fortunate case, will be the path of the eye. The pencil will never leave the paper from the beginning to the end of its journey. It will move from near to far and from high to low with more agility than a blind person's hand. It will travel from the edge of one form to another for the distinct purpose of realizing the totality of environment considered as form-space. It will show no partiality either to form or space.

The result of this study will be a network of lines and a transparent complex of planes tilting at various angles and cutting across each other in depth. If it should seem lacking in compositional unity, another kind of plane may be laid over certain areas to pull them together: an amorphous, tonal plane made by cross-hatching, or simply by moving the pencil back and forth across the paper lightly and rapidly.

A plane may be flat or curved, opaque or transparent, may exist in a drawing or painting, or may be the very real surface of a physical object. It is often conceived, in a narrow geometrical sense, as a parallelogram or trapezoid, but this is too limiting in every way, as we shall see.

Shape and form can be attained from another direction: from the center outward. The results will be active instead of passive, positive instead of negative, as opposed to the linear approach. A shape created only with line seems to retain the character of a man-made article; it can be changed only by external addition or subtraction. A shape created from the center outwards seems capable of alteration from within, as with living things. One could start with a point and allow it, the germinal center, to "grow,"

IV-2

spread, extend itself to the limit of its energy. If it develops as a perfect circle, it will exert pressure equally in all directions against the space around it. If its development is less than equal in all directions, it will, like most shapes and organisms, yield to the pressure of its environment along parts of its frontier. One could diagram these forces by means of axes radiating at several degrees from the heart of the form. The counter-thrusts from without could be shown by means of arrows [IV-2].

EX. 2

The student may create several shapes of this type with soft charcoal or conté crayon, building outward slowly, using a kneaded eraser and perhaps white conté or chalk to "carve" or "correct" each shape as desired (after which it must be sprayed with fixative). Very likely most will pertain to the family of the circle, and included among them will be a variety of biomorphic shapes.

IV-3a

Families of Form

If we can agree with Cézanne that geometry is the basis of all form, and that the infinite complexities of natural forms may be reduced, for artistic purposes, to the familiar cube, sphere, cylinder, and cone, or to their two-dimensional counterparts, the square, circle, and triangle, we stand in a happier relationship to our task. We have already observed how the eye, instead of receiving sense data passively and indiscriminately, tends to transmute many of the burgeoning, "untidy" forms of the world into their simplest sensory categories—whereby tree trunks approximate cylinders, houses approximate cubes, apples and heads approximate circles or spheres, and mountain peaks approximate cones. The nature of visual perception involves an abstracting and clarifying of shapes and boundaries toward "good" gestalt, "good" shapes. Indeed, this activity would

IV-3b

3] See Rudolf Arnheim, "Perceptual Abstraction and Art," in *Toward a Psychology of Art* (Berkeley: University of California Press, 1966), pp. 27–49.

4] See Herbert Read, "Informality," in *The Origins of Form in Art* (New York: Horizon Press, 1965), pp. 89–96.

5] See David Bergamini and the Editors of LIFE, "Topology: The Mathematics of Distortion," in *Mathematics*, LIFE Science Library (New York: Time Inc., 1963), pp. 176–81.

IV-4 Brancusi. "The Newborn." First stage after a marble of 1915. Bronze, 5¾ x 8¼ inches. Collection, The Museum of Modern Art, New York. Acquired through the Lillie P. Bliss Bequest.

IV-4

seem to lie close to the heart of artistic formation.[3]

Therefore, we may be justified in placing certain forms or shapes in simple family groups in order to appreciate their origin and essence. Having done this, we shall be able to recognize other forms as composites of two or more family strains. Many will be of a rather complex nature and require the most intensive looking. Even beyond these are a host of "informal," inarticulate, "distorted," or ambiguous shapes—such as clouds, stains, islands, and lakes (see Part VI)—that seem to defy geometrical classification, and are "gestalt-free."[4] But they and the simpler categories are subsumed in a new system proposed by a recent branch of geometry known as topology, in which objects are classified according to "genus." These classifications are not without a certain visual logic, even if they do transcend purely esthetic considerations.[5]

EX. 3

Choose a square, circle, or triangle, and proceed as in EX. 2, above. Start with the basic geometric itself and then create 12 or more variations upon it. Arrange these in a series, allowing each variant to appear to develop naturally from the previous one. The method employed may be both additive and subtractive, in the sense that the shape may be expanded or a portion of it deleted. Charcoal or conté and a kneaded eraser and white conté may be used both to extend and contract the shape. The final variant may bear only a vestigial relationship to the original shape [**IV-3a, b**].

One could go about the matter in a purely subtractive way by starting with a primary shape cut from construction paper, and then creating several dynamic variants by paring away a significant portion of the shape for each variant. Again, the series should appear to develop very much as a cell metamorphoses or divides, each shape being a stage in the pattern of growth or change. Or one could start with a shape (or a three-dimensional form) pertaining to one family, and end with a shape (or form) pertaining to another. A square or a cube, for example, could be made to metamorphose, little by little, into a circle or a sphere.

We are reminded of Brancusi's sculpture "The New-Born" (which Edward Lucie-Smith, the English critic, called "a sublime visual epigram"), based on his favorite form, the egg, a member of the family of spheres [**IV-4**]. Brancusi (1876–1957) was careful to retain the form of the egg, which interested him not only because of its intrinsic beauty, the beauty of its subtle contours—its long axis terminating at a blunt end and a more pointed end, providing the kind of variety lacking in the sphere—but also because of its significance as the primal form of life. It was the latter consideration, one may suppose, that

led him to "develop" the form by means of a few abrupt planes, with the hope of insinuating the slow, mysterious turning of life at the moment of entering the realm of time and being. The import of the piece deepens if it can be seen also to pertain to the "origins of form in art," which are also the origins of "knowledge of being, of reality."[6] "In the creation of symbols is foreshadowed the emergence of reflexiveness in the world. . . . For to symbolize something artistically is, in a very pertinent sense, to symbolize oneself experiencing that something, and so one comes not only to a better knowledge of the defining characteristics of the thing, but also to a better knowledge of oneself."[7] Thus, form takes on a more important meaning.

A rather humorous piece on the theme of revelation, of form disclosing being, is John Flannagan's "Triumph of the Egg," in which the form is an amalgam of egg, emergent chick, and the granite boulder from which it was carved. Form becomes the "true shape of content."

EX. 4

a• These examples anticipate the next logical step: realization of these geometric entities and one or more variants in three dimensions—height, width, and thickness [**IV-5**]. The first decision concerns the kind of material to be used, whether marble (or alabaster), wood, or plaster. Plaster is probably the cheapest, most readily available, and easiest material to "work," if perhaps the least appealing texturally.

If plaster is chosen, the first act will be to cast a block from which the basic form may be carved. A ½-gallon cardboard milk carton could serve as a mould. If filled to the top with plaster, it will produce, when firm and divideable, two square blocks approximately 4 × 4 × 4 inches in size.

IV-5

The plaster should be prepared with care. Fill a clean mixing bowl (preferably plastic) with an appropriate amount of cool, clean water and sprinkle fresh plaster into it with a circular motion of the hand until the plaster rises above the surface of the water in little islands or an atoll. Allow the plaster to absorb the water and then stir gently with the hand submerged; stop stirring as soon as the mixture is smooth. Then pour the plaster into the carton and allow it to harden.

When the plaster is sufficiently hard, tear away the carton and proceed to carve the block with open rasp (Surform, a brand name), cabinet rasp, penknife, and sandpaper into the desired basic form—cube, sphere, cone, or cylinder. Then continue to carve the form in such a way as to enhance its design qualities without departing altogether from its original identity. One may cut away much or little, create flat planes or curved planes, or both. One may bore a hole (or holes) through the form, opening it out to the space around it.

6] Read, "The Origins of Form in the Plastic Arts," in *The Origins of Form in Art*, p. 88. For a discussion of what would appear to be a dangerous trend in recent art, see Erich Kahler, *The Disintegration of Form in the Arts* (New York: George Braziller, Inc., 1968).

7] Matthew Lipman, "The Aesthetic Presence of the Body," *The Journal of Aesthetics and Art Criticism*, XV, No. 4 (June 1957), 431.

8] Other types of form would be container form or planar form (e.g., a seed pod, a box, a bowl), open form (e.g., a piece of welded sculpture), and kinetic form (e.g., a mobile in motion).

The hole may change direction, grow larger or smaller, go from a squarish shape to a round or ovoid shape. The form may be divided into two or more parts. It may be painted so as to create a path of movement from one part to another, or to establish a point of strong emphasis or a livelier play of negative (concave) against positive (convex) surface. It is important that the total form be considered at all times, that the eye be encouraged to explore its profiles, its "horizons," from all angles, and be allowed to pass from one area to another with a mixture of recognition and surprise. **b●** It would be possible to create a large spherical shape in *papier-maché* from a balloon (in the manner described below) and, without altering its form, paint shapes on its surface in such a way as to entice the observer to move pleasurably from one area to another. Contrast, continuity, positive-negative relationships, and large and small shapes oriented in various directions would be the sole means of realizing a marriage of form and shape.

Purchase a balloon of greater size and thickness than the ordinary. Blow it up and tie tightly, allowing it to hang at a convenient height in a room of fairly uniform temperature. Coat it evenly with vaseline and apply dry strips of paper towels or newspapers to it; the vaseline will serve as a kind of adhesive. Then immediately apply three or four layers of paper cut in narrow strips and dipped in a wheat flour paste (paperhanger's glue), taking care to eliminate excessive paste, and keeping the paste at the consistency of heavy cream throughout the operation. Apply the strips to the balloon in all directions in order to achieve a strong, even surface.

When the paper is thoroughly dry, deflate the balloon and mount the form securely on a dowel and base by means of more strips of paper dipped in wheat paste or a stronger adhesive. Apply the design to the surface of the form, being careful not to dampen it too much. Shape and form must relate to each other like hand and glove.

Most of the designs that result from either of these experiments will be of the type called closed form, in view of the fact that they will maintain their volumetric or pneumatic thrust against the space around them, despite the incursion of some pressure from without in shallow, concave areas [**IV-6**]. Some, however, will be examples of what we shall refer to as pierced or penetrated form—those that admit space deeply into the center of their mass, or are invaded through and through by a hole or holes.[8]

Someone once said that Eve gave Adam only half an apple, since he was able to see only one-half of the fruit at a glance. But had she taken the trouble to remove the core by boring a neat hole right through the apple before presenting it to her husband, Adam might have been able to apprehend something of its far side and its thickness in the same instant. This little story, for all its facetious-

IV-6

IV-7

ness, does emphasize one truth: the act of looking at form requires a kind of patience and perspicacity that goes beyond merely seeing it.

Closed or pierced forms are usually types that appeal immediately to the sense of touch. It is said that their appeal is to haptic sensations (from the Greek word *haptos*, "able to lay hold of"). It is the opinion of Sir Herbert Read that sculpture in general begins in a kind of sensibility not influenced only by vision, but as much or more by a "multitude of tactile impressions,"[9] and by both internal and external functions. We forget to what an extent we enjoyed touching things as children, and often even to what an extent we live in the body, unless it happens to be causing some discomfort or disability.

If one were walking along a barren, sandy beach and came upon two objects, a jagged stone and a smooth, water-worn pebble, both of about the same size and material, chances are one would pick up the pebble and ignore the rough stone. The pebble would be turned over and over in the fingers, weighed and fondled by both hand and eye. If particularly ingratiating, it might even be taken away to form part of a collection. In addition to being of greater tactile and visual interest than the rough stone, the pebble would represent a form at the end of the process of erosion. Its "life history" would include having once been a fragment, like the stone, and having submitted to another kind of experience: the action of water, sand, and other pebbles across its surface for perhaps hundreds of years. It will have achieved an

9] Herbert Read, *The Art of Sculpture* (London: Faber and Faber, Ltd., 1956), p. 32.

10] Paul Jacques Grillo, *What Is Design?* (Chicago: Paul Theobald & Co., 1960), p. 36.

IV-8

IV-8 A design in metal, based on forms of discontinuity. Its sentiment or form quality is the opposite of any that pertains to the principle of continuity —the family of the thorn versus the family of the fruit.

orderly continuum of concave and convex, deep and shallow planes, a balance of greater and lesser surface tensions—a unity in diversity that humans, young and old, find very much to their liking [**IV-7**].

We have, in the jagged stone and water-worn pebble, two archetypal forms: the form of discontinuity, which includes the cube and triangle families and all plane polygons and solids, and the form of continuity, which encompasses the family of curves, including all curved surfaces and volumes. These forms pertain to our earlier discussion of dividual (dependent) and individual (integral or self-contained) structures in Parts I and II, and include forms that occur in both natural and man-made structures and in geometry [**IV-8**].

"In geometry, discontinuity is expressed by the *angle* and all polygonal (or polyhedric) forms—while the circle and all *curved* lines and surfaces represent the continuous. Elementary algebra and arithmetics deal with the discontinuous, while integral calculus and its baby—analytic geometry—are based on the theory of continuity and has for its most widely used symbol the S curve. In nature, *crystals* represent discontinuity, while forms of *life*, plants as well as animals, seem to have the monopoly of continuity."[10] The eroded forms of inorganic substances— rocks, hills, and mountains—and the *pre-eroded* forms of organisms that move about in water (e.g., seals, dolphins, fish) or that evolve or move against continuous pressure (e.g., bones or wings) are of a sort also found in human artifacts of great sensual and symbolic significance.

If we take the cube and the sphere as examples of the two opposing archetypal forms referred to earlier, we discover that many eroded and pre-eroded forms *and* man-

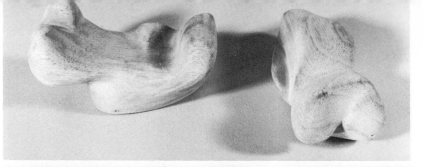

IV-9a

IV-9b

made forms of many types and functions are an amalgam of continuous and discontinuous surfaces. Wooden tools and implements (bowls, handles, and ladles), ceramic objects and stone artifacts (celts, banner stones, and other ceremonial objects, mortars and pestles) are made of both flat and curved planes. The abrupt, articulate planes of the cube create a strong contrast, resulting in a sharp break between light and shadow at each corner, whereas the curved surface of the sphere allows the eye to glide effortlessly from one area to another and modulates light and shadow broadly and evenly.

EX. 5

One could carve a piece of sculpture from plaster, marble, or wood that would demonstrate the appeal of a certain kind of form to both hand and eye. Balsa wood, because of its ease of carving, would serve well. Obtain a piece about 3 × 3 × 6 inches in size and carve it with pocketknife, cabinet rasp, and finally sandpaper in such a way as to provide a path for every movement the hand and fingers are able to perform. Create thick and thin parts, steep and gentle hills, and broad and narrow valleys. Make it possible for hands and fingers to pass without too much difficulty from one side of the form to another. The final piece may be varnished lightly to improve its surface [IV-9a, b].

EX. 6

Inasmuch as the form resulting from the above procedure is likely to be of as great an interest to the eye as to the sense of touch, it should be studied carefully and drawn on paper in a manner that has already been experienced to some extent. In EX. 2d, Part II, lines were used to create the effect of a fluid ground, a system of hills and valleys. These lines, pertaining to only one family of lines of maximum curvature, could be used alone or in conjunction with another family of isoclines, running in the opposite direction, to describe the rising and falling surfaces of any part of the carving.

Artists have often used modelling or shading to describe form, but these geodesic or orthogonal lines, used either strictly or loosely, may function effectively with or without shading. Indeed, one traditional type of shading used in drawings, engravings, and etchings is based on the orthogonal lattice: cross-hatching. The hatches follow the slopes of the form or surface in two directions.

Use pencil for this study so that many erasures may be made in the directional movement of each line as it caresses the form (see II-9). Bear in mind the experience of EX. IIh, Part II, where a kind of distortion was used in order to describe, as unambiguously as possible, forward and backward movement in the graphic image. Exaggerations are necessary in order that the true nature of the form

IV-10

may be revealed. Allow the lines to move closer together as they slide into the valleys and over the horizons of the form. Adjust the angle of their descent according to the steepness of the valleys.

One quickly exhausts the form of the sphere and the cube; they offer the same "information" on all sides. But a modified sphere or cube is capable of offering a variety of faces and profiles. It will keep the eye busy exploring its undulating surfaces, its "topography," and feeling out its internal dynamism. African, Egyptian, and ancient Mediterranean sculpture, and the works of such modern sculptors as Brancusi, Arp, Noguchi, and Wotruba, seldom depart very far from spheres, cubes, and cylinders. They ring endless changes on these geometric archetypes. An effective tension arises between these archetypes, as "norm bases," and the deviations from them.

Dynamic Shape/Form

For the sake of contrast, we now move to a kind of shape that bears little resemblance to geometric order. If it has order at all it is of a kinetic nature, and the single image is only one of a chain of metamorphoses. At some earlier phase, it might have lain as dormant as a seed or an embryo. But whether we conceive of shapes of this sort in a biological way, or look upon them simply as random happenings, is not important to our present purpose.

EX. 7

a● Take a wide hair or bristle brush and a generous supply of dark or black paint or India ink and put down, in the most free and spontaneous manner, several shapes of an active or unstable nature [**IV-10**]. Connect some or all of the shapes with broad lines or tendrils, if desired. Examine the results. If these marks are not considered sufficiently energetic or coherent, allow them to dry, tear or cut them into large and small pieces, and reassemble them in a totally different way. Allow the pieces to stand apart, touch, or overlap. Then paste them down on a new ground. Try to transform their relationship by improving their energy, at the same time strengthening their internal order [**IV-11**].

IV-11

IV-12

This study, like many others, may be carried out in three dimensions, incorporating actual as well as virtual space.

b● Take a piece of hardboard (masonite or plywood) of about 18 × 9 × ¼ inches, or a good, stiff cardboard of a smaller size. Paint it a light color on one side and a dark color or black on the other side. Then cut it jig-saw fashion (*not* as one would cut a pattern from a piece of cloth, afterwards throwing away the "scraps") in a variety of shapes, giving no particular thought to the shapes as such, except to make some large and others small. Reassemble the pieces edge to side, in a more or less perpendicular fashion, with a strong, fast-setting adhesive (perhaps adding a slower but stronger glue to the joints after the faster glue has dried). Try to achieve the greatest interest throughout the whole assemblage from all points of view. Make the design self-supporting without wasting pieces on a part that functions merely as a base. Finally, repaint certain areas of the dark sides with the lighter color and certain areas of the light sides with the dark color in order to create the greatest unity and continuance of movement—the eye's path in and around the form. These repainted areas may be shapes or directional lines tying elements together or providing sensory emphasis where needed. They may be

used to arouse a sense of anticipation and surprise in the observer as he moves from place to place, and to provide an experience of expanding and contracting proportions [**IV-12**].

We are reminded at all times of the co-existence of form (or shape), space, and movement. Even the blank paper or canvas becomes an arena for action once its perfect blankness is violated.

EX. 8

Perform one or two space-filling experiments by allowing the paint to feel its way outward, upward, or downward, like roots or tendrils into the white space of a large piece of paper [**IV-13a, b**]. Make broad planes behave in the manner of lines. Let them explore the space in all directions. They may resemble the major branches or roots of a tree, or the ribbons of a heavy liquid as they work their way downward through a glass of water. Make them appear to twist forward and backward as they describe circuitous paths through the white void. Use a medium to large, flat brush and free-flowing paint.

The Plane

Plane figure: a portion of a plane limited by lines either straight or curved. When the bounding lines are straight the figure is rectilinear. When they are curved the figure is curvilinear (Webster's New 20th Century Dictionary, 2nd ed.).

Plane: a surface more or less approximating to a geometrical plane (Webster's New International Dictionary, 2nd ed.).

These dictionary definitions of the plane are included in order to distinguish between shapes of organic and inorganic nature. The word itself suggests a geometric or inorganic figure, or a family of quadrilaterals or curved forms—squares, rectangles, rhomboids, trapezoids, triangles, geometrically

IV-13a

IV-13b

IV-14

IV-14 "Portrait of Émile Zola," by Edouard Manet. 1868. Louvre, Paris. (By permission of Photographie Giraudon, Paris.)

This portrait of the famous novelist, painted just over a hundred years ago, is a significant beginning of modern art. It serves as a lesson in modern art, in that Manet reveals, as though for our benefit, the nature and origins of the new vision. He has placed on the wall, to the left and to the right of Zola's head, two Japanese works: a vertical painting of landscape with bird, and a print of an actor. Note the almost total lack of shading in both the treatment of Zola and the Japanese actor, where we would in fact, expect no shading. Note the use of overlapping throughout the composition.

Manet has given us another "clue" in the reproduction of the early Velásquez painting in the upper-right corner. The evolution of Manet's realist style from traditional shading to a more flat, coloristic technique parallels, to some extent, the development of Velásquez' style, some two hundred years earlier. Overlapping the Velásquez is a reproduction of Manet's own "Olympia" of 1863, which caused an even greater disturbance than this painting of Zola (Zola had defended Manet's "Olympia" and "Luncheon on the Grass," 1863, against critical outrage).

curved surfaces, and figures of several classifications. They play an especially important part in all types of linear perspective (central perspective, isometric perspective, and so on), in Cubism, abstract and non-objective art (Constructivism and Neo-plasticism), architecture, and three-dimensional design. They impose special disciplines, whether used pictorially or three-dimensionally.[11] Normally, they are associated either with man-made or crystalline forms—those that reveal their structures clearly and openly. In drawing, the paper is the original geometric plane. It is made to give way to other planes inscribed upon it, some parallelling the surface, some tilting variously in depth, some overlapping, some creating subtle transparent effects. The development called Cubism (*ca.* 1907–1921) gave a new syntax and meaning to all of these planar functions; in those styles that sprang up in the wake of Cubism, planes, lines, and colors became the principal means of expression, often entirely independent of source.

Having defined the plane in rather strict Euclidean terms, we can afford now to refer to it in somewhat broader applications. The history of planes in modern art could start with the art of Edouard Manet (1832–1883), who transformed mid-century Realism, the Realism of Courbet, into something forward-looking and unique. Perhaps it was his interest in Japanese prints that led to his invention of a style called *peinture claire*, assisted, no doubt, by his keen appreciation of the technical innovations of Hals (*ca.* 1580–1666). Velásquez (1599–1660), and Goya (1746–1828). His characteristic paintings from about 1862 onward reveal a systematic elimination of traditional modelling (chiaroscuro), a steady lightening of both form and space, and a tendency to achieve depth by the overlapping of forms, as in

Japanese prints. These forms, because of their flatness, took on the characteristics of planes—anticipating the art of Matisse by at least 40 years. Manet and other artists of his time would learn more than this from Japanese prints; for example, they learned the use of rhythmical and structural lines, the use of a high angle of vision, and, in the case of Gauguin, the use of exotic decorative motifs.

Manet's overlapping forms treated flatly as planes are our main interest here. Examine an early painting—his "Portrait of Émile Zola" (1868) [**IV-14**]. The two Japanese works seen in the background offer both historical and technical clues. Japanese prints had been known to Manet and his friends since about 1856. An oriental shop specializing in prints and other imported items was opened in Paris in 1862. Then, by rare good fortune, the Japanese section of the 1867 World's Fair, held in Paris, provided all the excitement needed to hasten development of a new style.

If Japanese prints show no trace of modelling, Manet's Zola shows little enough—and this is only the beginning of his characteristic approach. Japanese prints exclude all unnecessary background information and create space by simple overlappings. Manet begins to do the same in this painting. Starting with the right leg overlapping the left leg, the right hand overlapping both leg and book, the book overlapping the books on the table, and they, in turn, overlapping the ink well and the assortment of papers, right through to the particular choice of prints mounted on the wall, one has all the evidence one needs of the arrival of a new pictorial discipline.

This new vision, this new way of realizing form and space, would not be lost on Manet's younger associates, the Impressionists, or on Cézanne, who, because of his deep

11] "Man is the animal that draws lines which he himself then stumbles over. In the whole pattern of civilization there have been two tendencies, one toward straight lines and rectangular patterns and one toward circular lines. There are reasons, mechanical and psychological, for both tendencies. Things made with straight lines fit well together and save space. And we can move easily—physically and mentally—around things made with round lines.
"But we were in a strait-jacket, having to accept one or the other, when often some intermediate form would be better."— *Plet Hein* [from Jim Hicks, "A Poet with a Slide Rule," LIFE Magazine, Oct. 14, 1966, p. 66].

instinct for form, would discover in Manet, and in the art of Corot (1796–1875) and Poussin (*ca.* 1593–1665), a visual language that included more than the "pure openness" and transiency of Impressionism. Cézanne used Impressionist color in the service of a richer pictorial structure. He found effective equivalents for trees, houses, boulders, fruit, bottles, and mountains; these were, in most instances, both frontal and tilting planes, large and small. His application of paint in shingle-like strokes, a refinement of his pre-Impressionist use of the palette knife, was his way of constructing form and space alliances from the smallest unit, the plane of the brush stroke itself, to the larger form—a method he preferred to call "modulation" rather than modelling. Whether stated abruptly or subtly, minutely or broadly, his basic structural element was the color plane. In his use of it, whether in portraits, land- scapes, or still-lifes, he never lost touch with the underlying abstract features, the geo- metric archetypes—cubes, spheres, cylinders, and cones.

The color plane, starting with the individual brush stroke, would incite the interest of Matisse and his friends, the Fauves, Derain, Vlaminck, Dufy, and others, and, somewhat later, the Cubists, Picasso and Braque (though Braque was a Fauvist before be- comining a Cubist). The latter two at first showed less interest in color-plane problems than in the plane itself as a means of an- alyzing form—form on its own and in a space- time context. They reduced the plane to a near-geometric element in greys, earth colors, dull blues and greens in order to reconstruct form pictorially from several angles of vision (Analytical Cubism, 1907– 1911). Here again, Cézanne's insistence on presenting the object from several points

of view—from the front, sides, and top, simultaneously—established an important precedent. These liberties, amounting to a kind of distortion, were one of his most valuable legacies, ranking in importance alongside his use of open and closed struc- ture. They demonstrated that the artist need not merely copy nature, but can recreate and transform the image according to his need. Cézanne's paintings suggested not only a new visual grammar, but a new syntax that would develop through more than one stage in the Cubism of Picasso, Braque, and others [**P-8**]. They would extend their seminal influence through Cubism to architecture, sculpture, and design. The color plane, broadly extended, the transparent plane, and the concept and use of discontinuity and juxtaposition[12] would characterize the visual language of the twentieth century.

An infinite number of experiments could be devised for the study of planes in both two- and three-dimensional contexts. At some point, however, planes should be examined in their simplest relationships. By going back as often as possible to basic articulations, one may learn to avoid a purely decorative design, or one that lacks integral structure.

Planar articulation is not too different from linear articulation, except that the plane asserts itself in two directions instead of one. EX. 6, Part II, will serve as background to the following experiments. Planes, like lines, are capable of bisecting, intersecting, and overlapping one another at various points and various angles, or may stand apart in an "open" relationship. In addition, planes may overlap in both opaque and transparent relationships; this gives them an advantage over line. They have greater architectonic possibilities, especially in their ability to interpenetrate each other.

12] See Roger Shattuck, *The Banquet Years* (Garden City, New York: Anchor Books, Doubleday & Com- pany, Inc., 1961), pp. 332– 51.

P-8

P-8 Pablo Picasso. "Dog and Cock." 1921. Oil painting, 61 × 30¼ inches. Yale University Art Gallery, gift of Stephen Carlton Clark. The second phase of Cubism, called Synthetic Cubism, which started in about the year 1912 with the use of pasted paper, or *collage*, reached some sort of perfection in 1921 in paintings such as this one. Picasso used the color-plane, without suppressing natural images, to create a number of paintings that can be described as classic in their high degree of order, integrity, and intensity. From the point of view of color, this composition is based, first, on contrast of value, and, second, on contrast of hue. Values range from pure black through a number of greys and colors in dark, middle, and light registers to white. These achromatic values and colors are organized in groups or complexes. Within these complexes, each value or color or each area takes its place forward or backward in depth in a disciplined manner. Placement, recurrence, overlapping, interlocking, and patterning affect the spatial position of each portion.

The complexes function as follows: A reddish complex moves in from the right side and from the bottom in the same direction as the dog's head. It reaches a minor climax in the crimson of the dog's tongue, but culminates finally in the pure spectrum red of the cock's comb.

A grey complex moves in from the left and terminates at an advanced position in the point pattern of the newspaper lying beneath the five black and white pieces of fruit and their yellow and green wrapping (?). Without the patterning of this area—irregular points serving as equivalents for type—this area would not hold its proper position. Bold patterns or textures tend to play to the fore.

A yellow complex rises diagonally from the dog's feet to the broken yellow corner to the right of the dull green bottle. It achieves a moderate chromatic climax in the three yellow areas touching the fruit.

A small green complex connects the areas surrounding the fruit with the ghostly, green bird-bottle, thus continuing the thrust of the right leg of the table.

A black complex includes the dog, parts of the cock, and the shadow sides of the fruit.

A white complex links table to eyes and fringes of hair of the dog, to fruit, to fruit compote.

Finally, a blue shaft, an equivalent of sky and the brilliant day, strikes downward from the upper left, and, as it does, jumps forward to touch the dead cock and the edge of the yellow wrapping paper (?), and backward again between the legs of the dog and the table.

The composition divides horizontally through Picasso's signature and the upper edge of the newspaper, and, again, through the tip of the dog's tail, the eye of the cock, and the edge of the table (see P-2). It divides vertically along the left leg of the table, through the cock's eye and body and through the compote. It also divides vertically, again, through the right leg of the table, through the truncated wedgeshape at the top of the newspaper and along the right side of the bottle.

EX. 9

Take a piece of veneer or matt board about 1½ or 2 inches wide, or less, dip it into India ink or water paint that is neither too thick nor too thin, and drag it at various angles across smooth paper. Study the results. Supplement these flat planes with planes made picket-fence fashion by stamping with the edge of the cardboard, as in EX. 1c, Part II. Then combine both types of planes and some that are made entirely by outlining in a design where elements tilt and fluctuate inwardly and outwardly. Some of the planes may be cut from opaque or transparent paper, in which case certain transparent effects may be achieved by overlapping, one medium being superimposed on another. Free experimentation may follow and planes may be articulated in as many ways as possible, as long as structural coherence is not lost sight of entirely.

IV-15

IV-15 Left: a square divided into a tangram. Right: a tangram of the same size as the one to the left transformed into one of an infinite number of designs.

In his book, *The Thinking Eye*,[13] Paul Klee illustrates what happens to a line or geometric figure on a regular grid after the lines of the grid have become somewhat displaced. In another illustration, he shows what happens to the regular projective relationships themselves—the flat, identical sections of the grid—when the grid is wrenched out of shape. Each section is converted into some kind of trapezoid or an occasional rhomboid, and, by the law of obliquity, the whole grid is turned into a rhythmically distorted structure with all manner of inward-outward projections.

The fluctuating planar structures in Section III of Josef Albers' book, *Despite Straight Line*,[14] are based primarily on the principle of obliquity. They have much the same fascination as crystals, and bear at least superficial resemblance to a Chinese game known as the *tangram*.

The tangram

The tangram consists of a square that is divided into seven pieces, or "tans": five triangles, large, medium, and small, a square, and a rhombus. These may be arranged in any way to make any kind of image or pattern [**IV-15**]. The value of this game, aside from that of good entertainment, is the way it trains the eye to appreciate the special virtues of working with limited means. "Further, the game helps to sharpen the powers of observation through the discovery of resemblances between geometric and natural forms. It helps the student to abstract: to see the triangle, for example, as a face, a tree, an eye, a nose, depending on the context in which the pieces are arranged. Such observation is essential in the study of visual symbols."[15]

13] Paul Klee, *The Thinking Eye* (New York: Geo. Wittenborn, 1961), pp. 252 and 255.

14] Josef Albers, *Despite Straight Line* (New Haven and London: Yale University Press, 1961).

15] Paul Rand, "Design and the Play Instinct," in *Education of Vision*, Vision + Value Series, ed. G. Kepes (New York: George Braziller, 1965), p. 159.

Pure Plane Experiments

EX. 10

a● Pure plane experiments could start with pieces of heavy poster paper, illustration board, or cardboard of a uniform size, e.g., 2 × 2 inches, by means of which basic relationships could be demonstrated clearly and effectively. Two colors, light and dark, on alternate sides of each plane could be used to add an extra note of contrast.

Relate two, then three, then perhaps four to six (or even more) planes to each other in as many ways as possible, starting with simple articulations —bisecting and intersecting relationships—and proceeding to more complex arrangements of both structural and rhythmical interest. In the latter developments, ¼-inch strips of balsa wood may be used as supports, if necessary.

Other plane studies may be made of paper alone, or of paper and cardboard combined. (Useful information on folded paper techniques may be found in a well-illustrated book[16] by Pauline Johnson.) Some could combine balsa wood or cardboard panels and paper of one or more colors in the following manner.

b● Start with a basic module in the shape of a panel of balsa or cardboard measuring approximately 3 × 6 inches. Attach other pieces of balsa or cardboard to this in any direction desired, bearing in mind that these attachments and the panel itself will serve as supports for both flat and curved planes of paper. Similarly, wooden supports of various sizes and shapes—straight and curved— may be covered with primed or unprimed canvas or cotton duck and painted in simple planar patterns with two or more colors. Such a design could be free-standing, or could project from a flat ground and involve a controlled play between form and space, both virtual and actual.

c● One could also cast a rectangular block of plaster, as in EX. 4a, above (this time using a quart milk carton as a mould), and use this for carving a design consisting entirely of flat and curved planes. It could be carved on one side only, in high and low relief. Several pieces (each measuring approximately 3 × 3 × 6 inches) could be placed side by side to form a larger composite design.

d● For a third study, one could start with an aluminum, tin, or brass panel of about 4 × 13 inches and cut and bend it in a variety of ways, taking care not to cut it unduly, or to cut away any part of it, or to cut it in such a way as to weaken it, the idea being to transform the two-dimensional plane immediately into a three-dimensional design of the greatest interest from all angles of vision. Operating paradoxically in the contrary direction is the flat strip of paper which, if given a half twist and connected end to end, will form a Möbius strip which is one-sided! See

IV-16 A relief design of tilting planes, made of cardboard and corrugated paper painted black and white.

IV-16

Mathematics (LIFE Science Library), 182–83, and works by Swiss artist Max Bill.[17]

Other structures could grow out of previous two-dimensional studies, e.g., EX. 9 above [**IV-16**].

Shape and Plane Developments

It would be useful at this point to go back to the first studies in "Rediscovery of Color" and examine them for qualities that might have been overlooked at the time they were done. Perhaps it was enough then to have discovered the physical qualities of pigments and colored objects, without going very deeply into their psychological consequence. It takes a great deal more experience of color, as we have seen, to appreciate fully such factors as warm and cool contrast, complementary contrast, clash, the various types of color interaction, and so on. It takes still more time and experience to understand and utilize efficiently, in even the simplest design, the spatial dynamics of color—color as area and, simultaneously, as depth, i.e., color as *color-space*. Here is where most principles pertaining to the use of color converge. Our admiration for great colorists like van Gogh, Matisse, Bonnard, Léger, Klee, Albers, and Motherwell (contrast of value and contrast of extension[18]) increases with this insight.

Re-examine the swatches of color of similar hue and those of dissimilar hue for their tendency to spread or contract, and to advance and recede. Turn them upside down or to one side or another to see if position has anything to do with their spatio-plastic behavior.

EX. 11

The following studies have to do with shape and plane development; in many of them, color and texture will play a decisive role. Textures may be both actual and simulated, rough and smooth, hard and soft, as seen in the assemblages. It will probably have already been observed that, in most circumstances, rough textures tend to advance and smooth surfaces to recede.

a● One could start with concordant or sympathetic shapes of an inorganic nature. Two would be enough to manage at the beginning. They could be cut from paper so that they can be manipulated freely in various ways. They could be allowed to touch, overlap, and stand apart at different positions and distances, each relationship being examined carefully for such psychological qualities as attraction and repulsion, vertical and horizontal balance, and advancing and receding action. These qualities are apt to be more apparent if the two shapes are of different sizes and colors or values, or of different textures.

Warm colors often seem comparatively near and large; they "spread." Yellow spreads more than orange or red. The cool colors tend, in most situations, to withdraw, to appear both smaller and more distant. Greys tend to retract. Black, however, usually maintains almost as strong a forward position as white. But here and elsewhere, color and value contrast, hard and soft edges, and other figure-ground factors are influential, often in unpredictable ways. We have learned to anticipate the sly transformations caused by color interaction. Hard-edge shapes may become soft-edge shapes, depending on the nature of the inner and outer colors. Proportion, placement (high or low, left or right), and density are also important factors. As if these were not enough, the eccentric and concentric energies of colors and their spatial position are greatly affected by the kind of shapes they occupy—whether rounded or pointed, broad or narrow, and so on. The

16] Pauline Johnson, *Creating With Paper* (Seattle: University of Washington Press, 1958).

17] Margit Staber, *Max Bill*, Art in Progress Series (London: Methuen and Co. Ltd., 1964).

18] "Color is a question of quantity, i.e., extension in space."—R. Motherwell.

IV-17a

IV-17b

IV-17a and b (a) Sasanian stucco medallion with boar's head, from Damghan. (In the collection of the Archeological Museum, Tehran.) (b) Sansanian textile with boar's head motif. (By permission of the Museum for Central Asian Antiquities, New Delhi.) These two Sansanian designs of a boar's head illustrate the degree to which the medium may influence the working out of an idea. The stucco medallion (a) is relatively realistic in treatment, but the marvelous textile design (b) antedating Picasso by about 1500 years (see P-8, "Dog and Cock" by Picasso, the head of either the dog or the cock, or any one of Picasso's drawings of heads for his "Guernica"), is probably the result of an inspired response to the technical demands of weaving.

"color game" seems to resemble a game of chess, except that rules apply much more strictly to chess than they could ever apply to color. (A game of sorts could be based on these observations. Place a number of planes of the same size and shape but of different colors side by side. Examine them carefully and determine their *apparent* discrepancies of size and spatial position. Then, using the same number of planes and the same colors, expand or contract the sizes of the planes so that they *seem* to match the known, *factual* size of the original planes. Obviously, any change of color or value in the ground against which these planes are seen will alter their apparent size and position in depth.)

Geometric shapes or planes may share the same edge, may "hinge" on each other to create cubic articulations or stepwise movements in depth. Solid planes may be used with open, linear planes, overlapping, touching, or separated. The latter do not have to be defined on all four sides; two edges are sufficient to define a plane and its direction. Even one line can suggest a transparent plane having both horizontal and vertical axes. Basically, there are only two types of spatial planes: those that lie parallel to the pictorial surface, and those that move

IV-18 Open and closed structure. A few simple examples of closed structure on the left, with complementary examples of open structure on the right. Closed structure is characterized by firm, unbroken edges or surfaces. Open structure is characterized by interrupted, discontinuous, "soft" edges or surfaces admitting much form and space transaction. Or, as in the third example on the right, line and color or value are pulled apart and allowed to function somewhat independently and in different relationships to the ground (see works by Matisse and Dufy, and Cubist works by Picasso, Braque, Gris, Léger, and Motherwell, e.g., his "Western Air," 1946–47).

19] Gyorgy Kepes, *The Language of Vision* (Chicago: Paul Theobald, 1948), p. 77.
20] Shattuck, *The Banquet Years*, p. 347.
21] See André Lhote, *Treatise on Landscape Painting* and *Figure Painting* (London: A. Zwemmer, 1950, 1953).

obliquely to the picture plane. Whether solid, open, or transparent, planes are capable of activating the space around them, of setting up currents of movement and tensions in all directions.

Planes of transparent paper or cellophane may be used exclusively or with opaque planes, or an effect of transparency may be created by allowing one solid shape to overlap another and then adjusting the color and value of the median area according to one's wishes, i.e., whether the overlapping will seem to be achieved by one plane or the other, or whether there will be an effect of mutual penetration. This effect of mutual penetration is of particular interest to us today, for the significance of interpenetration, simultaneity, inside-outside extends to almost every human activity. As Gyorgy Kepes states, "Transparency . . . implies more than an optical characteristic; it implies a broader spatial order. Transparency means a simultaneous perception of different spatial locations. Space not only recedes but fluctuates in a continuous activity. . . . Today there are hardly any aspects of human endeavor where the concept of interpenetration as a device of integration is not in focus. Technology, philosophy and physical science are using it as a guiding principle. So do literature, painting, architecture, motion picture and photography, and stage design."[19]

One of the most important contributions to "a new kind of coherence, a new unity of experience,"[20] is seen in the second development of Cubism, often referred to as Synthetic Cubism *(ca. 1912–1921)*. All of the plastic energies liberated by the earlier phase, where objects were submitted to the most rigorous analysis, were now reorganized, compressed, and interwoven [**IV-17a, b**]. Color was allowed once again to assume an

important role in the over-all plastic ensemble. Broad color planes were allowed to pass in and out of form and space in an extension of the idea of open structure and bridge-passage.[21] Images were reduced to their most essential structures [**IV-18**].

IV-18

IV-20b

IV-19

IV-20a

IV-19 Two similar organic shapes (warped circles) in a definite format. The problem was to activate and unify the entire area.

IV-20 Compositions with two dissimilar shapes.

b● After experimenting with shapes of an inorganic nature, try two or more shapes of an organic nature [IV-19]. They will require a somewhat different articulation from the curved or flat geometric planes. But, again, play around with touching, balancing, and overlapping relationships. Allow one shape to lie within another. Look for contrast of size, color, texture, placement, and axial orientation.

c● Then try placing together two or more shapes that pertain to two dissimilar categories, i.e., two or more complementary shapes [IV-20a-d]. In the previous studies, a certain degree of harmony was present from the outset in the shapes themselves; they shared a distinct family resemblance. But in this study, harmony must be discovered in the way shapes are related to each other and to their mutual environment. This is a more difficult undertaking, calling for a more sensitive and instinctive feeling for balance and unity. These inharmonic shapes must find their place and resolve their differences in a larger plastic unity.

Some or all of these experiments in the use of harmonic and inharmonic shapes may be carried out three-dimensionally in the form of a relief construction, where shapes will not only relate to each other as area but also relate to each other at different levels. Cardboard, poster paper, construction paper, and corrugated paper may be used throughout the design [IV-21a, b].

d● A conflict of opposites may inhere in single shapes which represent a hybridization of two generic types. Each would have some organic and some inorganic feature, either by addition or subtraction. Each would belong to both the family of curves and the family of straight lines and angles.

e● An arrangement could be made of several of these in either an open or delimited field where the most effective results would be obtained from a kind of mutual contrast. Two or more colors could be used.

But shapes or forms do not have to be an uneasy blend of two opposing species. They

IV-20c

IV-21a

IV-20d

IV-21b

may resemble forms in nature in which parts differ because of function, but grow out of each other inevitably and harmoniously. Examine, for instance, the sprouting seed or the metamorphosis of the butterfly from egg, to larva, to pupa, to fly. Examine the skeletal, digestive, or reproductive systems of any fairly large organism, or the simpler structures of microscopic plants or animals. Re-examine the more familiar forms of flowers, vegetables, and fruits, of tools, toys, clothes, and other human artifacts.[22] Both a formal and a psychological investigation of a common object—such as a chair—could profitably take the form of a series of drawings. Each drawing would be about some aspect of the object, and, because the object is so familiar, each drawing could be a play upon positive and negative (figure-ground) relationships and upon ease or difficulty of recognition. The latter would involve the student in a search for those parts and details in which the greatest psychological interest is concentrated (the seat, perhaps, in the case of the chair—see Part VI) [**IV-23**].

f• Create several compound shapes, i.e., shapes made of several organic and/or inorganic shapes, which are the results of a significant and agreeable coming together of various formal ingredients. Give special attention to shapes that appear to twist and turn in depth, even though they may exist, like other shapes, simply as silhouettes [**IV-24a, b**].

g• The same study may be carried out three-dimensionally in plaster by joining similar or contrasting forms. Cubic forms may be cast as in EX. 4a, and organic forms may be cast in large sausage-shape balloons made of thick rubber. Loose, freshly-mixed plaster may be funnelled into the prestretched balloons and, as it starts to harden, squeezed or pressed into a variety of bio-

E S S A Y O N S C U L P T U R E 1 9 6 4

arc	
arch	plane
aisle	hull
bridge	oar
bench	lens
ball	plank
bin	square
beam	range
booth	line
flange	peg
cairn	mast
bell	ridge
cam	stance
cone	scale
chair	pole
groove	pit
chord	pyre
crux	spike
cog	strake
dike	spine
crypt	rack
ground	rib
depth	rail
disk	spire
cup	throat
dome	spool
ditch	roof
height	rim
field	room
door	stair
hub	throne
edge	stake
floor	sill
length	rod
frame	slab
gate	stile
keg	trench
grid	stool
joint	slot
source	sun
mound	tomb
hill	truss
log	trough
hole	waist
notch	wall
sphere	urn

IV-22 A poem by the sculptor, Carl Andre. Reprinted by permission of Mr. Andre and *Art in America* (see footnote 22).

IV-23 So powerful, as a psychological center, is the seat of a chair that when the normal seat is replaced, as it is here, by that of a motorcycle, the result is almost alarming. The whole chair seems to undergo a change: its gender from feminine (*la chaise, la silla*) to masculine; its character from passivity to aggressiveness. This piece could be placed in any exhibition of Dada or Surrealist objects, where similar incongruities jolt the viewer out of old, routine responses.

IV-22

IV-24a

IV-24b

22] A poem **[IV-22]** by sculptor Carl Andre [first published in an article by Barbara Rose, "ABC Art," *Art in America*, Vol. 53, No. 5 (October-November 1965), 67], consists of an anthology of short, trim words of common usage that ring with the same hardness of structures to which they refer—ingenious, tectonic structures, in most instances.
Forms in Japan by Yuichiro Kojiro, with splendid photographs by Yukio Futagawa (Honolulu: East-West Center Press, 1965), presents and elaborates upon a few of these and other forms—Forms of Unity, Forms of Force, Forms of Adaptation, Forms of Change, extending to numerous, imaginative subcategories.

morphic forms. One could create more forms by pouring plaster into rubber, paper, or plastic containers—paper and plastic bags and cartons, folded cardboard or corrugated paper, rubber balls, and inner-tubes. These forms could then be altered, additively or subtractively, and joined directly to other forms with more plaster (if the forms have been allowed to dry out, wet them thoroughly before adding fresh plaster).

We are reminded of the inventions of Jean Arp—shapes and forms that are the products of a sensibility acutely attuned to natural phenomena, to the laws of growth, as well as to the "laws of chance," as he calls them. In much of his work, free association and humor have also been allowed to enter the creative process. Humor, poetic imagination, intelligence, economy of means, and faultless craftsmanship have come together in a splendid unity.

IV-23

IV-25

IV-27

Figure-Ground Studies [IV-25]

The concluding studies in this part are arranged with the idea of providing some experience not only in the relationship of figure to ground, but of figure to ground in cricumstances that encourage invention. Therefore it is hoped that these and the nature studies that follow in Part V will demonstrate the importance of source. Invention consists in finding poetic-plastic equivalents for thoughts, feelings, and sensory experiences and it continues, in one way or another, to the end of each creative undertaking. Without a grounding in source, this activity cannot be expected to develop in diversity, depth, and authority. The student will want to return again and again to even the most humble ideas, objects, or motifs. He must also be able to recognize both structural and expressive potentialities in all kinds of material and have the ingenuity to translate these into surprising images.

EX. 12

Vertical balance

a● The first study is a simple one that has to do entirely with vertical balance. It brings into play the kind of kinesthetic tensions one feels while watching a difficult balancing act at the circus. It elicits a feeling of suspense ("Will the next one succeed or will he or it bring the whole structure down to earth in a chaotic heap?"). A subtle adjustment of weights and energies across the vertical pull of gravity must result in a static-dynamic synthesis at all times. There must be maintained at every moment an "asymmetrical oscillation, wholly subservient neither to gravity (static) nor to momentum (dynamic)" [IV-26].[23]

This experiment may be made with pieces of torn paper, the greater the variety of size and shape the better. Arrange six or eight shapes above each other, with attention to movement and counter-movement. Take full advantage of major and minor axial thrusts in each piece. Draw these axes in, if you wish. They will help to clarify the

23] Klee, *The Thinking Eye*, p. 389.

IV-25 "Two Ravens," by Bryan Wilson. 1964. Oil painting, 46 × 48 inches. The artist, in addition to "capturing" the expressive attitudes of the birds in two bold silhouettes, has related shape to space—positive to negative—with rare simplicity and vigor. (Photograph courtesy The Alan Gallery, New York. Reproduced by permission of Lawrence Bloedel, Williamstown, Mass.)

IV-26

system of checks and balances throughout the precarious arrangement.

We discovered in Part III that it is impossible to divorce a color from the ground around it, whether the ground be another color or simply a neutral white, black, or grey. They effect each other mutually. Similarly, shape and ground must be considered equally if they are to share a lively existence. Each must be the condition for the reality, the vitality of the other.

Figure-ground reversal

Normally, a smaller area tends to be the figure, but when the two areas, figure and ground, begin to approach equal size and balance, the relationship starts to become unstable, requiring continual reorganization of the visual field [**IV-27**]. The focus of the eye will alternate between figure seen as ground and ground seen as figure in positive-negative reversal.

b● Create a free design or composition of one or more shapes of any type in which shape and space, figure and ground, may be "read" interchangeably. These images may be realized in paint or in areas cut from black and white paper.

Artists have always been aware of the relationship of positive areas to negative areas in a design or painting, but none has demonstrated more eloquently the interplay of solids and voids than did the ancient Greek vase painters and certain modern artists, notably Matisse, Picasso, and Braque. Matisse, in his designs made of cut paper, and Picasso and Braque, in their drawings, prints, and paintings, encourage the observer to look with almost as much interest to the

IV-28 Georges Seurat. "Seated Boy with Straw Hat." 1882. Conté crayon drawing, 9½ × 12¼ inches. Yale University Art Gallery, purchased through the Everett V. Meeks Fund.

Robert L. Herbert, on page 56 of his book, *Seurat's Drawings* (Plainview, N.Y.: Shorewood Press, 1962) makes the following remarks: "Running through most of Seurat's early mature drawings is a special kind of chiaroscuro which he called 'irradiation'. This is the concept, which can easily be verified in the observation of the natural world, that light and dark tones mutually exalt each other as they come together." Leonardo, he says, had extolled the virtues of this kind of contrast, and writers like Charles Blanc, Chevreul, and Rood, whose color theories Seurat respected, had explained the phenomenon clearly. The drawing, "Seated Boy with Straw Hat," one of several studies for the painting, "Bathers" (1883–84), illustrates more than one kind of 'irradiation': the dark values of back, chest, and face against the lighter background, and the "simultaneous contrast shading" of hat, arms, and legs. In each of the latter, there is dark (inner) opposing light (outer) on one side, and light (inner) opposing dark (outer) on the other side. Then, in the more conventionally shaded areas—in the cast shadows along the ground—there is open transaction between form and space, disallowed in other parts.

"shape" of the background intervals as he does to the figures themselves. He is almost forced to participate in the tension between one area and another. Many Cubist works challenge the observer to a game of simultaneity, forcing him to oscillate between one or another way of seeing an image. Braque would present both the front view and the profile of a face in one and the same shape. In order to see it, the eye must focus first on one, then on the other aspect. It cannot focus clearly on both at the same instant.

Endotopic-exotopic treatment

Some mention was made in Part III about a type of shading that Leonardo seems to have originated. We find it in most of his drawings and sketches. It was a type that had little to do with the play of light—directional light—and strong shadows, even though it would lead to the rich, theatrical illumination of Baroque paintings a century or more later. It is sometimes aptly described by the Italian word *sfumato* (as though "blended" or partially dissolved). Indeed, it is as though Leonardo wanted to locate his forms, whether near or far, in an environment filled with a soft light, in contrast to the vacuum-like space of earlier works. This device and others that sprang from his inventive mind helped to establish a tradition that continued well into the second half of the nineteenth century. But by the time the Impressionist revolution had reached maturity in the 1880's, another pictorial order was seen to be emerging. An attempt was being made to bring about a more intimate relationship of form to space, and of each to the picture surface. If Seurat's Divisionist technique is the most instantly recognizable feature of his art, his most elusive and least expected

device is a kind of shading one would hope to discover somewhere in the works of Leonardo. It also owes little to directional light and cast shadows; but, for all that, it differs in most instances from Leonardo's usual method and purpose. This is the simultaneous contrast shading described earlier (Seurat referred to it as "irradiation" [IV-28]. It, and other elements found in the drawings and paintings of Cézanne (open and closed structure, multiple perspective, axial tilting),[24] would be adopted by Picasso and Braque in their first Cubist paintings (i.e., in Analytical Cubism). Form-space articulations would be pushed to a degree hitherto unimagined. Both the interior and exterior contours of form would be analyzed and reduced to precise flat and curved planes. These would then be treated according to Seurat's simultaneous contrast shading in somewhat the following manner.

If two adjacent parallel planes are graduated in opposite directions, from dark to light, they will share one area where all differences of value are minimized or dissolved. This is an area of bridge-passage, a fluid middle ground; important though it be in a drawing or a painting, no matter how it is achieved, it usually goes unnoticed. It is that part of a work that provides respiration and subtle transaction between form and form and form and space.

Paul Klee attached a great deal of importance to this method, and referred to it as "endotopic and exotopic treatment." Characteristically, he made both plastic and poetic use of it. Functionally, it provided a way of creating forward and backward movements on the picture plane, inasmuch as forms shaded from without (exotopically) tend to move to the fore, while forms shaded from within (endotopically) tend to move to

24] See Erle Loran, *Cézanne's Composition: Analysis of His Form with Diagrams and Photographs of His Motifs* (2nd ed; Berkeley: University of California Press, 1959).

the rear. The simultaneous treatment of both inside and outside—inner and outer energies—leads to the important concept of interpenetration. This in itself is enough to recommend it to many artists who have no use for the conventional type of shading.

c● Create a design in which certain areas are treated endotopically and others exotopically [**IV-29a, b**]. Allow some areas to strike a compromise between these by treating them both from within and from without along different boundaries. One could start this design with a curved or angular line that described several areas by doubling back upon itself, or one could create much the same pattern with a string, gluing it to paper once its figure has been determined. Following this, shading could be achieved with charcoal or conté, or with pen, pencil, or brush by means of hatching.

Hard and soft edges

Hard and soft edges also influence the disposition of a shape in space. Hard edges tend to cut the shape away from the ground, causing it to assume a forward position, as though overlapping the ground physically. Soft edges tend to yield to the ground and the space around them in perhaps a more feminine way; they establish a more open relationship. But there are situations in which very closely related colors and values, which normally glide in and out of each other with ease, require the use of hard-edge shapes for purely structural reasons. Without them, the design would break down into mere atmospheric effects. Ben Nicholson, the English artist, has created an art that hovers between pure geometry and pure atmospherics. The controlling factor is the hard edge of most of his images. They "shore up" the delicate whites, blues, and other tints, and make them play a more definite role in the composition.

IV-29a

d● Try several experiments with pastel or conté crayons on various colored grounds—and some with white on black and black on white—in which hard and soft shapes vie with each other for dominance and position. Look for colored pastels that have a tantalizingly close relationship to the ground, in value if not in color. Use them in both hard and soft shapes in contrast to colors that stand out in bold relief against the background. Make use of some shapes that have both hard and soft edges.

Camouflage

These figure-ground studies will remind one of camouflage in nature. Nature and art seem to meet on curiously equal terms in this area, in the sense that both presuppose the phenomenon of vision. Predatory animals and insects must blend with their natural backgrounds in order to catch, and other

25] Adolf Portmann, *Animal Camouflage* (Ann Arbor: The University of Michigan Press, 1959), p. 9.
26] See LIFE Nature Library (New York: Time Inc.): *The Fishes, The Insects, Ecology, The Earth*, etc.; see also S. Tolansky, *Optical Illusions* (New York: Pergamon Press Inc., 1964).

IV-29b

less aggressive creatures must merge with their environment in order to keep from being caught. "Camouflage implies a seeing eye from which to hide."[25] The new science of ecology has shown to what an extent nature will go to alter the shape and appearance of living things in order to prepare them for the battle of survival. Her ingenuity is endless. It is almost as though she takes a special delight in some of her "inventions"; for example, the insect that looks like a leaf or twig, or the fish that takes on the coloring and weedlike appearance of the area where it lurks in ambush for smaller fish.[26]

e● The student may wish to pursue the problem of camouflage in his own way. He may resort to the use of lines, spots, stripes, and other "markings," both inside and outside the figure. He may also decide to use ragged, interrupted, or repeated outlines to soften the transition from figure to ground—to make the figure "play out" gradually into its environment.

Active and passive shape and ground

Disguise ("cryptic coloration") is only one aspect of nature's optical trickery. At the opposite extreme is display ("warning coloration"), and frequently the same bird or insect can alternate almost immediately between concealment and exhibitionism, hiding its brilliant patterns one moment and flaunting them the next.

Similarly in art, shapes and forms may be displayed against a ground that is the very opposite of their nature. An active shape may be placed on a passive ground or a passive shape on an active ground. Either is an example of maximum figure-ground contrast, especially if bold patterns and bold contrasts of color or value are used. The effect is of strong dissonance, with important spatial

significance. An active shape on a passive ground can be expected to advance. The more active it is in comparison with other shapes, the more it will push to the fore. A passive shape on an active or roughly textured ground will appear to retreat to a position *behind* the ground, creating a strange void.

f• Create a design in which an active shape is related to a passive though not necessarily neutral ground. Then create another design of the opposite nature. The shapes may be painted or cut from construction paper, or both shape and ground in either design may be taken, in whole or in part, from magazines, newspapers, or other printed matter.

An active shape means one made of acute angles, amplitudes, or pressure points, or that reaches outward aggressively into space. Passive shape means one that turns inward upon itself, like a hibernating animal. An active ground may simply be one that differs in any way from a blank surface, though normally one expects it to contain a pattern of points, lines, smaller shapes, or textures.

A development on found images

g• The search for shape or form in magazines, newspapers, and other expendable items of daily use may be continued. Collect as varied an assortment of objects as possible, both flat and three-dimensional—photographic reproductions, letters and numbers (large and small), corrugated paper, cardboard and other paper products of many patterns and textures, colored cellophane, printed fabrics, textiles, wooden objects, plastics and other scraps—and examine them for visual motifs. Study the way they assert themselves formally, physically, or as images of psychological or esthetic interest. Alter them in any way, additively or subtractively. Combine them with each other. Paint out, draw, or paint around or across any part of them. Play one kind of image against another—flat against illusionistic, two-dimensional against three-dimensional, bold against weak, chromatic against achromatic. Try them against different grounds. Cut certain photographic images in strips and spread the segments so as to enhance their implied movement. Cut or tear other images and displace the fragments in such a way as to strengthen their dynamic, structural, and expressive qualities. Give special attention to scale or "psychological size" of objects (i.e., those aspects that surpass their normal, measurable size).

Pattern and process

Passive and active or stable and unstable shapes may be taken up in another problem that involves constancy and change. A passive shape that is submitted to internal or external forces will tend either to mutate, divide, or disintegrate, depending on whether the process be slow or fast. Whatever the nature of the drama may be, it is possible to treat the action diagrammatically as an uninterrupted sequence of patterns or as discontinuous "form-events." The study of motion—the movement of water, the flight of birds—was undertaken by Leonardo with as much seriousness as he devoted to anatomy and geology. He was the first to investigate scientifically the function of wings (aerodynamics). His sketchbooks contain several drawings of birds in which the beating of wings has been presented as a comprehensible sequence of "stills." More often than not, the movements and changes that take place around us are either so rapid (the movement of insects and animals) or so slow (the growth of plants) that they are impossible to grasp

with the unaided eye. This is why one of
Leonardo's favorite subjects had to await the
present age for further experimental study.
Both mechanized movement and the technical
means of studying movement of all types
("tools of observation") had to follow the
scientific and industrial developments of the
past two centuries.

Étienne Jules Marey (1830–1904) was the
first of a number of men to occupy themselves
with the "central concept of our epoch:
Movement," and to devise ways of recording
it in all its forms. At the start of his career,
he devised a way of recording the human
pulse. In his last studies, in 1900, he found a
way of registering the flow of air on a sensi-
tized plate. This represented a development
stemming from Marey's graphic portrayal of
movement on a smoke-blackened cylinder
in the 1860's to his photographic portrayal of
the "true form of movement" in space by
1890. His two- and three-dimensional studies
of flying birds in 1885 carried forward the
work begun by Leonardo over 300 years
earlier. His means was, of course, the camera,
one of the most valuable inventions of the
first half of the nineteenth century, which, by
the end of the century, had become some-
thing more than a novelty.

The camera—both the still camera and the
motion picture camera—has extended
enormously our vision and grasp of those
forms and movements which, for one reason
or another, escape the naked eye. It continues
to provide a repertory of images, available
to almost everyone, exceeding many times
over the visual range of former times. Sud-
denly we find ourselves with almost too much
optical experience and information to cope
with. We must digest some or all of it both
intellectually and emotionally and turn it to
some good in art, architecture, and the total

IV-30a

IV-30b

environment of man. It is especially important
that movement, technological or motorized,
be understood in order that it may be brought
under some sort of external and internal
control, in the street and in the mind. Natural
form and movement must be more acutely
appreciated, too, lest men forget their link
with rhythms more ancient than pistons.

h● Allow two heterogeneous elements, passive
and active, to enter into a relationship [IV-30a, b].
The tension between them will initiate movement.
The aggressive element may be a line or some
kind of point thrust, or it may be a shape of reso-
lute energy and mobility. The other shape could

react in a variety of ways. It could absorb its adversary or undergo radical changes, not excluding the possibility of utter defeat. Or, in the end, it could strike a compromise with the aggressor wherein the two would adapt to each other in perfect harmony. Arrange the drama in at least three or four acts or episodes. Try to visualize the sequence of events in the most original way, avoiding all the graphic clichés of popular illustrations. Create clear and effective diagrams of a cinematic nature. Use crayon, paint, or mixed media, including collage.

A scroll

This series of studies may be concluded with a scroll or frieze that would combine not only the elements, concepts, and devices referred to in this part, but also those dealt with under "Point," "Line," and "Color" (Parts I, II, and III) [**IV-31**]. The frieze idea has been introduced before. It was taken up in Part II in connection with the Fibonacci Series (EX. 6d). The problem is to sustain a movement, an impulse, from one end to the other of a long horizontal area. The movement, whether rhythmical or non-rhythmical, must seem to exist not only in the dominant elements, but in the total current of form and space. One cannot describe a movement adequately without also describing the space through which it passes.

IV-31 A scroll or frieze, approximately 18 inches long, sustaining a movement of considerable variety and spatial fluctuation from left to right.

This has never been more strongly realized than in art and architecture since the first decade of this century. Cubism, the art of Delaunay, the Futurists, and the Constructivists, and especially the art of the cinema, have provided ways of apprehending movement analogous to scientific concepts and the technological reality of the twentieth century. But there is much more to be done in all media before present concepts and conditions are brought within the range of human cognition and feeling. They must be visualized, "made visible," and given some kind of meaningful structure that will be both tangible and symbolic. In many respects the problem is not new, but the forms and symbols must be new, the structure must be new.

i● The scroll may be made approximately a yard long and six or seven inches high—or any height or width considered appropriate. It may be made on hardboard, heavy paper, or canvas. The action may extend from edge to edge of this format, or may take place quite comfortably within this area, avoiding the periphery.

Use any medium or combination of media. Allow color and texture to help establish various degrees of depth along the route. Textures may consist of markings or rubbings made directly on the surface, or they may be applied, as in collage. Try to recall the experience of interval relations and sequences that was gained in the Fibonacci design. Although the area need not be divided into rigid and contrasting segments, it could be organized in such a way as to bestow a similar expanding and contracting pulsation from place to place.

The composition could be treated climactically or non-climactically. That is to say, it could start quietly and build up to a moment of great excitement at the middle or toward the end, or it could move along on a fairly even level from beginning to end. The first treatment would be characteristic of traditional, Western drama and music. At the culminating point, the words, sound, or action strive to unleash the main import and energy, following which there is a marked decrease of tension—the *dénouement*. The second type of composition would be typical of most jazz or Oriental music, or perhaps of a modern novel or play (e.g., James Joyce's *Ulysses* or Samuel Beckett's *Waiting for Godot*), where there is a "flattening out" of structure and incident. The "moment of truth," instead of occurring at one point towards which everything builds, is fragmented and disseminated throughout the whole work. The concatenation of events may be crowded or sparse. It may move slowly, in the manner of a solemn procession, or it may hurtle along with all the noise and speed of an athletic contest. Shape, color, and continuity must pertain to the action or mood intended. They must embody it in every part, not merely suggest it.

PART V

Nature Studies

The supreme beauty is in the forming power.
LANCELOT L. WHYTE*

Every age interprets nature (and, therefore, man)[1] in its own way—through its religion, philosophy, science, and its arts. This seems preeminently true of Western civilization, where one discovers a continual shifting of attitude from the time of Parmenides (active about 450 B.C.) to the present day. With gradual alienation of the self from an all-embracing, spiritual or mythic reality that accompanied the theoretical-literate-scientific development of the Western mind, there has arisen periodically the need for a new synthesis accommodating new perspectives on experience and nature. This has been sought spontaneously on the planes of both thought and intuition. During certain periods, these and other strata of mind and emotion appear to have interacted remarkably well, despite the rise of class and commerce, the accumulation of wealth and power, the increasing conflict of generations, and other unsettling events. At other times, noticeably since the

beginning of the last century, they appear to have drifted farther and farther apart in what they have borne. Thus, Romantic art and poetry approached nature almost exclusively along the path of feeling, while scientific thought advanced with mounting confidence along an entirely separate route and, in so doing, became the main element of continuity and faith in the social processes of the last hundred years or more. Our twentieth century world, where technology, mass media, and the great "fetish of money" threaten to dominate both the pattern and content of our lives and where nature is looked upon as something to be "conquered," is the result of this unhappy divergence of man's perceiving and ordering functions—so much so that the "image of the self held in past eras has been effaced from the universe in which even nature seems to be an abstraction."[2, 3]

But modern science has yielded more than technology. It has provided a view of nature

*] Lancelot L. Whyte, *Accent on Form*, World Perspectives, Vol. 2 (New York: Harper & Row, Publishers, 1954), p. 196.

1] Ortega said that each epoch *is* an interpretation of man. José Ortega y Gasset, *Meditations on Quixote* (New York: W. W. Norton & Company, Inc., 1961; Norton Library, 1963), p. 113.

2] Wylie Sypher, *Loss of the Self: In Modern Literature and Art* (New York: Random House, Inc., 1962), p. 15. See also Erich Kahler, *The Tower and the Abyss: An Inquiry into the Transformation of Man* (New York: The Viking Press, 1967).

168

V-3

3] Apropos of this dilemma, the distinguished poet W. H. Auden has made the following observations: "I may be wrong; but I think we are nearing the end of a period in which the philosophers and scientists were convinced that the 'reality' behind the appearances was a soulless mechanism; and the artists, in reaction, rejected the phenomenal world in favour of the cultivation of their subjective emotions—an attitude summed up by Blake's statement: 'some people see the sun as a round disk the size of a guinea, but I see it as a host crying Holy, Holy, Holy,' in which he denies all value to what his physical eyes see. . . . Now that their own researches have forced upon scientists the conclusion that 'objective' truth about physical reality is not scientifically attainable, it should be easier for artists to return to the common-sense notion that the only world which can be 'real' for us as the one in which we all, including scientists, are born, love, hate, reproduce, die, is the world offered us by our senses, three-dimensional and geocentric, where objects have clearly defined edges and are either in motion or at rest. Consequently it is possible, I believe and hope, that we shall return to the kind of art which was traditional until two centuries ago, an art in which, as Professor Erich Heller has said: 'The emotions do not interpret; they respond to the interpreted world.' It is even possible that we may recover a sense of phenomena as sacramental signs, a sense based upon the conviction that, both in art and in life, to quote Wittgenstein: 'Ethics and aesthetics are one, and a condition of the world like logic.' " (A talk entitled "Nowness and Permanence," reprinted in *The Listener*, BBC Publication, London, March 17, 1966, pp. 377–78.)

that greatly exceeds all previous horizons. The "immense journey"[4] of life and the unimagineable size and age of the universe now exist in our consciousness as components of a vast scale that includes the tiniest particles and patterns from which the miracle of life itself springs. With all this—and much more that pertains uniquely to life in the twentieth century, including the "new scene of electronic involvement"[5] (instantaneous worldwide communication)—there exists the need for yet another kind of unity, centered (it would seem inevitably) upon scientific inquiry, but extending to the realm of lived experience. A true unity or transformation, whether based upon science, theology, or metaphysics, will manifest itself in all dimensions of human life.

More consideration should be given to a persistent and widespread interest in form, the dynamics of growth,[6] and structure[7] that has arisen during recent decades, for this seems capable of pointing a way to new organizing principles. To the extent that this interest cuts across boundaries that once separated scientific method and artistic vision, there is reason to believe that a viable synthesis will be achieved wherein art and science and all uses of imagination and nature no longer exist as strangers, and sentiment and reason no longer proceed in mutual isolation toward the destruction of all hope of human freedom. Facts, measurements, and a narrow logic of causality, the main preoccupations of nineteenth century scientists, will give way at last to relationships, to structural patterns and complexes. A one-sided interest in parts will submit to an interest in the integrated whole. Structure will assume greater importance than surface appearance in both art and science. "In place of the arithmetic of nature, we now look for her geometry: the architecture of nature."[8] Jacob Bronowski concludes an article on "The Discovery of Form" with this statement:

> For fifty years we have been living in an intellectual revolution, in which interest has shifted from the surface appearance to the underlying structure, and then from the gross structure to the fine organization of minute parts in which only the total pattern expresses an order. And while critics have argued who has the monopoly of the new vision, and which culture ought to scorn the other, artists and scientists have gone quietly about their business of feeling and expressing the same common revolution.[9]

This interest in structure has led to a reexamination of many of the forms we take for granted in our environment. These have become the focal point of a vision that sees not merely fixed objects and surfaces, but rich patterns of energy in even the smallest details, and order and diversity, symmetry and asymmetry in systems of hitherto unappreciated complexity. Instead of viewing nature according to the old faith of mechanistic atomism ("the how, not the why"), we are encouraged to seek her on at least two levels simultaneously: the higher level of supra-elemental systems, and the lower level of smaller and more unpredictable components.[10] This hierarchy admits of regularity and stability in the larger entities, and of variety and uniqueness in the individual forms. We recognize, for example, that no two rivers are alike and no two seashells identical, even though the latter may belong to the same species.[11] Over-all order and individual deviation strike a balance of inexhaustible beauty.[12] ("What better way to retain the spirit of youth," asks physicist Lancelot L. Whyte, "than to sense hidden meanings and promises of new vistas in the forms around one?")[13]

4] The book *The Immense Journey*, by the noted scholar and naturalist Loren Eiseley (New York: Random House, Inc., 1957).

5] Marshall McLuhan, *Understanding Media: The Extensions of Man* (New York: McGraw-Hill Book Company, 1965), p. x.

6] See, for example, Sir D'Arcy W. Thompson's classic study, *On Growth and Form* (London: Cambridge University Press, abridged edition, 1961).

7] Even in the structure of human intellect, as conceived by anthropologist Claude Lévi-Strauss, and in human speech, as dealt with in structural linguistics.

8] Jacob Bronowski, "The Discovery of Form," in *Structure in Art and Science*, ed. G. Kepes (New York: George Braziller, 1965), p. 56.

9] *Ibid.*, p. 60.

10] See Paul Weiss, "Organic Form: Scientific and Aesthetic Aspects," in *The Visual Arts Today*, ed. G. Kepes (Middletown, Conn.: Wesleyan University Press, 1960), pp. 181–94.

11] See the article by Luna B. Leopold and W. B. Langbein, "River Meanders," and accompanying diagrams and illustrations, in *Scientific American*, Vol. 214, No. 6 (June 1966), 60–70.

12] See W. A. Bentley and W. J. Humphreys, *Snow Crystals* (New York: Dover Publications, Inc., 1962).

13] Lancelot L. Whyte, "Atomism, Structure and Form," in *Structure in Art and in Science*, ed. G. Kepes (New York: George Braziller, 1965), p. 20

The problem is to recognize, more acutely than ever before, the context in which forms in nature function. The object must be made to expand beyond its outward appearance by virtue of our understanding something of its inner workings, its dynamic relationship to environment, its cosmic "depth." The microscope, camera, and other optical instruments are of great use to us in this endeavor,[14] but our own powers of perceptive judgment are also required. George Rickey, maker of kinetic sculpture, has this to say about the artist and nature:

"Nature" is usually thought of by artists as the appearance to the eye of objects in the environment. It has been their great nourisher, whether recorded obediently by a Willem Kalf in the seventeenth century or modified beyond recognition by a prehistoric Luristan harness maker. This "nature" has been employed by countless generations as model, inspiration, and instructor. The artist has only sporadically transcribed it with verisimilitude. Nevertheless, in all epochs, even our own, "nature" reveals itself as the matrix in which the serious artist lives and moves and has his being. For the kinetic artist, too, nature is omnipresent and is always nudging his elbow. For him it is source book, example, competitor, analogy, tyrant, seducer, and also inexorable adversary. Nature has offered to the artist's eye landscape, figure, still-life and also geometry, light, intervening space (shallow and deep)—all well understood since the fifteenth century, and all fundamentally static. But nature is also "natural laws": gravity, Newton's laws of motion, the traffic laws of topology, the laws permitting the motion of a ship or the trembling of the earth, or the laws controlling the physiology and psychology of vision.
Nature is rarely still. All the environment is moving, at some pace or other, in some direction or other, under laws which are equally a manifestation of nature and a subject for art. The artist finds waiting for him, as subjects, not the trees, not the flowers, not the landscape, but the *waving* of branches and the *trembling* of stems, the piling up or scudding of clouds, the rising and setting and waxing and waning of heavenly bodies, the creeping of spilled water on the floor, the repertory of the sea—from ripple and wavelet to tide and torrent, the antics of people, schools of fish, companies of soldiers, heads of wheat, traffic jams, bees and ants—the "very many" in motion, the quivering of the aspen or the cowering of the panicked mouse, or, also part of "nature" in that it is part of his environment, the rotations and reciprocations in his car and his appliances, the swinging of cranes and bridges, the thrust, lift, and drop of planes, the random bouncing and rolling of a ball whether on grass, clay, or a roulette wheel, and those movements of sub-atomic particles never to be seen, but mapped and inferred from the tracks in the bubble-chamber and vague and awesome accounts in the press. The catalogue of the manifestations in nature that painting and sculpture have hitherto left out is endless.[15]

The first requirement is to *see* forms and movements with more than passing curiosity. The artist must give special attention to small details and happenings, and to all of those external and internal phenomena that usually go unnoticed.[16] He must know forms and their actions as intimately as the naturalist or woodsman knows the forest—out of both the front and the corner of his eye, from both near and far, and with some sense of wonder.[17] But he cannot be content merely to see, passively or actively. Vision must carry through into another realm. It must pass from receptivity to productivity, from percept to poetic image by a process of creative transfiguration.

A noted American writer, when asked by a group of students and would-be writers to comment on source, inspiration, and how one sets about writing, responded in the following manner. One usually writes about one of two things, he said: about what one loves, or about what one fears or hates—the "urgent mysteries." He said that, in some

14] See Gyorgy Kepes, *The New Landscape in Art and Science* (Chicago: Paul Theobald and Co., 1956), and Andreas Feininger, *The Anatomy of Nature* (New York: Crown Publishers, Inc., 1956).

15] George Rickey, "The Morphology of Movement: A Study of Kinetic Art," in *The Nature and Art of Motion*, Vision + Value Series, ed. G. Kepes (New York: George Braziller, 1965), p. 110.

16] G. C. Argan, in an article on Jean Dubuffet, makes this observation: "When Paul Klee said that art renders the invisible visible he was claiming too much. With Dubuffet, art is content to render the visible visible, since not all that is visible is seen. He doesn't lift the mysterious veil of Maya, he takes away the blinkers. He makes us see . . ." ["L'Antropologo Dubuffet," *Art and Artists*, Vol. 1, No. 1 (April 1966), 15].
"I cannot help feeling that the things closest to us, the most constantly before our eyes, are also the ones that have at all times been the least perceived, that they remain the least known."—*Dubuffet.*

17] See Jack McCormick, *The Life of the Forest* (New York: McGraw-Hill Book Company, 1966). Also John Hay, *In Defense of Nature* (Boston: Atlantic—Little, Brown and Company, 1969).

instances, these extremes of feeling appear to be curiously linked, and the author will write about both in the same poem or story. He offered the analogy of skiing, saying that the pleasure of skiing must surely be related somehow to the fear of death or injury; it is this fear and one's efforts to master it that bring to the surface an exhilarating sensation of life (i.e., what one loves).

One may conclude from this idea that art is either a celebration of things loved or cherished, or some kind of condemnation of things feared or despised; at no time would it have been emotionally neutral in origin and import, except in some recent art, which smacks of scientism or some other form of modern reductionism.

The art student may falter at the threshold of conceptual expression with much the same sense of bewilderment as that of the student writer, wondering where to turn in the midst of all the forms and phenomena of man and nature, wondering how he can relate his strong but vague feelings to that which stands or moves before him in the world. No one can be of much help to him at this point, beyond encouraging him to make some kind of beginning. After the first determined step, one thing usually leads to another on a broadening plain.

EX. 1

The student could start here, as in previous studies, by choosing any natural object of manageable size and condition, preferably one that may be turned in the hand and incorporates enough items of interest to sustain him through a series of studies in color, texture, form and structure. It may also be of a sort that he could examine, without too much difficulty, both inside and out. Objects differ greatly in what they present. Some proffer much of one element but very little of another. But even this can be deceptive. Those that appear colorless at first glance often reveal, on closer examination, the most subtle range of color. Every object is a thing of structure; confirmation of this proposition may require a search that leads from gross appearance to the most minute cell or building block. One must be prepared to explore an object to the heart of its formal arrangement or schema. While doing so, there may occur one of the rarest moments in life, when the startling reality of a form suddenly unfolds and augments the field of consciousness. At such a moment, the ordinary becomes extraordinary.[18]

A series of studies could start with a color study of the object, and end in a three-dimensional design based on some or all of the elements discovered either by direct observation, intuitive analysis, dissection, or research. The first group of studies should be exploratory in nature, each concentrating on one or two elements to the exclusion of others. The color study could be one in which every kind and quality of hue is reproduced as an equivalent and put down broadly on paper in patterns and proportions derived directly from the object. Some forms reveal a different color structure in different parts. Their internal colors may differ greatly from their external colors, requiring a separate transcription. Whether in the whole object or in some detail, the colors should not be seen as a decorative adjunct, but as part of the unique history of the form. Every change of color should denote a change of quality or condition.

Another study could concentrate on the texture of the object, and equivalents could be sought in either actual or simulated surfaces [V-1]. Depending on the nature of the object, pattern may have such a close relationship to texture that the two will need to be treated together. Normally, however, pattern and texture are considered separately,

18] If a sense of awe—man's highest sentiment, according to Goethe—is an uncommon emotion in the twentieth century, in spite of the astonishing vistas that have been opened out on the universe by science and technology, surely a sense of curiosity or even affection toward things of nature is not beyond the capacity of most people. "Everything has within it an indication of its possible plentitude" (José Ortega y Gasset, *Meditations on Quixote*, p. 32). There are writers, artists, and composers who still seem able to celebrate these "plentitudes," e.g., Lou Harrison in his *Four Strict Songs*, recorded by Louisville Orchestra Commissions (LOU-582), which is remarkable in the light of the following statements by Sir Kenneth Clark from an essay on modern civilization entitled "Heroic Materialism and the Awakened Conscience" (*The Listener*, May 22, 1969, 713–20): "The scientists who are

V-1 One of several exploratory studies of a peanut. Linear patterns. Pencil.

V-2 One of several exploratory studies of a seashell. Conté.

V-1

best qualified to talk [on the future] have kept their mouths shut. J. B. S. Haldane summed up the situation when he said: 'My own suspicion is that the universe is not only queerer than we suppose, but queerer than we can suppose.' 'I saw a new heaven and a new earth, for the old heaven and the old earth had passed away.' Which reminds us that the universe so vividly described in the Book of Revelation is queer enough; but with the help of symbols, not beyond description. Whereas our universe cannot even be stated symbolically. And this touches us all more directly than one might suppose. For example, artists who have been very little influenced by social systems have always responded instinctively to latent assumptions about the shape of the universe. The incomprehensibility of our new cosmos seems to me, ultimately, to be the reason for the chaos of modern art.''

V-2

pattern being understood here as consisting of regular schematic repetitions, and texture as a surface quality that is either smooth and undifferentiated or the result of random or extremely varied elements.

Next, the form of the object could be examined both for its general or primary and particular or secondary aspects. A seashell, for example, will follow the principle of the spiral that pertains to the supra-elemental order of its particular family and to a great many types of seashells, but it will also reveal the effects of time, accident, and environment on its own individual development [**V-2**]. The same would be true of a leaf or a flower. Any successful study of form in nature must move freely between the general and the particular, the part and the whole, and take into account the interdependency, the oneness of materials and processes.

This group of studies exploring source will provide ideas and images for further development in both two- and three-dimensional designs. Examine the studies carefully for lines, shapes, forms, colors, textures, and patterns that can be extended beyond their original context in the object. Structural equivalents, if stated with sensibility and authority, have a way of assuming separate identities and careers. Their energies, instead of being easily exhausted, will survive an unbelievable amount of manipulation and change. They will not be sterile, as are those forms that are the result of imitation.

EX. 2

Before proceeding to a final two-dimensional study, make a few trial studies in which various elements are combined in several ways. Experiment with scale (relative dominance), placement (high and low, touching, not touching, overlapping), and movement (forward, backward, rising, falling, rhythmical, nonrhythmical). Allow each

element to remain pliable, "fluid," and open to change, to combine and recombine freely with other elements.[19] Try tearing the image into two or more pieces and reconstituting it in a slightly different way on top of another sheet of paper. Pull it apart, shift the parts up or down, overlap them, and so on. Paste them in their new positions, and then perhaps work into them again. This treatment will not only cause the image to "grow," it will cause it to fluctuate more in depth and awaken it to its environment, improving its ecological drama.

While still in the ferment of experimentation, go directly to the large two-dimensional study [**V-3**]. It may be done on heavy watercolor paper, primed masonite, or any other ground large and durable enough to withstand a considerable amount of rough handling. Again, the medium may be water paints—designers' colors, casein, or acrylic—or an assortment of materials, depending on the imagery and the kind of development foreseen. Avoid materials and effects that are merely decorative.

A similar series could derive from man-made objects or from objects of mixed origin and structure [**V-4**]. It could start with small exploratory studies, including one or more that come from a tactile rather than a visual experience of the object [**V-5**]. This could help to establish a more subjective response to the object, and lead thereby to a richer imagery. Maria Montessori realized the necessity of developing every sensory faculty in the individual. In the schools that she founded, very young children are inducted into all types of experiences, skills, and disciplines through an extensive use of the senses, particularly the sense of touch.[20] Explore the object manually and take note of every quality perceptible to the senses of touch, temperature, and pressure. Determine whether it is hard or soft, pliable or resilient,

V-4

V-3

V-3 A final two-dimensional study based on a crystal.

V-4 An assemblage of objects made of rubber and plastic: the pink torso of a doll, a white conical form, and a red plastic form.

rough or smooth, geometric or organic, regular or irregular, bulky or thin, defined or amorphous, heavy or light, warm or cool, flexible or stiff, silken or crinkly, fibrous or prickly, wet or dry, and so on. (Is it a combination of these qualities?) Try to find graphic equivalents for every sensation. Use wet and dry media, or so-called mixed-media. Unite all equivalents—textural and formal—in an image that will stand on its own merit. Certain elements will be emphasized or exaggerated, as in the sculpture of the blind, or the drawings and paintings of van Gogh. Van Gogh never failed to respond intensively and often haptically to the forms, colors, textures, and movements that commanded his attention, nor did he fail to find for them the most cogent marks and symbols.

The line, shape, form, color, and texture analogues obtained by both sight and touch[21] could be developed freely in oil paints, rather than water-based paints, on primed hardboard. This surface is recommended not only because it is cheaper and more readily available than canvas, but because its hard-

19] See Fig. 4, p. 46, from *Education of Vision*, Vision + Value Series, ed. G. Kepes (New York: George Braziller, 1965).

20] See Maria Montessori, *Dr. Montessori's Own Handbook* (Cambridge, Mass.: Robert Bentley, Inc., 1964).

21] Exploratory studies could be undertaken in a more elaborate way, e.g., by first creating a minuscule "environment" of forms, shapes, and colors of various sorts and materials inside a cardboard box—an "anthology" of objects, mainly of twentieth century origin: cartons, toys, household objects, advertisements, photographic reproductions from magazines, etc., and some natural objects. Torn or cut construction paper may be used. The box could be opened on any side, and holes cut in it so that its interior spaces may be viewed from several angles.

V-5

 V-6

V-5 Fourteen exploratory studies from the assemblage shown in V-4. Oil paints on paper, collage, and charcoal. Each study represents an attempt to find color, shape, and line equivalents of some aspect of the assemblage. No single study is meant to contain more than a little of what is seen from a particular angle; but this much is perceived with concentration and excitement. Special attention is given to structure and to form and space relationships.

These studies become source and inspiration for further developments in painting, graphics, or sculpture. (Student work, Barry Summer School, So. Wales, Mr. Tom Hudson, director of studies.)

Some forms, shapes, and colors could be applied to the outer surfaces of the box near the holes, with the idea of establishing "inner-outer" correspondences and tensions—color echoing color, shape rhyming shape through the holes. Lettering on the box may be taken advantage of. The stimulating, heterogeneous data provided from many directions may then be translated into point, shape, form, color, and texture equivalents of piquant imagery, involving space, startling contrasts, as well as many subtle transactions [**V-6**]. [See Graham Collier, *Form, Space, and Vision*, 2nd Ed. (Englewood Cliffs, N.J.: Prentice-Hall, Inc., 1967), pp. 245–47.]

ness and smoothness allow a more direct, rapid, adventurous handling of the elements and the medium itself. One should be able to put down (with artificial sponge, palette knife, rag, or brush), wipe away, and readjust the components with speed—constructive acts alternating freely with destructive acts—until a true synthesis is achieved.[22] This can happen only by virtue of the imagination, which, in the opinion of critic Dore Ashton, "never allows a perception to remain in its raw direct state, if indeed there is such a thing."[23]

EX. 3

Finally, re-examine the work in progress from its beginning and select those ingredients that offer possibilities for three-dimensional development, especially those that pertain more directly to structure of a tectonic order[**V-7a-c**]. Give careful consideration to the kinds of material with which a volumetric design can be made. Good results are obtainable from the use of paper products alone, such as cardboard, corrugated paper, construction paper, and *papier mâché*, but other materials, including metal, metal foil, styrofoam, wood, cloth, and plaster may also be used, separately or together. Color and texture may play an important part. But no matter what the perceptual ideas and building materials may be, the end product must be far removed from a literal representation of the original object. It must be the final stage of a transformation, involving "visual thinking" or an interplay of invention and discovery.

V-7a

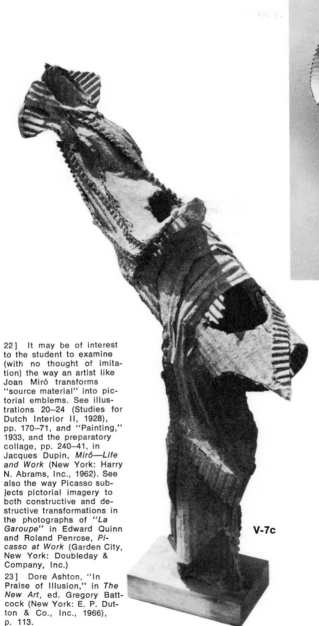

V-7b

V-7c

22] It may be of interest to the student to examine (with no thought of imitation) the way an artist like Joan Miró transforms "source material" into pictorial emblems. See illustrations 20–24 (Studies for Dutch Interior II, 1928), pp. 170–71, and "Painting," 1933, and the preparatory collage, pp. 240–41, in Jacques Dupin, *Miró—Life and Work* (New York: Harry N. Abrams, Inc., 1962). See also the way Picasso subjects pictorial imagery to both constructive and destructive transformations in the photographs of *"La Garoupe"* in Edward Quinn and Roland Penrose, *Picasso at Work* (Garden City, New York: Doubleday & Company, Inc.)

23] Dore Ashton, "In Praise of Illusion," in *The New Art*, ed. Gregory Battcock (New York: E. P. Dutton & Co., Inc., 1966), p. 113.

V-7a A final three-dimensional study that evolved from an examination of shrivelled chinaberries. *Papier maché* (formed over a balloon), cardboard, and colored papers.

V-7b A final three-dimensional study that evolved from a spotted leaf. Cardboard.

V-7c A final three-dimensional study that developed from the stalk of a rose bush. Cardboard and corrugated paper.

Sentiment, Sign, and Symbol

Forms, colors, densities, odors—what is it in me that corresponds with them?
WALT WHITMAN*

Most people would have little difficulty recognizing the experience of Leonardo, of Sung Ti,[1] a Chinese painter of the eleventh century, and of many other artists—the experience of finding images of all types in clouds, rock formations, and the cracks and stains of old walls. Leonardo wrote in his *Treatise on Painting*: "It should not be hard for you to stop sometimes and look into the stains of walls, or ashes of a fire, or clouds, or mud or like places, in which . . . you may find really marvelous ideas." Suddenly a pattern of lines, shapes, or colors received directly from without will correspond with some pattern, some structure of experience buried under the surface of consciousness.

Modern psychiatry takes advantage of this phenomenon in the familiar ink-blot exercises, developed by Swiss psychologist Hermann Rorschach as a means of revealing hidden characteristics of patients suffering some kind of mental disturbance. According to the method that bears his name, a series of ambiguous silhouettes are presented to the examinee, and his report of what he sees in them, entirely by free association, is subjected to analysis. Questions such as these are applied: Does the patient tend to see the figure as a whole or does he emphasize the details? Is he influenced more by form, by movement sensations, or by coloring? Does he usually see human beings, animals, plants, or landscapes? Are his responses unique or are they very much like those of other people? The examiner arranges each detail of the responses in such a way as to obtain a true "picture" of the subject as a total personality, including his interests, talents, and problems.

A somewhat similar procedure has been taken up in modern art and modern artistic theory, particularly in that development known as Surrealism. The suggestive powers of lines, colors, shapes, and forms are

*] Walt Whitman, "Locations and Times," from *Leaves of Grass* (New York: Aventine Press, 1931), p. 285.

1] See E. H. Gombrich, *Art and Illusion: A Study in the Psychology of Pictorial Representation* (New York: Bollingen Foundation, 1961), Chap. VI, "The Image in the Clouds," pp. 181–202.

VI-1

allowed to coalesce in strange and fantastic images by a process that is almost entirely unconscious. The best of these sometimes have the fascination of symbols because they both have emerged through several zones of psychic experience.

Nothing is without precedence, even (or, perhaps, especially) in art. The "unconscious" or "automtaic" procedures recommended by the Surrealists, which may have appeared at first to be the complete denial of all "sane," traditional values, have an honorable ancestry not only in Leonardo's interest in random patterns in old walls, but, more particularly in a curious technique developed by English painter Alexander Cozens (ca. 1717–1786), and described as "a new method of assisting the invention in drawing original compositions of landscape." Cozens' "method" was to crumble a sheet of paper, flatten it out, and then, "while thinking generally of landscape, blot it with ink, using as little conscious control as possible."[2] These "ink-blot landscapes" would become rich repositories of "ideas" and images that could be elaborated into finished pictures.

The Romantic movement, to which artists like Cozens contributed, placed great importance on inspiration and feeling, while retaining an equally strong attachment to observed reality, the palpable variety and beauty of the natural world. But, by the end of the nineteenth century, artists, designers, and theorists would concentrate more and more on "pure" expressive values, residing not so much in subject matter in itself, but rather in those abstract or "musical" forms and relations that evolve out of the artist's treatment of subject matter, out of landscape in particular, and out of his "visual thinking." Maurice Denis' famous statement of 1890 was both the summation of prevailing ideas and convictions and a forecast of trends that would reach complete fruition in the non-objective art of the twentieth century, especially the art of Kandinsky and the American Abstract Expressionists. He said: "It must be recalled that a picture—before it is a picture of battlehorse, nude woman, or some anecdote—is essentially a plane surface covered by colors arranged in a certain order." (French Symbolist poet Stéphane Mallarmé, some 25 years earlier, had advised artists, indirectly, "To paint not the thing, but the effect that it produces.") Attention would be given increasingly to what has been referred to as the "essence" of forms, their primary features, physiognomical and affective qualities, expressive attitudes and "gestures."[3]

No single endowment in any artist is more important than his ability to invent meaningful shapes and structures.[4] These may be transformations of things discovered in nature, or may spring directly from the unconscious without reference to premeditated ideas or images. If they come from real depth of experience, they will have great visual attraction and the power to evoke rich and varied responses in each observer. They will exert the kind of magic peculiar to symbols.

Aniela Jaffé begins her essay on "Symbolism in the Visual Arts" with these statements:

The history of symbolism shows that everything can assume symbolic significance: natural objects (like stones, plants, animals, men, mountains and valleys, sun and moon, wind, water, and fire), or man-made things (like houses, boats, or cars), or even abstract forms (like numbers, or the triangle, the square, and the circle). In fact, the whole cosmos is a potential symbol.

Man, with his symbol-making propensity, unconsciously transforms objects or forms into symbols

2] H. W. Janson, *History of Art* (Englewood Cliffs, N.J.: Prentice-Hall, Inc., and Harry N. Abrams, Inc., 1962), p 468.

3] See E. H. Gombrich, "On Physiognomic Perception," in *The Visual Arts Today*, ed. G. Kepes (Middletown, Conn.: Wesleyan University Press, 1960).

4] "Inventiveness," explained M. L. J. Abercrombie in a talk on BBC radio, "is a mixture of controlled and uncontrolled processes. The creative process also demands a coming to terms with destruction." Picasso, he said, speaks of each picture as being "a sum of destruction," adding that, in the end, nothing is lost (*The Listener*, May 19, 1966).

5] In *Man and His Symbols*, conceived and edited by Carl G. Jung (New York: Doubleday & Company, Inc., 1964; copyright Aldus Books Limited, London), p. 232.

6] See Jacques Dupin, *Joan Miró—Life and Work* (New York: Harry N. Abrams, Inc., 1962), pp. 11–12, 462, and 464, for descriptions of Miró's attitude to nature and his use of found objects. See also S. Giedion, "Symbolic Expression in Prehistory and the First High Civilizations," in *Sign, Image, Symbol*, Vision + Value Series, ed. G. Kepes (New York: George Braziller, 1966), pp. 78–91.

VI-1 The seasons of the year. From Rudolf Koch, *Book of Signs* (New York: Dover Publications, Inc., 1930), p. 57.

7] "I will try to explain what I mean by metamorphosis. For me no object can be tied down to any one sort of reality. A stone may be part of a wall, a piece of sculpture, a lethal weapon, a pebble on a beach or anything else you like. . . .
"Everything changes according to circumstances: that's what I mean by metamorphosis. When you ask me whether a particular form in one of my paintings depicts a woman's head, a fish, a vase, a bird, or all four at once, I can't give you a categorical answer, for this "metaphoric" confusion is fundamental to the poetry." Georges Braque, from "The Power of Mystery," *Voice of the Artist*, 2 (London), *The Observer*, (December 1, 1957).

8] Carl G. Jung, "Approaching the Unconscious," in *Man and His Symbols* (New York: Doubleday & Company, Inc., 1964), p. 20.

9] See Bruno Munari, *Discovery of the Circle* (London and New York: Alec Tiranti Ltd. and George Wittenborn, n.d.).

(thereby endowing them with great psychological importance) and expresses them in both his religion and his visual art. The intertwined history of religion and art, reaching back to prehistoric times, is the record that our ancestors have left of the symbols that were meaningful and moving to them. Even today, as modern painting and sculpture show, the interplay of religion and art is still alive.[5]

Then she singles out three recurring motifs, the stone, the animal, and the circle, "to illustrate the presence and nature of symbolism in the art of many different periods," each motif having had "enduring psychological significance" from the earliest expressions of man to the art of the present day.

In a particularly interesting section on modern art, the author explains how a number of artists since the early years of this century have elected to deal almost entirely with abstract or geometric forms—circles, squares, and so on—while others have chosen the radically different procedure of investing special significance in found objects (*objets trouvés*), "ready-mades," and "disturbing" objects of all types. Artists as different as Picasso, Braque, Duchamp, Miró[6] Schwitters, Moore, and Rauschenberg have collected the strangest assortment of objects from beaches, attics, and scrap heaps—derelict objects of both natural and human origin. They have, in a sense, transformed them by projecting upon them some sort of psychic content; it could be said that they have given them a new animation by recognizing their unique structure, "personality," or sentiment, or by imagining the true extent of their reality.[7]

Symbols, according to the definition of eminent psychologist Carl G. Jung, are "natural and spontaneous products" that spring involuntarily from the unconscious. Unlike signs, which can do little more than denote the objects to which they are attached, point directions, or give orders, information, and warnings, symbols always stand for a great deal more than their immediate meaning. They are multidimensional, and there is always something about them that is beyond the grasp of reason—"something vague, unknown or hidden from us."[8]

Symbols may be of personal or communal significance. They may occur in dreams, in thoughts and feelings, in myths, and in all kinds of ritual acts, in a poem or a painting, or in drama; or, like religious and magical images found in churches, shrines, and museums all over the world, they may be the mysterious products of cultures which are of ancient and obscure beginnings. In any case, they come from the deepest and most fertile regions of the mind. They abbreviate and concentrate a great number of spontaneous and separate perceptions, ideas, and feelings, and (if we are to accept the opinion of Jung) contain those archetypal patterns that lie half-dormant in the human psyche, in the "collective unconscious."

If all shapes, lines, and objects can carry symbolical overtones, it is because our recognition of symbolic meaning is not merely an accident, but an essential part of observation. Perception and lived experience are united. These early signs (symbols?) of the seasons illustrate the power inherent in a few lines to arouse the most complex associations [**VI-1**]. Spring takes the form of a circle, itself one of the most powerful and universal of symbols.[9] Here, coupled with the two almost comic "sprouts," it suggests the germinating seed, regeneration, the miracle of birth. The lines signifying summer are the circle of spring thrown open. The

arms or branches receive the sun and reach outward in the hope of strength and fulfillment. Autumn contains the first straight lines, the inverted cross. Its curved lines flow downward instead of upward, suggesting a tree heavily laden with fruit. Winter is made entirely of rigid, straight lines, indicating, perhaps, the arrival of hard, bitter cold.[10]

One could start with lines more rudimentary than these—simple verticals, horizontals, diagonals, and curves—and discover meanings which, though perhaps not very precise, bear a definite relationship to mood ("sensa never come uncharged with emotion"[11]). Melodies, which are, in a sense, musical lines, also express the widest variety of moods. The intense, downward-turning lament, the animated dance tune, the slow, introspective chant, and the dignified national anthem are but a few characteristic examples.

Henry Rasmusen, in his book *Art Structure*,[12] shows 20 "expressive line symbols," some of which are very closely associated with architectural and natural forms: the high, pointed arch of the Gothic cathedral, the broad, rounded arch and dome of Romanesque and Byzantine churches, the pyramidal form of the mountain peak, and so on. Simpler lines, though equally effective, seem more general in origin and sentiment: "Verticals, suggesting stability, austerity, dignity," "horizontal lines, suggesting tranquility, repose, immobility," "diagonals, suggesting instability, movement, action," "rhythmic curves, suggesting grace, joyousness, youth."[13] Their effectiveness would seem to lie almost entirely in the pure visual character of their structure and orientation, not in the forms they suggest; it is arguable whether lines of this sort are truly "meaningful" out of some particular context, out of a "local habitation." In art of a more abstract or conceptual nature—ancient and medieval paintings, oriental and primitive art, and much modern art—lines and colors as such often carry the principal burden of expression (or can it be that normally we allow imaginative understanding or communion to extend only so far into these works; can it also mean that some works, no matter how attractive at first, are too minimal for sustained observation?).

But lines are not the only symbolic means available. Form, space, color, texture, and light and shadow (illumination), like harmony and instrumentation in music, are equally important. Great architecture frequently combines all of these. If it does not always succeed in doing so to advantage, it retains potentially "a unique power to integrate the arts of a period into one representative symbol of form."[14] Its title, "the mother of art," derives not only from its varied human, social functions, but also from its embodiment of the "style of mind" and spatial concepts of a period.[15]

Ernest Mundt, in his book *Art, Form and Civilization*, examines the relationship of the way of life or ethos of several periods of Western history to the concepts of space of each period, and the resultant symbolic and formal products. In his opinion, every product, large and small, bears witness to a unitary structure of mind, intuition, and feeling—or to a lack thereof. No object or pattern is without significance. The embellished capitals of columns and the portraits of a similar time and place,[16] the pottery, furniture, and other "tools for living," the style of writing, the printing, painting, and sculpture of any era share the same animating spirit, the same family temperament. A Gothic cathedral, a Gothic painting, a Gothic sculpture, Gothic philosophy—all have a "narrow,

10] See Graphics (graphic signs), in J. E. Cirlot, *A Dictionary of Symbols* (New York: Philosophical Library, 1962), pp. 116–26.

11] R. G. Collingwood, *The Principles of Art* (New York: Oxford University Press, 1958), p. 163.

12] Henry N. Rasmusen, *Art Structure: A Textbook of Creative Design* (New York: McGraw-Hill Book Company, 1950), p. 63.

13] *Ibid.*, p. 63.

14] Ernest Mundt, *Art, Form and Civilization* (Berkeley: University of California Press, 1952), p. 154.

15] Read John F. A. Taylor's eloquent comment on the nature of architecture in *Design and Expression in the Visual Arts* (New York: Dover Publications, Inc., 1964), pp. 220–21.

16] "A Greek figure is not just a shape in stone but the image of man in the light of which the Greeks lived. If you compare, feature by feature, the bust of a Roman patrician with the head of a medieval saint—as André Malraux has done with a spectacularly sharp eye in his *Voices of Silence* —you cannot account in formal terms for the difference between them: the two heads stare at each other and cancel each other out; they give us two different images of the destiny and possibilities of being a man. The Roman head shows us the face of the *imperium*, of power and empire, the Christian the face of the Incarnation, the humility of the earthly transfigured by the Divine." William Barrett, *Irrational Man: A Study in Existential Philosophy* (New York: Doubleday & Company, 1962), p. 60.

17] *Time* concludes an article on American architect Louis Kahn with these comments: "Kahn strives to make his concrete resolve the architect's most cantankerous problem: light. He pierces his silos and walls, even thought of 'wrapping ruins around buildings' to give character to sunlight by creating shadows, inveigles light inside through slit windows, arches and myriad fluctuations in the exterior of his structure. Enchanted with massive walls, he also seeks to punch through them, making elaborate models out of stiff cardboard in order to study how his buildings will work, but he builds his order out of light. And there is no catalogue for that" [*Time*, Vol. 87, No. 23 (June 10, 1966), 70].

vertical" quality, like hands pressed together in the attitude of prayer and adoration. By the same token, a Baroque staircase, with its "interlacing rhythms," incarnates a spirit very different from a heavy Renaissance stairway. A Greek vase and an English Medieval pitcher seem scarcely to relate to the same human species! In a modern work of art— for example, a piece of sculpture by Henry Moore—sentiment or expression may hinge on paradox. As his eye passes from one part of the work to another, the observer will be obliged to respond to seemingly irreconcilable forms and images—dark, menacing voids followed by broad, ingratiating areas, and these in turn followed by mounds, ridges, and other aggressive projections.

Illumination and color bear a special relationship to mood. Color, moreover, is capable of assuming symbolic dimensions, especially discernible in "tribal" and sacred art. Light, whether or not used to advantage by the designer, has the power of a natural phenomenon to transform the emotional climate, the ambience, of forms and spaces. It can alter in an instant the visual reality of places, as photographers, stage designers, and architects must realize.[17] Constable referred to the sky, through which light filters, as the "chief organ of sentiment."

Color, because it exists not only in materials but also in the form of paint that can be applied at liberty to surfaces, seems, by comparison, both manageable and permanent. Its qualities, though often elusive, can be studied with greater care and certainty than those of light. Therefore, it lends itself more readily to the artist-designer as a plastic element, a descriptive element, and a means of symbolic expression. It was seen in Part III how certain color combinations—contrast of hue, contrast of temperature, contrast of

complementaries, and so on—may be used to express quite definite moods. "Color chords," like musical chords, may be used to create the whole feeling-tone of a work, or to underscore the import of certain forms and relationships within the work.

The emotional and symbolical implications, the temperament, of individual colors have been the subject of inquiry by a number of theorists, beginning with Goethe and his famous *Theory of Color*, published in 1810. Evidently Turner studied Goethe's psychological interpretations, in which melancholy and anxious sensations are ascribed to green, blue, and purple, liveliness and lucidity to yellow, orange, and red, and seriousness to red, violet, and blue. These psychological effects are particularly present in these groups of three colors plus one or two intermediate colors (see Goethe's triangular diagrams). The findings of color theorists are no less interesting for having been arrived at mainly by intuition rather than scientific analysis. Their comments often reveal an acute insight into man's associative faculties. Johannes Itten has this to say about blue:

As red is always active, so blue is always passive, from the point of view of material space. From the point of view of spiritual immateriality, blue seems active and red passive. Blue is always cold, and red is always warm. Blue is contracted, introverted. As red is associated with blood, so is blue with the nervous system.

Blue is a power like that of nature in winter, when all germination and growth is hidden in darkness and silence. Blue is always shadowy, and tends in its greatest glory to darkness. It is an intangible nothing, and yet present as the transparent atmosphere. In the atmosphere of the earth, blue appears from lightest azure to the deepest blue-black of the night sky. Blue beckons our spirit with the vibrations of faith into the infinite distances of spirit. Signifying faith to us, for the Chinese it symbolized immortality.

When blue is dimmed, it falls into superstition, fear, grief and perdition, but always it points to the realm of the transcendental.[18]

He approaches each of the primaries and secondaries in the same way, taking pains to demonstrate how the sentiment of each color may be altered significantly by any change of value, intensity, or temperature. This may be accomplished either by admixture, the quality of light striking it, or the color that surrounds it. Thus yellow, "the brightest and lightest color, pertains symbolically to understanding, knowledge";[19] but when it is placed on a pink ground "simultaneous effect shifts it towards greenish yellow, and its radiant power is subdued. Where pure love (pink) reigns, reason and knowledge (yellow) seem to languish."[20]

Architects, artists, and designers would do well to avail themselves of greater insight into color psychology and color expression, if only because this aspect of color seems to have received least attention in training and application. Few artists have explored the emotional connotations of color as imaginatively as Paul Klee. Every one of his paintings, because it has a different theme, has a different color scheme. Most artists tend to employ the same colors in every work, regardless of subject or theme. One set of colors is made to serve all purposes.[21]

Surface textures and the nature of materials also contribute greatly to the feeling-tone of a work of art, to the architectural environment and all that it may contain— furniture, fabrics, and other utilitarian and esthetic objects. Rough and smooth, dull and shiny, hard and soft, warm and cold, opaque and transparent materials affect the unconscious centers of the individual through most of his receptive faculties, arousing

associations and feelings that often reach back to early childhood, when he was busy exploring the myriad phenomena of his world with total engrossment. Some societies retain this childhood experience, this "order of sensuousness," develop it and allow it to permeate all spontaneous and cultural acts. Others tend to repress it, thereby robbing the individual of both physical and emotional generosity, of organic wholeness, of creative self-awareness. "The Fur-covered Cup, Saucer and Spoon"[22] is, in a way, symbolical of a complacent, commercial-industrial society that narrows meanings and responses down to the "smallest area of satisfaction, to the area of consumer goods."[23] The primal human significance of a cup and saucer is rudely restored by their being presented as a disgusting fetish-like object. Presumably a Japanese ceremonial tea bowl, made by a potter, would not require such treatment, for it would still retain its uniqueness and a close tie to ritual, contemplation, and poetry.[24]

The following experiment in two parts may be looked upon as a summation of most of the work that has been undertaken from the beginning of this course. The coordination of chromatic, formal, and spatial ingredients will not be new, in view of the fact that all marks, shapes, and forms usually convey some element of feeling. But it is possible that all of these, in combination with actual space, with texture of various sorts, pleasant and unpleasant, and with light and shadow, will yield results that have not been experienced heretofore.

EX.

a● Choose a word,[25] a phrase, a poem, a scene from a play, a story, a song, a place, a piece of music, a season of the year, or a popular cele-

18] *The Art of Color* by Johannes Itten. Published by Reinhold Publishing Corporation, 430 Park Avenue, New York, N.Y. 1961. Pp. 135–36.

19] *Ibid.*, p. 132.

20] *Ibid.*, p. 133

21] It is well to point out that some artists and architects have little or no interest in "mood" as such. This quality, if it can be said to inhere in their work, does so mainly as a by-product. Robert Rauschenberg consciously rejects the use of associative colors, color combinations that are "emotionally loaded." See "The Artist Speaks: Robert Rauschenberg," an interview by Dorothy Gees Seckler, *Art in America*, Vol. 54, No. 3 (May-June 1966), 73–84. The composer Stravinsky rejects with even more emphasis the idea that the purpose of music is to "express" a sentiment, a mood, or what-have-you. Its essence, he says, is order and structure. But the composer Lou Harrison describes music as "emotional mathematics"!

22] A Surrealist object by Meret Oppenheim, 1936 (The Museum of Modern Art, N.Y.).

23] Ernest Becker, *Beyond Alienation: A Philosophy of Education for the Crisis of Democracy* (New York: *George Braziller*, 1967), p. 156.

24] Becker enlarges upon this idea in the following comments: "The progress of rationalism has blocked off rich areas of experience by attempting to divide sharply the world of the real and not real. For example, for the primitive who engaged in potlatch and gift exchange, the artifacts that were passed from hand to hand gave a richness of experiences that we cannot imagine. The Kwakiutl copper was a sacred gift, possessing the name of a god and filled

with magical powers which filtered into the one who kept it for a time before passing it on. To hold the gift in one's hands was to exist in a past-present-future of immense power and vitality, to join one's destiny for a moment with that of a god. We can only recapture some of this feeling by imagining that our Cadillacs were each named after a different god and radiated his power to our touch, that the automobile was a temporary embodiment on earth of a divine power. We would enjoy it all the more because we were under obligation to pass it on to another, and we would thrill seeing it go from owner to owner, growing in richness and beauty, happy only that it resided with us for a time. In comparison to this experience of the primitive, the standardized possessions of modern man, despite all their glitter, are shallow. True, they became parts of our ego, parts of our self-image, and fill us with that feeling of warm self-value that we call prestige. But they are essentially few-dimensional objects; they do not take root in an eternity or seal our union with higher powers" [from *The Birth and Death of Meaning: A Perspective in Psychiatry and Anthropology* (New York: The Free Press, 1962), pp. 148–49, by permission of the publisher. © 1962.]

25] For example: compassion, joyousness, tranquility, mirth, nostalgia, claustrophobia, fantasy, aspiration, expansiveness, conflict. See Rudolf Arnheim's interpretation of the characters in Picasso's "Guernica"— the bull, the mother, the child, and so on—according to "expressive attitudes" and "sentiments." *Picasso's Guernica: The Genesis of a Painting* (Berkeley: University of California Press, 1962), pp. 28–29. See also Arnheim's "Visual Thinking," *Education of Vision*, Vision + Value Series, ed. G. Kepes (New York: George Braziller, 1965), pp. 1–15.

VI-2

VI-2 A two-dimensional study in mood or sentiment based on a quotation from Paul Klee ("A blind minstrel led by a boy beating a tambourine was a 'rhythm forever' ").

bration that incites a mood. Consider whether this mood will lend itself, without too much ambiguity, to visual expression, whether spatio-plastic equivalents can be found that will embody it. Some moods may require very few elements, approaching austerity or emptiness, while others may require the use of a great many elements in very crowded circumstances. Whether it be at one extreme or the other, a certain economy of means is worth bearing in mind. The results will be all the more effective for having been arrived at with only those elements that are needed, and no more.

Develop either in a single study or through a series of studies a unique symbiosis of points, lines, shapes, colors, and textures (actual or simulated) that will serve as an equivalent for the

mood you have chosen. Use any medium or combination of media. Avoid, if possible, use of immediately recognizable forms and objects, or of previsualized symbols. Similarly avoid secondhand images and clichés. Approach the problem openly and experimentally, keeping the elements in a "fluid" state until some exciting incident begins to take shape. Use the most simple devices to make the "meaning" visible. Consider the appropriateness of *single* colors or limited combinations before plunging haphazardly into the use of many colors.

The final two-dimensional statement may exist quite freely within a general area, or may extend to the limits of the format in the manner of a composition [**VI-2**]. Its over-all size and shape

VI-3

VI-3 A three-dimensional extension of the same mood, deriving from Klee's quotation (VI-2). (The box was opened for photographing; it was meant to be viewed through a peep-hole.)

will depend on the nature of the theme, a vertical area presenting quite a different range of possibilities from a square or horizontal area.

(This part of the experiment could take a different direction altogether and stop short of three-dimensional development, if preferred. It could hark back to earlier experiments with marks in Part II and shapes in Part IV. The student could arrive at sign or symbol formations by an evolutionary process, paralleling the way small children and presumably primitive and prehistoric peoples have arrived at "diagrams," "combines," and "aggregates" from "basic scribbles." Spontaneous marks and shapes could be combined, modified, and crystalized into ideograms or clear graphic emblems. Or one could start with the practical problem of creating a set of signs for such subjects as Entrance, Exit, No Smoking, Telephone, and Post Office which would be understandable by peoples of all races and cultures.)[26]

b● The second phase will be three-dimensional [**VI-3**]. Symbols or motifs evolved in the first phase will undergo further development by yielding some of their autonomy to light and shadow and physical space. Find a cardboard or wooden box of appropriate size and shape and use it as a kind of "shell" in which to create a space-form environment somewhat in the nature of a stage design. But make it something more than an exercise in window display by refusing to merely fill the space with random bits and pieces. Reconstruct the space achitecturally. Determine its dimensions, directional thrusts, and spatial dynamics according to what seem to be the requirements of the feeling-idea.

Cardboard, paper, wood, fabrics, plastics, and other transparent and opaque, rough and smooth materials may be used, provided they lend themselves well to construction. Good craftsmanship is essential to this problem.

Light may be admitted from any direction by means of holes and slits in the box. Artificial light-ing may be used within the box where required, but, whether natural or artificial, illumination must be made to correlate with other elements. It may be allowed, in some instances, to play the dominant role.

The interior may be viewed through a peephole placed high, low, or in the middle of one side of the box, or, indeed, in the top, bottom, or a corner, depending on the nature of the design. Or one whole side of the box may be left open.

This study and all the others outlined in this course are not intended as ends in themselves, like model ships pushed through the necks of bottles; they are meant to be extended conceptually, technically, and imaginatively to problems of greater scope and, hopefully, to new spheres of consciousness. If they are to be of long-range value to the student, they must remain open at all times to further development. No program, however ambitious, can anticipate what this will be or when it will occur, nor can it anticipate very accurately the course of personal creative evolution beyond a certain point.

26] This, in fact, is the theme of articles entitled "Towards an International Symbology," by Stanley Mason, and "Icograda," by Margit Staber, in *Graphis*, 20, No. 116 (1964) 514–19, and, in part, the content of Yusaku Kamekura's book, *Trademarks and Symbols of the World* (London: Studio Vista, 1966).

PRELUDE:
REDISCOVERY OF COLOR STUDIES

1. Paints: water- or oil-based paints (see text) in all available reds, yellows, and blues. A tube of cadmium red (medium), cadmium yellow (light), pthalocyannine blue (Winsor blue, Shiva blue, Rembrandt blue, depending on the manufacturer), and white must be acquired by each student. The other reds, yellows, and blues could be purchased by the class as a group. Before long, however, each student will have to own quite a large selection of paints individually.

2. Brushes: a cheap 2-inch household paint brush and one or more ½- or 1-inch artist's bristle brush, flat.

3. Paper: heavy white paper, large size.

4. Drawing board of suitable size.

5. Portfolio: large size.

6. Palette: a rectangular board, baking sheet, or piece of plastic no smaller than 11 × 14 inches.

7. Miscellaneous: palette knife, rags, newspapers, a coffee can or jar for keeping water or turpentine, a strong, fast-drying glue, a generous collection of colored papers, scraps (see text).

It is strongly recommended that the student obtain a large-ring loose-leaf notebook with both heavy, plain paper and ruled paper for keeping visual material from magazines, newspapers, and so on, and notes and diagrams of all types relating to each problem.

PART I: POINT STUDIES

1. Pencil (5- or 6-B or Ebony), stick charcoal, black and white conté (No. 3), colored pencils or crayons, felt-tip pens.

2. Brush: Chinese bamboo.

3. Paints: assorted designers' colors.

4. India ink.

5. Papers: plain drawing paper (heavy, white, large size), colored construction paper.

6. Materials for stamps: white potato, gum eraser (optional).

7. Cutting tools: pocket knife or paring knife, scissors, single-edge razor blades.

8. Palette.

9. Miscellaneous: wooden dowels, rags, newspapers, cardboard, water container, rubber cement, Elmer's glue-all, fixative, ruler.

PART II: LINE STUDIES

1. Pencil (6-B or Ebony), flat pencil (soft), stick charcoal, black and white conté (No. 3), colored pencils or crayons.

2. Brushes: Chinese bamboo (medium or large), hair or sable brush (1-inch wide, flat), bristle brush (oil painting type, flat), small household paintbrush.

3. Paints: assorted designers' colors.

4. Papers: plain drawing paper (heavy, white, large size), manila paper, newsprint, engineering drafting paper.

5. Pens: crow quill, lettering pen (flat point), split-bamboo type.

6. India ink.

7. Three-dimensional materials: balsa wood strips (¼-inch and smaller), wire, toothpicks (round-type), assorted planks, strips of wood.

8. Miscellaneous: glue (fast-drying airplane model type, Elmer's, and rubber cement),

fixative, straight pins, ruler, transparent triangle, compass, cardboard or matt board, eraser.

PART III: COLOR STUDIES

1. Paint: a complete set of colors, oils or water-based, as in "Rediscovery of Color"; the three primaries and black and white, plus orange, alizarin crimson, violet, ultramarine blue, turquoise, permanent green (deep), and, perhaps, one or two of the Mars colors.

2. Other items: see materials for "Rediscovery of Color."

PART IV: SHAPE, PLANE, AND FORM STUDIES

1. Pencil (6-B), stick charcoal, black and white conté crayon (No. 3), colored crayons.

2. Hair or sable brush (1-inch wide, flat), bristle brush (flat).

3. Assorted designers' colors, India ink.

4. Papers: plain drawing paper (heavy, white, large size), manila paper, construction paper (assorted colors), newsprint, cellophane.

5. White plaster, balsa wood, hardboard, cardboard, corrugated paper, poster paper.

6. Miscellaneous: cabinet rasp, Surform rasp, penknife, plaster spatula, matt knife or single-edge razor blade, 2- and 3-dimensional scraps of all types, newspapers and magazines, fast-drying glue, Epoxy glue, fixative.

PART V: NATURE STUDIES

1. Pencil, charcoal, conté crayon, colored crayons, etc.

2. Paper: plain drawing paper (heavy, white, large size), paper products of all types (cardboard, corrugated paper, construction paper, etc.).

3. Brush.

4. Assorted designers' colors or other paints.

5. Miscellaneous: glue, scissors, matt knife or razor, etc.

PART VI: MOOD STUDIES

1. Pencil, brushes, pen and ink, conté crayon, colored crayons.

2. Plain drawing paper or illustration board, colored and textured papers of all sorts, cellophane, fabrics.

3. Assorted designers' colors or other paints.

4. A wooden or cardboard box of suitable size and shape, cardboard, construction paper, corrugated paper, *papier-mâché* egg trays, chicken wire or hardware cloth, fabrics, plastics, tape.

5. Miscellaneous: glue, scissors, matt knife, or razor.

INDEX

INDEX

Boldface number indicates illustration.

M

McCormick, Jack, 171n
Macintosh, Charles Rennie, 63
McLuhan, Marshall, 2n, 7n, 35, 46, 170n
MacNichol, Edward F.: on color perception, 90n
Malevich, Kasimir, 69
Mallarmé, Stéphane, 180
Malraux, André, 52, 183n
Manet, Edouard, 52: influence on Impressionists and Cézanne, 147; his *peinture claire*, 96; "Portrait of Émile Zola," **146**; precursor of Impressionism, 105, 124; use of overlapping planes, 147; use of warm and cool tones, 110
Marchand, André, 126, 129
Marey, Étienne Jules: study of movement, 165
Marks, 40
Masaccio, 62
Mason, Stanley, 187n
Masson, André, 76: color freedom, 112
Materials (and tools), 4, 42, 188–90
Matisse, Henri, 35, 64, **65**, 119, 159: achievement and influence, 129; anticipated by Manet, 147; as colorist, 86, 89; color and line independence, 112; on curves, 79n; "Piano Lesson" (1916) **P-2**; on proportion (extension) of colors, 112n; use of open and closed structure, **153**; use of outlining, 104; on use of "simple colors," 109n
Maxwell, J. C. (*see* Photography)
Mead, Margaret, 27n
Medieval decorators: as colorists, 89
Metric system of measure, 54
Mexican pottery, **10**
Michelis, P. A., 7n
Miró, Joan, 76, 181: color freedom, 112; transformation of source, 177n, 180n (*see also* Dupin)
Möbius strip, 150
Modelling (*see* Chiaroscuro): versus "modulation" in the art of Cézanne, 148
Module, 150
Mondrian, Piet, 119
Monet, Claude (*see* Impressionism): influence on Bonnard, 125; use of contrast of temperature, 110

Montessori, Maria, 2: on the development of sensory perception, 174
Moore, Henry, 181: sculpture and light and space, 113; sentiment and paradox, 183
Moreau, Gustave, 86
Morrison, Philip, 53n
Motherwell, Robert, 3n: on color extension, 151n; use of open and closed structure, **153**
Motif, 164, 181: definition, 12, 13; linear, 69; linear (2- and 3-dimensional), 80; point motifs (stamps), **18**, **19**
Movement, 71, 72 (*see also* Balance; Point; Tension): in architecture, 64; climactic and non-climactic, 80; climactic and non-climactic in art, drama, music, or literature, 167; in form and space, 68; linear and spatial, 81, 82; pictorial 64, 67; rhythmical and non-rhythmical, 48; as in a frieze or scroll, 80; and space, 166, 167
Munari, Bruno: on the circle (and the square), 56n, 181n
Mundt, Ernest: on concepts of form and space in several eras, 182, 183
Munsell color system, 86: the Munsell "tree," 87, 90; on the naming of colors, 91
Music, **12**, 57, 106, 107: chromatic and musical intervals compared, 120, 121; and color, 89; compared with art, 95 (*see also* Cage; Beethoven; Harrison; Partch; Stravinsky)
Mutual repulsion or clash: definition, 119; and color separation, 121, 122

N

Nairn, Ian: on architecture, 68n
Nakashima, George, 54, **55**
Natural order of color, 122, 123 (*see also* Discord)
Nature: color in, 6; differing conceptions or presuppositions and their consequences, 168
Neo-plasticism: use of color-plane, 147 (*see also* Mondrian)
Newman, Barnett, 112
Newton, Sir Isaac: prismatic colors, 91
New York Armory Show (1913), 109